The Complete Editor

The Complete Editor

Second Edition

James Glen Stovall
Emory and Henry College
Professor Emeritus, University of Alabama

Edward Mullins
University of Alabama

Boston New York San Francisco
Mexico City Montreal Toronto London Madrid Munich Paris
Hong Kong Singapore Tokyo Cape Town Sydney

Series Editor: *Molly Taylor*
Series Editorial Assistant: *Michael Kish*
Senior Marketing Manager: *Mandee Eckersley*
Editorial Production Service: *Omegatype Typography, Inc.*
Composition Buyer: *Linda Cox*
Manufacturing Buyer: *JoAnne Sweeney*
Electronic Composition: *Omegatype Typography, Inc.*
Cover Administrator: *Linda Knowles*

For related titles and support materials, visit our online catalog at www.ablongman.com.

Between the time web site information is gathered and then published, it is not unusual for some sites to have closed. Also, the transcription of URLs can result in typographical errors. The publisher would appreciate notification where these errors occur so that they may be corrected in subsequent editions.

Library of Congress Cataloging-in-Publication Data

Stovall, James Glen.
 The complete editor/James Glen Stovall, Edward Mullins.—2nd ed.
 p. cm.
 Rev. ed. of: On-line editing. © 1994.
 Includes index
 ISBN 0-205-43463-0 (alk. paper)
 1. Journalism—Editing. 2. Journalism—Data processing 3. Newspaper layout and typography. I. Mullins, Edward. II. Stovall, James Glen. On-line editing. III. Title.

PN478.E5S86 2006
070.4'1'0285—dc22

 2005043184

Printed in the United States of America
10 9 8 7 6 5 4 3 2 1 VHP 09 08 07 06 05

Contents

Preface ix

Chapter 1 The Job of the Editor 1

The Job of the Editor 3
Tools of an Editor 4
The Making of News 5
Beginning the Editing Process 7
Modern Challenges 13
Exercises 15

Chapter 2 Tools of the Editor 25

Grammar 27
Punctuation 29
Spelling 30
Dealing with Words 31
Common Writing Errors 33
Keepers of the Language 37
Exercises 38

Chapter 3 Style and the Stylebook 54

Wire Service Stylebooks 56
Journalistic Conventions 57
Language Sensitivity 60
Attention to Detail 62
Exercises 63

Chapter 4 Accuracy, Clarity, and Brevity 74

Accuracy 76
What to Check 78
References 79
Clarity 80
Brevity 84
Types of Writing 84
Four Characteristics of Media Writing 87
Exercises 88

Chapter 5 The Complete Editor 100

The Editor–Writer Relationship 101
Responsibilities of the Editor 102
Honesty and Fairness 105
Skepticism 105
Acting Ethically 106
The Five Commandments 112
Exercises 114

Chapter 6 Headlines and Summaries 132

The Job of the Headline 136
Types of Headlines 137
Principles of Headline Writing 140
Guidelines 143
Summaries 144
Conclusion 146
Exercises 147

Chapter 7 Pictures 155

The Photo Editor 156
Selection 157
Cropping 160

Digital Photography 164
Pictures on the Web 165
Ethics and Taste 167
Cutlines 169
Exercises 172

Chapter 8 Infographics 178

The Graphics Revolution 179
Defining Graphics Journalism 181
Type-Based Graphics 182
Chart-Based Graphics 185
Illustration-Based Graphics 188
Developing Infographics 193
Conclusion 195
Exercises 197

Chapter 9 Design and Layout 221

Visual Logic 222
Tools of Design 224
Newspaper Design 230
Types of Newspaper Design 231
Principles of Layout 233
Twelve Rules 236
News Judgment 239
Magazine Design 241
Web Design 243
Conclusion 245
Exercises 246

Chapter 10 The Editor and the Law 275

The Legal System 276
The First Amendment 278
Libel 279
Defenses against Libel 281
Constitutional Defenses 281

Privacy 284
Defenses against Invasion of Privacy Charges 286
News Gathering 286
Constant Vigilance 289

Appendix A Copy Editing Symbols 290

Appendix B Diagnostic Test 291

Appendix C Creating Charts in Excel 298

Index 305

Preface

When *On-Line Editing* first appeared in the early 1980s, journalism and journalism education were experiencing the first wave of the digital revolution. The book was designed to help students prepare themselves for editing by understanding and using the new tools that would be available to them. We tried to anticipate the technological developments that would take place.

Now, almost twenty years later, many of the hardware and software questions involving the editing process have been settled. Graphic interfaces, laser printing, digital photography, and the Internet are well-established technological feats. With this technology in place, the purpose of this book remains the same as it was originally: to help students learn to edit intelligently and competently by using the most up-to-date editing tools.

This new edition of *The Complete Editor* significantly updates *On-Line Editing* and previous editions of *The Complete Editor.* Our original purpose remains the same: to describe and explain the basics of the editing process. We have expanded the book to give more specific instruction in a variety of areas, such as layout and design and infographics. Because learning often occurs by doing, the book has exercises designed for in-class use so that students can conduct most of the steps of the editing process. We have significantly beefed up the number and variety of editing exercises, and we have added information about working with news web sites throughout the book.

Editing is important work, and it is real work, comparable to what carpenters and masons do in the building trades. But editing is also an important part of the journalism profession practiced by people who love words, clear thinking, and efficient communication. Editors are anything but paper pushers or, to update the phrase, computer hacks. Editing is a great job for the Information Age, one of the most useful in many venues. Editing jobs require hard work, but they are also exciting and satisfying. Editors build bridges that bring people and ideas together. Welcome to the world of editing.

In practicing what we preach, parsimony, we have also followed AP style for the most part, since it is the standard for virtually all of U.S. journalism.

Many people deserve our appreciation and gratitude for their help on this edition of the book:

Charles Arrendell was the first inspiration for this book. As chair of the Department of Journalism at the University of Alabama in the late 1970s and early 1980s, he encouraged and supported our initial efforts to put this publication together. Charles died a number of years ago, and we still miss him.

Our colleagues at the University of Alabama have been unfailingly supportive and helpful. Our good friend Matt Bunker was kind enough to look over the legal chapter of this book (Chapter 10) and save us from any embarrassment. Others who contributed in ways of which they were not always

aware are Kim Bissell, David Sloan, George Daniels, David Perry, and Wilson Lowrey, just to name a few.

On the Emory and Henry College campus, Teresa Keller, Tracey Lauder, Herb Thompson, and Paul Blaney have been kind and supportive of these efforts. Our special thanks goes to Ed Davis who supplied the data map used as an example in Chapter 8.

Bailey Thomson deserves special mention here. Not only did we enjoy his professional expertise, but we also reveled in his friendship. Bailey had as near to perfect understanding of the profession of journalism as anyone we have ever met, and his sudden death in 2003 left us feeling shortchanged. We miss him greatly and freely acknowledge that his fingerprints are all over this book.

Amy Kilpatrick was particularly generous in supplying many of the pictures used in this book. Cindy Coulter's careful reading of the manuscript of previous editions of this book has had a great influence on this edition.

Others who deserve more than just thanks are Bill Parker and others at the Chicago *Tribune*; Celeste Bernard for her essay on infographics; Molly Taylor and Michael Kish at Allyn and Bacon who shepherded this edition into publication; and our students, who after thirty years, continue to inspire and challenge us. We would also like to thank those who reviewed this edition for Allyn and Bacon: Loran E. Lewis, Jr., California State University, Fresno; Jim R. Martin, University of North Alabama; Carlton M. Rhodes, University of Arkansas at Little Rock; and Gloria Ruane, West Virginia University.

There are many, many others who deserve our thanks. We have been blessed with many generous friends and professional colleagues over the years.

Finally, our families—Sally and Jeff Stovall and Penny Mullins—showed more patience with us than we probably deserve while we obsessed about this book over many years. We thank them very much.

Jim Stovall
Emory, Virginia

Ed Mullins
Tuscaloosa, Alabama

The Complete Editor

chapter

1

The Job of the Editor

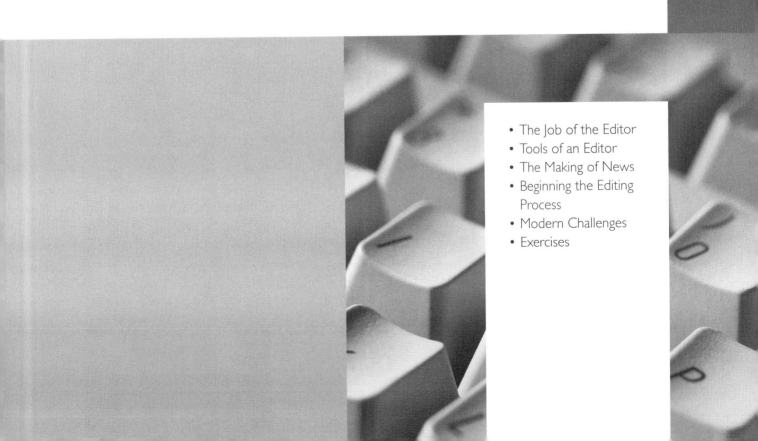

- The Job of the Editor
- Tools of an Editor
- The Making of News
- Beginning the Editing Process
- Modern Challenges
- Exercises

The St. Paul *Pioneer Press* shocked its readers—many of them avid fans of the University of Minnesota Golden Gophers basketball team—on March 10, 1999, by publishing a story that exposed academic dishonesty by members of the team and its coaches. The story, which had been weeks in the making, appeared in print just one day before the team was set to tip off against the Gonzaga Bulldogs in the first round of the NCAA tournament. Many Gophers fans believed that the team had a chance to make it to the Final Four that year.

Instead, because of the story, four members of the team, two of them starters, were immediately suspended, and Minnesota lost to Gonzaga the next night, ending the hopes of many of the newspaper's readers that their team would be part of the collegiate basketball elite.

The timing of the story had put the editors in a quandary. The story had been carefully researched by reporter George Dohrmann, who worked closely with sports editor Emilio Garcia-Ruiz. The two had told no one else on the staff about it for several weeks, fearing that word would get out and that the Minneapolis *Star*, the *Pioneer Press*'s major competitor, would start its own investigation. Every important detail needed to be confirmed or documented in some way, and that took time. Sources were reluctant to talk, and when they did, it was hard to get them to respond immediately.

Finally, around March 1, as the basketball season was drawing to a close, the story came together. The major parts of the story were solid. An academic counselor had written papers for a number of players; coaches had been aware that this had happened; and the athletic department had covered it up when the NCAA had heard something and inquired about it. Dohrmann spent several days nailing down the final parts of the story, and by March 9 it was ready.

But then there was the question of timing. The next night, the Gophers would play their first tournament game. Should the newspaper hold the story until the tournament was finished or at least until the Gophers had been eliminated? Would that be fair to the readers—or the teams that the Gophers were playing? What if the newspaper held the story, even for a day, and the *Star* or some other news organization got wind of it and broke it first? A scoop that had taken a reporter months to put together would be gone.

In the end, there was little choice. The story had to be printed. When it was and the Gophers lost the tournament opener, the editors came in for some blistering criticism from their readers and from Minnesota partisans. Even then-Governor Jesse Ventura weighed in, accusing the newspaper of "sensational journalism" and timing the story to hurt the team.

Scoops, the watchdog role of the press, the drive to beat the competition, angering readers—the story of the St. Paul *Pioneer Press*'s exposure of the Minnesota cheating scandal has all of these elements of modern journalism. (A complete and fascinating account of this drama is at the Journalism.org web site, http://journalism.org/resources/education/case_studies/minnesota.asp.) At the heart of the drama are the editors. While a careful and persistent reporter researched and wrote the story, editors made key decisions every step of the way to pursue and publish it. And it was the editors who faced an angry public when the story broke.

Journalism is a collaborative effort, and the people who make that collaboration work are editors. From copy editors who help writers to craft the language of their reports to executive editors who make key decisions about the direction of their publication, editors are vital to the production of what we know as journalism.

The Job of the Editor

No one has a more important job in today's media environment than the editor. Editors take on responsibilities far beyond those of a writer. Editors must not only be responsible for the work of reporters and writers but also have the whole publication in mind in going about their routines. They must understand the publication's purpose and approach in handling information and serving audiences. Editors must know the language and style rules of their publication. They must lead, cajole, and sometimes force their writers into doing their best work.

Editors must understand context. They must be sensitive to the nuances of how information fits together. They must have enough memory about recent and ancient events that they can judge the nature, credibility, and legitimacy of the information they present.

Editors must be deeply steeped in the culture of journalism. As a part of their nature, they must understand the importance of accurate information and the generally accepted procedures for ensuring accuracy. They must value the faith, trust, and intelligence of their audience. They must know that hard work is the norm—something that the profession assumes but also rewards.

Editors must also lead. They must have the highest standards and expect others in their environments to meet those standards. Their very attitudes and approaches to the daily routine of editing should tell all those around them that honesty, integrity, hard work, devotion to accuracy, intelligence, and humanity are the norm.

The job of the editor is more than just fixing copy and designing a good page. The editor sets the standard and tone for the kind of journalism that is practiced at a publication. That is why the job of the editor is the most important.

Figure 1.1

E. O. Wilson
On the need for editors

Thanks to science and technology, access to factual knowledge is destined to become global and democratic.... What then? The answer is clear: synthesis. We are drowning in information, while starving for wisdom. The world henceforth will be run by people able to put together the right information at the right time, think critically about it and make important choices wisely.

E. O. Wilson
Pulitzer Prize–winning scientist and author
Washington Post, June 11, 1998

Every place that handles information and puts it into some form for distribution needs an editor, a person who understands the information, the procedure by which it will be processed, and the medium through which it will be disseminated. We might traditionally think of editors as working for newspapers or magazines, but editors—no matter what their job titles—are everywhere. This Information Age cannot do without them.

Tools of an Editor

The tools of an editor have changed drastically in a short period of time. Only a few years ago the principal tools were pencils, eraser, paper, scissors, and glue. A typewriter was required for rewriting or headline writing. For headline writing the editor would need a head count guide. For layout and picture sizing, picture wheels, dummy sheets, and pica poles (a printer's ruler) were necessary.

Another tool that an editor needed was a set of copy editing symbols (see Appendix A). These symbols were used to correct copy in a standard and understandable way. One of the major purposes of hard copy editing was to prepare copy to be sent to a typesetter. In addition, an editor needed certain reference materials, such as a stylebook, a dictionary, a thesaurus, a city telephone directory, an atlas, an encyclopedia, and an almanac.

Today, these tools have been largely replaced by the computer. Editors use computers to call up stories, make changes in them, and save the files. They use computers to lay out pages, write headlines, and crop photos. Some computers even have reference materials, such as a dictionary, city directory, and stylebook, stored within their memory, so editors might not even need these books to sit on their desks. And, of course, editors today also have the Internet, a potential reference gold mine.

Although the tools of editing have changed a great deal, the most important tool of editing has not changed: The brain is the editor's ultimate tool. If an editor does not use that tool, all the physical aids in the newsroom will not help.

Editors must have agile minds. They must have a wide assortment of facts and concepts they can call up for instant use. They must know history and literature. Their knowledge of grammar and punctuation must be thorough. They need not be expert spellers (although it certainly helps), but they must be able to spot and question possible misspellings. They should know their communities geographically and socially. They must know where to get information as well as a reporter does; many editors spend a good deal of their time developing their own sources.

Editors must be able to find mistakes and to question what they do not understand. If an editor does not understand something in a story, few readers will. Editors must also be able to spot errors in logic or lapses in common sense. They should be wordsmiths, people who not only know how to use words precisely but also have a feel for the language and a love for good writing.

In addition to all of these traits, editors must have in their heads a clear idea of what kind of publication they are producing. They must know what is and what is not appropriate, what similar or opposing publications are doing, and the ins and outs of their own operation. Editors must edit with readers in mind, and to do that, they need some information on who the readers are and what they expect from the publication.

The editor described here is not superhuman. In fact, many such editors exist on many publications. But they did not become editors of high caliber overnight. For most it took years of hard work and concentration to acquire the tools of a good editor. And for all such editors maintaining and adding to those tools is a matter of constant effort. Students who wish to become editors must begin now by sharpening their skills and expanding their knowledge and sensitivity.

The Making of News

News does not happen naturally. It is the result of decisions made by journalists, particularly editors. Editors decide what events their news organizations will cover and what events will be ignored. Something mundane or routine can become a major news event because of the decisions of a few editors and news directors. A similar event (and possibly one that is more important) might be passed over completely.

The decisions about what is and is not news are based on some traditional news values that are widely shared in the field of journalism. Beginning students need to understand these values, for they are the basis upon which journalists decide whether or not an event is news. It should be noted that not all information that editors handle is news in the strictest sense. Much publication content is just useful information, such as library hours and bus schedules. Anything that an editor handles, however, deserves his or her best effort. Millions of events occur in our society every day. Only a few of them are selected by editors, and at least one of the following criteria must be present for an event to be classified as news.

Impact. Events that affect people's lives are classified as news. The event itself might involve only a few people, but the consequences may be wide ranging. For example, if Congress passes a bill to raise taxes or if a researcher discovers a cure for a form of cancer, the action will affect large numbers of people. These events would have impact, and they would be considered news.

Timeliness. Timeliness is a news value that is common to almost all news stories as well as to the useful information previously mentioned. Timeliness refers to the recency of an event. Without the element of timeliness most events cannot be considered news. For example, a trial that occurred last year is not news; a trial that is going on right now could be news. How much time has to elapse before an event can no longer be considered news? There is no specific answer to that question that will apply in every case. Most events that are more than a day to a day and a half old are not thought to be news. (Look in today's newspaper or watch a television news program to see whether you can find a news story about an event that occurred two days ago.)

Prominence. Prominent people make news, sometimes even when they are doing trivial things. The president of the United States is a prime example. Whenever he takes a trip, even for purely personal and private reasons, his movements are covered in great detail by the news media. The president is a

prominent and important person. Anything he does is likely to have an impact on the country, and people are interested in his actions. The president is not the only example of a prominent person who often makes news. Movie stars, writers, athletes, advocates of social causes—all of these people make news simply because they are well known. Or are they well known because they made news? Communication scholars would say both.

Proximity. Events close to home are more likely to be news than the same events elsewhere. For example, a car wreck that kills two people on a road in your home county is more likely to be reported in the local news media than the same kind of wreck a thousand miles away. We are interested in the things that happen around us. If we know a place where something goes on, we are more likely to picture that event and have a feeling for it and for the people involved.

Conflict. When people disagree, when they fight, when they have arguments—that's news, particularly if one of the other news values, such as prominence, is involved. Conflict is one of the journalist's—and the reader's—favorite news values because it generally ensures that there is an interesting story. One of the reasons courtroom trial stories are so popular with newspaper readers as well as with television watchers is that the central drama involves conflict: competing forces, each vying to defeat the other.

The bizarre or unusual. That which rarely happens is sometimes considered news. There is an adage in journalism: "When a dog bites a man, that's not news; when a man bites a dog, *that's* news." The adage refers to events that are relatively unimportant or that may involve obscure people, but they are interesting to readers and they enliven a publication. For example, it is not news when someone's driver's license is revoked (unless that someone is a prominent person); it is news, however, when the license that is revoked belongs to a person called "the worst driver in the state" because that person has had twenty-two accidents in the past two years.

Currency or trends. Issues that have current interest often have news value, and events surrounding those issues can sometimes be considered news. For example, a panel discussion of doctors might be held in your community. Normally, such a discussion might not provoke much interest from journalists. However, if the discussion topic were "The Morality of Abortion," the news value of the event would change, and there would likely be a number of newspaper, radio, and television journalists covering it. Issues with this value come and go, but there are always several such issues being discussed by the public.

A news editor must make decisions about the events to be covered on the basis of these news values. News values should be used in deciding the kind of information needed for a story and in helping the writer to organize the story so that the most important and most interesting information gets to the reader in the most efficient manner.

A journalist who is gathering information, writing a story, or editing one tries to answer the following six basic questions for the reader:

- *Who.* Who are the important people in the story? Is everyone included so that the story can be accurately and adequately told? Is everyone properly identified?

- *What.* What is the major action or event of the story? What are the actions or events of lesser importance? A journalist ought to be able to state the major action of the story in one sentence, and this should be the theme of the story.
- *When.* When did the event occur? Readers of news stories should have a clear idea of when the story took place. The *when* element is rarely the best way to begin a story, because it is not often the most important part, but it should come early in the story and should be clearly stated.
- *Where.* Where did the event occur? Journalists cannot assume that readers will know or be able to figure out where an event took place. The location or locations of the event or action should be clearly written.
- *Why and How.* The reader deserves an explanation of events. If a story is about something bizarre, unusual, or confusing, the writer should offer some explanation so that questions that the story raises in the reader's mind are answered. The writer also needs to set the events or actions in a story in the proper context. Reference should be made to previous events or actions if they help to explain things to the reader. Editors need to ensure that writers have done all of these things.

Beginning the Editing Process

The basic job of the editor is making decisions. Editors must understand their publications and their audience and make decisions that further the traditions of the publication and meet the expectations of the audience. Editors must also decide what reporters cover and what stories they write. They must decide on how those stories are structured and written. This book will deal with many of the decisions that the editor has to make.

Most editors, no matter what level they achieve within the news organization, begin their work as copy editors. That is, they read the work that other people have written and improve it. Even as they rise in the organization, most editors continue to be involved in copy editing to some extent. Copy editing is basic, and that is where we will begin. Examining the procedures of copy editing is also a good way of looking ahead at many of the principles and concepts of this book.

On a day-to-day basis, no set of decisions is more important than those the copy editor has to make with every story that he or she reads. The basic procedure of editing is reading a piece of copy, correcting technical mistakes (spelling, grammar, punctuation) and other problems of the copy, and making a judgment about the suitability of the copy for publication. Editors also direct coverage and plan content, deciding which events, ideas, and issues the rest of the world will find in their mass media. In doing all this, editors have several options: They may decide that the copy can be published with few or no changes; they may ask the reporter to rewrite it to add new facts or to give it a new emphasis; they may delay its publication for a more appropriate time; or they may decide that the copy or the subject matter is not the kind that should go into their publication and may "kill" or "spike" the copy.

An editor is generally the first reader of the story after it has been written (the first, we would hope, of many). The editor of a story is in many ways its most important reader because it is the job of the editor alone to make copy presentable to readers. If the editor does not do this, no one else in the editorial process will.

Ideally, a copy editor should be able to read through any story at least three times. Sometimes, of course, there isn't time to do that, but here we will assume that for any given story the time is available. Here is how that time should be used.

The first reading of any story should be a fairly quick one. This reading allows the editor to get the feel of the story—to find out what it is about and to spot any major problems that are readily identifiable. The editor should note the story content and structure. This first reading might be all that an editor needs to realize that the story should go back to the reporter for rewriting. As much as possible, editors should do first readings as if they know little or nothing about the subjects. This, of course, is the position of the average reader on first reading the story.

If the editor deems the story good enough for the rest of the editing procedure, the second reading should take place much more slowly. It is during this reading that the major editing is done. Accuracy, clarity, and brevity are the major goals of the editor. With these goals in mind, one should use the following procedures in editing any story.

The lead. The editor should pay particular attention to the first paragraph (often called the lead and pronounced "LEED") or, in the case of the magazine article, the introduction. It is the most important part of a story. A good lead will get the reader into a story; a boring or confusing lead will send the reader somewhere else. Does the lead convey the most important information of the story (if it is a news story)? Does it give the reader an accurate idea of what the story is about? Does it raise expectations in the reader that will be fulfilled by the story? Does it emphasize the proper facts? Does it need to be updated or localized?

Story structure. After the lead, the editor should deal with the organization of the story. Is the story put together in a logical manner, especially with regard to the lead? Facts should be given in a manner that will satisfy the reader. Not all of the facts can be given at once, nor should they be. The story should develop in a way that allows the reader to understand the information the story is attempting to convey. The editor's job is to make sure that happens.

Completeness. Every story should have all the facts necessary for the reader to understand the story. Although reporters and editors must make certain assumptions about the readers' prior knowledge, these assumptions must not be carried too far. For instance, an editor who is dealing with a city council story cannot assume that the reader has read last week's city council story. If some action that the council takes is a follow-up to action taken the previous week, the story must explain that.

Another area of completeness that is often overlooked involves the failure of a story to provide all of the facts the reader has been led to expect. A story might talk about a new day-care center that is about to open. The reader,

particularly a parent who might want to use the center, would want to know what hours the center plans to keep, what age children it will accept, and how much the care will cost. A story without such facts would be incomplete.

Grammar, spelling, and punctuation. A knowledge of grammar and punctuation and of how to use a dictionary are basic abilities an editor must have. No editor will survive without them. Words must be spelled correctly, and grammar and punctuation must conform to standard rules of English. The editor who consistently allows incorrect grammar and misspelled words into a publication is failing on the most basic level, and such a publication cannot maintain credibility.

Style. Every publication should have a set style, and every editor should ensure that the publication conforms to this style. Most newspapers use the *Associated Press Stylebook* and supplement this with a local stylebook. Style should not be a straitjacket into which an editor forces all copy; rather, it should be a help to writers and editors in achieving accuracy and consistency.

Objectivity. Is the story fair? Has the reporter attempted to gather all points of view? Are the facts slanted toward a particular opinion? Many journalists feel that objectivity is an unattainable goal, yet it remains a goal and tradition of American journalism, and the editor is the best insurance that this goal is being actively pursued. Point-of-view writing is permitted in some parts of the newspaper, particularly the editorial and sports pages, and "attitude" writing is the stock in trade of many magazines. But young writers and editors must first be seasoned in the discipline of objectivity before venturing too far outside that tradition.

Names and titles. Journalists should be particularly careful in the handling of names and titles, and editors must make every effort to ensure their accuracy. Names that have unusual spellings should always be checked. Editors need to remember that even the most common names can have uncommon spellings (such as Smith, Smyth, and Smythe). Nothing should be taken for granted in dealing with a person's name. There is no quicker way for a publication to lose credibility than by misspelling a name.

Titles, too, need special care. Formal titles should be correctly stated; they are extremely important to the people who hold them. Titles should also be descriptive of the jobs people have. If they are not, editors may consider adding a line of job description in the story if this will clarify things to the reader.

Taste, tone, and mood. A hilarious story about a car that flips over and bounces around a road isn't so amusing if two people were killed in the wreck. Editors should ensure that their stories convey the proper tone and mood and accurately reflect the facts. In deciding about taste, an editor often will have to weigh the importance of the facts and people in the story. For instance, when a president goes to the hospital for an operation on his hemorrhoids, an editor will have to decide whether that situation is important enough to merit a story. There are no ironclad rules governing taste, tone, and mood; there are only editors who have the sensitivity to make thoughtful and logical decisions.

Quotations and attribution. Good editors understand how to use quoted material properly. A good news story usually has a mixture of direct and indirect quotations, and a news writer must have a good sense of when to use them.

Most news stories will use more indirect quotations than direct quotations. An indirect quotation may contain one or a few of the same words that a speaker has used but will also have words that the speaker did not use.

Indirect quotations should maintain the meaning of what the speaker said but use fewer words than the speaker used. Competent writers quickly learn that most people use more words than necessary to say what they have to say. Writers and editors can paraphrase what people say and be more efficient than the speakers themselves. Journalists can get more information into their stories if they use indirect quotes.

If that is the case, why worry about using direct quotations at all? Why not just use indirect quotations all of the time?

Skillful writers and editors use direct quotations to bring a story to life, to show that the people in the story are real, and to enhance the story's readability. Occasionally, people will say something in a memorable or colorful way that the writer should preserve. Think about some of the famous direct quotations in American history:

"Give me liberty or give me death." *Patrick Henry*

"Read my lips. No new taxes." *George H. W. Bush*

"We have nothing to fear but fear itself." *Franklin Roosevelt*

"Four score and seven years ago . . ." *Abraham Lincoln*

Another reason for using a direct quote is that some quotations simply cannot be paraphrased. They are too vivid and colorful, and they capture a feeling better than a writer could. For instance, when Brent Fullwood was playing college football for Auburn, he was once stopped from making a game-winning touchdown against archrival Alabama as time was running out. Rory Turner, the linebacker who made the hit on Fullwood, was asked about the play after the game. Still high from his accomplishment, he said, "I waxed the dude!" That quotation would be impossible to paraphrase.

The following are some of the basic rules for using direct quotations in news stories:

- Use the speaker's exact words. Anything that is within quotation marks should be something that the speaker actually said. The words should be the speaker's, not the writer's.
- Use direct quotations sparingly. Good writers and editors will let people speak, but they won't let them ramble on. Most news writers avoid putting one direct quote after another in a story. Piling direct quotations on top of one another does readers little good.
- Use direct quotations to supplement and clarify the information presented in the indirect quotes. In a news story a direct quote is rarely used to present new or important information to the reader. It is most commonly used to follow up on information that has already been put in the story.

Knowing how to deal with direct and indirect quotations is one of the most important skills that a news writer or editor can acquire. It takes some practice to paraphrase accurately and to select the direct quotations that should be used in a story. The key to both is to listen—listen carefully so that you understand what the speaker is saying and so that you remember the exact words that the speaker has used. For the editor a sensitivity to the good quotation and to the reader's tolerance must be developed.

The correct sequence for a direct quote and its attribution is DIRECT QUOTE, SPEAKER, VERB. This sequence is generally used in news stories because it follows the inverted pyramid philosophy of putting the most important information first. Usually, what has been said is the most important element a journalist has; who said it, assuming that the person has already been identified in the story, is the second most important element; the fact that it was said is the third most important element.

One of the common faults among news writers is the inverted attribution: putting the verb ahead of the speaker.

"I do not choose to run," said the president.

This example violates one of the basic structures of English sentence: Subjects normally come before verbs. Remember, one of the major goals of the journalist is to make the writing of a story unobtrusive and the content of the story dominant. Sticking with basic English forms is one of the ways in which the journalist can do this.

One additional note: In publications, use the past tense of verbs in news stories unless the action is continuing at the time of publication or unless it will happen in the future. Writing

"I do not choose to run," the president says.

is inaccurate unless the president goes around continually saying it. Chances are that it was said only once. It happened in the past, and that's the way it should be written. Although you can find examples of the use of the present tense in many publications, it is not standard treatment. As with most rules, there are valid exceptions. For example, the style of most broadcast reports is to use the present tense even though the event has already happened, and the *Wall Street Journal* and many magazines use the present tense for all or most attribution verbs. Although that might work for the magazines and the *Wall Street Journal,* it is not the standard way to handle attribution for newspaper and Web journalism. Other tense exceptions, which we will cover later, are cutlines and headlines. Most headline and cutline verbs employ the present tense even though the events they describe usually have already happened.

Triteness and clichés. Even the most common news stories should have some freshness about them. Editors need to be sensitive to the fact that some words and phrases are being overused in their publications, and they should periodically attempt to change their habits. "Dead on arrival," "straight as an arrow," "very," "basically," "quite," "mainly," "really," and "actually" are all words and phrases that can easily show up too many times in a publication.

Transitions. Few things contribute more to the clarity of a story and the ease of reading than proper transitions. Readers should be able to follow the development of a story easily. Each succeeding part of a story should be tied to a previous part of the story. Readers should not be jolted by some totally new subject in the middle of a story. Transitions of sense—in which key ideas and phrases are alluded to—are better than transitions that depend on obvious transition words such as "moreover," "however," or "nevertheless."

Wordiness. A story should not be one word longer than necessary to maintain accuracy and clarity. Most reporters, especially young ones, use too many words. Editors should be on the lookout for such expressions as "a total of," "in order to," "as a result of," and "at this point in time."

Repetition and redundancy. Speakers who use the same words over and over quickly become boring, and so do writers. English is a language with a large variety of words that are easily understood by most people. Reporters and editors should take advantage of this variety and make sure they don't repeat major nouns, verbs, or adjectives in one sentence or paragraph.

A redundancy is a phrase or set of words in which the same meaning is transmitted twice. Some redundancies make writers and editors look foolish. "A dead corpse," "we should not forget to remember," and "apathetic people who don't care" are phrases in need of editing.

Libel. Watch the way in which people are described and quoted in a story. Will a person be held up to public ridicule because of the story? Will someone's position in the community be damaged? Is it possible that anyone will be deprived of livelihood because of the story? Remember that not only people but companies, associations, and products can be libeled. Editors should be particularly careful when a story deals with illegal, immoral, or unethical activity and should make sure that what the story says is correct and that the reporter has made every effort to write a complete story. But it is not only fear of libel that should keep us from mistreating people. As editors, we should respect our sources and our readers and show compassion for them in every situation.

Offensive language. Different publications maintain different policies on printing offensive language. Not too many years ago, the words "hell" and "damn" were regularly expunged from a story. Today, much stronger language finds its way into many publications. The editor's job is to see that the publication's policies are carried out. If no such policy exists, one should be developed that takes into account the goals of the publication and the sensibilities of its readers. As with most editorial decision making, it always helps to confer with others on sensitive matters.

Responsibility. An editor is responsible for any piece of copy that he or she handles. Copy that is confusing, that raises unanswered questions in the reader's mind, or that does not give the reader complete information should not be put into a publication. An editor never has the excuse, "Well, I knew there was something wrong with that story, but there was nothing I could do about it." If there is something wrong with the story that an editor cannot fix, the story should go back to the reporter. No editor can evade the responsibility for the copy that he or she handles.

Figure 1.2

We hold these truths

Everyone needs an editor. Thomas Jefferson presented his first draft of the Declaration of Independence to a committee composed of himself, John Adams, and Benjamin Franklin. Adams and Franklin both suggested changes in content and wording.

Modern Challenges

In addition to the difficulties and demands that confront them each day, twenty-first century editors face a variety of challenges that are unique to this era. Although each generation of editors has had its own contemporary problems, these have often had to do with changing technology or difficult political or social situations. Such situations also face today's editors, but they are burdened with problems that other editors have never faced.

One such problem is the multiplicity of news organizations and the wide variety of choices that readers and viewers have for obtaining news and information. Editors of previous generations knew that for most of the audience, access to news and information was limited to a relatively few outlets. This is no longer the case. The World Wide Web and a plethora of twenty-four-hour television news channels vie for the audience's time and attention. A television viewer with reasonable cable access may have as many as a dozen news channels available at one time. A Web user can get news and information from a

seemingly endless number of web sites. Even a newspaper reader can usually obtain more than the local newspaper on just about any city street corner. Gaining the attention of individual members of the audience has become an increasingly hard thing to do.

For editors of print publications, particularly newspapers, the wide variety of news outlets has exacerbated another continuing problem: the overall decline of readership, particularly among young people. Lack of young readers has been a serious problem for newspapers for more than two generations. Its seriousness has been mitigated by the fact that even if people do not read newspapers as young adults, they usually become newspaper readers as they settle into a career and community life. Newspapers are becoming aware, however, that with the current generation of young adults this development of the newspaper reading habit might not occur. Web sites independent of newspapers that gather and disseminate local news and information are still relatively few in number, but their ranks are growing, and they may present a significant challenge to newspapers in the near future.

Another challenge that is unique to this generation is the acceleration of the news process. Not only are more news organizations operating on a twenty-four-hour basis, but more of them are covering events live—even local or regional events. Before this acceleration occurred, a newspaper editor could count on several hours to question, edit, and prepare most articles. A television news reporter knew that the only deadline he or she had to face was that of the six o'clock or eleven o'clock news. Today, deadlines occur far more often than that, particularly if news organizations are operating a web site and its users are expecting to see the latest information there. The information on these sites has to meet the same standards that are applied to information in print or on the air, but editors have less time to enforce these standards. Journalism still has not figured out how to deal with the accelerated pace of news and information, and it will be the coming generation of editors (those who are likely to be reading this book) that will do so.

Yet another challenge for the modern-day editor is a more active and involved audience. With email and other means of communicating instantly, readers and viewers are more likely to be in touch with their media organizations, and the journalists themselves are more touchable. This situation represents a profound change from the environment in which journalism has been practiced until this point. Journalists and their editors have been relatively protected from their audiences and their complaints and suggestions. Technology has empowered the audience in a variety of ways, so that such insulation is no longer possible or desirable. The editors of the future will have to figure out to how manage and exploit the interaction they have with their audience.

Editors have always faced tough challenges in maintaining the standards of the profession and developing practices that ensure the news organization's credibility. Many of the factors just cited—the growth of technology, the multiplicity of the media, the acceleration of the news, and the interaction with the audience—will make maintaining those standards even more difficult. We are part of an age of free-flowing information and opinion, and journalistic ethics and integrity are often besieged by the drive to entertain and build audiences. Editors have to maintain a constant vigilance against people and procedures that would harm journalism's ability to deliver information in a fair and honest fashion.

1 Exercises

The exercises in this chapter present a variety of problems for an editor to solve. They are designed for the beginning copy editor. They should be read carefully, and the editor should not hesitate to change what needs to be changed and to ask questions for clarification or more information.

Exercise 1.1: Copy Editing

The following story contains a number of errors that need to be corrected. Many of them are technical and easy to spot. The story is a minor one, but to an editor, no error is a minor one. The point of this exercise is to demonstrate that the editor needs to pay attention to the details on every story. Follow your instructor's directions in doing this exercise. You should raise a question at any point where the copy poses a problem for you.

A 66 year old Junior College instructro from Hamblen won the masters' title in the State Open Checkers Tourney at a localmotel Sunday.

Hix Davenport who teaches electornics at Central state junior college out-scored fifteen opponents in the top division to cap the victory in the American Checker Federation Tournament.

His prze was 100 dollars.

In the secondary division—the majors' division—Luke Moane of Westville, Iowa was the top winner, bringing home $50.

"It's fun to play the game mostly, said Holley. "I like to win, but you cant aways win. I just enjoy playing the game."

The tourment drew 41 contestants.

Exercise 1.2: Copy Editing

The following story contains a number of errors that need to be corrected. Make any changes that you believe are necessary to make the story read more easily. Follow your instructor's directions in doing this exercise. You should raise a question at any point where the copy poses a problem for you.

BARABOO, Wis.—Hunters over the weekend kiled 14 racoons at the International Crane Foundation, wheree the animals have been xxxattacking rare birds.

Foundtion administrater Joan Fordham said Baraboo hunters Willard and jeff Giese and Matt Kannenberg shot 7 raccoons Friday night and more seven Sunday night.

Department Of Natural Resources game warden Dennis Jameson helped organise the hunt after raccons, unffazed by electric fences traps and nylon netting spread over the pens, killed three rare birds in as many nights last week.

The raccoons victims included Tex a rare whlping crane who became something of a celebrity because she pxxformed the crane mating dance with foundation director George Archibald before her 1st chick was born last month.

Foundation spokeswomen Sue Rogers said the hunters believe there may be as many as 50 raccoons in the nearby woods. Berrys have not yet ripened and the raccoons may be getting desprate for food she said.

Exercise 1.3: Copy Editing

As with the previous exercises, the point here is that no errors are minor ones. Follow your instructor's directions in doing this exercise. You should raise a question at any point where the copy poses a problem for you.

Flooding due to last nights rain storm, has damaged sevierely consturction work on the city's newest radio station.

WXXg, which was secheduled to go on the air next month, has had it's air date moved back at least a mont, according to station spokesman Linda Rival.

Miss Rival, who is also one of the station's co-owners and has been advertised as planning to be one of the station's diskjockeys, said the floods severely damaged the interiro of the station and knowked down the half-completed towar.

"We haven't detemined the full extent of the damage, said Miss Rival, but I's sure its going to be bad.

She said the station would be delayed at least a month in going on the air.

The flooding was caused by some heavy rains that feel throughout the state earlier in the weak. Several homs and businessses in the area of the station known as Flat plains was reported damaged.

Exercise 1.4: Editing a Speech Story

The following story is a speech story. It is not very good because the reporter did not do a good job in covering the speech. There is little that you can do about that. However, you can correct the errors and make it more sensible for the readers. Follow your instructor's directions in doing this exercise. The story contains a number of AP style errors, so you will need your AP stylebook to work on this exercise. You should raise a question at any point where the copy poses a problem for you.

Rev. Madison Holcomb, leader of the right wing God and Country political action group, spoke to a crowd of about 200 people last night who were gathered on the steps of the First Baptist Church.

Rev. Holcomb, of Kry Largot, Florida, spoke on a variety of topics, including abortion, homosexuality and the current efforts of his God and Country group to boycot television programs which are sexually implicit.

"Abortion is a sin against God and a sine against man," said Holcomb, as the crowd cheered and waved signs, some of which said, "Save the Unborn" and abort Abortion."

"A child is a human being from the moment of contraception, and that child has rights. The most basic right he has is the right to live."

Rev. Holcomb condemned homosexuality, calling it an an "abommination against God and man."

Holcomb praised the efforts of his God and Country group in their fight against sex on television by saying, "There's too much sex on television, and we've taken a stand against it," he said.

He said those efforts were having an affect and mentioned the fact that several shows from the last season which they have been bouycotting have been cancelled.

Even though Holcomb previously reported his group had raised more than 55 million dollars last year, he said at last night's meeting that they were short of money.

"We are in dire straights," he said. If you don't give, the Lord's work won't get done."

Exercise 1.5: Editing for Sense and Logic

Be careful with the following story. Even though it is written as a feature story, it is really a news story and should read that way. That is, it should be written in the inverted pyramid structure with a lead paragraph that tells the most important information in the story. Read each sentence carefully, asking yourself, "Does this make sense?"

INVERNESS, Scotland—Stories of the Loch Ness monster have fascinated residents and travelers in this remote area of the Scottish highlands for more than a 1,000 years. Now threee is yet another story to spur the interest of Nessie buffs.

The lastest "stiing" of the monster may have something different —pictures. While many have claimed to have seen the monster, few pictures of it have every been produced. The most famous is one taken by a London dentist in the 1039's.

Now, it seems, there may be another. Lonnie McKenzie, a crofter near Inverness, reported last week that he had seen the monster clearly and had watched it swim along the lock for several minutes. What he didn't report then but did reveal yesterday was that he had a camera with him.

"I didn't want to say anything about the camera." he told a reporter for the Inverness *Gazette* yesterday, "because I didn't want people to get too excited about it. Acually, I'm a pretty good photographer.

McKenzie said that he had film in the camera at the time and thought the condidtions for taking a picture that day were pretty good. There were some low hanging clouds, he said, but generall the air was clear.

The film, he said, was in a secret location and is now being developed. He won't say who is developing the film or where it is.

What is certain is that if the pictures do indeed show the Loch Ness monster, Lonnie McKenzie is sure to become a rich many. Two of London's largest selling newspapers, the Daily Mirror and the Sun, have already begun a bidding war for rights to publish the photographs, and sources say the price has gone over $150,000 so far.

Exercise 1.6: Asking Questions

One of the jobs of the editor is to ask questions about what he or she is reading and editing. This story, besides containing a number of errors, raises many questions that

need to be answered. Try to read the story from the point of view of the reader and think about what he or she would want to know.

If your instructor chooses to do so, he or she can act as the reporter, and you can ask the questions that this story raises.

A Midville Red Cross official said Saturday's Midville State and Junction Tech football game was the worst in terms of heat exhaustion cases in at least 20 years.

The victims were treated by volunteer medical personell in Memorial Stadium's three first aid stations according to red Cross volunteer Jody Johns.

At leaest 200 people were treated for head related ailments at the game. A total of thirteen were sent to local hospitals.

The stricken fans were so numberous that medics stretched them out on the staduim concourse near the Northeast station while treating them.

Three people, one of them a heart-attck victim, were sent to hospitals before the kickoff at 1:30 P.M. central time.

Five cardiologists were on standby during the game, to prevent a recurrence of the tragedy which occurred at the game thirty years ago, when six people died of heart attacks.

"We haven't lost anybody since 1979," local cardiologist Dr. Russell Turner said. Turner has worked at the medical stations for local games since 1976.

Johns said only one of the patients treated at the was "obviously drunk out of his mind."

"I've never seen a game like this," he said. "The heat got to them before the booze did."

In addition to the fans, several players suffered ill affects from the record-breaking heat. Tech's starting quarterback, Billy Bob Braun, played only one inning before collapsing. Tech managed to pull through and win without him by a slim margin, however.

Exercise 1.7: Copy Editing

The following story contains a number of errors, including several AP style errors. This is a good exercise for learning how a copy editor should use the AP stylebook. You should raise a question with your instructor at any point where the copy poses a problem for you.

A large oak tree, located on the Midville State campus and though to be one of the oldest in the state, was severely damaged yesterday.

The storm, which knocked down power lines in many parts of the city, ocurred between 4 and 5 o'clock yesterday afternoon. and hampered the movement of rush-hour trafic. University officials believe that the high winds, combinded with the ortting interior of the tree, caused most of the damage.

The tree is believe by university botonists to be in the range of 150 years old.

The tree was partially destroyed. The damage to the tree went unnoticed until this morning when two of the major branches of the tree fell.

The tree is located between the sociology and education buildings on campus. There are many legends surrounding the tree, including one that captured pirates during the Civil War were hung from the tree.

"I don't know if we'll be able to save it or not," Charles Fancher, associate professor of biology said. "Trees like that are usually not in good shape, and we may have to just cut it down and start growing another one."

Power was quickly restored to most areas of the city last night.

Exercise 1.8: Redundancy and Repetition

One of the big problems with the following story is the writer's use of repetitions and redundancies. This is a part of the overall problem of wordiness. This story could contain far fewer words and still relate the same information. You might also want to discuss with your instructor the overall legal situation that this story describes. The story is not about

a trial but rather about an appeal of one of the trial's procedural questions. When editing, remove the redundancies as well as making other changes you feel are necessary.

The state supreme court has order a Midville bar to cease and desist allowing dancers to perform completely nude dances on their premises.

The court ordered the Flesh Mill, located at 213 Broad Street, on the corner of Broad and Main Streets, not to permit certain kinds of floor shows, dances and performances which have been outlawed by a recent state law while the constitutionality of that law is being tested in the courts.

The court ordered the proprietors and owners of the shop to remove various acts, performances and demonstrations from the stage, tabletops and floors of the business.

The Flesh Mill owners, Heavy Heat and Bob Beatle, have sued the state and taken it to court, saying the state law which the state legislature passed last session unduly restricts and limits their rights as businessmen.

In the initial court battle which was initiated four months ago, state attorneys argued that the shop and all others like it in the state should have to abide by the law until the court had ruled on the law. Today the state supreme court agreed.

"This is not at all what we wanted to happen," said Bob Beatle, one of the bar's co-owners. Beatle added that he thought the ruling was a distortion of the legal and judicial system.

Heavy added that it was apathetic people who don't care about the constitutional rightsof others who allowed laws such as this one to pass.

Exercise 1.9: Copy Editing

The following story contains a variety of errors that might be found in any story. Be sure to use your AP stylebook in working with this story, and do not hesitate

to change anything that you believe should be changed. Ask your instructor for additional information if the story raises questions that are not answered.

Over half of the nation's high school principles favor some sort of corporeal punishment for students who are discipline problems, according to a survey conducted by the American Education Association (A.E.A.)

The survey found that 53% of the principals in the U.S. felt teachers and administrators should have the option of using corporeal punishment on students who were discipline problems. 29% of the principals disagreed, saying teachers and administrators should not have this option.

AEA president Virginia Howell said the survey showed that administrators are concerned with discipline and " "want as many options available as possible.

Classroom Discipline, she said, is a continuing problem for many teachers and principals.

"The discipline problem gets in the way of effective teaching, and its not fair to the students who are there to learn." she said.

Miss Howell said the results of the survey indicated that many people are not becoming teachers today because they don't want to deal with "the discipline problems their hearing about in the schools."

Exercise 1.10: Copy Editing and News Judgment

The following story has most of the information necessary for a reader to understand it, but the writer has missed the lead completely. You will probably need to rewrite the story to get the most important information in the lead and at the top of the story. Think about what the reader (not you, but a reader sitting at home reading this story) will want to know. Another problem with this story is wordiness. Rewriting the story should help with this problem.

Harvey S. Baker, president of Brickline Corporation, made an announcement today that his company has chosen Midville as the site for the company's newest plant.

Mr. Baker, whose company has 35 plants in the United States and around the world, said Midville was chosen because of its excellent location and favorable economic factors.

"The people in White Oak and the rest of the state have been most gracious to us and have made us feel very welcome," Mr. Baker stated.

Brickline Corporation, a subsidiary of Amalgamated Industrial Products, manufactures a line of packaging products for many goods found in retail stores. For instance, the corporation has contracts to make the packaging for several brands of soap and labels for cans of soups.

Construction on the Midville plant will begin within a month and is scheduled for completion in about a year. When operating at full capacity, the plant will employ about 300 people.

The plant will be located near the Brookhaven exit of Interstate 72 on Old Jug Factory Road. It will be on a 200 acre tract that was once part of the Queenland estate.

"We are very happy about this industry coming to our area, k plant will begin within a month and is scheduled for completion in about a year. When operating at full capacity, the plant will employ about 300 people.

Tools of the Editor

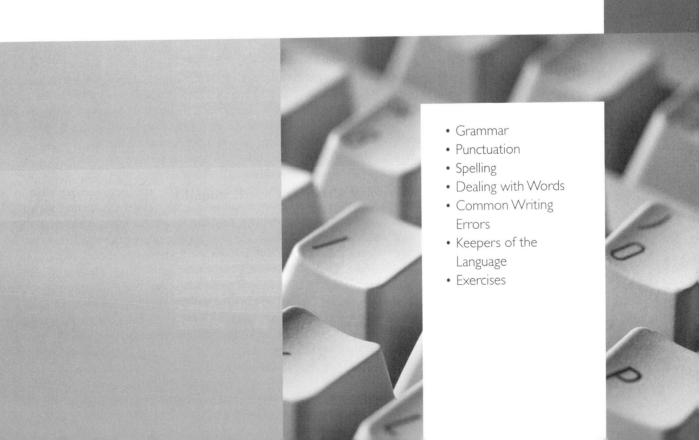

- Grammar
- Punctuation
- Spelling
- Dealing with Words
- Common Writing Errors
- Keepers of the Language
- Exercises

English is a basic tool of the editor. Like any other worker, the editor must know the tools of his or her trade thoroughly—what the tools can do as well as their limitations. Knowing when and under what circumstances they can be properly used is vital. Above all, a worker must know how to use the tools to get the job done. The editor needs to think of language as a tool, as a means of getting a job done. The editor who cannot coherently use the English language is like a carpenter who cannot saw a straight line. The products of such an editor or carpenter will not inspire confidence; nor will they be items that people want to purchase.

Unlike the carpenter's hammer or saw, however, the English language is an extremely complex tool. It has many nuances and subtleties. People spend years mastering English. There are many rules for its usage and many arguments over the propriety and relevance of some of these rules.

One thing that makes English so complex is its dynamic nature. English is the closest thing the world has to an international language. It is spoken and understood in nearly every part of the world. But no central control or authority governs its use. Consequently, the language is always changing. New words and expressions come into use as others fade. Old words take on new meanings. English is mixed with other languages. Spelling rules shift with differing usage. New phenomena that need description in the language occur almost daily. All this makes English an exciting but difficult tool.

Editors should not be in the vanguard of efforts to change the language. In fact, an editor's position in this regard should be a very conservative one, slow to accept change and accepting it only when the change improves the language and helps people to communicate. Some years ago a number of editors ran into some trouble on this very point. Thinking that the spelling of many words was clumsy and confusing (which it is), these editors arbitrarily changed the way some words were spelled in their newspapers. "Through" became "thru," "thorough" became "thoro," and "employee" turned into "employe." Acceptance of these changes was less than complete, and the editors had to beat a hasty retreat.

The editor should be the overseer of the language, working to promote its thoughtful and creative evolution while preventing changes that would degrade it.

The job of the editor, therefore, is not to change language but to use it. To do so effectively requires knowing the rules and conventions. Editors should know thoroughly the eight basic parts of speech (nouns, verbs, adjectives, adverbs, pronouns, conjunctions, interjections, and prepositions) and the basic unit of the English usage (the sentence) and its two main parts (subject and predicate). Not only should they have an eye for the language; they should also have an ear for it. Editors should know when things that are technically correct sound wrong. Beyond that, they should be able to recognize—and hear—the confusing phrase, the unclear sentence, and the absence of transition. They must be able to spot the confusion and illogic that are the harbingers of misinformation, inaccuracy, and a failure to communicate. Like the carpenter with a saw, the editor should use the language to make a straight line for the reader.

In journalism that straight line to the reader is the goal of the editor. Because having people read and believe a publication is vital to the publication's life, inspiring and holding readers' confidence is the job of the editor. The editor who does not use English correctly will annoy the reader and call the publication's credibility into question. A misspelled word will not destroy a publication, and an agreement error will not inspire calls for a repeal of the First Amendment, but too many such mistakes will convince the reader that the publication is not worth his or her time and money.

Figure 2.1

Theodore M. Bernstein

On using the language

If writing must be a precise form of communication, it should be treated like a precision instrument. It should be sharpened, and it should not be used carelessly.

Theodore Bernstein
Language guru and editor at the New York Times
One of his books on using the language is The Careful Writer.

Grammar

The following is not intended to be a complete grammar manual. There are many such manuals on the market, and the serious editor will have several on his or her bookshelf. These are the problems that are most likely to crop up in the writing you will be working with as an editor.

Subject–verb agreement. Singular subjects take singular verbs; plural subjects take plural verbs. A mistake of this kind most often occurs when the subject is separated from the verb by a long phrase containing a noun of a number different from that of the subject; for example, "The members of the team, which lost the last game of the tournament to its archrival by one point, was honored by the school." This mistake is an easy one to make and is sometimes hard to catch.

Another type of subject–verb disagreement occurs when there is a compound subject. "The man and his wife is standing on the street." Even though the subjects of this sentence are separately singular, together they are plural and should take a plural verb.

Confusion often occurs when nouns of different number are separated from the verbs by a prepositional phrase, as in the sentence "Disagreements of this kind is one of the army's major problems." The verb should agree with the subject, so in the above sentence the verb should be changed to "are," since the subject, "disagreements," is plural. A better solution would be to rewrite the sentence to get rid of "one," which makes the correct form awkward: "Disagreements of this kind are major problems for the army."

Pronoun–antecedent agreement. Disagreement between pronouns and their antecedents is one of the most common mistakes made by writers. One of the reasons for this is that such disagreements are generally accepted in spoken English. They are not acceptable in written English, however. Singular antecedents must have singular pronouns. It is incorrect to write, "The Supreme Court issued their decision today." "Supreme Court" is a singular noun

even though the court is made up of nine different justices. Consequently, it would be correct to write, "The Supreme Court issued its decision today" or "The members of the Supreme Court issued their decision today." Use a singular verb with any group of people referred to by a singular noun.

By the same token, plural antecedents must have plural pronouns. For example, "The Atlanta team and the St. Louis team had their game rained out." The "their" in this sentence refers to both teams and is correct.

Dangling participles. A participial phrase at the beginning of a sentence should modify the sentence's subject and should be separated from it by a comma. It would not be correct to write, "After driving from Georgia to Texas, Tom's car finally gave out." The car didn't drive to Texas; Tom did.

Active and passive voice. One of the most important grammatical distinctions that writers for the mass media should make is that between the active and the passive voice. The terms "active voice" and "passive voice" refer to the way in which verbs are used. If a verb is used in the active voice, the emphasis is on the subject as the doer or actor. Passive voice throws the action onto the object and often obscures the perpetrator of the action. It is formed by putting a helping verb such as "is" or "was" in front of the perfect tense of the verb. Look at the following examples:

> *Active:* John throws the ball.
> *Passive:* The ball is thrown by John.
> *Active:* The president sent the legislation to Congress.
> *Passive:* The legislation was sent to Congress by the president.
> *Active:* The governor decided to veto the bill.
> *Passive:* It was decided by the governor to veto the bill.

Generally, writers for the mass media try to use the active rather than the passive voice. The active voice is more direct and livelier. It is less cumbersome than the passive voice and gets the reader into the action of the words more quickly. When you edit your writing and find that you have written in the passive voice, you should ask, "Would this sentence be better if the verb were in the active voice?" Very often, the answer will be yes.

Sometimes the answer will be no. When changing passive voice to active voice puts the wrong emphasis in the sentence, the passive voice should be used. Consider the following sentence, "The victims were rushed to a hospital by an ambulance." If we practiced strict adherence to the active voice, we would change that sentence to read, "An ambulance rushed the victims to a hospital." The important part of that sentence is the victims, not the ambulance, however, so the use of the passive voice can be justified.

Take a look at the third set of examples above. In the passive voice sentence the indefinite pronoun "it" is used with the passive voice verb. This usage is particularly insidious because it obscures those who are responsible for an action. This construction—"it" with a passive voice verb—is unacceptable in writing for the mass media except in idiomatic uses (e.g., "It was raining hard when the plane landed").

Punctuation

The apostrophe. The proper use of the apostrophe probably gives more users of English more problems than any other form of punctuation. The apostrophe can be used in a number of ways. First, we use apostrophes to form possessives, as in "Mary's hat" and "Tom's book." If a word ends in "s" or the plural of the noun is formed by adding "s," the apostrophe generally goes after the final "s," and no other letter is needed. For example, the possessive of a word such as "hostess" is "hostess'." The plural possessive of the word "team" is "teams'." If the plural of a word is formed by adding a letter other than "s," the possessive is formed by adding "'s." For example, the plural possessive of "child" is "children's."

Even many professionals have problems when the word "it" and an apostrophe come together. Is it "its," "it's," or "its'"? Here are some rules worth memorizing: "Its" (without the apostrophe) is the possessive of the pronoun "it," as in "The band gave its best effort." "It's" (with the apostrophe) is a contraction meaning "it is," as "It's hard to tell." "Its'" makes no sense because "it" has no plural form.

Appositive phrases and commas. Appositive phrases follow a noun and rename it or give an additional bit of information. Such phrases are surrounded by commas in almost all cases. For example, in the sentence "Sally Smith, State's newest tennis star, was admitted to a local hospital yesterday," the phrase "State's newest tennis star" is the appositive to "Sally Smith." It is important to remember to put a comma at the end of the appositive; this is easy to overlook if the appositive is extremely long. For example, the sentence "Job Thompson, the newly named Midville Junior College president who succeeded Byron Wilson has accepted the presidency of the Association of Junior College Administrators" needs a comma after "Wilson." Many editors believe that writers overuse appositives. When you see one, consider turning it into a separate sentence.

Comma splices and compound sentences. When two independent clauses are connected, they must be connected by a semicolon or a comma and a conjunction. When two such clauses are connected only by a comma, that is called a comma splice or run-on sentence. For example, "Midfield won its final game, now the Tigers are the champs" is a comma splice or run-on sentence. The reader needs a conjunction or semicolon to help separate the two sentences. Also incorrect is the compound sentence with no comma before the conjunction: "Midfield won its final game and now the Tigers are the champs."

Commas between subject and verbs. Commas should be used to separate phrases and other elements in a sentence, but they should not be used solely to separate a subject from its verb. Obviously, you wouldn't write, "The boy, sat on the bench"; nor would you write, "The moment the train comes in, is when we will see her" or "Having no money, is a difficult thing."

Colons and semicolons. Colons should be used when the phrase or sentence before the colon anticipates the material that comes after it. For example, "There are four elements involved: gold, calcium, hydrogen, and oxygen." The semicolon should be used to separate a series of long phrases where a comma is inadequate, as in a series of names and titles, such as "John Jones, secretary of state; Jane Smith, secretary of the treasury; Ray Johnson, secretary of defense." A semicolon may also be used to separate the parts of a compound sentence when the writer does not want to insert a conjunction. "A terrible storm hit; many were killed."

Spelling

Spelling involves three thought processes: applying phonics, memorizing some words, and knowing the rules that usually apply to most words. Editors should know how to do all three. Phonics can be learned, either in one's early years or later. One must memorize words that are not spelled phonetically or do not follow spelling rules. However, most words can be spelled correctly without memorization because either rules or phonics applies to the majority of English words. Although dictionaries give more than one acceptable spelling for many words, for editors each word has one—and only one—correct spelling. Accepted spellings, like style, evolve over time. It is up to the editor to enforce his or her publication's correct spellings. Some spelling rules, with exceptions, are explained in the following paragraphs.

Doubling the final consonant. Adding an ending to a word that ends with a consonant often requires that the final consonant be doubled: *plan, planned; prefer, preferred; wit, witty; hot, hottest; swim, swimming; stop, stopped; bag, baggage; beg, beggar.*

There are a few exceptions. One illustrates the impact of the accent on certain syllables. Refer becomes *reference*, without doubling the "r," but the accent changes away from the final syllable when the suffix is added.

There are other exceptions—words ending in "k," "v," "w," "x," and "y": *benefit, benefited; chagrin, chagrined* (even though the accent stays on the final syllable of the new word).

Dropping a final "e." A final "e" is usually dropped in adding a syllable that begins with a vowel: *come, coming; guide, guidance; cure, curable; judge, judging; plume, plumage; force, forcible; use, usage.* Exceptions are: *sale, saleable; mile, mileage; peace, peaceable; dye, dyeing.*

Retaining the final "e." A final "e" is usually retained in adding a syllable that begins with a consonant: *use, useless; late, lately; hate, hateful; move, movement; safe, safety; white, whiteness; pale, paleness; shame, shameful.* Exceptions are: *judge, judgment; argue, argument.*

Words ending in a double "e" retain both "e's" before an added syllable: *free, freely; see, seeing; agree, agreement, agreeable.*

Retaining double consonants. Words that end in a double consonant retain both consonants when one or more syllables are added: *ebb, ebbing;*

enroll, enrollment; full, fullness; dull, dullness; skill, skillful; odd, oddly; will, willful; stiff, stiffness.

Using *all*, *well*, and *full* as compounds. Compounds of *all*, *well*, and *full* drop one "l": *always, almost, welfare, welcome, fulfill.* Exceptions are: *fullness* and occasions when a word is hyphenated (as with *full-fledged*).

Using "i" before "e." In words with "ie," the "i" comes before "e" except after "c": *receive, deceive, relieve, believe.* Exceptions are: *neighbor, weigh, foreign, weird, ancient, caffeine.*

Changing "y" to "i." A final "y" preceded by a consonant is usually changed to "i" with the addition of an ending that does not begin with "i": *army, armies; spy, spies; busy, business.*

Exceptions are: *shy, shyness; pity, piteous* (but not *pitiful*). The "ay" endings are usually exceptions: *play, played.*

Using "ede" or "eed." In deciding whether to use "ede" or "eed," use "eed" for one-syllable words (*deed, need, speed*) and for these two-syllable words: *exceed, indeed, proceed,* and *succeed. Supersede* is the only word that ends with "ede," while some words use "ede" as a suffix: *accede, concede, precede, recede.*

Plurals. You will also need to know some of the basic rules for forming plurals. Here are a few:

1. Most plurals for nouns are formed by simply adding "s" to the root word.
2. Nouns that end with "s," "z," "x," "ch," or "sh" usually require an "es" ending to form the plural: *quiz, quizzes; mess, messes; wish, wishes; fix, fixes.*
3. When a word ends with a consonant and then a "y," the "y" is changed to "i" and an "es" is added: *army, armies.*
4. When a word ends in a vowel and a "y," you can simply add an "s" for the plural: *bay, bays.*
5. Compound words without hyphens simply take an "s" on the end (*cupful, cupfuls*), but compound words with a hyphen take the "s" on the significant word (*son-in-law, sons-in-law*).
6. The *AP Stylebook* advises that "'s" should be used only in forming the plural of single letters (*A's, B's*) but not figures (*1920s, 727s*). Never use "'s" to form the plural of a word that is fully spelled out.

Dealing with Words

English works, as any language does, because of a combination of systems that students who seek to use it need to understand. Those systems are lexicon, grammar, semantics, and phonology.

Lexicon deals with the words that form the building blocks of the language. As society changes, new words must be created to express those changes. Certain rules govern the formation and development of words. We take words from a variety of sources (from ancient Latin to inner-city street talk), but English has developed some rules for using those words. We have prefixes and suffixes, for instance, that allow words to be formed into useful entities. The prefix "anti" lets a word approach the opposite of its accepted meaning; the suffix "ed" can be added to many root verbs to form the past tense. Standard dictionaries that we keep on our desks are the chief source of our knowledge of the rules of lexicon.

Much of this chapter has been devoted to describing the rules of *grammar* for what we consider standard English. Grammar is the way in which we string words together to describe complex thoughts, ideas, or actions. Grammar is also concerned with word order. The English standard order of words in a sentence is subject, verb, and predicate. That order is not followed in other languages, however. Because English is widely used, the rules of grammar are studied and evaluated continuously by people who use the language professionally. English is also a democratic language; common usage eventually formalizes many of the rules of grammar.

Semantics refers to the meanings that people assign to words. What a words symbolizes—or means—can change over time. The history of words and phrases, called *etymology,* can be fascinating to study, and many scholars spend productive careers pursuing the origins and derivations of words. Editors should pay particular attention to semantics because much of their work depends on a common understanding of the meanings of words.

English has many pairs and groups of words that have similar sounds and spellings but whose meanings are distinct and often quite different from one another. Although many people do not concern themselves with these differences, editors must do so. Here are a few examples:

- *Affect, effect.* Generally, "affect" is the verb; "effect" is the noun. "The letter did not affect the outcome." "The letter had a significant effect." But "effect" is also a verb meaning "to bring about": "It is almost impossible to effect change." There are better words than "effect" for this meaning.
- *Allude, elude.* You allude to (or mention) a book. You elude (or escape) a pursuer.
- *Averse, adverse.* If you don't like something, you are averse (or opposed) to it. "Adverse" is an adjective: adverse (bad) weather, adverse reaction.
- *Compose, comprise.* You compose things by putting them together. Once the parts are together, the whole comprises the parts. Avoid "is comprised of." It is passive and has a stuffy sound, besides being incorrect.
- *Demolish, destroy.* Both of these words mean "to do away with completely." You cannot partially demolish or destroy something; nor is there any need to say, "totally destroyed."
- *Flout, flaunt.* They aren't the same word; they mean completely different things, and they are very commonly confused. "Flout" means to mock or show disdain for. "Flaunt" means to display ostentatiously.
- *Imply, infer.* The speaker implies; the hearer infers. One may also infer general principles from a sample.

- *Marshall, marshal.* Generally, the first form is correct only when the word is a proper noun: John Marshall. The second form is the verb form: Jones will marshal her forces. And the second form is the one to use for a title: fire marshal Stan Anderson, field marshal Erwin Rommel.
- *Oral, verbal.* Use "oral" when use of the mouth is central to the thought; the word emphasizes the idea of human utterance. "Verbal" may apply to spoken or written words; it connotes the process of reducing ideas to writing. Usually, one speaks of an oral contract, not a verbal one, if it is not in writing.
- *Peddle, pedal.* When selling something, you peddle it. When riding a bicycle or similar means of locomotion, you pedal it.
- *Pretense, pretext.* They are different, but the distinction is a tough one. A pretext is that which is put forward to conceal a truth: She was discharged for tardiness, but this was only a pretext for general incompetence. A pretense is a "false show," a more overt act that is intended to conceal personal feelings: My profuse compliments were all pretense.
- *Principle, principal.* A guiding rule or basic truth is a principle. The first, dominant, or leading thing is principal. "Principle" is a noun; "principal" may be a noun or an adjective. Liberty and justice are two principles on which our nation is founded. Hitting and fielding are the principal activities in baseball. Robert Jamieson is the school principal.
- *Reluctant, reticent.* If he doesn't want to act, he is reluctant. If he doesn't want to speak, he is reticent.

Phonology is the system by which the language is spoken. A language has far fewer sounds than words; most English speakers get by with about forty sounds, or phonemes. Phonology allows a language to develop a standard way of being spoken so that we can understand one another. (Some would argue that writing constitutes a fifth system of the language because the rules of writing differ from the phonology rules. Not all experts accept that thinking, however.)

The rules of each of these systems are important because they allow us to have a common application of the language. They are "rules" not so much because they must be enforced but because they represent the common understanding that we all have about the language. If this common understanding did not exist, the efforts of a writer for the mass media to communicate with an audience would be frustrating or useless. That is why the professional must understand, use, and study the rules. The rules in each of these systems will undoubtedly change within the lifetime of the writer, but there will always be rules.

Common Writing Errors

In the 1970s the Writing and Editing Committee of the Associated Press Managing Editors Association identified a list of the fifty most common writing errors that its members encountered. The following problems are adapted from that list:

- *Afterward, afterwards.* Use "afterward."
- *All right.* That is the only way to spell it, despite some dictionaries' acceptance of "alright."
- *Annual.* Don't use "first" with it. If it is the first time, it's not annual yet.
- *Couple of.* You need the "of." It is never "a couple tomatoes."
- *Different from.* Things and people are different from each other. Don't write that they are different than each other.
- *Drown.* Don't say that someone was drowned unless an assailant held the victim's head under water. Just say that the victim drowned. The same is true for "graduated."
- *Due to, owing to, because of.* We prefer the last. Wrong: The game was canceled due to rain. Correct but stilted: The game was canceled owing to rain. Better: The game was canceled because of rain.
- *Either.* It means one or the other, not both. Wrong: There were lions on either side of the door. Right: There were lions on both sides (or each side) of the door. We think "both sides" paints the picture better.
- *Fliers, flyers.* "Flier" is the preferred term for an aviator or a handbill.
- *Funeral service.* A redundant expression. A funeral is a service.
- *Head up.* People don't head up committees. They head them.
- *Hopefully.* This is one of the most commonly misused words in the language today. It is really a nonword, so forget it. If used at at all, "hopefully" should be used to describe the way the subject feels— for instance, "Hopefully, I shall present the plan to the president." This means that I will be hopeful when I do it, not that I hope I will do it. And it is something else again when you attribute hope to a nonperson. If you write, "Hopefully, the war will end soon," what you mean is that you hope the war will end soon. But this is not what your sentence says. What you should write is, "I hope the war will end soon."
- *In advance of, prior to.* Use "before"; it sounds more natural.
- *It's, its.* "Its" is the possessive, "It's" is the contraction of "it is." Wrong: What is it's name? Right: What is its name? Its name is Fido. Right: It's the first time she's scored tonight. Right: It's my coat.
- *Lay, lie.* "Lay" is the action word; "lie" is the state of being. Wrong: The body will lay in state until Wednesday. Right: The body will lie in state until Wednesday. Right: The prosecutor tried to lay the blame on her. However, the past tense of "lie" is "lay." Right: The body lay in state from Tuesday until Wednesday. Wrong: The body laid in state from Tuesday until Wednesday. The past participle and the plain past tense of "lay" is "laid." Right: She laid the pencil on the pad. Right: She had laid the pencil on the pad. Right: The hen laid an egg.
- *Leave, let.* "Leave alone" means to depart from or cause to be in solitude. "Let alone" means to allow to be undisturbed. Wrong: The man had pulled a gun on her, but Mr. Jones intervened and talked him into leaving her alone. Right: The man had pulled a gun on her, but Mr. Jones intervened and talked him into letting her alone. Right: When I entered the room I saw that Jim and Mary were sleeping, so I decided to leave them alone.
- *Less, fewer.* If you can separate items in the quantities being compared, use "fewer." If not, use "less." Wrong: The Rams are inferior to the

Vikings because they have less good linemen. Right: The Rams are inferior to the Vikings because they have fewer good linemen. Right: The Rams are inferior to the Vikings because they have less experience.

- *Like, as.* Don't use "like" for "as" or "as if." In general, use "like" to compare nouns and pronouns; use "as" when comparing phrases and clauses that contain a verb. Wrong: Jim blocks the linebacker like he should. Right: Jim blocks the linebacker as he should. Right: Jim blocks like a pro.

- *Mean, average, median, mode.* Use "mean" as synonymous with "average." Both words refer to the sum of all components divided by the number of components. "Median" is the number that has as many components above it as below it. "Mode" is the score, or number, in a group that occurs the most.

- *Nouns.* There is a growing trend to use nouns as verbs. Resist it. Host, headquarters, and author, for instance, are nouns, even though the dictionary might accept their use as verbs. Using them as verbs could give you a monstrosity such as the following: "Headquartered at his country home, John Doe hosted a party to celebrate the book he had authored."

- *Over, more than.* These are not interchangeable. "Over" is best used for spatial relationships: The plane flew over the city. "More than" is used best with figures: In the crowd were more than a thousand fans.

- *Parallel construction.* Thoughts that are in series within the same sentence require parallel construction. Wrong: The union delivered demands for an increase of 10 percent in wages and to cut the work week to 30 hours. Right: The union delivered demands for an increase of 10 percent in wages and for a reduction in the work week to 30 hours.

- *Redundancies.* Easter Sunday: Make it "Easter." Incumbent Congressman: Make it "Congressman." Owns his own home: Make it "Owns his home." The company will close down: Make it "The company will close." Jones, Smith, Johnson, and Reid were all convicted: Make it "Jones, Smith, Johnson, and Reid were convicted." Jewish Rabbi: Make it "Rabbi." 8 p.m. tonight: All you need is "8 tonight" or "8 p.m." During the winter months: Make it "During the winter." Both Reid and Jones were denied pardons: Make it "Reid and Jones were denied pardons." I am currently available: Make it "I am available." Autopsy to determine the cause of death: Make it "Autopsy."

- *Refute.* The word connotes success in argument and almost always implies an editorial judgment. Wrong: Father McCormick refuted the arguments of the pro-abortion faction. Right: Father McCormick responded to the arguments of the pro-abortion faction.

- *Say, said.* The most serviceable words in the journalist's language are the forms of the verb "to say." In general, let a person say something rather than declare, admit, or point out something. And never let that person grin, smile, frown, or giggle something.

- *Slang.* Don't try to use the latest slang. Usually, a term is on the way out by the time we get it into print. Wrong: The police cleared the demonstrators with a sunrise bust. Right: The police cleared the demonstrators with an early morning raid.

- *Temperatures.* They may get higher or lower, but they don't get warmer or cooler. Wrong: Temperatures are expected to warm up in the area Friday. Right: Temperatures are expected to rise in the area Friday.

Figure 2.2

Redundancies

Columnist James J. Kilpatrick is a lifetime collector of redundancies, often engaging readers in his sleuth work. Here are some nuggets from Kilpatrick's collection, along with some others. What are your favorites?

12 noon	hot water heater
brutal beating	last ultimatum
completely totaled	old adage
consensus of opinion	old axiom
dead body	personal friend
died when he drowned	quartet of four finalists
fatally slain	reason why
forseeable future	sudden explosion
free bonus	sworn affidavit
free gift	the fact that
gather together	whether or not
ground rules	

- *That, which.* "That" tends to restrict the reader's thought and direct it the way you want it to go; "which" is nonrestrictive, introducing a bit of subsidiary information. For instance: The lawnmower that is in the garage needs sharpening. (Meaning: We have more than one lawnmower. The one in the garage needs sharpening.) The lawnmower, which is in the garage, needs sharpening. (Meaning: Our lawnmower needs sharpening. It is in the garage.) The statue that graces our entry hall is on loan from the museum. (Meaning: Of all the statues around here, the one in the entry hall is on loan.) The statue, which graces our entry hall, is on loan. (Meaning: The statue is on loan. At the moment, it's in the entry hall.) Note that "which" clauses take commas, signaling that these clauses are not essential to the meaning of the sentence.
- *Under way, not underway.* But don't say that something got under way. Say that it started or began.
- *Unique.* Something that is unique is the only one of its kind. It cannot be very unique, quite unique, somewhat unique, or rather unique. Don't use the word unless you really mean that the thing is unique.
- *Up.* Don't use it as a verb. Wrong: The manager said that he would up the price next week. Right: The manager said that he would raise the price next week.
- *Who, whom.* This is a tough one, because you have to know whether the pronoun is being used as subject or object. The nineteen-year-old woman to whom the room was rented left the window open. "Who" is the word that is used when somebody has been the actor. A nineteen-year-old woman, who rented the room, left the window open.

Figure 2.3

Classic language books for editors

Here are some modern and classic books about the English language that editors should know about. The professional editor should always have well-thumbed books such as these near at hand. They can be found online and in most large bookstores.

Thomas Berner, *Language Skills for Journalists*
Theodore M. Bernstein, *The Careful Writer*
Brian S. Brooks, James L. Pinson, and Jean Gaddy Wilson, *Working with Words*
Rudolph Flesch, *The Art of Readable Writing*
H. W. Fowler, *A Dictionary of Modern English Usage*
Norm Goldstein, *The Associated Press Stylebook and Libel Manual*
James J. Kilpatrick, *The Writer's Art*
Merriam-Webster's Collegiate Dictionary (one of many good dictionaries)
Porter G. Perrin and Wilma R. Ebbit, *Writer's Guide and Index to English*
William Saffire, *On Language*
William Strunk Jr. and E. B. White, *The Elements of Style* (the classic of the classics)
William Zinsser, *On Writing Well*

- *Who's, whose.* Though it incorporates an apostrophe, "who's" is not possessive. It is a contraction of "who is." "Whose" is possessive. Wrong: I don't know who's coat it is. Right: I don't know whose coat it is. Right: Find out who's there.
- *Would.* Be careful about using "would" in constructing a conditional past tense. Wrong: If Soderhelm would not have had an injured foot, Thompson wouldn't have been in the lineup. Right: If Soderhelm had not had an injured foot, Thompson wouldn't have been in the lineup.

Keepers of the Language

Many people believe that English is deteriorating because grammar is no longer taught with rigor in schools; because organizations, especially governments, use words and phrases to obscure meaning rather than enhance it; and because the general public accepts and encourages the misuse of the language. There is a general feeling that most people simply do not care about the language and are not disciplined enough to use it well.

Whether or not this is true, our age needs people who care about the language and who will serve as its keepers. Editors are such people. Good editors go beyond simply knowing the language. They become masters of the language and its use. As such, they are not obstacles to the changing nature of the language but conservative managers of that change.

chapter

2 Exercises

The exercises in this chapter deal with a variety of problems that are encountered in using the English language. Editors, as this chapter points out, must be masters of the language. Even experienced copy editors are constantly having to look up spellings, meanings, grammar, and questions of style. For these exercises you will need easy access to an AP stylebook and a dictionary.

Exercise 2.1: Language Problems

Correct the errors you find in the following sentences either by copy editing or by rewriting the sentence. Underline your corrections. When you find a sentence that is correct, write "Corr." next to it.

1. Although Drake was not expected to give UCLA much of a battle, everyone got their money's worth when the Uclans barely pulled it out, 85–82, in the NCAA semifinals.
2. Each one of the Miss Teen-Agers were judged on their talent, their poise and their personality.
3. The couple was married in 1966 and were divorced in 1967.
4. Each team was splitting their ends wide.
5. The North and the South each have six backs and six linemen which have been drafted by the NFL.
6. Everybody in the stadium was on their feet and screaming for a home run.
7. The library has been increasing their stack of books since their move to the new municipal building a year ago.
8. Any one of the three vice presidents is qualified to handle their job.
9. He told James that he was responsible for the error.

10. The losing team ate their dinner in silence.
11. Washington and Oregon each have won six games and lost two.
12. The mayor presented Nano Scarborough and myself to the governor.
13. Anyone who wants a personalized license plate should send in their application by April 15.
14. The coach said that if any player considered her too strict in enforcing team rules, they could turn in their uniform "right now."
15. Any one of the national civil rights leaders were available for consultation, according to the Massachusetts senator.
16. At least three farm products contain this strong fiber, and they can be made into fabrics resembling gossamer silk.
17. It's a first down for the Tigers on its own 28-yard line.
18. Cherry nearly came to blows with Axton after he had protested the nomination of Afelbaum.
19. His proposition will be submitted to the board, and it is likely that most of the members will agree with him.

Exercise 2.2: Pronouns

Most of the errors in the following sentences are in the uses of relative pronouns. There are also some misplaced relative clauses. Correct the errors either by copy editing or by rewriting the sentences. Underline your corrections. Some of the sentences are correct; write "Corr." next to them.

1. The epidemic has struck more than 60 persons, at least 11 of which have died.
2. He distributed the rat poison throughout the barn which he had bought that morning.
3. To the question of whom looked good in line, Walker replied with a warm smile: "I can't remember all of their names right now, but there were seven of them."
4. The senator pointed out that in September a vice-presidential candidate had not been named, and that voters could only express a preference for the nominee's runningmate, whomever he might be.
5. One of the constructive things that has come out of the meetings of the delegates is that some of them are determined to eliminate these red tape obstacles.
6. Who do you think State's quarterback will be?
7. He refused to state, did he not, whom the new employees would be.
8. The President declined to comment directly on the case of the undersecretary, whom the Attorney General says was promoted by his predecessor.
9. There are at least seven men who's integrity is to be investigated.
10. James Averette, who the president chose as Secretary of Commerce, is a colleague from the previous administration.
11. With Dietrich Fischer-Dieskau, famed German lieder singer, was his new bride, Christina Purgell, whom he met during a 1998 U.S. tour.

12. One player who you can depend on to make the all-star team is Will Soloman of Drake.
13. One player who is sure to be placed on the all-star team is Will Solomon of Drake.
14. They will seriously consider the mayor, whom they regard as "a terrific Republican property."
15. Regardless of who is chosen, the majority of the board members promise to support her.
16. It was Jody Foster, Academy Award winner, whom they wanted to meet.
17. She swore that she would see to it that Jacob Heidemann "got this important role."
18. The chairman of the Board of Regents is leading the fight over who is going to run the university—the board, the legislature, or the student protesters.

Exercise 2.3: Pronouns

In each of the following sentences, underline the correct pronoun.

1. No matter how you look at it, it was (she, her) whom they opposed.
2. My sister, who is two years older than (I, me), is much less hopeful.
3. Everybody stood erect except Dick and (I, me).
4. None was better prepared for the profession than (he, him).
5. Jack can play ball as well as you or (I, me).
6. We considered (she, her) to be the best actress in the company.
7. It must have been (he, him).
8. If I were (she, her), I would get a permanent.
9. None was more kind than (she, her).
10. You have lived here longer than (we, us).
11. It was (she, her) they considered last.
12. I must admit, between you and (I, me), I failed that last test.
13. The club sent three members to represent it—Tom, Don, and (I, me).
14. (Who, Whom) are they asking?
15. Nobody can be as lucky as (he, him).
16. Everybody had supposed it was (he, him) who threw the rock through the window.
17. For you and (she, her) to walk 25 miles would be tiring.
18. It is always (I, me) who gets severely punished.
19. Why were you counting on (they, them) to bring the cake?
20. Jack asked Mary rather than (I, me) to go to the show.
21. (Who, Whom) did it seem would be nominated?
22. The army sent three men to the conference—General Dans, General Bixby, and (I, me).
23. The campus policeman swore it was (they, them) whom he had seen.

Exercise 2.4: Pronouns

In the following sentences, choose the correct word by underlining it.

1. To (who, whom) should the letter be addressed?
2. (Who, Whom) will be selected for the chairmanship?
3. Do they know (whose, who's) putting up the money?
4. That is State's star player, (him, he) with the taped legs.
5. The coach is removing his star player, (him, he) with the taped legs.
6. Do you remember (who, whom) it was (who, whom) won the Nobel Prize in 1966?
7. Do you think that (we, us) students can do anything about today's fashions?
8. McGrath is the only woman here (whom, who) I know very well.
9. It appears to be Douglass (whom, who) was injured in the play.
10. Only John and (me, I) are to blame.

Exercise 2.5: Pronouns and Antecedents

In the blank before each sentence, mark an X if there is an error in the agreement of pronoun and antecedent.

_____ 1. A person at all times should guard themselves against slanderous tongues.
_____ 2. Someone has been here and left her calling card.
_____ 3. The sonnet was introduced by Wyatt and Surrey. They were love poems of fourteen lines.
_____ 4. Needless to say, everyone who invested in that stock lost their money.
_____ 5. If one becomes discouraged, you lose interest.
_____ 6. Every one of the veterans was responsible for their own lodging.
_____ 7. When anyone is irritated, it is best to let him alone.
_____ 8. Every pilot returned safely from their dangerous mission.
_____ 9. Bernie told his partner that he was a failure.
_____ 10. Everyone was dressed in his best and glad to be at the party.
_____ 11. They were told that all of the men would have to wait their turn.
_____ 12. Each of the dogs entered in this race has won his share of trophies.
_____ 13. We enjoyed our visit to the Bar X Ranch very much. They were extremely hospitable people.
_____ 14. The one or two members of the class who raise their hands answer most of the questions.
_____ 15. Either my sister or her roommate may miss her bus.
_____ 16. Neither of the two secretaries had brought their lunch.
_____ 17. Each of the horses entered their stall.
_____ 18. Neither of the boys would admit that he had missed school.

Exercise 2.6: Verbs

In the following sentences, underline the correct form of the verb.

1. A burglary ring of Dallas youngsters (lead, led) by a nine-year-old boy faced juvenile delinquency charges Monday.
2. Yesterday Patrick Welch (led, lead) the St. Patrick's Day parade.
3. Suddenly the children (sprang, sprung) from their hiding place and (sung, sang) "Happy Birthday to You."
4. He charged that the commissioners had not (payed, paid) him the stipulated fee.
5. William O. Dupree (strove, strived) hard to accumulate his first million.
6. He dived in and (drug, dragged) the body of the (drown, drowned) girl from the creek.
7. The ground was (froze, frozen) over, and one pipe had (burst, bursted, busted).
8. The Johnsons (use, used) to live in San Jose, California.
9. The teen-ager had (hanged, hung) himself. The body (hanged, hung) there for almost an hour before it was removed.
10. After questioning the youth for nine hours, the detectives (rang, rung, wrang, wrung) a confession from her.
11. She could have (sung, sang) "Yes, We Have No Bananas" and (drawn, draw) an ovation.
12. Carol Farmer had (sewen, sewed, sowed, sown) a dress all day and her husband had (sewn, sewd, sowed, sown) about 25 acres of wheat.
13. The candidate for Place 4 seemed to have his two opponents soundly (beat, beaten).

Exercise 2.7: Verbs

Correct the verb forms in the following sentences. If the sentence is correct, write "Corr." next to it.

1. My son rushed into the room, grabs his coat, and goes dashing down the hall.
2. A few minutes elapsed; then as suddenly as the storm appeared, it disappeared.
3. It has been very cold since we are here.
4. I am waiting for this dance for three weeks.
5. When we entered our cabin, we found some thief made off with our supplies.
6. I expected to have gone to Richard for the holidays.
7. On Saturday I discussed with Kelpert the material which he presented to the committee on Friday.
8. From 1934 until now he was director of the Community Hospital.

9. After some discussion we decided that real happiness did not lie in material things, but in the qualities of the spirit.
10. All the roads were blocked because the snow had fallen.
11. Unfortunately, we found that your credit rating is not up to our standards.
12. Can I go to the concert tonight?
13. I intended to have seen you about the exam.
14. He is studying French for several years, but he cannot speak a word of the language.
15. When Judy appeared, she was dressed in a filmy blue dress. In a few minutes the doorbell rings and in comes Stanley.
16. People in white seem to be everywhere in the physicist's laboratory, but no sound is heard.
17. When the respirometer started, the surgeon nods to the nurse and she hands him the instruments.

Exercise 2.8: Prepositional Phrases

In the following sentences, circle the preposition and underline the prepositional phrase.

1. Anderson worked in a London advertising agency.
2. Before sundown, all the men had returned home.
3. Many private fortunes were founded on privateering.
4. Quickly, the thief glanced down the long dark hall.
5. I heard about your very unusual problem.
6. These shirts are made of very fine imported domestic materials.
7. Four hundred thousand people passed through the turnstiles that year.
8. The chicken rode off perched on the rear bumper.
9. He replied, off the record, that he had voted to have the restrictions removed.
10. Where was he at the beginning of class?

Exercise 2.9: Conjunctions

Circle the conjunctions in the following sentences. Write "none" next to the sentence if there is no conjunction.

1. The woodsman was angry because someone had stolen his traps.
2. Spot the frogs with your flashlight; then shoot before they jump.
3. Whenever a pocket of air shook the bomber, the tailgunner shouted over the intercom, threatening the pilot with court martial and announcing repeatedly that he was going home.

4. Although I am a heavy sleeper, I awoke with a start when the lightning flashed, and I rushed to the window to see what had happened.
5. As he came in the door, he said he would whip any man in the room.
6. He goes golfing three or four times a week, but his game never improves.
7. The price that he wanted for the house was too high.
8. We ate ham and eggs.
9. We left the party early because we were tired.
10. He had a weary yet angry expression.

Exercise 2.10: Word Choice

This exercise is designed to check your ability to distinguish between commonly confused words. Underline the correct word in each of the following sentences.

1. I (except, accept) your invitation; everyone will be there (except, accept) Jane.
2. Will you give me some (advise, advice)? I (advise, advice) you to sell your mining stock.
3. Although that drug has a powerful (effect, affect), it did not (effect, affect) me.
4. At last the prisoners (affected, effected) their escape.
5. George had an (affective, effective) manner of speaking.
6. At last the children were (already, all ready) to go.
7. The grandchildren were (altogether, all together) that Christmas.
8. Martinez had (already, all ready) gone when I arrived.
9. There has been (altogether, all together) too much whispering.
10. An (angel, angle) appeared to him in a vision and said, "Please hand me a right-(angel, angle) triangle.
11. We looked up at the dome of the (capital, capitol).
12. Rodriguez supplied the (capital, capitol) for the project.
13. The president discussed the conflict between (capitol, capital) and labor.
14. (Course, Coarse) gravel was used as a base for the street.
15. The squad had its full (compliment, complement) of soldiers.
16. You know, of (coarse, course), that this is foolish.

Exercise 2.11: Word Choice

Choose the correct word for each of the following sentences.

1. He chased the ball (farther, further) than his teammates.
2. He pursued the subject (farther, further) than his classmates.
3. That's (alright, all right) with me.

4. The money was divided (among, between) four players.
5. The money was divided (among, between) us.
6. A charming (affect, effect) was produced.
7. Farming (implies, infers) early rising.
8. Since he was a farmer, his visitors (implied, inferred) that he got up early.
9. (Regardless, Irregardless) of the consequences, we intend to go.
10. (Leave, Let) it stand the way it is.
11. He had (less, fewer) men than in the previous campaign.
12. Robins are different (from, than) sparrows.
13. A winding road is (tortuous, torturous).
14. A painful ordeal is (tortuous, torturous).
15. It was (a most unique, a unique) balancing act.
16. Do you have a copy of the graduate catalog (laying, lying) around?
17. Did the students (lay, lie) out too long at the beach?
18. She does extremely (good, well) in mathematics.
19. No matter how you look at it, it was (she, her) whom they opposed.
20. His sister, who is two years older than (him, he), is much less hopeful.
21. Everybody stood erect except Sarah and (I, me).
22. None was better prepared for the profession than (she, her).
23. Jack can play ball as well as you or (I, me).
24. We considered (she, her) to be the best actress in the company.
25. It must have been (he, him).

Exercise 2.12: Possessives

Write the singular possessive of each of these:

1. the boy _____ coat
2. Gray and Perry _____ shop
3. John Keats _____ poems
4. Holmes _____ mansion
5. his wife _____ property
6. the puppy _____ ball
7. a hero _____ welcome
8. the princess _____ escort
9. a witch _____ broomstick
10. the notary public _____ sign

Write the plural possessive of each of these:

1. witch _____ broomsticks
2. child _____ toys
3. Holmes _____ autos
4. hobo _____ shoes
5. mouse _____ tails
6. fox _____ tails
7. farmer _____ magazines

8. woman _____ dresses
9. alumnus _____ newsletters
10. the Charles _____ reigns
11. policemen _____ beats

Exercise 2.13: Sentence Errors

Rewrite or correct the errors in the following sentences or improve the expressions.

1. The Midville (Dads, Dads') Club will hold its first (Dads, Dads') and (Sons, Sons') Banquet Tuesday night.
2. "I don't mind (you, your) baking cookies if you'll clean up afterward," the cook said.
3. The union gave 48 (hours, hours') notice before striking, and the strike was settled in one (hour's, hours') time.
4. The hunter, who did not bother with the smallest (deer's, deers) antlers, selected the two largest (deer's, deers') antlers for mounting.
5. "This coat is (yours, your's), but Harry's is not here," the teacher said.
6. The two (Sally's, Sallys) suits looked exactly alike.
7. "This one is (our's ours), but (who's, whose) is that?" the shopper said.
8. Willis met (Sharreys, Sharrey's) second-round rush with a sustained attack. (Willises, Willis') hard right to the stomach made his opponent's knees buckle.
9. The (Yankee's, Yankees') new manager would not comment on his team's prospects.
10. Although she said she could do a good (day's, days) work, she was unable in three (days, days') time to prove it.
11. Two bills were introduced, but prospects of (them, their) being written into law were poor.
12. The doctor prescribed two (tablespoonsfull, tablespoonfuls) every four hours.
13. The (men's servants, menservants') quarters were searched.
14. The parents could not bear the thought of their (child, child's) gambling.
15. The customer asked for a (quarter's, quarters) worth.
16. She is a friend of (Jane, Jane's).
17. Fans are looking forward to (Midville's, Midville) meeting Manchester Saturday.
18. Printers must watch their (P's, Ps, p's) and (Q's, Qs, q's).
19. In the poll there were 42 (yeses, yes's) and 51 (noes, no's).
20. The boy standing on the shore was not aware of the (storm, storm's) approaching.
21. The (boys', boy's) coat.
22. (Gray, Gray's) and (Perry, Perry's) shop.
23. John (Keats', Keat's) poems.
24. (Holmes', Holmeses') mansion.
25. A (princess', princesses') escort.
26. A (witch's, witches) broomstick.

27. (Childrens', Children's) toys.
28. (Farmers', Farmer's) magazines

Exercise 2.14: Punctuation

Insert the correct punctuation in each of the following sentences.

1. We may divide the poems into three classes narrative lyric and dramatic.
2. Stumbling toward the telephone I wondered who would be calling me after 11 00 p m
3. At any rate this much can be said The Council is not the vital organ it is supposed to be
4. Within two hours we had a strange variety of precipitation rain hail sleet snow
5. Promptly at 8 15 p m the minister began his sermon by quoting John 20 21
6. Whos going to do the dishes
7. On Thursdays the childrens department doesnt open
8. They havent said the property is theirs
9. Theyre not coming to see Freds new house
10. That boys one of the worlds worst at what he's doing now.
11. I didnt go to sleep until after 2 00 a m
12. He makes ladies hats and childrens coats
13. All her thoughts were centered on one objective marriage
14. In 1803 Thomas Jefferson said We have seen with sincere concern the flames of war lighted up again in Europe"
15. Blair regarded the demand for popular rights as a king might regard it as a mode of usurpation
16. The three causes are as follows poverty injustice and indolence
17. Intercollegiate athletics continues to be big business but Robert Hutchins long ago pointed out a simple remedy colleges should stop charging admissions to football games
18. Opponents give one main reason why gambling should not be legalized They say gambling establishments always attract gangsters and criminals

Exercise 2.15: Punctuation

Insert the correct punctuation in each of the following sentences.

1. I do not say that these stories are untrue I only say that I do not believe them
2. I had hoped to find a summer job in the city however two weeks of job hunting convinced me that it was impossible

3. The loan account book must be sent with each monthly payment otherwise there may be disputes as to the amount still owing

4. The *Daily World* though officially a state-owned paper handled the story with scrupulous if disdainful objectivity but many of the supposedly independent papers to everyone's surprise played up all the scandalous aspects of the case

5. The committee consisted of Webster the president of the bank Elton the bank manager and the mayor

6. Supplementary material will be found in W. D. Taylor Jonathan Swift Ricardo Quintana The Mind and Art of Jonathan Swift and Bernard Acworth Swift

7. As a reward for his services to his country the Duke was given pensions special grants and honorary offices and a fund was created to erect a memorial in his honor

8. From the high board the water looked amazingly far away besides I was getting cold and tired of swimming

9. There are no set rules which a performer must follow to become proficient in his or her art however there are certain principles regarding the use of mind voice and body which may help

10. After Lord Warwick expressed his desire with great tenderness to hear Addison's last injunctions Addison told him "I have sent for you that you may see how a believer can die"

Exercise 2.16: Punctuation

Insert the apostrophes as necessary in each of the following sentences. Many of the errors in these sentences have to do with the use of apostrophes in possessives, but there are also other types of apostrophe usage errors.

1. Its true that Robert Thomas car was found shortly after it was stolen, but its fenders were smashed and its tires were missing.

2. The presidents secretary has ordered a three-weeks supply of photocopy paper.

3. Fashions change every year—to everyones satisfaction but consumers.

4. After working with this company for a years time, you are given a two-weeks vacation with pay.

5. This book is Hans, whose collection of dime novels numbers over a thousand items.

6. Tex McCready, Associated Studios leading western actor, was a childrens and juveniles favorite during the 1930s; his income wasnt far from a hundred thousand dollars a year.

7. Dr. Daniels wouldnt have spent his whole years leave trying to establish the Ellins Brothers theory if he hadnt been convinced of its validity

8. Its too bad that the city of Newbridge cant keep its streets in the condition of those of the wealthier suburbs such as Glen Ridge.

9. The Stevenes arent at home this month; theyre visiting their relatives in Florida and wont be back until Christmas.

10. Count to 10,000 by 2s.
11. Cross your ts and dot your is.
12. There were suggestions that the childrens uniforms be modified.
13. It isnt the cough that carries you off; its the coffin they carry you off in.
14. Dickens novel is a very famous one.
15. Dobbs hand contained only two sevens and two fives and he wasnt confident when he called Bowers ten-chip raise.
16. Nickels next two books werent reviewed favorably, but they turned out to be popular as book club choices.
17. Who will administer the citys policies?
18. Who will administer the policies?
19. The cat is lying on its back, but I cant tell whether its dead or not.
20. Her designers hats are famous throughout the nation.
21. This pencil is Charles, not Marys.
22. The garages roof sloped sharply.
23. Robert Burns poems are favorites of ours.
24. In spite of its reputation, Hughes restaurant is not popular with the students; its too expensive.
25. Dont take Keats poem too seriously.

Exercise 2.17: Writing Errors

The following story contains a variety of errors. Correct them and make sure the story conforms to AP style. Raise questions about any problem you have with the copy.

State Bureau of Investegation Director Johnny Jolly told frustrated residents of Midville he couldn't give them details on the slayings of four young people in the last year.

But details were just what 200 townsfolk asked about during a town meeting with Jolly and two other investegating officials last night.

Jolly would not answer when Connie Russell, 22, asked wether the killer was a local person.

"Everybody in this town is just terrified to live normally," Russell said. "I can't go to the grocery store without carrying a revolver. I've become really dependant on that gun."

The first of the four victims was Midville High School cheerleader Beth Harris, 16, who was last seen walking to school on May 1. Her fully clothed body was found tied with a wire to a basketball goal at an abandoned house. A nickle was taped to her forhead.

The charred remains of Jeff Toumey, 15, of Ripton, who was visiting in Midville, were found in a garbage can July 15. He was last seen walking along a road to a friend's house.

Billy Henderson, 16, was abducted from his bedroom while vaccuuming his carpet August 1. His body was found in a antequated automobile a week later after an intensive search by law enforcement officers and volunteers.

Carol Ann Bellows, 19, vanished from a soroity sister's parked car September 4. Her nude body was located only 300 yards from the cite.

Peters said all four killings are definitly related. The Bureau of Investegation has produced a psycological profile of te killer, Peters said, but he would give no details on the profile.

The director also refused to answer questions on whether anything had been taken from the bodies that might identify the killers or on what the causes of death were.

Jolly did answer a question by a woman who wanted to know what law enforcment officers were doing about a prediction from a local psycic.

"She said it would happen again," Mrs. Bertha Nunne said.

Peters replied, "We're not in the habit of following psycics."

Exercise 2.18: Spelling

The following story contains a variety of errors, including a number of misspelled words. Correct all the errors and make sure the story conforms to AP style. Raise questions about any problem you have with the copy.

Eight-grader JoLinda McSpadden, daughter of Mr. and Mrs. Percy McSpadden, Route 3, Pineville, won the county spellilng bee yeterday by spelling "hemmorage" correctly when her rivals could not.

First runnerups in this year's contest were Terri Callaway, daughter of Mr. and Mrs. John Callaway, 16 Baker St., and Nancy Wood, daughter of Mr. and Mrs. Arnold Wood of 3701 Oakdale Road. Both girls successfully spelled "epiphany" to gain a tie for the second spot.

JoLinda, a student at Maplewood Junior High, was the first runnerup in last year's contest. She will go on to compete in the state contest next month in the state capitol.

The two first runnerups are seventh graders at Highland Junior High.

Jane McMillan, an English teacher at Maplewood and coordinator of this year's contest, said more than 300 students entered the three-day competion. She called the contest "an extremely successful one."

Many of the words we used this year were much more difficult than ones we have used in years past," McMillan said.

She pointed out that many of the contestants successfully spelled words like "pantomime," "liquify," naptha," and "questionnaire." JoLinda, she said, outlasted a number of good spellers.

I believe that JoLInda will do quite well in the state bee. She is very composed young lady who is not upset even when she is being hurried, giggled at, or otherwise harassed. That quality of coolness frequently works better than the agression shown by some contestants," McMillan said.

Exercise 2.19: Spelling

The following story contains a variety of errors, including a number of misspelled words. Correct all the errors and make sure the story conforms to AP style. Raise questions about any problem you have with the copy.

The spinal menigiitis outbreak which has plauged the valley area for two weeks is apparently over.

State health department officals have verefied reports that only one person with a confirmed case of the disease is still hospitalized in Greendale.

"We are absolutely delighted to report that 11 of the 12 Midville residents who were struck with menigitis have been released from Community Hospital," Tommy Beans, deputy assistant to the head of the health department, said yesterday.

The remaining patient,11 year -old Bonnie Johnson, had her firist symtoms sesveral hours after a family outing to Vinson park and the nearby national forrest campgrounds last Monday. She became the seventh person admited to the local hospital for spinal minigitis treatment in only 10 days. Her illness was complicated by a chronic resperatory problem, but physicians say her condition is good and that she will be released within days.

A number of neighboring counties have experienced a rash of menigitis cases this month. In Billson County, where 15 pre-schoolers were hospitalized in one week, two deaths have been atributed to the ailment.

Billson County Sherrif Ed Willis said he had no idea where the epidemic originated.

"We've checked out a number of possibilities, but I don't really think we are going to figure out where it began. I'm just happy that it is over," he said.

A total of 55 cases have definitly been treated at five area hospitals since March 1. Isolated cases have been reported in other parts of the state.

Beans said reports of futher cases at area schools are false. He added that it is important for the minigitis patience to take care of them selves.

"Good food and rest, with only a moderate amount of exercize, should take care of the weakness that follows menigitis.

Exercise 2.20: Writing Errors

The following story contains a variety of errors. Correct them and make sure the story conforms to AP style. Raise questions about any problem you have with the copy.

A local man remains puzzelled today over the mysterious disappearance of his automobile.

Billy Hendricks, 21, of 227 Fern St., said he drove to a supermarket near his home yesterday at around 2:30 p.m. to buy steaks for a nieghborhood

cookout. On leaving the store, he was "absolutely astonished" to find his dark blue 1990 Ford Mustang missing.

"I wasn't in that store for more than five minutes. I can't imagine how anyone could have stolen it. I had locked the car, and I had my keys with me. It was really an embarrasing situation to be in, standing there with my mounth hanging open in surprize," Hendricks said.

Although police assigned to the case have questionned local residents and others who were in the area at the time of the incident, they have practiclly no leads.

Sgt. Tommy Wilson, officer in charge of the investegation, said he has "little to go on."

"It could have been anybody from a profesional auto hustler to a kid out for a joy ride to some prankster friend of Mr. Hendricks. When you're dealing with an occurrance as strange as this one, you can't really rule out any possibility," Wilson said.

Wilson said he and his officers are constently working with police from all over the state on cases similar to this one.

"We keep tabs on various people who occasionnally deal in 'hot' cars, and one of them will inadvertantly make a mistake sooner or later. We can hope that one of those mistakes will get Mr. Hendricks' car back for us. And we do have other sources of information to depend on, informents in the car business who keep eyes and ears open.

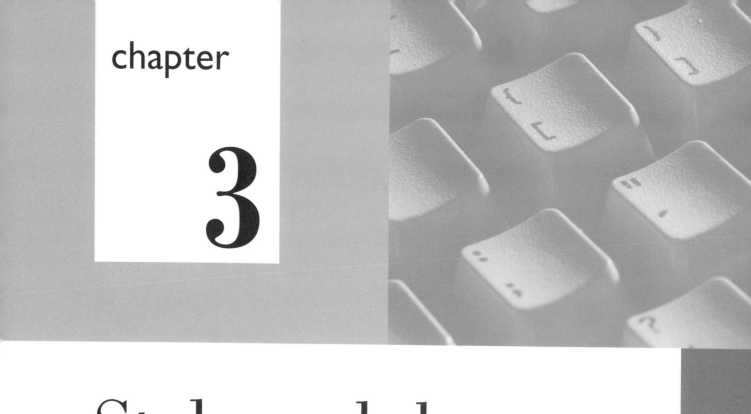

chapter

3

Style and the Stylebook

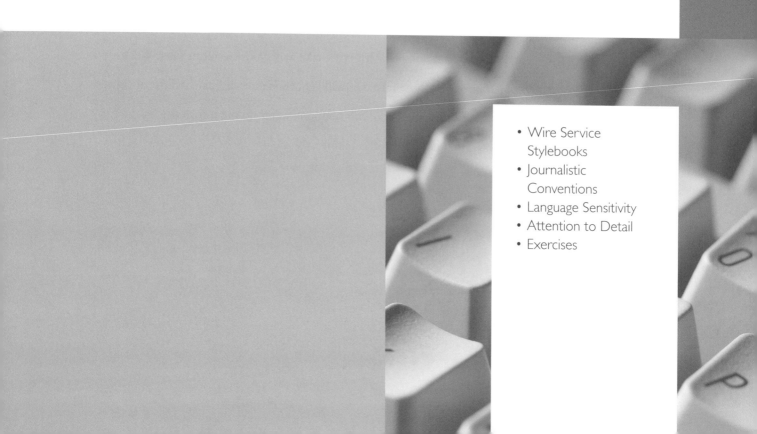

- Wire Service Stylebooks
- Journalistic Conventions
- Language Sensitivity
- Attention to Detail
- Exercises

English is an extremely diverse language, giving the user many ways of saying the same thing. For instance, 8 or eight o'clock, 8 a.m., 8 A.M., eight a.m., and eight in the morning can all correctly refer to the same thing. A reference may be made to the President, the U.S. president, the President of the United States, and so on. All of these forms are technically correct, but which one should a journalist use? And does it really matter?

The answer to the first question is governed by journalistic style. Style is a special case of English correctness that a publication adopts. It does so to promote consistency among its writers and to reduce confusion among its readers. Once a style is adopted, a writer will not have to wonder about the way to refer to such things as time.

Journalistic style can be divided into two types of styles: professional conventions and rules of usage. Professional conventions have evolved during years of journalistic endeavor and are now taught through professional training in universities and on the job. The rules of usage have been collected into stylebooks published by wire services, news syndicates, universities, and individual print and broadcast news operations. Some of these stylebooks have had widespread acceptance and influence. Others have remained relatively local and result in unique style rules that are accepted by reporters and editors working for individual publications.

For example, a publication might follow the *Associated Press Stylebook* and say that AM and PM should be lowercase with periods: a.m. and p.m. The writer will know that a reference to the President of the United States is always simply "president," in lowercase, except when referring to a specific person, such as President Clinton.

Likewise, the reader will not be confused by multiple references to the same item. Unconsciously, the reader will anticipate the style that the publication uses. Consequently, if a person reads a college newspaper regularly and that paper always refers to its own institution as the "University," in uppercase, the reader will know what that means.

Similarly, a reporter may follow the usual convention in newspaper writing and write the sequence of time, date, and place of a meeting although it might seem more logical to report the date before reporting the time.

Having a logical, consistent style is like fine-tuning a television. Before the tuning, the colors may be there, and the picture may be reasonably visible. Eventually, however, the off-colors and the blurry images will play on the viewer's mind to the point that he or she will become dissatisfied and disinterested. That could cause the viewer to stop watching altogether. In the same way, consistent style fine-tunes a publication so that reading is easier and offers the reader fewer distractions.

Beyond that, the question might still remain: Does style really matter? The answer is an emphatic "yes!" Many young writers think of consistent style as a repressive force that hampers their creativity. It isn't. Style is not a rigid set of rules that were established to restrict the creative forces in the writer. Style imposes a discipline in writing that should run through all the activities of a journalist. It implies that the journalist is precise not only with writing but also with facts and with thought. Consistent style is the hallmark of a professional.

Editors are the governors of the style of a publication. It is their job to see that style rules are consistently and reasonably applied. If exceptions are allowed, they should be for specific and logical reasons and should not be made on the whim of the writer. Editors should remember that consistent style is one way of telling readers that every effort has been made to certify the accuracy of everything in the publication.

Wire Service Stylebooks

For many years the Associated Press has published the stylebook that is used as the bible for style for newspapers around the United States. Most public relations departments and many magazines also use the sound advice in this manual as the foundation of their style rules. Because the Associated Press has published its stylebook in a form that is commonly available to students in universities around the country, we shall refer to that stylebook in this section of our discussion.

Here is some representative advice on style covered by the *Associated Press Stylebook and Libel Manual.*

Capitalization. Unnecessary capitalization, like unnecessary punctuation, should be avoided because uppercase letters are harder to read and make the sentence look uninviting. Some examples: Main Street, but Main and Market streets. Mayor John Smith, but John Smith, mayor of Jonesville. Felicia Mason, executive director of the Alabama Press Association. (Note the lowercase title after the name, but uppercase for Alabama Press Association, a formal name and therefore a proper noun.)

Abbreviation. The trend is away from alphabet soup in body type and headlines. But some abbreviations help to conserve space and to simplify information. For example: West Main Street, but 20 W. Main St. The only titles for which abbreviations are called for (all before the name) are Dr., Gov., Lt. Gov., Mr., Mrs., Rep., the Rev., Sen., and most military ranks. Standing alone, all of these are spelled out and are put in lowercase. Check the stylebook for others.

Punctuation. Especially helpful are the sections of the stylebook that deal with the comma, hyphen, period, colon, semicolon, dash, ellipsis, apostrophe, quotation marks, and restrictive and nonrestrictive elements.

Numerals. Spell out whole numbers below 10, and use figures for numbers 10 and above. This rule applies to numbers that are used in a series or individually. Don't begin sentences with numbers, as a rule, but if you must do so, spell them out. Use numbers for virtually all measurements and dimensions. For example: 5 feet 9 inches tall; the 5-foot-9-inch woman; 5-foot-9 woman; a 7-footer; the car left a skid mark 8 inches wide and 17 feet long; the rug is 10 by 12. The storm brought 1 1/2 inches of rain (with space between the whole number and the fraction). In tabular material, convert fractions to decimals. For fractions without whole numbers, use 1/2, 2/3, and so on.

For ages always use numerals: a 2-month-old baby; she was 80; the youth, 18, and the girl, 6, were rescued.

Spelling. In journalism a word has but one spelling. Alternative spellings and variants are incorrect (because of the requirement of style consistency). Make it "adviser," not "advisor"; "employee," not "employe"; "totaled," not "totalled"; "traveled," not "travelled"; "kidnapped," not "kidnaped"; "judgment," not "judgement"; "television," not "TV," when used as a noun; "per-

cent," not "per cent"; "afterward," "toward," "upward," and "forward" (no "s"); "vs.," not "versus" or "v."; "vice president," not "vice-president." Check the stylebook or a dictionary for others.

Usage. "Comprise" means to contain, not to make up: "The region comprises five states," not "five states comprise the region" and not "the region is comprised of five states." "Affect" means to influence, not to carry out. "Effect" means a result when it is a noun and means to carry out when it is a verb. "Controller" and "comptroller" are both pronounced *controller* and mean virtually the same thing, though "comptroller" is generally the more accurate word for denoting a government financial officer and "controller" is better for denoting a private sector financial officer. "Hopefully" does not mean it is hoped, we hope, maybe, or perhaps; it means in a hopeful manner: "Hopefully, editors will study the English language" is not acceptable usage of the word. Good editors may use some fad expressions because readers do, but they do not use them as crutches, and they should know when they are using them.

Dates. Feb. 6 (current calendar year); in February 1978 (no comma); last February.

Journalistic Conventions

A strong sense of professionalism has developed in journalism during the more than 300 years of journalism history in the United States. With this professionalism have come conventions in journalistic writing. As with rules of style, these conventions are known to trained journalists and are used by them to communicate things about their stories to readers. Most readers do not notice these conventions when they read a publication, yet most regular readers know these conventions and what they indicate about the judgments that editors and reporters make.

The conventions include both the basic structures of the stories and the individual ordering of facts. They even include words within sentences that are used regularly in certain types of stories.

Inverted pyramid. Though there is some argument about this structure among professional journalists, the inverted pyramid is the structure that is most commonly used for the modern American news story. For the editor the inverted pyramid structure means two things: Facts should be presented more or less in the order of their importance, with the most important facts coming at the beginning, and a story should be written so that if it needs to be cut, it may be cut from the bottom without loss of essential facts or coherence. The inverted pyramid is certainly not the only acceptable structure for the presentation of news, but its use is so widespread that if it is not used, the nature of a story must dictate the alternative form used by the writer. For example, short features and long take-out stories do not follow this form. Although efforts to replace the form as the dominant one crop up now and then, the inverted pyramid remains the most widely used. Now Web journalism has come along to reinforce its usefulness.

Types of stories. The news values that we discussed in Chapter 1 make it incumbent upon editors to cover and give importance to certain types of stories. These kinds of stories are handled so often that a set of standard practices governing how they are written has been established. For instance, the disaster story must always tell early in the story whether anyone was killed or injured. Another example of this routinization of stories is the obituary. Newspapers develop their own styles for handling obituaries, and some even dictate the form in which the standard obituary is written. For instance, the New York *Times* has a set two-sentence lead for an obituary: "Joan Smith, a Brooklyn real estate dealer, died at a local hospital yesterday after a short illness. She was 55 years old."

Other types of routine stories are those concerning government actions, the courts, crime, holidays, and weather. Part of an editor's job is to make sure that the paper covers these kinds of stories fully and that it reports other stories that have become important to the community that the newspaper serves.

Balance and fairness. One of the tenets of American journalism is fairness. Journalists should attempt to give all people involved in a news story a chance to tell their sides of it. If an accusation is made by a news source concerning another person, that person should be given a chance to answer in the same story. Journalists should not take sides in a controversy and should take care not even to appear to take sides.

Producing a balanced story means more than just making sure a controversial situation or issue is covered fairly. In a larger sense, balance means that journalists should understand the relative importance of the events they cover and should not write stories that overplay or underplay that importance. Journalists are often criticized for "blowing things out of proportion," and sometimes the charge is a valid one. Journalists should make sure that they are not being used by news sources and being put in a position of creating news rather than letting it occur and then covering it and presenting it.

The impersonal reporter. Closely associated with the concepts of balance and fairness is the concept of the impersonal reporter. Reporters should be invisible in their writing. Not only should journalists not report their own views and opinions, but they should also avoid direct contact with the reader through the use of first-person (*I, we, me, our, my, us*) or second-person (*you, your*) pronouns outside of direct quotes.

Reporters and editors inherently state their opinions about the news in deciding what events they write about, how they write about them, and where they place those stories in the paper. No journalist can claim to be a completely unbiased and objective observer and deliverer of information. Yet stating opinions directly and plainly is an unacceptable practice. For a reporter even to include himself with the readers is a poor idea. For example, the following lead is not acceptable because of its use of a first-person pronoun: "The Chief Justice of the Supreme Court said yesterday that our legal system is in serious trouble." A foreign citizen—someone who makes no claim to the legal system of the United States—might read that story; the reporter should write for that person as well. In magazines, for which the audience is more tightly defined, personal writing is more common, and "I" and "our" are frequently used. But in newspapers these approaches are limited to certain sections of the paper and to signed columns.

Sources. Much of the information that is printed in a newspaper comes from what we might call "official" sources. These sources are those that are thought to have expertise on the subject being written about, not those who may merely have opinions about the subject. An example of this reliance might be found in a story about inflation. A journalist writing a story about inflation would probably use information from government reports and the studies and opinions of respected economists and influential politicians. These would be the official sources, and they would have a large amount of credibility with the reader. An unofficial source might be a homemaker, who would certainly have an opinion about the effects, causes, and cures of inflation but who would not have information that would be credible in the mass media.

Young journalists often make the mistake of relying too heavily on one or the other of these kinds of sources, especially the convenient source. They interview people who have opinions about news events, such as their roommates, rather than people who can provide information to support an opinion about a news event. When a source is quoted in a story, it should be readily apparent why that source is used. Jill Johnson, a college student, is not going to have much credibility in a story about the use of child labor in Brazilian sewing factories, though she might have views worth reporting; however, Jill Johnson, the leader of the local chapter of the International Human Rights Coalition, will have higher credibility for such a story. Editors refer to a concept known as the "source ladder," with top officials, such as a university president, at the top rung, managers and technicians on the middle rungs, and consumers and interested citizens at the bottom. For balanced journalism all are important.

Another aspect of sources with which editors need to be concerned is the way in which sources are treated by reporters. Editors must establish clear guidelines for reporters about how sources are approached and interviewed and about the relationship that reporters establish with their sources. Most news organizations require that reporters identify themselves before beginning a conversation with a source and that the reporters make sure the source understands that he or she might be quoted in an article. When a reporter offers a source confidentiality, an editor should be involved in that decision. Many editors require their reporters to tell them the names of their sources, thus accepting along with the reporter the burden of keeping the source confidential.

Some editors maintain their own set of sources even though they might not be using them for original reporting. They do so to keep in touch with important areas that their news organizations cover and to have an independent source of information in case important or controversial stories come their way. Editors who stay in touch with the news at this level are more likely to be knowledgeable and effective in their editing and helpful to their reporters.

Attribution and quotations. Journalists should make it clear to the readers where information has been obtained. All but the most obvious and commonly known facts in a story should be attributed. Editors should make sure that the attributions are helpful to the reader's understanding of the story and that they do not get in the way of the flow of the story.

Journalistic conventions have grown up around the use of indirect and direct quotes. First, except in the rarest instances all quotes must be attributed. The exception is the case in which there is no doubt about the source of the quote. Even then, editors should be careful. Second, journalists disagree about whether a direct quote should be the exact words, and only the exact words,

that a person speaks or convey the exact meaning the quoted person intended, even if the words vary slightly. Most of the time, people's exact words will accurately express their meaning. If they don't, paraphrasing them and removing the quotation marks is the best approach.

Sometimes, however, a journalist must choose between accuracy of words and accuracy of meaning. People misspeak. When we know that they misspoke and we know what they meant, should we pillory them on their own words? Generally, no.

Finally, direct quotes in news stories rarely include bad grammar even if the person quoted used bad grammar. Quoting someone who uses English incorrectly can make that person appear unnecessarily foolish and can distract from the real meaning of the story. In a news story a journalist usually cleans up bad grammar in a direct quote. (Feature story writers may choose not to follow this practice.)

These conventions and others that you will learn about as you continue your study of journalism are important ones for journalists to observe if they are to gain the respect of their readers and colleagues. The conventions should not be looked upon as arbitrary rules that must be followed at the expense of accuracy and clarity. Rather, they are a set of sound practices that are extremely useful to journalists in the process of deciding what to write and how to write it.

Language Sensitivity

Editors must understand that language has the ability to offend and demean. Readers and viewers of the mass media are a broad and diverse group, and those who would communicate with them should be aware of language sensitivities of some of the people within that group. Although some people have gone to extremes in identifying supposedly offensive language, there are terms and attitudes in writing that should legitimately be questioned and changed. The current state of public discourse demands it.

Editors have not always paid attention to such sensitivities. Phrases such as "all men are created equal" and "these are the times that try men's souls" drew no criticism for their inherent sexism when they were first published, partly because women were not allowed to be a major part of public life. We may accept those phrases now because we understand the context in which they were written, but we would not approve of them if they were written in our age.

Editors should examine their copy closely to make sure that they have treated people fairly and equally, that they have not lapsed into stereotypes, that they have not used phrases or descriptions that demean, and that they have included everyone in their articles who is germane to the subject. The following are a few areas in which editors need to take special care.

Sexist pronouns. It is no longer acceptable to use the pronoun "he" when the referent might be a man or woman. "A student should always do his homework" should be "A student should always do his or her homework." In some instances rewriting the sentence using plurals is easier: "Students should always do their homework." Sometimes a sentence can be rewritten so that it does not require any pronoun: "A student should always do the assigned homework."

Titles. Many nouns that had sexist connotations are being phased out, often becoming not only gender neutral but also more descriptive. "Firefighter" and "mail carrier" for "fireman" and "mailman" are examples. Editors need to watch for gender-biased terms and pose alternatives.

Descriptions. Women have often been described in terms of their appearance, physical characteristics, and attire, whereas men are rarely described this way. Editors should be sensitive to what is relevant for understanding a story. Sometimes references to appearance and attire are important to an article, but often they are not. They are included gratuitously and as such are offensive.

Some argue that these descriptions occur because the audience—including women—is more interested in the appearance and attire of women than of men. The dresses of many of the women attending an event such as the Academy Awards are a central part of that annual story, sometimes as much as the awards themselves. Actresses try to outdo each other in wearing unusual or daring gowns. Ignoring that aspect of the event would not be responsible journalism. There are other instances, such as when female lawyers appear in a courtroom setting, in which references to women's attire are clearly inappropriate.

Racial descriptions and references might not be necessary. John Kincaid is the mayor of Birmingham, Alabama. To describe him as "John Kincaid, the black mayor of Birmingham" is not necessary unless it is important to the understanding of a story to know his race. The test here is to ask the questions "What if Mayor Kincaid were white? Would it be important to know that?"

References to the racial, ethnic, or religious characteristics of people who have been accused of a crime or who have been involved in criminal activity is another tricky situation for editors. Many racial groups and nationalities have been associated with undesirable characteristics or unpatriotic activity. In the nineteenth century immigrants from Ireland were thought to be lazy, stupid, and alcoholic. During World War I suspicion fell on people of German descent as being less "American" than others. The same thing happened to Japanese Americans during World War II when the government went so far as to put many in internment camps even though they had done nothing wrong. The attacks of September 11, 2001, led many people to suspect all Arabs and Muslims of being part of an international terrorism conspiracy. Editors need to guard against labels and descriptions that tie individuals or groups to nefarious beliefs or behavior when such references are not clearly warranted.

Stereotypes. Our society abounds in stereotypes, and not all are based on race. We describe women who stay at home as women who "don't work" when, in fact, they do work very hard at very important jobs. We refer to a "Jewish mother" as someone with certain hectoring characteristics, even though many Jewish mothers do not hector their children and many Gentile mothers do. We write about "Southern bigots," ignoring the fact that bigotry is not confined to a single region of the country. An older woman who has never married is called a "spinster," a reference that many see as derogatory. We should constantly question these blanket references and phrases to see whether they serve our journalistic purposes.

Illness and disability. U.S. society is taking some steps, by private initiative as well as by law, to open itself to people who have various handicaps,

disabilities, or limitations. One of the things that Americans should learn as this happens is that identifying people by these limitations is in itself unfair and inaccurate. To say that a person "has a handicap" is different from saying that a person "is handicapped." The way in which these limitations are referred to can also be disabling. For instance, to describe someone as a "reformed alcoholic" is neither complimentary nor benign; "reformed" implies that the person did something wrong and now the problem is solved. A person who is an alcoholic but who no longer drinks is "recovering." To say that someone has a "defect," such as a "birth defect," is to demean by implication (i.e., the person is defective). It would be better to say that a person "was born with a hearing loss." As with many situations, being specific makes using the general, and often offending, term unnecessary.

These are just a few of the areas in which editors need to maintain great sensitivity and to continue close examination of their work. Constantly questioning what is in the copy you read and making reasonable changes are not just the marks of a good editor; they are signs of a sensitive editor.

Attention to Detail

The editor's job is more than one of simply enforcing the rules, although enforcing the rules and establishing high standards are important parts of the editor's work. The editor must pay attention to the details, the small items as well as the large ones. The small items are the foundations of a publication's credibility. Errors in grammar or style might not be criminal offenses, but they chip away at the reader's faith in the organization. Ultimately, that faith—along with the long-term health of the publication—is in the hands of the editor.

3 Exercises

The exercises in this chapter are designed to help you learn to use the *AP Stylebook* and develop as a good journalistic editor. Editors have to pay attention to the details of what is written, but they also have to keep in mind the overall intent and direction of the writing, as well as the needs and demands of the publication for which they work. These exercises will ask you to work at these three levels in various ways.

Exercise 3.1: AP Stylebook

Make the following sentences, expressions, and words conform to AP style and correct grammar, usage, and spelling.

1. The campus chapter of The Society of News Design will meet in room 320 of the Communications building.
2. transcontinental, reelect, transsiberian, reexamine
3. Some Scotch people live in Mountain City, North Carolina.
4. five, ten, twelve, two and a half percent
5. The People's Republic of China is the largest country in the world, with over 1,200,000 people.
6. Margaret Jones Smith use to be the chairperson of the committee.
7. breakdown, fullfledged, infighting, Indo-China
8. Joseph P. Kennedy, Jr., was the president's older brother.
9. The instructor has a PhD in journalism.
10. Rank the following titles from one to five with the highest as one:

_____ Sergeant
_____ Major

_____ Colonel
_____ Major General
_____ Captain

11. The train is arriving at ten P. M. tonight.
12. The late Pontiff, John Paul the second, spoke several languages, including english, french and german.
13. William faulkner won a Nobel prize in literature.
14. like-wise, pre-historic, post-operative, holdover
15. The Labour Party lost the last election in England.

Exercise 3.2: AP Stylebook

Make the following sentences, expressions, and words conform to AP style and correct grammar, usage, and spelling.

1. Jane Smith, age three, won the tricycle race. her aunt Mrs. Joyce Jones was her sponsor. Miss Smith lives at 201 north 8th Street, Prairie, S.D. Ms. Jones lives at 28th Pl., NE, Praire, S.D.
2. The Southeast History Division (S.R.H.D.) of the Association for Education in Journalism and Mass Communication (AEJMC) will host a Colloquium Friday and Saturday, January 27-28, 1993 on Journalism History at the Downtown Ramada Inn in Tuscaloosa, AL. The Event is expected to be attended by eighty to one hundred participants from the southeast.
3. The couple have 10 dogs, 6 cats, and 97 hamsters. None of the pets have been inoculated against rabies. The vet locked them up in 2 4 bedroom houses and said he would send them even further away next time.
4. The faculty advisor said: "Your 1st class begins at 8:00 A.M.." "Please make," he added, "an effort to get to class on time". "Shall we call it a 'gentlemens agreement' "? the prefessor continued.
5. The churches program was to collect girl's clothing boys toys and childrens' furniture.
6. The rock and role group also played music from the Gay' 90's, the Class of '65 and the "Roaring Twenties."
7. Attending the meeting were Bill Ray, Athens; Jack Smith of Columbus, and Joe Jones, of Dayton.
8. She hoped to fulfill her ambition of becoming a navy nurse after basic training in San Diego cal. She would then be equiped more formerly to do her job for the U.S.
9. Miss Hepburn, the screen's unchallenged "First Lady", was the first performer of either sex to win three Oscars for best actress.
10. I waved at the girl, who was standing on the corner. (One girl was.)
11. I waved at the girl, who was standing on the corner. (She was not sitting on the curb.)
12. After a quiet vaction in the midwest the young Marine Biologist was ready for his trip to the Antarctic Region.

Exercise 3.3: AP Stylebook

Make the following sentences, expressions, and words conform to AP style and correct grammar, usage, and spelling.

1. After his trip through the south, the young Journalist was ready for his trip to Europe.
2. Frank Stanton is the former President of the Columbia Broadcasting System.
3. The press failed to reexamine what in reality was a transcontinental effort to reelect the Prime Minister of Britain.
4. Many Scotch people migrated to Mountain City, North Carolina.
5. Five is fifty percent of 10, ten is one percent of 1000 , and 12 is 25% of 48.
6. With over 1,200,000,000 people, China is the largest country in the world.
7. Margaret Smith was elected chairperson of the committee.
8. The break-down of parliamentary order has led to infighting and back-stabbing among members of the factfinding committee, especially in the diehard faction.
9. John F. Franklin, Jr., who was the older brother of South Trust Bank of Tuscaloosa President Barney Franklin, died October 4, 1997 in Athens, Ga. after a long illness.
10. The Professor has a PhD in History.
11. The train is arriving at ten P.M. tonight.
12. The Pontiff, Pope John Paul the first, spoke several languages.
13. William Faulkner won a Nobel prize in literature in 1948.
14. "Like-wise," the professor said, "I also believe that avoidance of research into the pre-historic and post-operative is a hold-over from the era of superstition."
15. The Labour Party won the last election in Britain.
16. "Co-operate during the preelection period," the party official said, "or be prepared to pre-heat your leftovers as a pre-flight exercise for your post-nuptials every postdawn from now until the post-mortem."
17. Rev. Johnny Milton led the sunrise service at 4:30 a.m. on Easter Sunday morning.
18. Flowers adorned either side of the altar.
19. Bronson's Company Incorporated is opening a new factory next month.
20. It was eight p.m. in the evening not 8 a.m. in the morning, when the gates swung open to the House of Horrors. The Hallowe'en Party wondered if they would live to see the clock strike 12:00 midnight, or, for that matter, 25 past eleven?

Exercise 3.4: AP Stylebook

Make the following sentences, expressions, and words conform to AP style and correct grammar, usage, and spelling.

1. Over 50,000 people attended the major league All-Star Game.
2. Jill Brody, normally the team's best runner, placed twenty-second in the 5,000 meter run; Janice Wilson, a freshmen walkon, was first.
3. 5,000-meter run. Janice Wilson, a freshman walk-on, was first.
4. By a 12 to 1 majority, the decision was to mix the ingredients in a ratio of 2 to 1.
5. A freelance should always pack an extra T shirt before going deep sea fishing with a group of attorney-generals.
6. The Gross National Product rose a tenth of a percent in the first quarter.
7. The researcher took her material from the "Encyclopedia Britannica" and the "Autobiography of Lincoln Steffens".
8. The precious stone was 20 carrots.
9. The group fundamentally performed a fund raising function.
10. John Phelps served as his father's lawyer.
11. The mode is the middle score in a group.
12. The mean is the most frequent score.
13. The median is determined by adding the scores and dividing by the number of scores
14. dance troop, Boy Scout troupe
15. Texarkana, AR.
16. Harlingen, Tex.
17. Salt Lake City, Utah
18. Sioux, City, IA
19. Albany, NY
20. Honolulu, Hawaii

Exercise 3.5: AP Stylebook

Make the following sentences, expressions, and words conform to AP style and correct grammar, usage, and spelling.

1. co-operate, preelection, pre-heat, preflight, pre-dawn, postmortem
2. The Reverend Johnny Milton led the Easter services at 4:30 A.M. this morning.
3. Flowers adorned either side of the altar at the Brown-Morris wedding.
4. Bronson's Co., Incorporated, is opening a new factory near Wilsonville next month.
5. 8:00, 8 o'clock in the morning, 12 noon, 12 p.m., 1:36 A.M.
6. Over 50,000 people attended the midsummer All-Star baseball game.
7. Bill Brody, the school's best runner, placed 22nd in the Regional Track Meet this year; Howard Wilson, a freshman, was 1st.
8. The French Army and the U.S. Army joined forces today in an effort to keep the peace in war-torn Lebanon.

9. Mix the ingredients in a ratio of 12-1.
10. A 12-to-one majority in the voice vote expressed the widespread approval of the bill.
11. Karl Teague, Dean of the College of Arts and Sciences, will address the graduating class at 11:15 in the morning.
12. freelancer, duffle bag, sister in laws (plural), t-shirt
13. The Gross National Product rose significantly in January, 1994.
14. The case in question is now in Federal District Court.
15. I found my material in the "Encyclopedia Britannica," in "The Autobiography of LIncoln Steffens," and in several magazine articles.

Exercise 3.6: Copy Editing, AP Stylebook

Copy edit the following story to conform to AP style and correct grammar, usage, and spelling. Deal with other problems, such as wordiness and lack of clarity, that you find.

Suzie Headacher, who taught inner-city children from a housing project about caring for small animals in limited space, today was named one of six national winners in the 4-H agriculture education program.

Headacher, 18, received a scholarship during the 60th National 4-H Congress in Chicago. The Congress opened Sunday and continues through Thursday.

Selected by the Cooperative Extension Service, Headacher and the other five winners were presented their awards by Johnson-Fertilizer Company, sponsor of the 4-H agriculture education program. Awards were arranged by National 4-H Council.

"Miss Headachers' unique project illustrates to all of us the value of thinking beyond our limitations. She had the courage to conceive of a New York City where kids can see animals somewhere besides zoos, and she did something toward fulfilling that vision," the National 4-H Council President said.

Headacher was one of four state 4-H'ers who won national honors and scholarships.

Exercise 3.7: Editing Problems, AP Style

Copy edit the following story to conform to AP style and correct grammar, usage, and spelling. Deal with other problems, such as wordiness and lack of clarity, that you find. Remember that in a journalistic setting, words should be used literally for what they mean. This story presents other problems that editors may face and that you might want to discuss before editing.

When the city coucil met Monday night in the city hall council room, several councilment reacted violently to Mayor Johnson Greene's proposed $26,000 increase in city spending appropriations for next year.

"There ain't know way we can handle that kind of spending without raising taxes," Council Member Fred Watson said.

Watson and others say they cant see why the mayor failed to suggest an increase without coming up with any additional income for the ciey.

The higher bdget results from increases in appropriations in the protection a persons and property category and in pollution contrl.

The budget includes $121,000 for protection of persons and property, $16,000 over last years budget.

This incerase was because of the installation of traffic signals at main Street and Florida ave and Main STReet and Wilson Boulevard, and the adding of personnel in the Police Department

Budgeted for the pollution insector's office was $105,000, an increase of $8725 ovet last year.

The council also acted Monday to stop issuance of solicitation permits until it ca review and possible revise the existing ordnance.

The action stemmed from an incident last week when tw comeptitive groups of magazine soliciters stated fighting in th street and were ordered to leave the city.

The council said residents have complained about "high pressure salesmen being allowed in the city.

In other business, te cuncil awarded a contract for a new police car to ogden Auto Sales Co. for $1,969 with a tradein of a present police car.

Exercise 3.8: Editing Problems, AP Style

Copy edit the following story to conform to AP style and correct grammar, usage, and spelling. Deal with other problems you find. Rewrite the story as you think necessary.

A local elementary school teacher has apologized for calling a fellow instructor a "Klansman" and has agreed to pay about $2000 in court costs.

The letter of apology Tuesday from Lacey McGruder to Charles Peace avoided a Circuit Court trial of the $150,000 defamation of character suit Peace had filed.

The suit said McGruder had labeled Peace a "Klansman" and had told people he marched with the Ku Klux Klan during a demonstration in Centerville on September 8, 2003.

In addition to writing the apology, McGruder agreed to pay court costs and other expenses incurred by Peace in filing the suit against her.

in the letter of apology McGruder said she did not see Peace in the Klan march and "my statements were based on rumors that were circulating at the time and upon statements that were made by others to me. I apologize to you for those statements made by me.

"I now realize that repeating these unfounded statements and rumors hurt you personally and I deeply regret this."

Exercise 3.9: Copy Editing, AP Style

You might need additional information to edit this story properly. If your instructor chooses, he or she can play the role of the editor and answer your questions about the story. Copy edit the story to conform to AP style and correct grammar, usage, and spelling. Deal with other problems you find.

WILSONVILLE—City fathers have gone to court to fight state officials in a zoning battle involving convicts.

Defendants in the suit are the Department of Corrections; John Willet, Carol Largess, Bob Mathews, and Clarnece Copper.

The city filed suit in Weston County Circuit Court seeking an order requiring the state Department of Corrections to remove several temporary facilities for housing inmates in south Wilsonville. The suit said the tent-like units located near the National Guard Amory on U.S. Highway 322 violated city zoning ordinances.

The land is owned by the Corrections Department and is zoned for industry. The suit alleges the three units, which house some 20 female work-release inmates, were placed on the south Wilsonville property without the consent or authorization from the city council or Wilsonville Planning Commission.

Among other things, city zoning ordiances specify that no temporary structure in any district shall be used in a manner that is dangerous or otherwise objectionable to the surrounding areas.

Residents in the area complained about the "huts,", and the city council last week warned the prison system that they should be moved immediately or legal action would be taken. The warning was the second since April.

Prison officials say they were in the right because, they say, a previous court case exempted state operations from local zoning ordinances.

The city's suit says the state's structures are on lots which aren't big enough to meet minimum standards outlined in the zoning ordinances.

The suit also contends the defendants "illegally connected" the housing facilities to water and sewer lines at an existing building without the required permit from city utilities. A hearing date has not been set.

Exercise 3.10: Copy Editing, AP Style

Copy edit the following story to conform to AP style and correct grammar, usage, and spelling. Deal with other problems you find.

Three classes of second-graders at Midville Elementary School have made use pf 40 pounds of things most people would rather throw away; toilet paper cylinders, egg cartons and empty spools, and the products of the students's efforts are on display in the school's are gallery.

Caterpillars, bunnies, Easter baskets, and puppets are included in the display along with more ambitious efforts such as Jo Anna Moore's model of a steamship made entirely of styrofoam.

The art project was one component of an enviromental awareness program formulated by the state Enviromental Association in a booklet called "Recycling: Using the Unusable."

The entire Woodvale school system has adopted the program, whih includes collection of aluminum, showing film strips, and a campus clean-sup day.

"The purpose is to make children more aware of the potentail value of things we normally throw away, Woodvale Principal Donna Estill said.

Exercise 3.11: AP Style Test 1

This exam consists of twenty-five sentences and three choices for each. Select the answer that conforms to AP style.

1. The kickoff is set for 11:45 _____.
 a. AM
 b. A.M.
 c. a.m.
2. The public address announcer asked, "Is there a _____ in the house?"
 a. doctor
 b. Dr.
 c. Doctor

3. He lives at 127 Elm _____.
 a. Street
 b. St.
 c. Str.
4. The philosopher was born in 360 _____.
 a. Before Christ
 b. B.C.
 c. BC
5. The operation was performed by _____ Louise Smith and Fred Jones.
 a. Doctors
 b. doctors
 c. Drs.
6. Early this _____ he opened his eyes for the first time in a week.
 a. a.m.
 b. A.M.
 c. morning
7. Tennessee became a state on _____ 1, 1796.
 a. June
 b. Jun.
 c. date should read "6–1-1796"
8. He became a _____ citizen only last year.
 a. United States
 b. U.S.
 c. US
9. _____ called for a summit meeting with European leaders.
 a. The President
 b. Pres. Bush
 c. President Bush
10. I looked for him somewhere along _____ Avenue.
 a. 5th
 b. Fifth
 c. fifth
11. The soldier had already gone through two _____.
 a. courts martial
 b. court martials
 c. court-martials
12. The Jefferson County _____ failed to indict anyone for the crime.
 a. Grand Jury
 b. grand jury
 c. grand Jury
13. Ken Griffey _____ is now on the same team with his father.
 a. junior
 b. Junior
 c. Jr.
14. He had to take the exam _____ times before he passed it.
 a. 2
 b. two
 c. twice
15. His October _____ deadline was drawing close.
 a. thirty-first
 b. 31
 c. 31st

16. The colors of the flag are red, white _____ and blue.
 a. comma
 b. semicolon
 c. no punctuation
17. Exxon _____ announced it was raising its prices for oil.
 a. Corp.
 b. Corporation
 c. corporation
18. His inauguration took place on the steps of the _____.
 a. capital
 b. capitol
 c. Capitol
19. The neighborhood group decided to withdraw _____ lawsuit.
 a. its
 b. their
 c. they're
20. _____ Joseph Barlow appointed all of the members of the committee.
 a. Lieutenant governor
 b. Lt. Gov.
 c. Lieutenant Governor
21. The _____ was a term used to describe conflicts between the United States and the former Soviet Union.
 a. Cold War
 b. cold war
 c. Cold war
22. His first thought was to get in touch with the _____.
 a. Federal Bureau of Investigation
 b. FBI
 c. U.S. FBI
23. The _____ comes on Wednesday this year.
 a. fourth of July
 b. Fourth of July
 c. 4th of July
24. The president summoned _____ Smith to the Oval Office.
 a. Sec. of State
 b. Secretary of State
 c. secretary of state
25. With _____ of the game left, the star player was injured.
 a. two-thirds
 b. two thirds
 c. 2/3

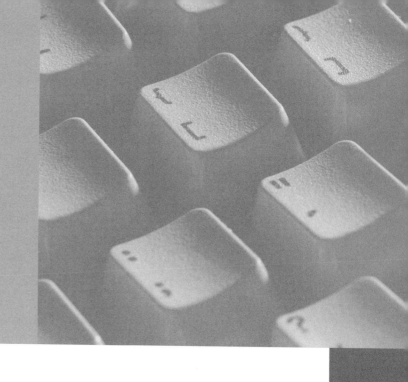

chapter

4

Accuracy, Clarity, and Brevity

- Accuracy
- What to Check
- References
- Clarity
- Brevity
- Types of Writing
- Four Characteristics of Media Writing
- Exercises

The story was datelined Palestine, West Virginia, and appeared in the New York *Times* in March 2003. The first paragraph described Gregory Lynch, father of Jessica Lynch, an Army private who had been captured by the enemy during the U.S. invasion of Iraq that spring.

Mr. Lynch, the story said, "choked up as he stood on his porch here overlooking the tobacco fields and cattle pastures, and declared that he remained optimistic."

Pfc. Lynch had been missing since her unit had encountered the Iraqis less than two weeks after the war had begun. Although U.S. forces had been making steady progress toward Baghdad, they had met more resistance than expected. Lynch's capture was symbolic of the troubles the Americans were having. About two weeks after her capture, on April 1, Lynch was rescued by a special forces unit. Her rescue became one of the major news events of the war, and although she had done relatively little, she became a symbol of U.S. military prowess.

From the time she became famous, everyone wanted to know about Lynch, her family, and her background. The New York *Times* sent one of its star reporters, Jayson Blair, to West Virginia to see where she was from and to talk with her family, neighbors, and friends.

Blair filed a story filled with colorful quotations and detailed descriptions, including the line in the second paragraph above. The problem with the story is that most of it was not true. Blair never went to West Virginia, and he never talked to any of Lynch's family or friends. Most of the story was either made up or plagiarized from other sources.

How could an editor know this? After all, Blair had been one of the *Times'* best young reporters. He had kept the newspaper ahead of other news organizations with his work on the D.C. area sniper story a few months earlier. He had the clear confidence of the top editors of the paper, particularly Howell Raines, the executive editor, and Gerald Boyd, the managing editor. In the daily business of journalism editors have to trust their reporters.

Still, with this particular story and with the sentence quoted here, alarm bells should have gone off in the head of someone in the editorial process. Tobacco fields? West Virginia? Virginia, not West Virginia, is a state that is noted for growing tobacco. West Virginia is mountainous and not well suited for tobacco. West Virginia produces some tobacco (as do many states), but the pairing of tobacco and West Virginia should have raised the eyebrow of some editor and provoked a question or a phone call checking to see whether the description was true.

A look at a map might have added to these doubts. Palestine is located north of Charleston, closer to Ohio than to Virginia. This is an unlikely place to have a tobacco field, much less "tobacco fields" that could be seen from someone's back porch.

Less than a month after the story ran, Blair had resigned from the *Times,* and much of his journalism for the previous two years had been discredited. He had made up facts for dozens of stories. Many of them, such as the line about tobacco fields in West Virginia, could have been checked easily by a sharp-eyed editor. In fact, some were, and suspicions about Blair's reporting grew among the subeditors of the *Times.* But the errors were overlooked or dismissed by those who maintained their faith in Blair's ability. (The story of Blair's downfall, which ultimately led to the resignation of Raines and Boyd and a restructuring of the editorial process at the *Times,* can be found at Journalism.org, http://journalism.org/resources/briefing/archive/blair.asp.)

The first job of any editor at any level is to help ensure the accuracy of the information that the news organization presents. All other concerns are secondary. The second job is to make sure the information is clearly written and presented in a context that allows the reader to understand it. The third job is to aid in presenting the information efficiently so that the reader's time is not wasted. Accuracy, clarity, and brevity—along with precision, which was discussed in the previous two chapters—are the characteristics of writing that all editors should strive for.

Accuracy

Accuracy is the most important consideration of an editor. Accuracy is the central reason for much of what an editor does. In the pursuit of accuracy a word of doubtful spelling is checked, one last fact in the story is looked up, or a source is called close to deadline when some part of a story is in question.

A reputation for accuracy is a publication's most valuable resource. Not only does it inspire the confidence of readers, but an obvious willingness on the part of editors to strive for accuracy opens up new sources of information for the newspaper and often gets the paper out of embarrassing and dangerous legal entanglements. A reputation for accuracy might be the surest way to ensure the survival of the publication. One example of this is the reputation for reliability that the New York *Times* built during the "yellow journalism" era. While other papers, especially in New York City, were trying to outdo one another in their sensationalism and outrageousness, the *Times* remained a calm, thoughtful voice that readers found they could count on. Today, the one New York paper that survives from that era is the New York *Times*.

No substitute exists for accuracy. Readers are notoriously unwilling to accept the very reasonable excuses that reporters are inexperienced, that the publication is understaffed, or that the paper was having a busy news day. Few readers have any concept of what the pressure of deadlines can do to good reporting or editing. What they do understand is that a headline did not accurately reflect the content of a story, that the capital city of their home state was misspelled, or that their child was misidentified in the cutline of a picture that included several other children. Readers won't easily forgive such mistakes, nor will they forget them. Just a few errors are enough to get a publication in trouble, damage its credibility, and demonstrate to readers that it is unworthy of their attention—and money. Like weeds in a garden, a bad reputation needs no cultivation; all it needs is a start.

For an editor the pursuit of accuracy is a state of mind. An editor must be willing to check everything that is in doubt and must be willing to doubt anything. An editor must cast a cold eye on the work of the reporters, even those with the most experience and the best reputation; the editor must demand an accounting from them as much as from novices. The editor must even be willing to doubt his or her own knowledge and experience and must occasionally recheck what he or she knows to be true. Such editors can make life hard on themselves and those around them, but their efforts will pay dividends for the good reputation of the publication.

Figure 4.1

Dates

Somewhere in the development of education, dates fell out of favor. They were thought to be tedious and—worse—"irrelevant." The problem is that we can't do without them—at least, an editor can't. Knowing when something happened helps an editor to put other information in context. Dates help us to understand and judge information. An editor needs to have a long list of dates in his or her intellectual arsenal. Here are a few that should be there.

July 4, 1776: Declaration of Independence signed
July 1–3, 1863: Battle of Gettysburg
November 19, 1863: President Lincoln's Gettysburg address
April 14, 1865: Lincoln shot at Ford's Theater; died April 15
November 11, 1918: World War I ends
October 29, 1929: Stock market crash begins Great Depression
September 1, 1939: Germany invades Poland
December 7, 1941: Japanese bomb Pearl Harbor
June 6, 1944: D-Day; allies invade Europe
August 6, 1945: Atomic bomb dropped on Hiroshima
December 1, 1955: Rosa Parks refuses to give up her seat on Montgomery bus,
 beginning the modern Civil Rights movement
February 20, 1962: John Glenn is the first American to orbit the earth
September 15, 1963: 16th Street Baptist Church in Birmingham bombed
November 22, 1963: President John F. Kennedy shot
April 4, 1968: Martin Luther King killed in Memphis
July 20, 1969: Neil Armstrong is the first man to walk on the moon
May 4, 1970: Four students killed at Kent State University
May 15, 1972: George Wallace shot
June 17, 1972: Burglars break into the Democratic party headquarters at Water-
 gate apartment complex in Washington
August 9, 1974: Nixon resigns over Watergate revelations
August 16, 1977: Elvis Presley dies
January 28, 1986: *Challenger* explodes shortly after liftoff
April 19, 1995: Federal building in Oklahoma City bombed
January 1998: First reports surface of President Bill Clinton's affair with a White
 House intern; scandal eventually led to U.S. Senate impeachment trial in 1999
September 11, 2001: Terrorists attack the United States, flying planes into the
 World Trade Center towers in New York City and the Pentagon in Washing-
 ton, D.C.; a fourth plane is hijacked and crashes in Pennsylvania
March 2003: U.S. forces invade Iraq
Inclusive dates:
1861–1865: American Civil War
1903: Wright brothers' first flight
1914–1918: World War I
1919–1933: Prohibition
1925: Scopes monkey trial in Tennessee
1930s: The Great Depression
1939–1945: World War II
October 1962: Cuban missile crisis

What to Check

An editor cannot check every single fact in a story. (A few magazines, however, take pride in doing just that.) Time pressures will not allow a daily newspaper editor to do this even if the resources were available. Instead, an editor must be alert to the things in a story that are most likely to be wrong. Certain elements of stories should always raise some questions in the minds of editors. The following is a list of some of those elements.

Names and titles. There is no quicker way for a publication to lose readers than to misspell names. A name is a person's most personal possession; to misspell it shows inexcusable sloppiness on the part of the writer and editor. If there is any way possible, names should always be checked for proper spelling. Titles present another problem area for journalists. An editor should do his or her best to ensure that titles are checked and correct. Titles, of course, should conform to AP style or the style used by the publication, but otherwise they should be technically correct, that is, they should be written as those who use them regularly would write them. For instance, most people probably think that a person who teaches at a college or university is a "professor." That title would suffice for most readers, but for those who know better there is a vast difference between "professor" and "assistant professor." The journalist should seek technical as well as general accuracy in titles. An efficient and effective editor knows where to look or whom to call to double-check these important matters.

Numbers. Any time there are numbers in a story, bells should ring in the editor's head, especially if those numbers are supposed to add up to something in a story. An inconsistency in numbers is easy to check if the answers are contained in the story, but such inconsistencies are often overlooked. Too many editors look at numbers and assume that they are correct. Editors cannot make such assumptions safely. They need to make sure that percentages add up to 100 and that all other numbers add up correctly.

Places. Editors should be extremely careful about describing places and place names. To say that something is happening in Nashville when it is really happening in Knoxville, to describe St. Louis as the capital of Missouri, or to write that Holland is part of Scandinavia can make a publication look foolish.

The story's inner logic. We have already said that the numbers in a story should add up correctly. So should the facts. Readers should get a good idea of the time sequence of a story even if the facts of the story are not presented in chronological order, as they almost never are. Questions that are raised in one part of the story should be answered in another part of the story. One example of not answering questions raised in a story would be saying, "This building is the third tallest in the state," and not mentioning what the two taller buildings are. All of the facts in a story should have a logical relationship to one another, a relationship that the reader can easily discern. Throwing facts into a story without proper transitions and a logical sequence presents obstacles to readers that can ultimately decrease their interest in a story or in the publication.

References

Certain references should be near any editing desk. If you find yourself working at a publication where these references cannot be found, you should ask your supervisors to provide them. Once these references are available, learn to use them efficiently. They are fundamental to doing good work as an editor. They will answer most of the common questions you will encounter, so using them should become automatic.

Here are five of the basic and commonly used references.

Dictionaries. Any person who works with words will find a dictionary an indispensable reference tool. A publication of any size should have a large dictionary for reporters and editors. Smaller dictionaries should be provided to individual editors. Dictionaries are most commonly used to help people spell words correctly, but they can have many more uses. Many dictionaries contain a gazetteer (a dictionary of place names); a glossary of foreign phrases; grammar and punctuation guides; maps; the names, identifications, and life spans of famous people; and a list of colleges and universities in the United States.

Atlases. A road atlas and a world atlas are essential references. Reporters and editors must locate places and events for their readers. It is especially important for a newspaper to have accurate, up-to-date maps of the area that it covers, preferably a large wall map that can be used by anyone. Such a map can save the publication a lot of time (and money) and provide another means of ensuring a story's accuracy. Editors should be particulary careful about the world atlases they use because international borders have changed a great deal in the last two decades.

Almanacs. Almanacs provide a wide range of information that can be easily referred to. For instance, an almanac can tell you how many people live in Boise, the members of the Baseball Hall of Fame, and the way Californians voted in the last presidential election. One of the chief advantages of almanacs is that they are relatively recent; many are published annually. Another advantage is that these annual almanacs are usually inexpensive. A newspaper operation that cannot be persuaded to purchase more expensive reference material will usually provide an almanac for its copy editors. If not, editors who plan to advance in the craft will buy their own. One of the most useful almanacs is *The World Almanac and Book of Facts*. This book contains features that include a chronology of the year's major news stories; population; sports; weather; economic statistics; presidential biographies; maps; basic information on cities, states, and nations; U.S. and world history; weight and measurement conversion tables; a perpetual calendar; lists of prize winners; colleges and universities; and a list of noted personalities with their places of birth and birth dates. It also has the text of the Constitution, the Declaration of Independence, and the Gettysburg Address (www.worldalmanac.com/wab-newsletter.htm).

Another extremely useful reference is the *Statistical Abstract of the United States*. The standard summary of U.S. government statistics, the *Statistical Abstract* has been published annually for more than 100 years. Use it to find data on population, birth, marriage, divorce, and death rates; educational statistics such as

enrollment figures and graduation rates; crime rates; unemployment rates; GNP; poverty rates; consumer price indexes; interest rates; and housing, business, agriculture, and selected comparative international statistics (www.census.gov/statab/www/).

Directories. The most common directory is the telephone directory, and there is usually one at every desk. Although telephone directories go out of date quickly, they are easily used to check the spelling of names and other local facts. If a university, large industrial plant, or military base is located near the newspaper, chances are that these places will have their own telephone directories, and the newspaper office will need a copy of these as well. The second most commonly used directory is the city directory. Sometimes city directories are expensive, but they are well worth the money. A city directory goes beyond the telephone directory in listing the names of the residents of a town, their home addresses and telephone numbers, their occupations and places of business, and their spouses. In addition, a city directory will have a list of all the addresses in the city, usually listed by street name and number and who the occupant of each address is; a list of the telephone numbers in sequence and in whose name the phone is listed; and the officers and proprietors of businesses in the community. A city directory is really indispensable to a serious news operation.

An example of a good directory is the *Official Congressional Directory*. This is the official source for basic information on Congress. It includes biographical sketches of members with descriptions of their congressional districts, lists of committee assignments and committee staff, and maps of congressional districts. The names, addresses, and phone numbers of foreign ambassadors and consular offices in the United States as well as a list of U.S. ambassadors abroad are also here (www.gpoaccess.gov/cdirectory/index.html).

Encyclopedias. Large news operations will probably have a set of encyclopedias available. These can be extremely useful in providing background information for stories and in checking facts of a less current nature. A good set of encyclopedias can mean an enormous expansion in the editor's ability to check facts, but encyclopedias can be an expensive addition to the publication. Most publications have a library, where previously published stories and articles are systematically filed. Large publications have put most of this material online, accessible from the writer's desk. And the World Wide Web contains direct access to the entire contents of many encyclopedias. A few online encyclopedia services are Encyclopedia.com (www.encyclopedia.com/), Wikipedia (en.wikipedia.org/wiki/Main_Page), Columbia Encyclopedia (www.bartleby.com/65/), and Encarta (encarta.msn.com/Default.aspx).

Clarity

Accuracy is not enough. After accuracy, clarity must be one of the chief goals of an editor. Facts that are unclear are of little use to the reader. The English language is extremely versatile, but that versatility can lead to confusion when the language is in the hands of amateurs. Editors must be experts in the language and in the proper and clear organization of a story. Editors must be on constant guard against writing or story structures that could be confusing to the reader.

Like the pursuit of accuracy, the pursuit of clarity is a state of mind for editors. It must be constantly with them, and they must make sure that every-

thing they do in some way promotes the clarity of the copy with which they are working. Editors must look at a story with a fresh mind, one that is loaded with facts but at the same time unencumbered with too much knowledge of the subject. Like the reader, the editor must approach a story as one who was not there and did not see it happen and who has probably not discussed it with anyone. This approach is doubly difficult for an editor who may in fact know a great deal about the story's subject. Editing for clarity demands a rare degree of mental discipline on the editor's part.

The opposite of clarity is confusion. Confusion can infiltrate a story in many ways, and it is the editor's responsibility to eliminate this confusion. A common source of confusion is the reporter who does not understand what he or she is writing about. A writer who does not understand his or her subject is highly unlikely to be able to write about it so that other people can understand it. Reporters rarely recognize this shortcoming, however, and it is up to the editor to point it out and to make any necessary changes, assisted by the reporter.

Clear writing is an art, but it is also a skill. Expressing thoughts, ideas, and facts in a clear way is one of the most difficult jobs writers have, even though the product might read as if the clarity were easily accomplished. The mind moves much faster than we can write or even type. Thoughts can be easily jumbled, and so can writing. The key to clear writing is understanding the subject we are writing about. When a writer can express his or her thoughts about a subject in clear terms, then that understanding has been achieved.

Following are some tips for helping writers and editors achieve clarity.

Keep it simple. Many people believe that they can demonstrate their intelligence by using complex terms (such as "terminology"). Their language, they think, will show others that they have mastered a difficult subject or that they speak or write with authority. Consequently, they use big words and complex sentences to express even the simplest ideas.

The problem with this attitude is that people forget their original purpose for writing: to communicate ideas. Any writing that draws attention to itself and thus draws attention away from the content is ineffective. Writing, especially in the mass media, should be as simple and straightforward as possible. Reporters and editors should use simple terms and sentence structures. They should avoid piling adjectives and phrases on top of one another. They should use their talents and intellect not to talk down to their readers, but to transmit ideas and facts as efficiently as possible. They should tell a story, not deliver a report.

Avoid jargon. Jargon is specialized language that almost all groups in society develop. Students, baseball managers, doctors, and gardeners use words that have special meaning for them and no one else. Journalists are not doing their jobs if they simply record jargon, however accurately, and give it back to the reader. Today's journalists must be translators. They must understand the jargon of different groups they cover but must be intelligent enough not to use it in their stories. Editors, too, must keep an eye out for the jargon that can slip into stories. Editors must make phrases such as "viable alternative," "optimum care," and "personnel costs" mean something to the reader. They cannot simply thrust such phrases on the reader and believe that they have done their job adequately.

Be specific. Journalists must set the stage of the story for their readers. They must make sure that the readers have a clear picture in their minds of what is going on, when it is happening, where it is happening, and how it is taking place. Reporters and editors cannot assume that readers know very much about the stories they write and edit. They cannot get by with telling readers that it was "a large crowd," "a long line," "a handsome boy," or a "beautiful girl." Stories are built on facts—little facts and big facts. Sometimes the little facts will make the difference in whether a reader understands a story.

Readers who have not seen what a reporter has seen will not know what the reporter is talking about. One aspect of this problem occurs with the use of "the," especially by inexperienced reporters. For example, a lead might begin in the following way, "The City Council Tuesday approved funds for purchasing the new computer system for the finance department." A reader is likely to ask, "What new computer system?" While covering the story, the reporter kept hearing everyone talk about "the new computer system," so that is what appeared in the story. Editors need to watch closely for this kind of assumption and to make sure that readers are not left behind by what a reporter writes.

Check the time sequence. Most news stories will not be written in chronological order, but readers should have some idea of the narrative sequence of the events in a story. When the time sequence is not clear, readers can become confused and misunderstand the content of the story.

Use transitions. Transitions are necessary for smooth, graceful, and clear writing. Each sentence in a story should logically follow the previous sentence or should relate to it in some way. New information in a story should be connected to information that has already been introduced. Readers who suddenly come upon new information or a new subject in a story without the proper transition will be jolted and confused. The following first paragraphs of a story about the high costs of weddings illustrate the point about transitions:

> The nervous young man drops to one knee, blushes, and asks that all-important question.
>
> What about all the planning involved in a wedding, from reserving the church to choosing the honeymoon site? June and July are the traditional months for making the big decision, according to Milton Jefferson of the Sparkling Jewelry Store.
>
> Jefferson said most engagements last from seven to 16 months.
>
> A woman sometimes receives a ring that has been passed down through her fiancee's family for generations, or maybe her boyfriend has bought an estate ring....

The lead assumes that the reader will know what "that all-important question" is. This assumption might be acceptable if the second paragraph properly followed the lead, but it doesn't. Instead, it plunges the reader into the subject of planning a wedding; the reader has no indication from the lead that this subject is coming next—and what happened to "that all-important question"?

The second sentence of the second paragraph introduces yet another new subject to the reader, again without the proper transition. The reader is taken from a question about planning to the traditionally popular months for weddings with no connection being made between them. In addition, the attribution forces the reader

to make another transition. The reader must work out the following unspoken connections: "The man is a jewelry store owner. Jewelry stores sell wedding rings. The jewelry store owner is then an authority about when weddings occur."

The third paragraph introduces yet another new subject: the length of engagements. Again, the story has no transition. The reader is merely bombarded by one fact after another.

The fourth paragraph talks about how prospective brides attain their wedding rings. What does this information have to do with what has just been said? The writer has left it to the reader to figure it all out. The writer has said, "My story is about weddings. Therefore, anything I put in my story about weddings is okay."

It's not just the writer's fault, however. It was an editor who let this story get into print with no consideration for the reader. Editors are just as responsible as writers for seeing that these things do not happen.

Although a number of techniques have been mentioned in this section that will help the writer and editor to achieve clarity, the key to clarity is for an editor to take on the point of view of the reader. A good editor understands what the reader is likely to know and what needs to be told in the story. That editor can anticipate the questions the reader might have and make sure that the article answers them. The good editor does not read a story for pleasure; rather, the editor reads with the critical eye of an intelligent member of the audience.

Figure 4.2

Tired words

Some phrases, once sharp as a tack, have lost their luster over time (as in this sentence). There are so many clichés that we cannot avoid them all, but we must try. Straightforward writing using specific details would banish most clichés. Here are a few among thousands.

at long last	go to any lengths
back in the saddle	goes without saying
beat around the bush	gory details
best and brightest	ground to a halt
better late than never	hard as a rock
bitter end	in high gear
charmed existence	in his element
concerted effort	in the final analysis
crying shame	in this day and age
cut to the chase	left no stone unturned
cutting edge	makeshift morgue
diamond in the rough	poor as a church mouse
down but not out	rich as Rockefeller
do your own thing	seen but not heard
down on her luck	strong as an ox
drum up a crowd	try and try again
drunk as a skunk	up to your neck
fall off the wagon	vast open spaces
fall on deaf ears	

Brevity

"Brevity is the soul of wit," according to Polonius, Shakespeare's ill-fated character in *Hamlet*. However, Polonius was one of Shakespeare's most verbose personalities. Words came tumbling out of his mouth. He went on and on. Not only was he verbose, he was boring. Polonius was one of those people everyone tried to avoid. He talked too much.

Publications can do the same thing. They can use too many words, piling phrase upon phrase and letting the sentences run on long after the thoughts have run out. They put too many words in the way of what really needs to be said.

Editors need to recognize when writers are being long-winded. They should remove the well-turned but unnecessary phrase and eliminate that which has already been stated. The process can go too far, of course. Accuracy and clarity should never be sacrificed for brevity's sake, but brevity should be another major goal in the mind of an editor.

Many editors approach editing a story thinking that it deserves to be a certain length and no longer. Sometimes a writer writes 300 words and an editor wants only 200. How does one go about paring such a story down? Here are some tips:

- *Get to the point.* What is the story about? What happened? What does the story need to tell the reader? An editor needs to be able to answer those questions in the simplest terms possible. Answering those questions is sometimes the hardest part of writing or editing, but once that is done, the job can become much easier.
- *Watch for redundancies and repetitions.* Redundancies show a lack of disciplined thinking. They slip into writing unnoticed, but their presence can make the most important stories seem silly. Repetition is also an indication that the editor was not concentrating on the story. Sometimes facts need to be repeated for clarity's sake, but this is not often the case.
- *Cut out the unnecessary words.* There might be words in a story that simply add nothing to the meaning of the story. These words are hard to pin down, but a sharp-eyed editor can spot them. They are words like "really," "very," and "actually." They are simply phrase makers and don't tell the reader much.
- *Wrap it up.* Finally, when the information has been presented, the story should end.

Types of Writing

Most journalistic situations will offer three general types of writing with which an editor must deal: briefs, short narratives, and long narratives. The exact form that these types will take and the demands on the writer and editor will depend on the publication. The editor must be an expert in dealing with all three.

Briefs. Briefs include headlines, summaries, refers (pronounced "REE-fers," also called teasers), infographics, and cutlines. (Headlines, cutlines, and infographics are covered more thoroughly in later chapters, but they will be introduced here.) These are short pieces of writing that demand extreme efficiency in the use of the language.

Anyone who has tried to write a newspaper headline properly, with all of its rules and restrictions, knows how difficult that can be. The headline writer must have a clear idea to begin with, and then words must be weighed carefully. They must be accurate and clear, and they must present specific information. They must follow the conventions of most newspaper headlines in that they must simulate a complete sentence with a verb.

Headlines on news web sites and in magazines are not as restrictive, but they demand the same creativity. Headline writers have to think clearly and use few words while observing the rules of their publication. Within these confinements they must be creative, lively, interesting, and accurate.

Summaries and refers demand the same characteristics in slightly different form. A summary is a one- or two-sentence passage that gives the reader a good idea of what to expect in a long piece. Summaries are used in most print publications and web sites. Refers are more specifically used on newspaper front pages and magazine covers. Their function is to direct readers to stories in other parts of the publication.

Infographics (covered in Chapter 8) combine text and visual elements to help the reader understand the information that is being presented. Because of space limitations, the information that is presented must be useful, and the text has to use words efficiently.

All of these forms of writing are difficult to produce. They demand that the editor not only understand the information completely but also understand what information is of the essence or is the most important for the reader. They also demand a wide vocabulary and a grasp of the exact meanings of words.

Short narratives. Short narratives in most journalistic publications take the inverted pyramid form. (The use of the word "narrative" indicates prose and does not imply any specific organizational structure.) The inverted pyramid is a long-standing and excellent narrative structure for presenting information efficiently. Periodically, journalists and educators try to kill it, but its usefulness is such that it keeps coming back. Writing for the Web especially has given new life to the form.

The highly developed nature of the inverted pyramid—its standardized rules and writing conventions—seems at first glance to make it almost formulaic. All a writer has to do is learn the form and plug in the information, it is thought.

The intellectual processes that are involved in writing the inverted pyramid, as with any writing, are much more complex. The writer has to decide what information is most important and must put the information in a logical and approximately descending order of importance. Those decisions are sometimes easy, but sometimes they are not. The distance that an editor has from the information itself can help the writer with that selection.

The writer (and editor) must always keep in mind the source of the information because journalistic convention demands that information be attributed. Attribution, direct quotations, and paraphrasing are standard conventions of journalistic writing that must be observed by the writer and enforced by the editor.

Many of the other journalistic conventions and writing customs of inverted pyramid news stories are found in the checklist on page 111. Editors should have a good sense of when to apply these to the copy they edit.

Figure 4.3

Little things

"We're finding that the basics are the starting point to rebuilding credibility. It's generally the little things that are eroding our credibility," said Julie Pace Christie, media consultant and codirector of a 1999 ASNE credibility study. One major finding: More than one third of adults said that they see mistakes in spelling and grammar in their newspaper more than once a week; 21 percent said that they saw them almost daily.

Long narratives. Long narratives in the journalistic sense are interpretative articles, analysis and in-depth pieces, and feature stories. This kind of writing must exhibit many of the conventions of the short narrative—factual presentation, attribution, direct quotations, paraphrasing, and so on—but the purpose is quite different. Rather than simply presenting information in an efficient form (as the inverted pyramid should do), this kind of writing takes an idea and develops it for the reader's deeper understanding. These pieces need to have a unity of theme, style, and structure that might not be necessary in the short narrative.

Unity is a most important concept for the long narrative. The article should have a single, central theme that is developed throughout the piece. The writer—and subsequently the editor—should be able to state this theme in one or two short sentences. The theme is not a subject or topic statement ("This article is about the problems that waiters and waitresses have in restaurants."). It should be more specific, but it should also be broad enough to allow some development. ("Waiters and waitresses employ many skills that most customers never see, from saving a life by knowing first aid to dispensing emergency marriage counseling on Valentine's Day.")

Often, the development of a central theme will come after the writer has begun the research on the article. A writer might have an idea about an article, but the theme will not emerge until some information is gathered. At that point, the writer can direct his or her research to gathering information that will help develop this central idea.

An editor should look for a statement of a central theme somewhere early in a long narrative piece. If the editor does not see it or cannot detect it, the piece should be sent back to the writer for additional focusing and possibly more research.

Once a central idea has been formulated, the writer should ask, "What are the various aspects of this theme that need to be developed?" By listing these aspects, the writer can form an outline that will help him or her to put the information together. If we take the example above—the central idea of the difficulties of waiters and waitresses—we might come up with the following aspects of that theme that would help us to develop a long narrative around this subject:

- Uneven training
- Surprises, demands of customers
- Physical demands, hours
- Responsibility without authority (e.g., slow cooks)
- Wages and tips
- Changes in menus

All of these aspects relate to the central idea of the story. As the writer researches the article, his or her ideas might or might not pan out as subjects for the article, but they serve to direct the research.

The writer should at this stage become a reporter and look for ways to illustrate, explain, or develop these aspects of the story. Some of the tools that a writer can use for this purpose are facts (statistics, history, characters, details, etc.), examples (specific people in specific situations), anecdotes (short stories with definite beginnings and endings that make specific points), and quotations and paraphrases from people who are clearly relevant to the topic.

Some topics lend themselves to a long, chronological narrative, which becomes the structure of the writing. The writer can still use many of the tools listed in the previous paragraph to fill out the narrative.

Editors should be good sources of ideas for developing the aspects of a central theme. Editors and writers should discuss a long narrative at each stage

of its development. Once the research begins, a writer can become so inundated by information that the focus of the piece is lost. A good editor, unencumbered by a lot of details and standing in for the reader, can help the writer to maintain the focus on the theme.

When an editor sees a draft of a long narrative, he or she should consider how the article develops its central idea and should try to help the writer get closer to that goal. In doing that, the editor must examine the following specifics.

- *Introduction.* Stories should have an arresting or interesting introduction, a way of getting readers into an article. A writer might do this by techniques such as a bold, broad statement; an illustrative anecdote; or a question and answer. Whatever technique is used, an introduction must be directly relevant to the central idea of the story.
- *The nut graph.* Early in the article the writer should tell the reader why the story was written—what it's about, the context of the story, and what the reader can expect to find out. This is as close as the writer will come to stating the central theme of the story.
- *Transitions.* The various aspects of the story should be tied together with good transitions to let the reader know that while various aspects are being covered, the article is following a consistent theme.
- *Sources.* Live sources should usually be introduced before they are quoted. Writers should make clear why the sources are in the story and what expertise or relevance they have. Writers should use sources for their relevance, not convenience.
- *Conclusion.* A story should be brought to a satisfactory and logical end, often bringing the reader back to the point of the introduction. Sometimes the conclusion will look toward the future, or it might be a grand summary. Beginning and endings of long narrative journalism contrast the most with inverted pyramid journalism.

Writers and editors should concentrate on making long narratives rich in information rather than in writing. The writing (like all good writing) should be modest. It should call attention to its content, not to itself. In fact, it is the need for extra fact gathering in long narrative journalism that justifies the greater length. To put it succinctly (albeit ungrammatically), "To write good, you have to have something good to write."

Four Characteristics of Media Writing

All writing for the mass media, as we stated at the beginning of the chapter, should exhibit four characteristics: accuracy, clarity, brevity, and precision. This and the previous two chapters have tried to explain the editor's role in achieving these characteristics. The basic tasks of journalism—writing and editing—are neither easy nor simple. They require practice and hard work.

But they are just the beginning of the work that an editor must do. To be a complete editor, a person must understand the other jobs that are required by the publication and, more important, the wide responsibilities that an editor has in maintaining the standards of the journalistic profession.

4 Exercises

Each of the stories in this chapter's exercises presents a set of problems that copy editors are likely to encounter on a daily basis. Students will have to draw on all of the information and skills they have acquired from the first four chapters to edit the stories successfully. Read the introductions to the exercises carefully and follow your instructor's directions.

Exercise 4.1: Accuracy

The following story contains a number of inaccuracies and inconsistencies that you will need to correct. The list of questions that follows the story will help you to spot some of these.

Convicted murder and rapist Jimmy Allen appeared at a news conference at the state penitentiary in the state capital tonight and disavowed all efforts to save his life today.

He said he is ending his five years of appeals and is "ready to die" for his sins.

Allen, convicted three years ago of raping and murdering the wife of a Greenback grocery store owner and then later killing her husband, lost his final appeal for a stay of execution from the state's highest court, the U.S. Court of Criminal Appeals, last week.

Since that time, Allen said at a news conference just a few feet away from the state prison's gas chamger, he has "made peace with the Lord" and is ready to pay for his crimes.

Allen is scheduled to die in the electric chair at midnight on Sunday night.

Meanwhile, David Lauver, an attorney with the state chapter of the American Civilian Liberties Union, said he was preparing another appeal to the State Supreme Court and an appeal for clememcy to the governor.

"We don't believe the state should be in the business of killing people," Lauver said. "We are appealing on the ground that the death penalty is cruel and unusual punishment." Lauver said the Sixth Ammendment prohibits that.

Allen disavowed the ACLU petitions, however, and told newsmen that he would "rather die than spend the rest of my life in prison."

John Clark, the prosecutor in the Allen case, said last night he was "glad this appeal business was over" and hoped that the execution would be carried out on schedule. "No one likes to see anyone die, but if anyone ever deserves to, this man does," he says.

Questions

1. What is the state capital?
2. What is the state's highest court?
3. What method of execution does the state use?
4. What does "ACLU" stand for?
5. What does the Sixth Amendment to the U.S. Constitution say?

Exercise 4.2: Logic and Consistency

The following story contains some key flaws. Edit the story and discuss these inconsistencies with your instructor. Make sure these flaws are cleared up in your final version of the story.

Midville residents are being asked to limit the amount of water they use over the next two weeks during this summer's drought.

Residents are being asked to turn off water when brushing teeth and shaving, to stop watering lawns, washing their cars and refilling their swimming pools.

Midville gets 90% of its water from Lake Houston in northern Green County.

The city too has cut back on water consumption, including park watering, said city engineer Christine Leatherwood.

At its last meeting, the City Council approved an ordinance establishing a water conservation alert and fines for violating it in the event the city's water supplies could not refill within a certain time.

In a severe water conservation alert, which would only occur during a major dister, no outdoor water use will be allowed at an time except by a hand-held hose, including golf courses and nurseries.

A fine of will imposed during the alert if the ordinance is violated.

Exercise 4.3: References

Use a resource such as an almanac, Internet sites, or other references to answer the following questions.

1. How many barrels of oil did the United States import in 1996 and which country supplied most of the oil to the United States that year?

2. Imagine that there has been a robbery at 1611 Main Street (or any address that your instructor gives you) and your managing editor has told you that your newspaper cannot get any information from the police and that reporters have been barred from the scene. He wants you to call a neighbor right now and find out all you can. Get the neighbor's name and telephone number.

3. A caller has told the city desk that she has some information that needs to be given to the public. She says that she can't talk now, but that if you will call her in thirty minutes, she will reveal some important information. The editor wants to know the person's name and asks you to help. The editor gives you the telephone number. (Your instructor will supply the number.) Whose telephone number is it, and where does that person live? What kind of work does the person do?

4. Where is Eclectic, Ala. (or another city identified by your instructor)?

5. What are the names of the associate professors of English at your university?

6. Jimmy Carter was the forty-third president of the United States. True or false?

7. In what year was your university founded?

8. In what year was your city incorporated?

9. How many churches are in your city?

10. How many weekly newspapers does your state have? How many dailies?

11. Who is editor of the state's largest newspaper?

Exercise 4.4: Logic and Consistency

The following story has a number of problems, particularly with clarity of language and transitions. Edit the story to take care of these and any other problems you find.

A young Cottonwood man who in 2004 pleaded guilty to breaking into an automobile and drew a 10-year prison sentence has filed a petition acting as his own attorney charing a judge with improper conduct that allegedly deprived him of a fiar trial.

Jerry Gene McBay was 19 in November of 2004 when he was charged with a felony count of breaking and entering an automobile. He and a friend were accused of cutting a car's radiator hose late at night in the parking lot of the Double Portion Church of Christ on Old Sawmill Road.

A chase by witnesses ensued and the two were soon arrested, records showed.

McBay was sented to ten years' imprisonment by Judge A.S. Snider for the crime after being denied youth ful offendor status and probation by the judge. Charges against the other youth were dropped. Records showed that

McBay had one previous conviction, for disorderly conduct, although he has had other criminal charged placed against him.

In his 13-page hand-written petition, McBay claims that Snider was "close to" the victim in the case through membership in the same church, that Watson acted improperly in rejected a prosector's recommendation for a lesser sentence after plea bargaining in the case, that the judge mishandled the attempted admission of evidence relating to the severity of McBay's sentence and that Snider has a family connection with the school arson case that he said was brought against him for political reasons.

"When my recommendations are refused, I prepare to go to trial because I assume that is all I can do," said Assistant District Attorney Tim Stoner, who brought the petition to the court after it was mailed to him by McBay from aprison in Starkville where he is serving his sentence.

Stoner explained the he was the prosecutor in the case and that he had recommended McBay be sentenced to a year and a day in prison for the offense, but that his recommendation was rejected by Snider.

Exercise 4.5: Wordiness

Edit the following story. Watch out for wordiness problems.

A private economic research organization has announced the findings of its latest study which shows that the biggest growth in new jobs and population over the next 20 years will take place in Texas, California and Florida.

The Wyatt Institue of Environmental Studies has announced that its study is based on numerous federal and state government figures and statistics, as well as those from many of the major private industries operating in this country.

The study results indicate that a total of 20 per cent of the American workforce will be employed in those three states by the year 2010.

The three states will account for 8.4 million of the 30 million new jobs to be created in the next two decades, the association said, and for about 30 percent of the projected population increase during that period.

The association estimates that the recorded 226.5 million in 1990 population of the United States, will grow by 40 million by the year 2010. Texas will gain the most in terms of population, by adding to it population 5.5 million people, it added.

The smallest increase in jobs—a total of 130,000 over the next 20 years—will occur in the District of Columbia, Delaware and Vermont, said the association.

The biggest growth in jobs in the next two decades will take place in services, trade, communications and finance, it said.

Exercise 4.6: Editing Problems

Edit the following story so that it conforms to AP style. Make sure you deal with other problems in the story. You should discuss with your instructor any additional information you need and incorporate it into the story.

A majority of people in the state favor the raising of Federal taxes on cigaretes and alcoholic beverages, according to the poll conducted by the state's lagest newspaper.

The propsed "sin taxes" were endorsed as a means of raisng tax revenues and to discourage smoking and drinking, according to the Oct. 25-26 telephone poll of 1,598 adults in a scientific random sample.

Fifty-two per cent said they think state taxes on cigarettes should be raised, while 41% said they should not.

The 52 per cent who said cigarettes taxes should be raised broke down this way: 5 percent said taxes should be reasied to increase revenues, 10 percent to discourage smoking and 33 percent both.

Fifty-five per cent said Federal taxes on alcoholic beverages should be raised broke down this way: 11 percent said taxes should be raised to increase revenues, 9 percent to discourage drinking and 35 percent both.

The state Senate Budget Committee recently drew up a number of proposals to raise taxes next year, including one which would double the excise taxes on cigarettes, liquor, wine and beer.

The proposed increases, which Senate leaders say will be considered next year, would raise the price of a pack of cigarettes by 8 cents, the price of a gallon of liquor by $10.50, a barrel of beer by $9 and a gallon of wine by 34 cents. These increases will riase the prices of cigaretts and alcohol significatly over the price in neighboring states.

Sixty-two percent of the poll respondents said they drink alcoholic beverages, while 32 percent said they smoke cigarettes.

the results of the polls can vary from the opinions of all Americans because of chance variations in the sample. For a poll based on about 1,600 interviews, the results are subject to an error margin of 3 percentage points either way because of chance variations.

Exercise 4.7: Wordiness and Language Problems

Edit the following story so that it conforms to AP style. Make sure you deal with other problems in the story.

A total of 3 men were arested on Chicago's south side yesterday at around 2:30. The charges were: posession and intent to distribute 30,000 methedrine tablets. The drugs worth is estimated at $150 thousand dollars.

Toby Willetson, a special ageant with the Federal Bureau of Investigation, said the arests were the final result of a 3-month undercover investigation by his agency and other law inforcement personnel.'

Willetson identified the two as Clem Forrest, 49, of Miami, and Newt Felton, 34, of Houston, Tex.

Forrest was arrested near 6th Ave South and 23rd St. and Felton was apprehended a few blocks away.

Willetson said the drugs, known by their street name "speed," were aparently brout to Midville from Florida for sale.

In addition to the Methedrine, two cars and two riffles were confiskated.

Felton is on federal parole in another drug case. If convicted, he receive the maximum sentence of 40 and a fine of $240 thousand.

Forrest may be subject to a five-year sentence and a $5000 fine.

Exercise 4.8: Language Problems and Wordiness

Edit the following story so that it conforms to AP style. Make sure you deal with other problems in the story.

The Green County Comission borrowed more than $500,000 from restricted accounts to meet current expenses. Thats according to a state audit released last Friday.

Much of the indebtitude remains in an unpaid condition, according to county officials.

Loans totaling at least $320,000 were made from the countys road fund to the gasoline tax fund according to the audit that covered the period from October. 1, 1990 through September 301994.

By law, the county's road fund—called the "RRR fund"—only can be used for resurfacing, restoring and the rehabilitation of county roads.

The other loan totaling $100,000 was made from proceeds of the county's 1998 general obligations warrant to the general fund to meet current expenditures. The money from the warrant can be used only for capitol outlay expenditures.

The county was notified at the end of July by the state and started a repayment plan then, officials said.

Examiners found the county did not follow the bid law on the purchase of cleaning supplies for 1998 and the minutes of county commission meetings was not indexed from June 1997 through Sept., 1998.

"Several county funds had deficit fund balances," the audit states.

County Commission Clerk Tony Sanks says that steps were taken to repay the loans, with about $175,000 of the road fund loan already repaid. "We're taking steps now to pay it off, he said.

Exercise 4.9: Editing Problems

This story is somewhat longer than others in this section and presents a variety of problems for the editor. Read through the story and discuss it with your class or instructor. Is there information that the reporter has left out that is necessary for the story's clarity? On the other hand, is there too much information?

A Midville policeman shot a criminal during a struggle early Tuesday, then had his weapon turned on him before the suspect fleed and was overpowered by two other officers, police said.

Officer David Stuart shot Anthony Douglas, 31 of Duval Street, in the left side as they grappled over Stuarts .357-caliber handgun pistol behind a house in the 1000 block of Cherokee Street early in the morning shortly after 2 a.m., police said.

After being shot, Douglas continued to fight and Stuart fired again but missed, police said. Douglas then managed to take Stuart's eapon and pointed it at the officer before running off, police say.

The suspect was found moments later hiding near apartments several blocks away on Murray Hill Court, said police spokesman Tom Regan. Two officers nabbed him, Regan said.

Douglas apparently discarded the deadly weapon after leaving Stuart, Regan said. Investigators found it in a yard near the scene of his altercation with the officer, he said.

Douglas a convicted felon who was released from the penitentiary in December and was listed in stable but guarded condition Tuesday evening at Springhill Memorial Hospital, a spokeswoman declared.

Stuart was scratched during the confrontation, but the spokeswoman said that between the suspect and he, neither was bad hurt. It was difficult to tell who's injury was worst.

Douglas will be charged with first-degree robery because he took Stuart's weapon by force, Regan said. He likely will face more additional charges, the spokesman insisted.

Stuart, a five-year veteran, will be assigned to administrative duties until the departments shooting examination team finishes its review, Regan said. The special group of officers investigates any use of deadly force by officers.

The reviews of any fatal police-involved shooting is routinely sent to the district attorney's office, Cashdollar said. He said a report on Tuesday's shooting must be sent to District Attorney John Johnson Jr.

No one is more interested than him in such shootings, Tyson said. Such inquiries have only one purpose getting at the truth, he added. The district attorney spoke like he would look into the matter personally.

Tuesday's chase-and-struggle began shortly after 2 a.m. when Stuart, patroling Duval Street noticed an older model Dodge 600 parked in Baumhauer Park, police said. When Stuart turned his marked cruiser around to check out the car, the vehicle drove off in a hurry with its lights off, police said.

Stuart confronted Douglas at gunpoint as he leaped out of the passengers side of his car, but Douglas grabbed the weapon, police said. Douglas broke away and ran around the side of a house, where Stuart again met him with his gun drawn from his holster, police said.

Douglas grabbed the gun and tried to move it toward Stuart's face, according to police. Stuart forced the gun down and fired a shot, hitting Douglas in the side, police said. The scuffle continued, however, and Stuart tripped over an air-conditioning unit, losing control of his gun, police said. Douglas picked up the weapon, pointed it at Stuart and ordered him to flee, police said. When Stuart slipped, Douglas ran off, police said.

Thompson and officer Tim McDonald spotted Douglas moments later near apartments in a cul-de-sac on Murray Hill Court, Regan said.

Reagan said he was "not aware" that investigators had found anything illegal in Douglas's vehicle. The investigation, however, is continuing. The spokesman added that he did not know what affect such a finding might have or whether a jury might be adverse to such evidemce.

Exercise 4.10: Editing Decisions

Editing this story properly demands that the editor make some decisions about how it is written and what information it presents. Edit the story so that it conforms to AP style.

Storms dumped more than 3 inches of rain in spots as they rolled through Green County Monday, flooding streets and contributing to several traffic problems.

Heavy rains led to high water standing in low places as the storms moved northeastward. A check with law enforcement agencies turned up no reports of major damage as of early Monday night.

The state troopers' office in Evergreen reported several minor incidents on rain-slick roadways.

"But nothing major," a spokeswoman said.

Outside of street flooding, "we haven't heard of any damage. We did have some hail in Atmore dime size and smaller," said Gary Bostic, warning coordination meteorologist with the National Weather Service in Atlanta.

By mid-afternoon, the weather office at Midville Airport had recorded 3.67 inches since midnight.

About 1.3 inches fell in Jonesville, added the weather service's Sarah Mallet. She said law enforcement officials were trying to substantiate a report of possible wind damage in Brown County.

In Green County, a few Gulf States Power Co. customers found themselves without power when the storms disrupted service. The company experienced brief, scattered outages including some in west Mobile near the malls. Power was restored after about half an hour, the company reported.

Much of the stae was placed under a severe thunderstorm watch Monday as a cold front closed in, triggering the storms in the warm, unstable air ahead of the front. The storms also prompted a special marine warning for the coastal waters. But by early evening, most of the watches had been canceled.

The storm system stretched from the Midwest to the Gulf Coast.

The northern sections of the state took the brunt of Monday's nasty weather. The weather service received reports of numerous downed trees and power lines in the northern tier of counties.

The weather service in Atlanta issued a tornado warning for part of Beaver County in the central part of the state after radar indicated a possible twister shortly before 3 p.m.

The Complete Editor

- The Editor–Writer Relationship
- Responsibilities of the Editor
- Honesty and Fairness
- Skepticism
- Acting Ethically
- The Five Commandments
- Exercises

Editors and writers do a delicate dance. The writing and editing process requires that they pay constant attention to one another. They must try to read each other's minds and understand the verbal and nonverbal cues that are being presented. They must cope with personality differences and tensions that may arise. They must also deal with the stress of their working environment—the multiple demands and the deadlines.

The product of this dance should be something worthy of the publication, and it is the editor's job to make it so. Good editing, like good writing, is rarely easy to achieve.

The editor's job is to make sure that copy is free of errors, logical, and unified. The writing should rise to the standards of the publication and should meet the readers' expectations. Writers, of course, have these same responsibilities, but as creators of the copy, they do not have the wherewithal to do all of these things. That is one of the main reasons why the editor exists and why the editorial process for any publication is in place.

The Editor–Writer Relationship

Editing is a partnership that an editor enters into with the writer. Professional writers understand that in most situations, they will rarely be on their own. The editorial process demands that the writer's products come under the scrutiny of some other person. That person, or people, must then take as much responsibility for the writing as the writer does. At the reporting and writing stage of journalism the writer is the senior partner in the relationship with the editor. At the editing stage, the editor becomes the senior partner. "Partner" is the key word.

A good way to operate in this relationship is for both the writer and the editor to recognize the strengths that they bring to the process. The writer should be the expert on the subject and substance of the writing. The writer should know the sources of information about the subject and should have a means of assessing their completeness and credibility. Good reporting means that the writer knows far more about the subject than he or she is able to put in an article.

The writer should also be an expert in the approach the story takes. The writer should understand the material so thoroughly that he or she has considered a variety of tacks the writing could take. The approach that the writer has taken in putting the material together should be obvious and appropriate, and the writer should be able to defend it to the editor if necessary.

The editor's strength in this relationship lies in both ignorance and expertise. On first reading, an editor can simulate the position of the reader—someone who knows nothing or very little about the subject. An editor can ask the same questions about the copy that a reader would ask, the main question being "Does this copy make sense?" Here, the editor is acting as the reader's representative.

That representation should be active rather than passive. In other words, the editor should—must—recognize instances of lack of clarity. The editor must point out legitimate, unanswered questions that the writer has failed to address.

This "ignorance" is not the only strength that an editor brings to the editing partnership, of course. An editor should be an expert on the publication for which both the writer and the editor are working. The editor must know what the publication's standards are, what it will accept and not accept, who the audience is, and the possible effects any story will have on any member of the audience and on the publication's reputation.

The editor is the person who is held accountable for these awesome responsibilities.

Another area of strength that an editor is likely to have is a broader range of experience in the field of journalism than the writer's. Editors usually get to their position through the reporting and writing process. At some point in their careers they should have been doing what the writer has done, and that experience should have imbued them with some empathy for the difficulties the writer faces. In addition, editors will probably have worked with a variety of writers. Having seen the approaches of different writers, they may be able to offer suggestions and approaches to a writer based on the experience of others.

In this same vein a good editor will probably have a broader view of the field of journalism than the writer's. The editor will have been able to see a greater variety of publications, will have studied other journalistic environments and situations, and will have discussed the care and feeding of writers with other editors. This broad view of the field should add a source of stability to the editor–writer relationship.

Finally, the editor should be a confident wordsmith. Editors should know and understand the application of standard rules of grammar, punctuation, and style. They should be aware of trends in the language, the changing meanings of words, and the development of jargon and clichés. Good editors maintain a keen interest in the language.

Ideally, the editing process works because both the writer and the editor believe that they are trying to produce a good piece of writing. Both realize that they have a stake in making the writing good. Each should be sensitive to the pressures of the other's job and sometimes even of the other's personal life. Their relationship should be one of respect and good faith.

Ultimately, the editor is the senior partner in this relationship. The editor, or in many cases a team of editors, must decide whether or not a story is to be published. And the writer has to live with that decision, for better or worse.

Responsibilities of the Editor

An editor should ensure that a story is accurate, complete, precise, and efficient.

Accuracy is the chief goal of the editing process. Presenting accurate information in an accurate context must be the priority for the editor and the writer. The editor *must* raise questions about the facts in a story, and those questions must be answered to his or her satisfaction.

The editor must be concerned not only about the individual facts but also about their sum. Do all of the facts together present a correct and fair context for the reader and for those who are involved in the story? Thousands of discussions on this very point take place at publications every week.

Completeness means that a story does not raise questions that it fails to answer; it also means that the writer and editor have included enough information that the reader can understand the story. Editors must maintain a sense in which they understand when a story is incomplete. They must demand that writers revisit their copy to answer all of the story's significant questions. Few things are more frustrating to a reader than to be left wondering about a story or what it means. It is the editor's job to see that this does not happen. It bears repeating: The editor is the reader's representative, regardless of the medium.

Precision is also the editor's responsibility. Precision has to do with the use of the language and the proper style for the publication. Editors must guard against the writers who use words whose meanings and implications readers will not understand. The editor is the enforcer of the general and local style rules of the publication.

Sidebar 5.1

Coaching

In the 1990s several reporter–editor relationship concepts emerged. They did not replace older ones but instead clarified them.

The most widely accepted new approach was coaching, which unifies editors and reporters as a team to address the planning and modification of any story. Instead of existing in separate worlds in which writers write and editors edit, writers and editors come together by coaching to brainstorm during all phases of the story and to repair stories that have jumped the track.

In *Coaching: Editors and Reporters Working Together—The Essential Guide for Reporters and Editors* (1992) Roy Peter Clark and Don Fry of the Poynter Institute explain coaching. It is best suited for enterprise pieces—longer stories that take more time to write and research—but can be used in abbreviated form for breaking stories. Instead of fixing, editors question reporters about ways in which they might improve the story and what additional information might strengthen and enliven the story. Earlier generations of editors might have jumped in and taken control of the story, giving orders rather than letting the reporter find his or her own path to a better story.

Advocates of coaching say that it leads to better reporting and writing, greater initiative by reporters, and better editor–reporter relationships. Critics say that it is far too time consuming for most situations in daily journalism.

Efficiency is one of the most difficult characteristics for a writer to detect about his or her writing. That's where an editor comes in. An editor should be able to spot the words, phrases, and passages that do not add to the substance of an article. Every word should carry some weight. If it does not—if it is redundant, unduly repetitious, or simply unnecessary—it should be cut.

All of these are duties to the copy that the editor deals with. The editor also has certain duties to the writer that engender an atmosphere of respect and trust. Some of these duties are as follows:

- Editors must be sensitive to a writer's style. To some degree, writers should be given license to present information in the style with which they are comfortable. This license is more limited in the world of daily journalism than it is in magazine or newsletter publication.

 Still, editors in all publications should remember that writers take great pride in their work. Editors should not make arbitrary or needless changes when those changes do not improve the copy substantially.

- Any major changes in the copy should be checked with the writer if possible. The editor often has the power to change anything he or she pleases, but that power should be exercised judiciously. Asking questions of a writer or making suggestions is generally a more effective way of handling problematic copy than simply making changes and letting the writer see them in print.

 Most writers with any experience have stories about how an editor changed their copy and did not tell them—and the editor turned out to be wrong. Editors should remember that they can be wrong, too.

- Editors should not change the wording of a direct quotation. Again, checking with the writer on questionable quotations is the first duty of an editor. When a direct quotation appears that does not make sense or does not fit well into the story and the editor cannot reach the writer, the editor should either cut it out or paraphrase it unless he or she has independent knowledge about the quotation. An active editor might go so far as to telephone the source to ask for a clarification.
- When serious disputes about a story arise between a writer and an editor, a third person should be asked to consult. Often a third person can see things about copy that neither the writer nor the initial editor can see. They might be able to suggest ways to satisfy both the writer and the editor.

Editors should remember that it is the writer's name that is going on the story, not the editor's. The editor might have more experience, responsibility, and power than the writer, but the writer has professional effort and pride invested in the copy. The editor not only must make sure the copy meets the standards of the publication but also must do so in a way that encourages the writer to do his or her best in the future.

It is a delicate dance.

Figure 5.1

Editor's notes

One means of editing that is used in the age of computers is for an editor to make notes within a draft of the copy such as this example. These notes are then sent back to the writer for correction or explanation. This process can take place numerous times until both the writer and the editor are satisfied.

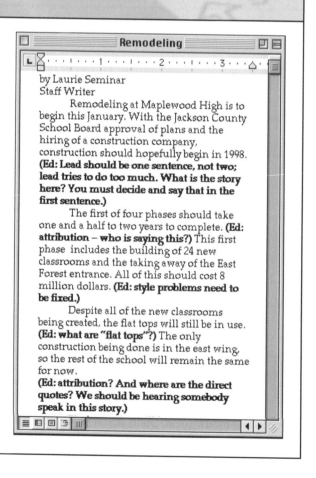

Honesty and Fairness

The editor's responsibilities go far beyond the relationship to the writer. An editor must make decisions that affect every part of the news organization and sometimes even the entire profession of journalism. The work of an effective editor, as well as the decisions he or she makes, rests on the foundation of honesty, fairness, and skepticism.

As with all human endeavors, journalism operates on an assumption of honesty. Journalists are expected to deal honestly with their fellow journalists, their sources, and their audiences. (As with all human endeavors, this assumption is imperfectly realized.) Editors have a special responsibility to exhibit honesty and to maintain personal standards of honesty because they are the leaders of their organizations. An editor who displays any dishonest behavior, however small, who shades the truth, or who cuts corners in the journalistic process will send a message to others at the publication that the news organization condones such behavior.

Earlier in this chapter we discussed the editor's relationship with the writer. It should be clear from that discussion that at the basis of the relationship is a personal honesty that both the writer and the editor must display. That same honesty must be manifested in the way in which the editor deals with others who have dealings with the publication.

One of the important constituencies is the people who advertise in the publication. Some editors do not have to deal with advertisers at all; other spend much of their time doing so. Generally, the larger the publication, the fewer dealings an editor will have with advertisers. Where editors do come into contact with advertisers, the guidelines of the publication—and those of the profession at large—should be fairly applied. The ideal of modern journalism is that advertising should be separated from the editorial decisions that journalists have to make. (This condition is sometimes referred to as the "separation of church and state.") In practical terms, this ideal means that the news department should not give an advertiser special treatment because he or she advertises in the publication; nor should an advertiser be able to influence decisions made by the news department because he or she buys advertising. Many publications have policies or guidelines that support this ideal, and it is up to the editor to apply those guidelines and to make decisions that will enhance the publication as an independent voice in the community.

Another characteristic that editors must exhibit is fairness. Dealing fairly with reporters, advertisers, sources, people involved with the news, and the general public is an essential part of the editor's job. As with honesty, what an editor does personally in this regard has an impact on the entire publication and sets the tone for others in the news organization. Many people assume that journalists favor individuals, groups, or causes; they do not automatically assume that journalists will treat certain people—the politically prominent or powerful, for instance—in the same way that they would treat people who have little power or standing in the community. It is up to the editor to apply and enforce policies and standards that show that the publication is fair and independent.

Skepticism

Another asset—indeed, a necessity—for the editor is a well-developed and intelligent skepticism about the world and the people who surround the world of journalism. Skepticism is not cynicism, the thinking that everyone is dishonest,

corrupt, or working from a hidden agenda and advancing their own interest to the detriment of others. Rather, skepticism is the willingness to raise questions about information or even people involved in the news process. It is the willingness to examine assumptions and to revise positions and beliefs. An editor tests what he or she reads or hears against logic and credulity.

An editor should be unwilling to trust anyone or any piece of information at face value, particularly if there are reasons to raise questions about it. The era in which we live has certainly given us plenty of those reasons. Many Catholic priests abused children who were in their care, and the church organization covered up such charges. Military guards abused prisoners in the war in Iraq, and the U.S. government was less than vigorous in stopping that abuse. Large companies lied about the condition of their finances to induce investors to keep investing their money. Athletes have enhanced their performance by using banned substances. Colleges and universities regularly violate NCAA recruiting rules to gain an advantage over their competitors and then try to hide the violations when they are caught. Even academics and scientists deceive the public about their research to get credit that they do not deserve or to receive grants or research funds. The list of practical reasons to be skeptical could go on and on. Even journalists do not always tell the truth or level with the public. (See the discussion of Jayson Blair at the beginning of Chapter 4.)

Despite all of these reasons to be skeptical about what one reads or hears, it takes some courage to be skeptical. For many of us, our upbringing has taught us to be trusting—particularly of many of the institutions in society—and that trust is a generally admirable quality. We certainly want to believe what the government tells us and that clerics, businesspeople, and journalists practice the tenets of honesty and fairness. We want to believe that the games we watch are based on adherence to the rules and principles of fair play.

Editors must keep themselves open to the possibilities that these people might not be all they seem and that the operations of society are not always fair and open. The editor's job is not to accept but to question.

Acting Ethically

Ethical behavior is a persistent concern of journalists at every level of the profession. Doing the right things, advancing the interests of society at large, and causing the least harm to individuals are goals that all journalists wish to achieve. Situations constantly arise, however, in which it is far from clear how those goals can be achieved. Although this section is not meant to contain a full discussion of journalism ethics, it does identify some of the most persistent problems and the profession's attitude toward them.

Falsifying information. Journalists should not make things up. They should not create "facts" that do not exist. They should not put words into the mouths of people who did not say them. They should not extend assumptions into information unless that information can be independently verified. The first duty of the journalist is to present true and accurate information. Nothing about the profession, it would seem, should be clearer.

Yet the journalism of the past few decades has been filled with stories of reporters who simply made up information. Jayson Blair's tenure at the New

Sidebar 5.2

Do the Math

When an editor encounters a number in any story, he or she should understand how that number was derived. If it is the result of some mathematical calculation, the editor should perform that calculation independently. Here are a few types of numbers that editors must deal with.

Percentage

A percentage is a mathematical means of showing how a part of something relates to the whole. All of something is 100 percent. A part of something would be less than 100 percent. Half of the whole is 50 percent.

A percentage is derived by dividing the number representing the part by the number representing the whole. That will produce a number less than 1. The percentage is the first two numbers to the right of the decimal point.

For instance, the population estimate for the United States in 1999 was 272,945,000. Of those an estimated 33,145,000 lived in California. To find what percentage of citizens lived in California, we would divide the smaller number by the larger one. Thus, we can say that 12 percent of the people in the United States lived in California in 1999.

Percentage of Change

Sometimes we want to get an idea of how much something has changed from one point to another. That, too, is often expressed as a percentage. Let's say that the population of California in 1990 was 29,811,000. How much did it change from 1990 to 1999? We first subtract the 1990 population figure from the 1999 figure and get 3,334,000. That's how much the state grew in those years, but what was the percentage of change? To find that out, we would divide this difference by the 1990 population figure. So the population of California grew by about 11 percent.

York *Times* is not the only such instance, or even the most prominent one. In 1981, Janet Cooke, a reporter for the Washington *Post,* won the Pulitzer Prize for a series of articles about a small boy who was a drug addict on the streets of the nation's capital. When the editors of the *Post* found out that Cooke had made up much of what she had written, they returned the prize and issued an apology. Stephen Glass, a writer for the *New Republic* magazine, was found to have created many of the people and incidents in the stories he wrote for the magazine in the late 1990s. (His story is told in the movie "Shattered Glass.") Jack Kelly, a star reporter for *USA Today,* covered many of the most important stories for more than a decade until 2004, when the newspaper discovered that many of his sources did not exist. After an investigation Kelly resigned from the paper.

No sin against the profession is worse than falsification. When it is discovered, the profession is damaged, and the career of the person who did it is usually destroyed. The news organization for which the journalist worked is embarrassed, and its credibility is lessened. Presenting as true what is not true attacks the very foundation of the profession.

Plagiarism. A related problem that haunts journalism is plagiarism—the copying of the work of another and presenting it as one's own.

Plagiarism, like falsification, is a form of dishonesty and violates an understanding that the journalist has with the audience. One of the fundamental procedures of journalism is that information is presented so that readers and viewers have an idea of its source. The basic assumption of this presentation is that the journalist has gathered the information and what is not directly attributed is a product of the journalist's observation or experience. When journalists take the words and ideas of others and use them so that they appear to be the creation of the journalist, that's plagiarism.

The act of plagiarism shows the journalist not only to be dishonest but also to be a thief. Plagiarism is a form of stealing—taking the information, words, and expressions that another person has created and using them as the journalist's own. Plagiarism reveals a flaw in the journalist's character, making any work that he or she does subject to disbelief.

Plagiarism, like falsification, is a cardinal sin against the profession. Few people who get caught doing these deeds have much of a future in journalism. They cannot be trusted.

Conflicts of interest. Less clear-cut for journalists than falsification or plagiarism is the area of conflict of interest. Journalists are supposed to be independent observers, working for the news organization and no one else. Some journalists take this sense of independence to extremes by not joining any social or civic organizations. A few even declare that they will not vote or participate in politics in any way.

Yet most journalists seek to balance their professional demands with the desire to be active and participating members of their communities. They join religious, social, civic, and even political organizations. Editors and publishers are actively sought as members of civic and even commercial boards of directors. They have expertise and a communitywide view that few others have. Some editors have even been known to run for and hold public office (something that most in the profession would disapprove of).

So how can journalists balance these conflicting loyalties—the loyalty to the profession and the loyalty to the desire to be a good citizen and a contributing part of the community? Most journalists do this by trying to separate their personal activities from the organizations and events that they cover. For example, a journalist who is a member of a church that finds itself in the news would be expected not to have anything to do with the coverage of the story. Journalists are also expected to report (and get approval for) any employment they have outside of the news organization.

News organizations cannot monitor all of the activities of their reporters and editors, of course, and they depend on their employees to be honest and forthright about what they do. Journalists are expected to inform their editors when situations arise in which there might be conflicts of interest. A journalist's loyalty to the news organization requires that he or she not put the organization in jeopardy or open it to criticism by allowing a conflict of interest to develop.

Another clear tenet of journalistic procedure is that reporters and editors should not accept compensation from any individual or organization for a news story other than the news organization for which they are working. Journalists are rarely offered money to do a story (although that has happened),

but they are offered many other types of gifts and gratuities. Theme parks and recreational destinations regularly give free travel and accommodations to travel writers. Movie theaters give tickets to reviewers. Promoters of sports events not only give tickets to sports writers but also offer special accommodations during the event, such as special rooms where food and drinks are free. Most news organizations have specific rules about what reporters can accept; sometimes, it is an item or service that is less than $10 in value. That would preclude even being taken to lunch by someone who has an interest in a story or the coverage of events. Even with the rules, however, news organizations have to rely on the reporters to be honest enough to turn down such gifts or report them when they are made.

Privacy. Another area that creates ethical dilemmas for journalists is the privacy of individuals they cover. Although privacy does have some force as a legal concept (see Chapter 10), journalists generally do not run afoul of privacy law. As long as journalists obtain information legally—that is, they do it without trespassing or stealing—they are not likely to suffer legal consequences by publishing it.

But the human aspect of publishing information about people or even using their names does—and should—give journalists pause. Many people who are caught up in news events do not seek the limelight and are uncomfortable having their names published or broadcast. They would prefer not to be the objects of attention by journalists or the reading and viewing public. These people become involved in news situations, and journalists, to do their jobs, must seek information from and about them.

When these situations are depicted in movies or television dramas, journalists are often depicted as rude, obnoxious, and unfeeling. The reality is usually quite different. Occasionally, journalists are persistent, but they often try to respect the wishes of those who are caught in news situations. They find that there is little point in trying to persuade an unwilling source to talk or give information. Resourceful reporters know that there are many ways to get information, and harassing an individual is unnecessary and counterproductive.

Sometimes editors face the decision of whether to publish very private or embarrassing information about an individual. The most publicized instances have concerned sexual activities of presidents or presidential candidates, but other instances of publishing private information pose dilemmas for journalists. For instance, consider the following situations:

- The 75-year-old mayor of a town drives his car off a dark roadway. No one is hurt, and the police issue no citations.
- A woman is taken hostage by her ex-husband. She is made to undress to prevent her from escaping. When police surround the house where she is being held, she has an opportunity to run, and she takes it. She escapes, but a news photographer takes her picture while she is getting away.
- A woman who has been the county court clerk for thirty years is found dead in her home. Her death is ruled a suicide. She had just returned from the funeral of another courthouse employee, also a woman, who had committed suicide three days earlier.
- The city's United Way campaign is headed by a locally prominent businessman. He is unable to attend ceremonies celebrating the end

of the campaign because, according to your reporter, he has checked himself into an alcohol rehabilitation center.

Reporters and editors must decide whether such information is relevant and necessary to present an accurate and fair picture of the people and events in a story. These decisions are easier when the people who are involved have thrust themselves before the public by running for public office or participating willingly in public debates, but as these situations demonstrate, the decisions that an editor must make are not always so clear-cut.

Bias, unfairness, selective reporting. When most people think about bias and the news media, they are likely thinking about some kind of political bias. For years the news media have been tagged as more "liberal" than their moderate or conservative audience, even though there is much evidence that conflicts with this perception. The more common and persistent problem with bias is not political, however, but what we might call point-of-view bias, and it does not have much to do with politics.

Every reporter approaches every story with a point of view, not necessarily political but one based on experience and inclinations. Journalistic procedure requires that reporters go through certain steps to gather information and talk to certain people. Usually, these sources are experts or officials who are involved with the subject the reporter is covering. Which sources the reporter chooses, or has the opportunity, to interview will greatly influence the outcome of the story, more so than any political bias that the reporter has.

Editors should try to help reporters by identifying different points of view and requiring the reporters to include as many points of view about a controversial topic as they can in their stories. Reporters should try to get different versions of an event that they do not personally witness. They should also try to quote people as accurately as they can, even though most reporters do not have a good shorthand note-taking system. In doing all of these things, a reporter constantly exercises personal judgments about the information that is being gathered. The reporter and editors have to make selections about what to use in a story and what to leave out. If an editor is particularly interested in a story, the editor's views about what is included will also come into play. Considerations of time and space—how close the deadline is, how much room is available for the story—are also influential in this selection process.

The outcome of this process is not always satisfactory to news consumers who are part of a story or who are vitally interested in it. They will complain that the story is biased, especially if it does not include their opinion or point of view. In a sense, they are correct. As reporters and editors select information, even as they select what stories and subjects they will cover, they are exhibiting a bias that leans toward their own inclinations about what is important and what their news organizations can do, given that they have limited resources.

Editors struggle with these dilemmas every day. The decisions that they make are often ones of expediency, since they work under deadline pressure and in a competitive environment. Undoubtedly, they have their personal points of view about the events they cover, and sometimes those inclinations have a major influence on how stories are presented. But how could it be otherwise? Journalists are humans who attempt to achieve the status of objective observer but rarely succeed.

Sidebar 5.3

Inverted Pyramid Checklist

When you are editing an inverted pyramid news story, use the following checklist to go over the story. Make sure the story is correct in each of these areas.

Leads

- Information should be presented in order of importance with the most important information in the lead paragraph.
- One sentence, 30–35 words maximum.
- The lead tells the most important information in the story and gives specific facts.

Second Paragraph

- Expand or develop some idea in the lead.
- Should not drop into a chronological narrative.

Attribution and Direct Quotes

- All major information should be attributed unless it is commonly known or unless the information itself strongly implies the source.
- Don't dump a string of direct quotations on the reader.
- Direct quotations should be no more than two sentences long.
- Direct quotations and their attribution should be punctuated properly. Here's an example: "John did not go with her," he said.
- Elements of a direct quotation should be in the proper sequence, as in the example above: direct quote, speaker, verb.

AP Style

- Always use it.
- Check numbers, dates, locations, titles, etc.

Check the Following

- Pronoun–antecedent agreement.
- It, its, it's.
- "It is," "there is," "there are" structures; avoid these. They are passive and vague.
- Use the past tense, not the present.
- Comma splice or run-on sentence, such as:

 He picked up the ball, he ran down the field.
 Sally does not know where he is he is not here.

 These are grammatically incorrect.
- Use an "'s" to form a possessive, not a plural.
- Any paragraph more than three sentences is definitely too long; any paragraph that is three sentences is probably too long.
- **Wordiness:** Have you checked for verbiage, redundancies, unnecessary repetitions, etc.?
- **Name, title:** When you put the title before a name, do not separate them with commas. WRONG: Game warden, Brad Fisher, arrested the trespassers. When the name comes before the title, the title

Sidebar 5.3 (Continued)

should be set off by commas: Brad Fisher, the game warden, arrested the trespassers.

- Use transitions to tie your paragraphs together. Don't jump from one subject to another in a new paragraph without giving the reader some warning.
- **Names:** Check them once more to make sure they are spelled correctly.

The Five Commandments

Complete editing demands that editors observe five general commandments in helping writers and reporters to produce their best work.

Thou shalt not accept bad writing. Attitude—that's what we're talking about here. An editor should be a good guy (or gal). An editor should understand the pressures and difficulties that a reporter faces. An editor should be sympathetic when a writer tries hard.

But an editor should never read a piece of copy that he or she thinks is inferior and say, "Well, I guess that's the way the writer really wanted to say it." Nor should the editor justify bad reporting by saying, "I guess the writer knows more about this than I do." And the editor should not disclaim responsibility by saying, "It's the writer's story, not mine."

An editor must take responsibility for the copy that he or she reads. An editor must develop high standards of reporting and writing and then expect writers to live up to them. Finally, an editor should reject copy that does not meet those standards.

Thou shalt not tolerate bad language. We have discussed precision to some degree already in this chapter and earlier in the book, but this part of editing is so important that it has to be elevated to the level of a commandment.

Any editor of any publication is a guardian of the language. Not only should the editor know the rules of grammar, punctuation, style, and usage—and enforce those rules—but the editor should also have a keen interest in the state and dynamics of the language. The editor's bookshelf should be filled with books about the language, and the editor should have several language references at hand—in addition to a dictionary and the *AP Stylebook,* of course.

A good editor does not tolerate "near misses" in the use of words (for example, "noisome" when the writer really means "noisy") and does not give in to language fads or clichés. The good editor is slow to accept change in the language.

Figure 5.2

Ludwig Mies van der Rohe

God is in the details.

Ludwig Mies van der Rohe
Architect

And the good editor is someone in whom the writer—often secretly and sometimes begrudgingly—has confidence as an expert in the language.

Thou shalt not figure out what the writer is saying. An editor must make sure that writing is as crystal clear as possible.

Most writing is not so incoherent that it cannot be understood. Look at the illustration on page 104. The story that the writer wrote is terrible, but with careful reading, it can be understood. Should the editor let that copy go with the thought: "Well, I know what the writer was really trying to say, so I guess the reader will be able to figure it out, too"? Absolutely not.

Clarity is often lost when the writer has too much information and too many ideas. Too many facts get rolled into a sentence, and the sentences themselves run on too long. The editor should help to sift through the facts and parse the sentences so that they will make efficient sense to the reader.

Thou shalt not forgive faulty logic or contradictory information. The chief goal of the journalistic process is to present accurate information. But what if a reporter presents information in one part of a story that contradicts information in another part of the story? What if a writer says something in a paraphrase that seems to be contradicted by a direct quotation? And what if information in a story is irrelevant and serves to confuse rather than enlighten the reader?

All of these conditions make it into print far too often, and when they do, it is just as much the fault of the editor as of the writer. (Take a close look at the example on page 104; good editing would have caught the contradiction and faulty logic of the story.) An editor should always question the assumptions and information that the writer is presenting. An editor should read the words that the writer uses for what they mean literally. (Journalism has little tolerance for figurative writing.) Editors should always be constructively critical of the copy that comes in front of them.

Thou shalt do the math. By all means, do the math. Make sure that things add up. Make sure that the percentages make sense. Make sure that you as an editor understand the mathematics in a story even if the writer doesn't seem to.

Pay attention to the details in a larger sense, too. Journalism is not a profession that tolerates loose ends, unanswered questions, contradictory information, or faulty logic. Lapses have a way of getting into print, on the air, or on the Web. They will be duplicated many times, and readers and viewers will notice.

And the editor shall bear the responsibility of it all.

chapter

5 Exercises

The exercises in this chapter are designed to take you beyond simply fixing spelling, punctuation, style, and syntax. You will need to read the items carefully and question the things that do not make sense or that need more explanation. Remember the five commandments of the complete editor that were explained in this chapter.

Exercise Example: Critiquing

The following story contains a number of errors and items that need to be questioned by an editor. Some of these errors and items are underlined and have corresponding questions listed after the story.

Firefighters awaiting contruction of station

Firefighters at Station No. 2 <u>may soon have</u> a home of their own.

After two years of sharing a building with Midville Fire Station No. 1, work on a new station is expected to start <u>as early as April.</u>

In 1966, Station No. 2 was torn down to expand Memorial Stadium on University Boulevard.

Members of both units now shar quarters at Station No. 1, located in the downtown area, and some firemen agree that <u>it has been hard living in such close quarters.</u>

"Things have been kind of difficult because we don't have a lot of room," said Eddie Elmore, an 11-year veteran of the fire department, currently working at Station No. 1. "I sleep in the training room because we had to put beds in there and other place to house everyone."

Capt. Joe McCollum said <u>there are 18 firemen</u> at Station 2, six on each of the three shifts.

Along with sleeping quarters, <u>timing has also been a problem.</u>

"It is very difficult to try to get across town to the university during rush hour. It takes us longer to get there, but, considering the circumstances, we do pretty good," said Lt. Don Odum of Station No. 2.

Station No. 2's firefighters handle calls from the university area <u>to as far as the Alberta community.</u>

"The university really needs to have a fire station close than where we are now," Odum said.

Robert Trane, vice president for financial affairs and treasurer at the Midville State University, said <u>the problems</u> arose in the beginning with trying to find a location for the new station.

"It was our responsibility to find a location for the station, and, at first, we had some difficulty doing that," Trane said.

"But it is the responsibility of the city to provide the funds for construction.

The Midville City Council approved $1.25 million on Jan. 13 to construct a new fire station at the university.

"The locate of the new station will be at the old armory, known as the McWilliams Building on University Boulevard," Trane said.

The University Press and Fleet Operations occupied the building previously.

"The University Press has already moved to a temporary location downtown on 19th Avenue," Trane said.

"Fleet operations will also move there in a couple of weeks."

The McWilliams Building will be torn down, and the new station will be constructed in the sourther part of the lot, McWilliams said.

"The demolition papers have already been written up, and the actual building will hopefull start the first of April," said Robert Grogan, deputy chief of the Fire Department.

<u>More meetings are planned,</u> and an <u>exact time frame</u> for completing the project has not been set.

Editor's notes:

Lead is vague, uncertain. Will they or won't they? What is the news here? What is this story about? The lead doesn't tell us.

". . . as early as April." Just say "in April." Or find out when the work is going to begin.

". . . it has been hard living in such close quarters." That's probably true, but the story isn't specific. What has been so hard about it? The following quote doesn't add to or illuminate this information.

". . . there are 18 firemen . . . " Confusing. Does this include both stations? How many firemen are there at one time—total? Is the building divided in some way to give separate quarters in the same building?

". . . timing has also been a problem." Misuse of the word. What she is really saying is "the time it takes to respond," not "timing." And by the way, how long does it take to respond, compared to where the old station was located?

". . . to as far as the Alberta community." Why not just say ". . . to Alberta City"? And what distances are we talking about?

"Robert Trane . . . the problems." What problems? It is unclear to the reader what problems are being referred to here, although it may be crystal clear to the writer.

The Robert Grogan quote: why wouldn't construction start on the first of April. Who is in charge here?

"More meetings are planned . . ." More meetings for what? The writer needs to have more consideration for the reader.

". . . exact time frame." Does she mean "schedule"? This is indicative of the flabby writing in this story.

The striking thing about this critique is that the editor has read the story sentence by sentence and has not been afraid to question anything about this story. Even some things that seem to make sense do not stand up under close examination.

As an editor, you should read every story in this way, demanding that writers use words literally and present information logically. You should question fuzzy thinking and not be afraid to point out a lack of clarity.

Remember the five commandments of the complete editor:

- Thou shalt not accept bad writing and bad reporting.
- Thou shalt not tolerate bad language.
- Thou shalt not figure out what the writer is saying.
- Thou shalt not forgive faulty logic or contradictory information.
- Thou shalt do the math.

Exercise 5.1: Critiquing News Stories

Write a critique for this story like the one in the critique example. Read the story carefully and question everything. Suggest ways to rewrite the copy where necessary.

County scrambles to find new project

BRANDEN—A decision by the McKay Water System to fund an expansion project through the Farmers Home Administration has the county scrambling to come up with an alternative project to use in an application for the state Department of Economic and Community Affairs grant funds this year.

Representatives of the Ball Co. met in a public meeting with commissioners at the close of the commission meeting to discuss the funding process and try and come up with another project for the year to give the county a chance at $500,000 in available grant funding. The Lee-Walker area was suggested for study, as was the Bradley area. The application must be made by April 1.

The county commission also voted to approve a personnel plan pay schedule, the next step in putting a personnel system in place in Escambia County.

Under the schedule, 12 pay grades are set up to classify employees according to job titles. The pay for any employee within a grade is then determined by years of service. Under the system, starting employees make less than those on the same job with many years of service.

The scale will go into effect starting on Oct. 1, if all goes as planned, with one third of the increases due some employees paid at that time, and one third in October 1995 and one third the following year. Project director Gail

Thomas said about half the county's employees will see a pay increase at the outset, and others may receive an increase when the project is 100 percent in place. No employee's salary will be decreased as a result of the system that will cost about $100,000 in salary and benefits, officials said.

The commission also:

Voted to declare three bridges emergency situations. The Little River Creek bridge and Bean Creek bridge on County Road 30 in Walleye are closed to all but light traffic and the Broken Leg Creek bridge on Canaan Church Road is closed. The bridges were found to be unsafe after routine inspection. Work to repair wooden and concrete supports should be completed by week's end, according to county engineer Dan Battles. The damage was likely caused by overloaded trucks.

Responded to statements by Rep. Trey Blalock, D-Pollard, regarding House Bill 42. In a press conference last week, Blalock said the bill was ruled unconstitutional because of one sentence. Commissioner Stan Doakes said the state Supreme Court's ruling only dealt with the section involving the sentence mentioned, and that other sections of the bill would likely have made it unconstitutional as well.

The bill that would have given Sheriff Hawse Trimmer control over federal inmate contracts and revenue has been dropped.

Exercise 5.2: Critiquing News Stories

Write a critique for this story like the one in the example at the beginning of this section. Read the story carefully and question everything. Suggest ways to rewrite the copy where necessary.

Rhodes to plead guilty to gun, lying charges

Lincoln county commissioner Gamage "Jack" Rhodes Junior will plead guilty next week to charges of carrying a machine gun and lying to the FBI, automatically losing his office while dodging more serious drug-related charges, court documents indicate.

Rhodes 46 is scheduled to plead guilty Tuesday in federal court. The three-term commissioner and former Sheriff's Deputy was arrested in Feb. on charges that included selling cocaine, marijuana and methamphetamine in Lincoln County.

He was also accused of pointing a gun at his ex-girlfriend's head to threaten her before she testified for a federal grand jury last year. He has been held in Lincoln Metro Jail without bond since his arrest.

Rhodes likely will be sentenced in July.

He faces a maximum of ten years in prison for the gun conviction and five years for the lying conviction. Federal sentencing guidelines will offer a shorter range because of Rhodes' clean record. It was unclear Thursday how long the sentence actually will be.

Prosecutors will likely dismiss the remaining counts of the indictment for allegedly dealing crack, marijuana and methamphetamine and threatening the witness.

Once he pleads guilty, Rhodes is automatically ousted from the Lincoln County Commission District 1 seat he held since 1984, representing Middletown and several small communities.

Probate judge John H. Armstrong and county attorney Michael Underdunk were unavailable for comment Thursday. Defense Lawyer Paul Brown could not be reached for comment.

Rhodes' seat is up for election this year. Lincoln County Democratic Party chairman John Young said Rhodes recently indicated he would not seek re-election.

Testimony in a two day court hearing in February suggested the commissioner and former lawman led a secret life as an abusive drug addict.

His son, 19-year-old Eric Rhodes, told the FBI that the elder Rhodes has been "hooked" on methamphetamine since 1997 or 1998, according to testimony. "He got hooked about eight years ago," Rhodes said.

A videotape seized from Rhodes' home on August 29 showed him smoking what appeared to be methamphetamine, or "crank," with Girlfriend Rene Thompson, before they had sex. A second man is also seen smoking the substance, U.S. Magistrate W.E. Smith wrote in his order jailing Rhodes until trial.

Ms. Thompson told the FBI that Rhodes hit her and abused her with a three-pronged frog gigger. She is in federal custody for her protection.

Rhodes mother, brother, pastors, high school teacher and others from the Middletown area described him as non-threatening during the hearing. "A danger? He's a help to the community," said his mother, Josephine M. Rhodes, 72. "He always was truthful. He is not a liar. He's a very dependable person," added his brother, Homer.

Exercise 5.3: Critiquing News Stories

Write a critique for this story like the one in the critique example. Read the story carefully and question everything. Suggest ways to rewrite the copy where necessary.

Voters kill tax plan to fund county library

Oneida—Official election returns show voters defeated by a somewhat wider margin than expected a Lincoln county tax issue that could have given the public library enough local support to stay open for the next twenty years.

Certified results show that by a vote of 1166 to 1087, county voters refused to ratify the tax which they approved in 1994. The alabama attorney general's office last year advised county officials to have the vote ratified because it was not properly advertised for the 1st election.

The tax was to become effective October 1 and provide sixty thousand dollars a year to the library system. But because voters nullified the 1994 vote the library may lose State and Federal funding and ultimately lose its new building which is less than five years old because it was built with Federal money that restricts use of the building to a library. The building is eighty five feet long and thirty five feet wide and accomodate nine foot book shelves.

The library board is scheduled to meet tonight to discuss options available to keep the library open. The closest library from the main library in Chatom is in Jackson, fifteen miles away.

We are in an outrageous situation said Fulmer Owens President of the Lincoln county commission. I dare say that only our Public Schools will have libraries unless voters come to their senses something I dont think is going to happy soon. Its depressing.

Many local citizens expressed similar concern. Commission vice chairman Herb Poteet predicted that county leaders would be reticent to step out front again on a tax issue. The sheer enormity of the anti tax victory will scare politicians away Mr. Poteet said.

The certified results also show that voters by a vote of 1733 to 543 approved creating a revenue commission post which will combine the offices of Tax Collector and Tax Assessor.

Although the salary for the Revenue Commissioner has not been set combining the two offices is expected to save the county sixty thousand per year.

Exercise 5.4: Critiquing News Stories

Write a critique for this story like the one in the critique example. Read the story carefully and question everything. Suggest ways to rewrite the copy where necessary.

Expanding water plant may be necessity for Northridge

northridge—With a steadily growing population, Northriidge City Council members are considering a $6 million water treatment plant expansion as a possible way to meet increasing demand.

The plant has the capacity to treat 5.08 million gallons of water per day. However, realistically, the most water it can process is 4.4 million gallons in a 24-hour period, said plant Superintendent Marty Dane.

The plant serves water customers through two tanks: Uptown Tower and the Samson Tower.

Dane said the plant has operated at its maximum capacity during dry summer months. In 2004, between Aug. 28 and Sept. 12, the area experienced one of the dryest periods since Northridge opened the water treatment plant in 1990.

"We were producing all the water we could, and the tank levels were dropping every day," he said. "We didn't run out of water because we normally keep about a 3.5 million (gallon) water reserve."

Before the Northridge plant opened, the city was purchasing 1.9-million gallons of water per day from Tuscaloosa.

Now, the average water flow from the Northridge plant to its customers has doubled to 2.9 million gallons a day.

Dane said the increase in water-demand, along with the times the plant has operated at maximum production level, prompted city officials to start considering a plant expansion.

Northridge City Administrator Charles Sweatt said the City Council is considering a proposal to double the plant's size.

"The plant has got to be enlarged," Sweatt said.

The council hired Woodbridge Associates to draw up a preliminary plan for an expansion and met with them Thursday to discuss its options.

Woodbridge Associates Engineer Jim Wentzel said a growth-projection study of the city since it first formed in 1870 shows continual, rapid growth. From 1870 to 1970, the city grew from 2,273 residents to 9,435.

By 2003, city water service was being provided to 20,024 people.

If Northridge continues to grow at the same high rate, by 2020 it will provide water to 52,321 people, Ezell said.

However, he said, on a more conservative scale, the estimated growth by 2020 will be around 41,062.

"With the new Green County High School and toll bridge being built, Northridge is definitely going to see continued growth," Wentzel said.

He estimated that water system customers now use about 138 gallons daily.

Bob Woodbridge said the projected growth figures were used to determine the water plant's expansion needs through 2020.

If the council agrees to double the plant's size, it will be a mirror image of the current processing setup. The office space will not increase.

Sweatt said the project will not mean an increase in water rates. It will be financed through a bond issue.

He said the council would like to get the capital from the State Revolving Fund. The fund is now only used to wastewater treatment plants, but Sweatt said he hopes the Legislature will pass a bill that will allow the money to also cover water treatment plants.

"The advantage to using the revolving fund is that it has a fairly significant lower interest rate, anywhere from one to three percent less than the open market," Sweatt said. "That would mean a lower payment."

If the Legislature does not approve the proposed legislation, the bond issue will be funded on the public market, he added.

Sweatt said the city council plans to make a decision about the expansion in February.

If the council votes for the expansion, Woodbridge said his firm will begin designing the project in March. Construction could begin in late summer or early fall and it would take 18 months to two years to complete.

Exercise 5.5: Critiquing News Stories

Write a critique for this story like the one in the critique example. Read the story carefully and question everything. Suggest ways to rewrite the copy where necessary.

Sharp words, accusations fly between commissioners

MIDDLETOWN—Commissioner Wendy Roberts accused commissioner Samuel Radkin Sr. Tuesday of an "in your face" attempt to side-step the rest of the Winona County Commission to put park signs on public accesses in Mrs. Roberts's district.

Sharp words and accusations flew between the two during a workshop Tuesday.

Radkin, Chairman of the Commission's parks committee, ordered Sonny Powell, Supervisor of the county Parks Department, to put up the signs on the parcels near Yupon, Holly, Palmetto and Live Oak Streets along U.S. 98 south of Hiteville.

Mrs. Roberts accused Radkin of waiting until the rest of the commissioners and county administrator Jim Zumwalt were at a workshop in Shelby county February 26 through 28 to order Powell to put up the signs. Radkin was the only commissioner who did not attend the workshop.

Radkin has demanded the County take fast and aggressive measures to reclaim what he called public property. Other commissioners have called preserving public property a priority, but have sided against Radkin in order to take a slower, more cautious approach.

Mrs. Roberts said she realized only last week that four signs had been put up at Radkin's demand. Radkin had no authority to give that order without the rest of the commission's approval, she said.

Radkin denied that he acted improperly, pointing to commission meeting minutes last year in which the county had approved the signs for "parks and landings."

"It's my duty to see that they [Parks Department employees] do what the commission says they do," Radkin remonstrated.

He said the timing of his request to Powell and the commission retreat was a coincidence, saying he did not know when the other commissioners were at the three-day workshop.

The entire commission had been notified about the retreat during meetings in which Radkin was in attendance. Radkin said he ordered the signs in Mrs. Roberts's district because residents there wanted those accesses marked and because the Parks Department had recently finished clearing that property.

He said it was his understanding that signs would be erected each time the parks division clears an access.

Mrs. Roberts said Tuesday she wanted the Parks Department to remove the signs until the commission votes on the matter.

"The staff is being caught between two commissioners and it's not right," Mrs. Roberts said.

But county employees will leave the signs in place until the commission can vote on whether to remove them, Zumwalt said. The next commission meeting is Tuesday.

Mrs. Roberts and Commissioner Dean Smythe of Luckytown said when they voted on the signs they did not intend to place them on every parcel of county property, but only in approved county parks.

Commissioner Frank Burt of Middletown said he envisioned that public accesses would eventually be marked, but not with the park signs.

The county owns hundreds of parcels that have come to it through tax liens, as rights of ways and other deals. The County, however, has no list of those parcels.

"If we, in fact, approved these signs, we better have a bunch of them made up," Mrs. Roberts said.

The commission should be selective about which property such signs are placed on, Smythe said.

Smythe said one of the parcels that had been marked for public use appeared in a photograph Mrs. Roberts provided to be little more than a drainage ditch. Smythe suggested a better sign for the parcel might be "This is a public ditch."

"I would be ashamed to send a family with kids down there," he said. Inviting the public to all parcels by putting up signs indiscriminately puts the county at risk of having someone step in a gully or find themselves in an area known to be infested with snakes.

"If we're going to establish a new area," Smythe said, "as a park or public access, I'd like to have a look at the area to determine how it needs to be handled.

"We've got to be careful . . . We've got areas out there that we on't need to invite the public to."

Exercise 5.6: Critiquing News Stories

Write a critique for this story like the one in the critique example. Read the story carefully and question everything. Suggest ways to rewrite the copy where necessary.

Brisk market opens for authentic crafting

In centuries past, long before the advent of vinyl and veneer, furniture making was an art form. Our woodworking forefathers took great pains to choose the finest materials and the most elegant proportions, creating objects of enduring function and beauty.

Today, a rising interest in Colonial American furniture, coupled with the limited number of antique originals, has created a brisk market for authentically crafted pieces at affordable prices.

That's the market targeted by Peoples Supply Co., an antiques and fine reproduction business housed in a 1902 general store in Silverhill. Joseph Spalding, a retired family practice physician who operates the store with his wife, Lou, completely renovated the two-story wooden building before opening for business last year.

"We are the only dealer in South Alabama for D.R. Dimes," he said, "and as far as I know, there is only one other dealer in the entire state."

A New Hampshire furniture studio known for top-quality Windsor chairs, tables, cupboards and desks, D.R. Dimes Ltd. produces pieces that hold their original value and often appreciate with the passage of time.

A slightly different, but no less unusual, approach to furniture is taken by another artisan represented at People's Supply. Vintage Redwood, a small company in California, crafts rockers and picnic tables from heart redwood. Since the timber is virtually impossible to find today, all Vintage Redwood products are made from recycled redwood wine vats.

"It's amazing to think that the tree was cut in the 1930s, and that wood has been in a wine vat for 60 years," Spalding said, "but it makes some of the nicest rockers I've seen."

Spread throughout the store are select pieces by Lexington and Bob Timberlake, reproduction pine furniture by Southern Furniture Reproductions, and fine pieces of 18th century American furniture by Eldred Wheeler.

The Peoples Supply Co., after decades as a thriving general store, still provides plenty of old-fashioned atmosphere. The original shelves still fill every available space along enormous walls, and the original store safe and dry-goods counter remain.

Outside, along a wrap-around porch more than 60 feet long, rockers are poised for friendly conversation and wooden barrels recall the times when nearby parking spaces were occupied by mules, instead of automobiles.

Spalding laughingly refers to the two floors of the building as "the men's floor" and "the women's floor." Downstairs, large furniture pieces mix with a collection of antique hand tools numbering well over 1,000. In old

"I've been collecting tools for more than 20 years," Spalding said. "Lately, it has become increasingly popular, especially among men. There are several big, national tool collectors' associations."

Upstairs, in the living quarters that housed the family who operated Peoples Supply Co. in its heyday, Mrs. Spalding displays a more feminine inventory, including restored antique linens, bedroom furnishings and old-fashioned household goods.

Change is made from a mammoth cash register, ornately decorated in nickel-plated brass. Spalding is unsure of its age, but it was refurbished in 1915 at the National Cash Register Co. When senior citizens' groups visit the store, the gilded register is often one of the first things they notice.

The store itself, already included on county and state historical registers, is now awaiting final approval for inclusion on the National Registry of Historical Places.

Spalding hopes his business will provide another chapter in the store's long story.

"The rapid growth in this part of the county, combined with the increasing interest in antiques and fine reproductions, should work to make this a success," he said.

Exercise 5.7: Rewriting a Story

The following story needs to be thoroughly rewritten. The information in the story is good and generally complete, but the style is not journalistic. Wordiness is a real problem, too.

Teens can take some steps to reduce auto insurance costs

Although auto insurance for teens, particularly males, is high, some steps can be taken to reduce the bill. Understanding these steps and exploiting them can result in some decent, but not great, savings.

First, the best way to keep insuraces rates at the lowest levels is a clean driving record. One way to maintain that record is to pay for small accidents rather than reporting them to the insurance company.

Other steps may also benefit teenage drives. For instance, many insurance companies offer a decent student discount of 10 to 20 percent if you keep your grades up. This generally means a B average. Most insurance companies will then lop another 10 to 20 percent off if you complete a driver's education course. For these discounts, just about all insurance companies require forms to be completed, and some companies will only offer the good student discount at grade eleven.

Another discount that may be available is what insurance companies call a "multi-car discount." In this case, "multi-car" will usually mean three or more cars. All these discounts can be coupled with an "umbrella" discount, which means your whole family's insurance—health, job, life and homeowners—is under the same company.

Still another, lesser-known way to shield against insurance sticker shock is to find insuracne companies that exist only to insure certain people who qualify, such as government workers, veterans, armed forces members, et cetera. These companies, known as niche marketers, are often cheaper than the bigger, national companies, but you have to qualify. Even if you qualify, some companies might insure only health or life, and not auto.

One example of niche marketer, GEICO, which began by insuring only government employees. The company has now branched out to insure non-government employees.

Insurance rates will not decrease until age twenty-one, and only then if the driver has a clean record. One of the few things that will bring rates down is marriage, but even that won't reduce them significantly.

Insurance companies see a high risk in insuring teenage drivers, and with good reason. In the Unitd States, 5,670 teens were killed in 1995 from vehicle crash injuries. Auto accidents are the leading public health problem for people 13–19 years of age.

It's not just that teens have more accidents than any other age group. Teens have different kinds of accidents. Statistically, teens are far more often at fault in an auto accident, and their accidents and violations are more likely to involve speeding than older drivers. Teens are also more likely to be involved in fatal single-car accidents. Not surprisingly, roughly half of fatal accidents involving teens occur at night, particularly weekend nights.

The sixteen year old age group has the highest percentage of all age groups for crashes involving speeding, single vehicle crashes, and driver error, as well as the highest vehicle occupancy.

Needless to say, rates skyrocket if a driver starts having accidents. Mr. Greg Tyler, a former State Farm insurance adjuster, said that a surcharge of 7–10 percent will be added for a young driver's first accident, 25–30 percent on top that for a second accident, and, if the insurance company doesn't drop the driver, as much as 50 percent on top of the last two for a third accident. That's as much as a 90 percent raise in insurance premiums after three accidents.

As well as accidents, moving violations such as speeding tickets, running red lights, and reckless driving, will catapult insurance rates. Avoid all tickets, although Tyler says, "A (young) male who gets speeding tickets is a self-fulfilling prophecy."

A good amount of a driver's insurance will depend on the kind of car he or she drives. Tyler says this is because there is a statistical correlation between the type of car driven and the amount and type of accidents that type of car is involved in. He says a Pontiac Trans Am and a Nissan 300ZX are among the highest to insure.

Other, smaller factors about the type of car may also affect insurance rates. Suffixes, such as DX, si, EX, LX, and Esi, can take rates up or down, depending on what they denote. Safety features, such as anti-lock brakes, airbags, and passive restraint seat belts, will often bring insurance rates down somewhat.

Don't expect a driver to get discounts on insurance if he or she works for an insurance company. For a variety of legal reasons, that doesn't happen.

Despite the steps you can take to reduce premiums, insurance for teens is going to be amazingly expensive. Just shop around, and get all the discounts you can, while avoiding all tickets and accidents. Just look foward to turning twenty-one and getting that first big discount.

Exercise 5.8: Rewriting a Story

The following story needs to be thoroughly rewritten. The information in the story is good and generally complete, but the style is not journalistic. Wordiness is a real problem, too.

Local teen gets chance to visit nation's capital

MIDDLETOWN—It was last summer when Zickeyous Smythe had the wonderful opportunity to take an all-expenses-paid free trip to our nation's capital, Washington D.C. The Middltown high school senior was one of twenty-four students in the state chosen by the National Rural Electric Cooperatives of America for the honor.

His senior year has been busy and there is still much to do before he finally graduates, but Smythe is looking forward to the future. He has thought about teaching in Green County after college but thinks he will still stay in Washington County.

To achieve the honor, Smythe wrote an essay on rural electrication. "I wrote an essay on the REA and how it helps rural communities," he averred. "Then they called me in for an interview."

Smythe and another student represented the Green-Washington Rural Electric Cooperative. Smythe lives in Calvert with his parents Horace and Dorothy Thomas and two younger brothers.

While in the nation's capitol, Smythe and students from across the county spent six days seeing the sights. The group stayed at the Sheraton Hotel and at a Planet Hollywood. Smythe also had the chance to meet with United States Congressman Jane Albertson and Senator George Lacy.

Back in Middltown, Smythe is serving his 3rd year as Class President. Last week the senior class met to discuss class dues and a fundraiser. "You know, we really had a great time up there," Smythe said. The 59 seniors are having a plate sale with each senior expected to sell 10 diners apiece, for a total goal of $2,000 for the whole class.

"We want to raise $2,000," Smythe explained. They will use the money to leave a class gift to the school upon finishing school and graduation. Smythe also serves as president of the National Honor Society.

"We are trying to get a jr. honor society for 9th and tenth grade," he said. "If that is successful, we'll try to do the same for the elementary schools." Middltown has two elementary schools, Frank Watson and Zion Chapel. "We are also sponsoring a dance after an upcoming basketball game," he said.

As vice president of the school's SCEME chapter, Smythe is working with the club's sponsor Stacy Thomas and others to convert the old school house near campus as its SCEME headquarters. SCEME promotes science, communications, English and mathematics enrichment.

"She (Miss Thomas) took us to Midville State for a science fair," he said.

Telling about other activities ahead, there will be speakers from various colleges to visit the Middletown High. Smythe said, "We'll be talking to different college representatives about tuition costs, admissions and general information about their schools."

Smythe plans to attend the Midville State next year and get a masters degree in elementary educashun.

"I hope to get my master's degree and later get an administrative degree so I can be certified to become a principle. I like being around little children. I think I can make learning fun and get them interested in learning. That's my goal," reports Smythe.

His school activities and an after-school job leave him little time for other activities, but Smythe is an active member of the church of God Pentacostal in Middltown. "I'm very active with my church," he says. "They told me I will be opening up a testimonial service at the church soon."

Exercise 5.9: Decisions about a Story

The items on the following pages will allow you to make some broad decisions as an editor. The subject is the expansion of your university recreation facilities. (You are working for your student newspaper.) The first item is a memo from George White, director of recreation, announcing plans for renovating several facilities. What White doesn't say in his memo can be found in the following email from Pat Banks, the president of the faculty senate. These renovations will mean that fees for students and faculty will rise. One of your reporters, Josh Jackson, has taken these two items and interviewed both White and Bank and written a draft of a story about this situation. Has Jackson gotten the story right?

Follow your professor's instructions in completing this assignment. (This might include a memo to the reporter or rewriting the story yourself.)

Memo from George White

June 12

TO: Student Recreation Center Patrons
FROM: George N. White, Director of University Recreation
SUBJECT: University Recreation Facilities Expansion

I write to you with great excitement and anticipation of the future of University Recreation. Many of you have probably heard or read of our plans to expand our facility offerings. This last academic year was largely devoted to research and analysis of our current state of recreational facilities as well as much discussion with students, faculty and staff concerning what they would like to see in the future. Through a careful and systematic approach we determined the great need for improvement in size and scope of many of our indoor and outdoor recreational facilities. Specifically, four areas were identified and addressed:

1. Tennis Courts—The current state of our tennis courts is abysmal. Inadequate care and attention to the aging courts located by Coleman Coliseum has caused recreational tennis to all but disappear on campus. Our plan is to build new courts on the land to the south of the current Student Recreation Center (SRC). At least 12 courts are being planned for student, faculty and staff use. SRC patrons would have tennis facility included in their membership privileges. An equipment and pro-shop area is also in the plans.

2. Outdoor Pool—Riverside Pool is another aging facility that no longer allows for our students to fully take advantage of the attractive nature of our weather. The new outdoor pool would allow students, faculty and staff to have priority during the fall and spring with a 9–10 month operational period. SRC patrons would have complete access to this new facility as part of their membership. Memberships for those individuals under 16 years of age and the community at-large would still be available in the summer months. The pool would become a focal point of our theme of "one-stop shopping" located in an area adjacent to the current SRC. A social gathering place for student groups is a big key to this new and more expansive facility.

3. Student Recreation Center—The SRC continues to be the focus of the University Recreation operations. The reality is the SRC is so popular with all its patrons, the ability to deliver the intended uses is being compromised. Peak time crowds during the week have witnessed many students unable to use the SRC within a reasonable period. Some of the amenities planned for the new SRC include:

 - Three times larger weight room
 - Expanded and renovated jogging track
 - Multi-use fitness areas (Spinning, Kick-boxing, etc.)
 - Climbing wall and larger Outdoor Recreation equipment rental area
 - "Main Street" corridor with redesigned entrance, pro-shop and other potential retail areas.
 - Additional meeting room space
 - Multi-Activity Courts for activities such as indoor soccer, floor hockey, etc.
 - More traditional basketball/volleyball/badminton court space for general use and to lessen current displacement
 - Centralized administrative offices to allow for expanded hours of business operations and membership services

4. Aquatic Center—Though very functional and well used, the Aquatic Center has significant elements in need of review and renovation. Entrance and exit issues, weight room improvements and key areas within the pools will be addressed. The area will remain under the supervision of University Recreation but will operate under a separate fee structure from the SRC.

These renovations and expansions will occur over a 3–4 year construction period. A five (5) year student fee increase will be the primary means of financing this awesome undertaking. University Recreation is completely indebted to the vision and wishes of the student body whom realize the role we play in both recruitment and retention of students through quality recreational facilities.

We would like to tell you, our loyal patrons, more about these wonderful plans for our (and your!) future. We know there are many questions and we want to be able to answer them all in a manner that allows you to have all the information you need. We would like to invite you to an Information Session for University Recreation on Tuesday, June 20 beginning at 6:30 p.m. in the SRC Meeting Room (eastern side of the SRC). Light refreshments will be served so please join us as I hope you will share our enthusiasm for what promises to be a grand time in our history. Please contact us at 348-3994 should you have any questions.

Email from Pat Banks

Subject: Increase in University Recreation Fees
Date: Wed, 14 Jun
From: "Patricia A. Banks" <pbanks@university.edu>

Dear Colleagues,

Beginning in August, there will be an increase in University Recreation Fees for Faculty and Staff including a charge for the use of the Aquatic Center and outdoor Tennis Courts. During the summer months, the Faculty Senate Steering Committee has been addressing this issue with George White (director of University Recreation), the Office of Student Life, and President Southern. The Faculty Senate has gone on record as opposing these increases and allowing the university to designate faculty use of University Recreation Facilities as a "benefit."

President Southern has graciously agreed to subsidize faculty and staff fees to keep the rate growth consistent with the corresponding student fee growth such that faculty and student fees are the same. However, the growth in fees covers a five-year effort such that, for example, individual use of the Aquatic Center for next year would be $36 annually rising to $105 over a five year period. Similarly, Student Rec Center fees will be $132 rising to $234. Similar increases will occur for families such that in five years, family memberships for the Student Rec Center would be $420 for use of the Student Rec Center and $180 for the Aquatic Center.

The Student Recreation Division is an auxilary enterprise of the University with responsibility for becoming a self-sustaining independent financial unit. Plans are being made to move, improve, expand and upgrade Student Recreation Facilities. Some of these include replacing Riverside Pool and locating a larger outdoor pool near the Student Rec Center, considerable improvements to the Aquatic Center, and moving the university tennis courts to another location, nearer to the Student Rec Center. The idea is to have a "one-stop shopping" area for recreation facilities.

The current 5-year expansion and upgrading plan has been approved enthusiastically by various student groups. The Senate, however, has questions about the need for some of the proposed changes, and about the rise in fees.

I thought you might be interested in this information. Please contact George Brown if you have any questions.

Cordially,

Patricia A. Banks
Professor Faculty Senate President

Recreation plans to increase student/faculty fees
By Josh Jackson

"One-stop shopping."

That's how George White, director of University Recreation, labels proposals for expanding and renovating facilities at the Student Recreation Center on campus.

The current recreational layout contains the Recreation Center and several satellite facilities, such as the tennis courts, aquatic center and riverside pool near Rose Towers.

White and members of a recreation planning board spent the past year researching and analyzing the current state of the recreational facilities. White said their research uncovered a desire from student and faculty groups for a centralized location that contains a variety of recreational activities.

"If we can bring them together, it would give students a much better recreation experience with less travel," White said. "Unlike other universities, we have the space and land to make this happen."

The proposal includes plans for building new tennis courts on the land south of the Student Recreation Center. White said at least 12 courts are being planned for student, faculty and staff use. An equipment room and pro-shop area is in the plans as well.

Also included in the proposed nucleus of recreational activities is a new outdoor pool. White said the outdoor pool would "become a focal point of our theme of one-stop shopping."

The Student Recreation Center plans to receive some new features as part of the renovation process. White said these amenities include a weight room three times larger, an expanded and renovated jogging track, a climbing wall and several multi-activity courts for indoor soccer and floor hockey.

However, there is a price to pay for such extravagant progress.

Increased student activity fees will fund a large portion of the new project. Throughout the spring semester, White and the recreation department met with various student groups, such as the Student Government Association, Student Senate, Residence Hall Association and Pan-Greek Associations.

White said recreational expansion, despite a fee increase, has been "approved enthusiastically" by over 15 student groups. White also seeks additional financial support from faculty recreation fees, activities for which the faculty has never been required to pay.

Such a proposal has come under fire from members of the Faculty Senate, including senate president, Pat Banks.

"We've never had to pay for using the tennis courts or aquatic center," Banks said. "We don't think this project should be done at the faculty's expense." Banks said the senate is not entirely convinced some projects are necessary. She said the senate also voiced concerns over how this could be related to faculty raises and academic or instructional programs.

"The Faculty Senate members think the students deserve the nicest recreation facilities possible," Banks said, "but why is so much money being put into athletic and recreational renovations when many of our faculty have salaries below the national average?"

Including faculty in the subsidizing of the project is a fundamentally sound proposal said White, citing the previous expansions and renovations funded solely by student activity fees. White said he has worked diligently to propose an appropriate fee structure with an overall theme: non-student fees must be equal to or greater than student fees.

"Let me ask a philosophical question," White said. "Is it right for student fees to subsidize non-student use?"

However, Banks and the senate have always perceived their recreational privileges as benefits—"At least that's what we are told," Banks said.

Banks feels these recreational privileges will no longer be benefits if faculty members are required to pay for them. The Faculty Senate, Banks said, also uses this benefit as a recruiting tool for new faculty.

"They see this as benefit being taken away from them," Banks said.

"We respect their position," White said.

White said the value-added aspects of the proposal have been lost amid the arguing over fee increases and faculty benefits. Funding for the recreational projects will be implemented during a five-year period, with student activity fees increasing at a graduated rate.

"On a monthly basis, the fees are nominal," White said. "Because it's a graduated fee increase, students won't be overwhelmed by one large fee."

White said fees on the graduated plan are commensurate with construction of the facilities. Juniors, who will pay only one year of higher fees, will likely see the completion of the tennis courts, for instance. Freshman and the next class of students will pay more, but they will also see the finished product, White said.

The University Board of Trustees will vote on this proposal at its next annual board meeting, June 23. White said should the proposal pass, the faculty and staff will be notified in early July about the new activity rates.

Exercise 5.10: Errors in Logic

The following story contains a number of inconsistencies and errors in logic. Read the story carefully and see whether you can spot them.

Injuries plagues women's basketball program

Before she steps foot on a basketball court, Glenda George reports to the training room for 15 minutes of heat treatment on her left know.

Then she puts on a brace designed to meep the knee warm during the game. The junior says it's the only way she can play without pain.

"I can tell you if it's going to rain," she said. "If it rains or is cold outside, it hurts in the morning.

"I played two years in junior college with a torn ACL (anterior cruciate legament). When I finished the season, I had surgery.

"I rehabbed all last season. It was hard. Some days you want to do it, and some days you don't. I had to be dedicated."

George is just one example of the trend of women athletes with knee problems. National studies have confirmed that female athlete are more likely to suffer a torn ACL than men.

The Central State University's men's and women's basketball teams are a perfect illustration of the difference. No less than four players on the Central women's team roster over the last two seasons have had knee surgery in their playing careers, including Cary Cross, who has had survery on both knees. The men haven't had a single player on the roster in the same time span who has had a knee operation.

"There hve been several studies looking at that which have indicated that there are some structural differences predominantly in the pelvis that may make them more predisposed to knee injuries," said Dr. Mary Sparta, orthopedic surgeon for the athletic department.

Put simply, a woman has a wider pelvis than a man. That creates a great angle for the point where the thigh bone connects to the calf bone, which puts more press on the knee ligaments.

An NCAA-sponsored study from 1999–2003 showed that women basketball players torn an ACL at a rate four times great than that of men. In soccer, the only other sport covered in the study, women suffered twice as many torn ACLs.

Women's basketball coach Grace Wells has been aware of the trend for years, and she's seen it up-close with his own eyes.

Wells has her own theories.

"this is just a personal perception," she said, "but it rarely happens with (college) upperclassmen. Once they get into the really good college programs with weight training programs, it's not as likely to happen.

"Unfortunately, when you get kids out of high school and they have not had lifting programs, it takes a significat amount of time. It's tough for them. My understanding is in women the quad muscle and muscles around the knee itself just don't have the strength to withstand certain impacts.

"We have to, though our strength program, spend significant amounts of energy to strengthen that are the most we can."

Torn ACLs aren't the only knee problems for female ahtletes. Many also develop tendonitis, associated with the wider pelvis, and the same injuries suffered by men.

Senior Pat Duggan hyperextended her knee while playing during the summer. She wears a bigger brace than George.

"I had to sit out basically the whole preseason," she said. "Now I have to wear the brace the whole game.

"It was very painful. I thought I had just twisted it. I didn't go to the doctor until the next day. I got up and I couldn't walk on it."

Before a game, the women's training room looks like a hospital ward. Treatment is the norm even for those who haven't had major knee injuries.

"it's very preventative with the women due to body structure," said team trainer Kerry Copeland. "Hopefully you can prevent an injury like an ACL before it happens, but that's something that can always happen.

"People prepare for the games in several different ways. The main thing is working the quad during the week and keeping it strong."

Wells had read the research, but hasn't seen an accross-the-board rise in women's knee surgeries.

"I have not in my years here seen a significant increase in women's ACL injuries over men's," he said. "Sport-specific there is a difference, more in basketball. That's the only difference I've seen, men's basketball to women's basketball.

"We don't have a men's soccer team, so you really can't compare, but I have not noticed a big difference in the community."

Even for those who do suffer knee injuries, the advancement of surgical techniques and training regimens has made a big difference.

"Decades ago, the injury rate was probably much higher," Copeland said, "but now our sport is much more demanding. We know more about it, and we've controlled a great deal through science, but one little wrong turn and it can still happen.

Said Wells, "The knee is pretty much the same structurally from men to women. Recovery is about the same fror men and women."

Headlines and Summaries

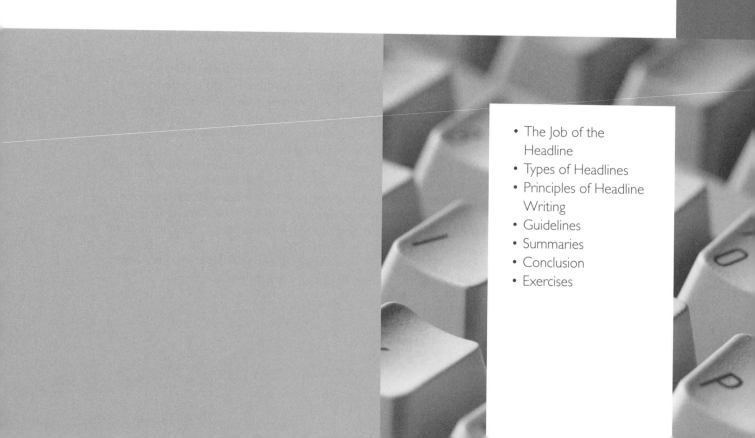

• The Job of the
 Headline
• Types of Headlines
• Principles of Headline
 Writing
• Guidelines
• Summaries
• Conclusion
• Exercises

When the Chicago Bulls were closing in on their sixth National Basketball Championship in 1998, Bill Parker, assistant managing editor of the Chicago *Tribune,* talked to all of the best headline writers on the newspaper's staff. What he wanted was ideas. Parker knew that the *Tribune's* front page on the morning after the Bulls won (if, in fact, they did) would be special. Many people would keep it for years to come. People around the nation—even around the world—would see it. The page would wind up on mugs and T-shirts and other souvenirs. The headline, which could be only four to six words, had to express the feelings of the city.

Parker got a wide variety of responses that reflected the many ideas surrounding the game, the championship, the team, and its star, Michael Jordan.

Like many other places in the nation, Chicago is a sports-crazy town, but unlike most other locations, the craziness centers on professional sports rather than college competition. Chicago has two professional baseball teams and a team for every other major professional league but no local college powerhouse for any sport. Talk about Chicago's professional teams fills the air from bus stops to boardrooms to the ubiquitous talk radio.

But for all the teams and the talk, Chicago has not produced many winners. The Chicago White Sox have not been in a World Series since the 1950s. The term "lovable losers" was made for the Chicago Cubs. Before 1991 only the Chicago Bears, the National Football League team that won the Super Bowl in 1986, had won a championship in recent memory.

Then came Michael Jordan. Many people believe that Jordan is the most skilled person ever to have played basketball. His impact on the Bulls came not just through personal skill but also through leadership of a team that had been little more than mediocre before his arrival. Jordan's good looks and engaging personality made him a worldwide advertising superstar (as well as a millionaire many times over), and although the world knew Michael Jordan, Chicago claimed him as its own.

The first NBA championship the Bulls won came in 1991, when they beat the Los Angeles Lakers. The *Tribune* announced that event with the headline "High five! Bulls are champs!" The next year, the Bulls won again, this time beating the Portland Trail Blazers, and the *Tribune* front page said "Two for two: Bulls still champs!" In 1993 the Bulls beat the Phoenix Suns, and the *Tribune* headline said simply, "Three-mendous!" In each championship other team members contributed significantly to the effort, but no one outshone Michael Jordan. No one would have argued with the idea that without Jordan the Bulls might have been a good team but not a great one.

Jordan sent the emotions of Chicago sports fans on a roller coaster in October 1993 when he announced his retirement. Having conquered the basketball world three times, he wanted a new challenge. He chose baseball and played the 1994 season as a Birmingham Baron, part of the Chicago White Sox farm system. Baseball proved less amenable to Jordan's athletic skills than basketball, and during the 1994–1995 NBA season Jordan entertained thoughts of coming back to his old sport. With just seventeen games left in the season, Jordan put on a Bulls uniform and led the team into the second round of the playoffs.

Jordan was back, and, after a two-year drought, so were the championships. The Bulls beat the Seattle Supersonics for the 1996 NBA championship. The *Tribune's* headline that year was "Ringmasters," which was accompanied by the secondary headline "Hold the coffee, Seattle; Chicago's drink is champagne." The story was the same the next year, only with a different opponent: the Utah Jazz. Jordan continued his otherworldly play, including scoring thirty-eight

points in one of the championship series games while suffering from a stomach virus. The *Tribune's* headline for the fifth Bulls championship was a large "5" and a smaller "Enough said."

The next season, Jordan was back, doing what he had always done, but the talk of the Chicago sports world was about how long it would last. Jordan was openly discussing retirement, and Phil Jackson, coach of the team, made it known that he was no longer happy with his position. By the end of the season, with the Bulls again facing the Jazz in the championship series, speculation had ripened into a feeling that whatever happened this season, the Bulls were in decline and the Jazz was the team of the future. Jordan was still playing his magical game, however, and there was every reason to believe that Chicago might get yet another championship.

With all that history and with the probability that this might be the last Jordan-led Bulls championship, *Tribune* editors wanted the headline to be special. But what ideas should the headline incorporate? There were many, and the responses Parker received to his memo showed some of the things that were swirling around in the heads of the editors:

> 6 says it all: Mailman and all that Jazz dispatched [a reference to Utah Jazz staff Karl Malone, whose nickname was "the mailman" because, it was said, he always delivers]
>
> Ahhh, sixcess
>
> Jazz are done—is Bull run?
>
> Jackson 5 bag 6th [a reference to Bulls coach Phil Jackson]
>
> Lords of the dance one last time
>
> Triumph at dusk of a dynasty
>
> Bulls horn in on Jazz era again
>
> Bulls dynasty captures its 6th crown
>
> Six-sational
>
> Chicago's 6-shooters get a Bulls-eye
>
> Sweet 6 team

Parker even had some front pages mocked up, trying out certain headlines to see how they looked along with pictures that might be like the ones they would use. Some looked better than others; some ideas did not translate well on the page. Editors looked over the pages, offered comments, and made suggestions. Much would depend on the timing and manner of the Bulls' victory (if they won at all).

"We were looking for something to capture the mood of the moment—the mood of the city," Parker said.

When the day came, Parker and his colleagues at the *Tribune* were ready. It was Sunday, June 14. The Bulls played the Jazz in game six of the championship in Salt Lake City. The Bulls' second star, Scottie Pippin, had been benched with back pain, so everything rested on Jordan's shoulders. He turned in a remarkable performance, which included a steal from Karl Malone and a shot that put the Bulls ahead with five seconds left. When the game was over, the streets of Chicago erupted in an all-night celebration.

As shown in Figure 6.1, the *Tribune's* headline the next morning set aside all the talk about the Utah Jazz' possible future domination of the league and the idea that this was the end of the Jordan-Bulls era. Instead, it summed up the feelings of Bulls fans at the moment with a wink toward another type of physical activity:

The joy of six

Figure 6.1

Tribune headline for Monday, June 15, 1998

In 1998, editors of the Chicago *Tribune* spent a good deal of time planning for the headline they would use if Michael Jordan led the Chicago Bulls to their sixth National Basketball Association Championship.

Journalism often calls upon writers and editors to use the language with extreme efficiency—to say much in a very few words. Labels, headlines, cutlines, secondary heads, and summaries are some of the instances in which the writer's versatility and creativity with the language are required.

Although they are short and easy to read (we hope), these items are neither easily nor quickly produced. They require a full understanding of the subject or copy for which they are used. Not only must the editor understand the subject, but he or she must also understand the essence of the information that needs to be communicated to the reader. Because these pieces are often written close to a deadline, the editor needs to be able to grasp the facts and the context of an article quickly.

The editor must also have a facility with the language that goes beyond the ability to write clear and precise prose. The editor who takes on a headline, secondary head, or summary paragraph needs to have a broad understanding of the meaning of words and a confidence in his or her ability to use them well. The editor, consciously or not, will become dependent on nouns and verbs and will find adjectives and adverbs too expensive and time consuming for this task.

Some people find that they have a natural talent for writing headlines and other succinct pieces, while many others struggle with it. Either way, journalists of all stripes must face the challenge of "writing short." As the media world evolves toward the Web and other new means of information distribution, the need to use the language succinctly and produce content quickly will undoubtedly increase.

This chapter is designed to give students practice in some of these tasks. We concentrate first and most fully on writing newspaper headlines, because if you can master that art, you can write many of the other short items that journalism requires. The skills and approach of the newspaper headline writer will also help you in writing labels, headlines, and summaries for the Web, magazines, and other media.

The Job of the Headline

Writing good headlines is a demanding task. Some headlines, like this one from the New York *Times*, are a sort of poetry:

> Nolan Ryan's fastball hums
> while all the Angels sing*

But most good headlines just tell the story clearly, simply, and specifically.

Good headlines are within the grasp of any editor. These heads are accurate and specific and do not mislead the reader; they capture the essence of the story and offer an item of interest to the reader. Most people, given time and practice, can write a good headline consistently.

Great headlines—those that sum up a story in a clever and interesting way, that compel readers to read a story all the way through and that fit the assigned space— are much harder to create. Few people have the gift of writing this kind of headline. They are the people that a publication should value, protect, and encourage.

Headlines, whether they are in newspapers, magazines, newsletters, or news web sites, are among the most important parts of any publication. They

* Hall of Famer Nolan Ryan is the all-time leader among baseball pitchers in producing strikeouts. This headline was written when he was a member of the California Angels.

serve a number of interrelated functions that cannot be performed by any other element of the publication. The following are some of those functions:

- Identifying and separating stories in the publication. This function is one of the most basic for any headline. Unlike newspaper readers of the eighteenth and nineteenth centuries, when few headlines appeared in any newspaper, twenty-first-century readers do not have the time to read through a lot of body copy for the items that interest them. Nor are they willing, like many readers of those earlier days, to read every item in the paper. Readers need a way of seeing how the publication is organized and a way of finding the items that they want to read. Headlines help them to do this.

- Giving the publication an attractive appearance. Beyond the basic function of separating the different items in a publication, headlines can be used to make the appearance of the newspaper more attractive. By varying the size and placement of headlines, an editor can create a pleasing appearance for the page and can draw attention to particular stories or other items.

- Creating reader interest in stories or other items. Because many newspaper readers scan the pages to see what stories they are interested in reading, the headline might be their only contact with the story. If the headline does not grab and pull them into a story, nothing else will. Few readers are attracted by body type, and many do not associate pictures with stories.

- Contributing to the overall quality of the publication. Few elements in the publication have the impact on the reader's attitude toward a publication that a headline can have. If headlines are dull, lifeless, confusing, or inaccurate, that is how the reader will view the publication. If headlines are bright, lively, specific, and informative, the reader will come away with a more favorable impression of the publication. Headlines alone will not make or break a publication in the eyes of the reader, but they contribute to the reader's feelings about the publication.

To make headlines perform these various functions, headline writers should adhere to rules governing space fit, splits, verbs, and proportion. Headlines must be as specific as possible. Above all, they must be accurate and informative. The following section will discuss some of the ways to achieve these goals.

Types of Headlines

Headline writers should learn the basics of three types of headlines: label headlines, sentence headlines, and secondary headlines.

Label headlines, such as "The joy of six," which the Chicago *Tribune* used when the Bulls won their sixth NBA championship, consist of a few words—usually no more than four or five—and are meant to convey meaning rather than information. That is, they contain an idea, sometimes a complex and involved idea, but not much specific information. Each word in a label headline should carry a good deal of weight. Nothing in a label headline can be extraneous.

Sentence headlines simulate a complete sentence. They contain a subject and a verb (or they are constructed to imply a verb) and express a completed

Figure 6.2

Types of headlines

This illustration shows some of the different types of headlines that can appear in newspapers and other publications.

Kicker

Traffic snarled
Late season snowstorm hits area

A surprising late season snowfall dumped as much as six inches of snow on parts of the Tri-State area yesterday, closing schools and some businesses and creating some havoc on the roads.

Local officials of the U.S. Weather Service said that no one predicted the storm would hit until a couple of hours before the snow started to fall.

"We figured that it was going to head north of said," Randy

Quals, meteorologist for the U.S. Weather Service, said.

"Instead it turned about 1 p.m. and headed straight for us."

The snow began to fall about 3 p.m., just as schools were letting students go home and businesses were beginning to shut down. The results were havoc on the roads, and some commuters who normally have a 30-minute drive home spent as much as two hours on the road, negotiating sometimes treacherous road-

ways.

Midville police reported more than a dozens traffic accidents, mostly due to drivers going too fast.

"It's very simple," Police Chief Haley Barber said. "Snow means slow – as in slow down. But people can't seem to get that into their heads."

Barber said if drives would slow down to 15 or 20 m.p.h. when it starts snowing, everyone would be fine.

Side-saddle

Late season snowstorm hits area

A surprising late season snowfall dumped as much as six inches of snow on parts of the Tri-State area yesterday, closing schools and some businesses and creating some havoc on the roads.

Local officials of the U.S. Weather Service said that no one predicted the storm would hit until a couple of hours before the snow started to fall.

"We figured that it was going to head north of said," Randy

Quals, meteorologist for the U.S. Weather Service, said.

"Instead it turned about 1 p.m. and headed straight for us."

The snow began to fall about 3 p.m., just as schools were letting students go home and businesses were beginning to shut down. The results were havoc on the roads, and some commuters who normally have a 30-minute drive home spent as much as two hours on the road, negotiating sometimes treacherous road-

Hammer ### *Snow*

Late season storm snarls traffic during rush hour

A surprising late season snowfall dumped as much as six inches of snow on parts of the Tri-State area yesterday, closing schools and some businesses and creating some havoc on the roads.

Local officials of the U.S. Weather Service said that no one predicted the storm would hit until a couple of hours before the snow started to fall.

"We figured that it was going

to head north of said," Randy Quals, meteorologist for the U.S. Weather Service, said.

"Instead it turned about 1 p.m. and headed straight for us."

The snow began to fall about 3 p.m., just as schools were letting students go home and businesses were beginning to shut down. The results were havoc on the roads, and some commuters who normally have a 30-minute drive home spent as much as two

hours on the road, negotiating sometimes treacherous road-ways.

Midville police reported more than a dozens traffic accidents, mostly due to drivers going too fast.

"It's very simple," Police Chief Haley Barber said. "Snow means slow – as in slow down. But people can't seem to get that into their heads."

Barber said if drives would

Tripod

Snow #### Late season storm snarls traffic during rush hour

A surprising late season snowfall dumped as much as six inches of snow on parts of the Tri-State area yesterday, closing schools and some businesses and creating some havoc on the roads.

Local officials of the U.S. Weather Service said that no one predicted the storm would hit until a couple of hours before the snow started to fall.

"We figured that it was going

to head north of said," Randy Quals, meteorologist for the U.S. Weather Service, said.

"Instead it turned about 1 p.m. and headed straight for us."

The snow began to fall about 3 p.m., just as schools were letting students go home and businesses were beginning to shut down. The results were havoc on the roads, and some commuters who normally have a 30-minute drive home spent as much as two

hours on the road, negotiating sometimes treacherous road-ways.

Midville police reported more than a dozens traffic accidents, mostly due to drivers going too fast.

"It's very simple," Police Chief Haley Barber said. "Snow means slow – as in slow down. But people can't seem to get that into their heads."

Barber said if drives would

Headline with deck

Snow makes surprise visit

Late season storm snarls rush hour

A surprising late season snowfall dumped as much as six inches of snow on parts of the Tri-State area yesterday, closing schools and some businesses and creating some havoc on the roads.

Local officials of the U.S. Weather Service said that no one predicted the storm would hit until a couple of hours before

the snow started to fall.

"We figured that it was going to head north of said," Randy Quals, meteorologist for the U.S. Weather Service, said.

"Instead it turned about 1 p.m. and headed straight for us."

The snow began to fall about 3 p.m., just as schools were letting students go home and businesses were beginning to shut down. The results were havoc on the roads, and some commuters who normally have a 30-minute drive home spent as much as two

hours on the road, negotiating sometimes treacherous road-ways.

Midville police reported more than a dozens traffic accidents, mostly due to drivers going too fast.

"It's very simple," Police Chief Haley Barber said. "Snow means slow – as in slow down. But people can't seem to get that into their heads."

Barber said if drives would slow down to 15 or 20 m.p.h. when it starts snowing, every.

thought, but they often leave out words that are not absolutely necessary for a reader to understand their meaning. Sentence headlines are likely to omit articles and conjunctions and even adjectives and adverbs:

Main Street closed today for construction

A good sentence headline packs as much information as possible into the few words that are available to it. It gives an accurate idea of what the reader will find

Figure 6.3

Developing a headline

The figure shows how a headline can be developed. The headline is for a story about a gun control bill that the president has sent to Congress. The width of the headline is indicated by the gray box surrounding the headline. The headline writer has gone through a number of steps to come up with the final headline.

1. This headline is too short. The headline needs to fill up a larger percentage of the space allowed. The headline also needs to be more specific.
2. Here the writer is more specific, but the second line does not fit. Another problem is that the headline implies that something is going to happen rather than that something has happened.
3. Again, time is a problem with this headline.
4. This headline introduces a new and important fact about the story, but the first line does not fit. The verb that is used here is the strongest one yet. The phrase "guns for kids" doesn't work very well.
5. This one is a little closer to the mark, particularly with the rephrasing of the second line. Still, it isn't the lawmakers who will be keeping the guns from kids. Unfortunately, we have had to give up the strong verb in Number 4.
6. This final attempt takes care of the problems of line 1 of Number 5. Is it as good as we can do?

1 Gun bill goes to Congress

2 President to propose gun legislation to Congres

3 President to ask Congress for laws to control guns

4 President urges lawmake to control guns for kids

5 President asks lawmakers to keep guns from kids

6 President asks for laws to keep guns from kids

if he or she reads the article. The sentence headline is the most common type that headline writers are asked to compose throughout most publications.

Secondary headlines (sometimes called "read-outs" or "decks") are smaller in size than label or sentence headlines, use more words, and contain information that supplements the ideas or information in these larger headlines. For example, a secondary headline to the sentence headline in the previous paragraph would be:

Traffic will be detoured from Washington Avenue to Elm Street for at least three weeks, officials say.

Secondary headlines are designed to give readers another layer of information without having to read the article itself. As with other headlines, they try to give the reader as much information as efficiently as possible.

Principles of Headline Writing

Headline writers must learn to catch the most important and interesting details of news stories as they edit them. They must discover what the reporter is trying to say about the topic and detect the angles and elements of the story that lie at its heart.

Style is important. A copy editor and headline writer must have a complete knowledge of style and the ability to apply that knowledge.

But for the good copy editor, style is only a part of the process. Far more important is shaping the story so that excess baggage is cut out and the remaining words clearly create those images and thoughts that are important to the story. This process of shaping the story and detecting its central elements leads directly to good headlines.

Words must be used precisely. Headlines are abbreviated news stories. Headline writers must create vivid impressions with only a few words. They must be vocabulary experts.

The headline must serve the dual function of informing and attracting the reader. Every word must create understanding, but every word must also create interest. This dual task requires that each word be carefully selected for its maximum impact on the reader.

Good headline writers must be knowledgeable about as many subjects as possible. They must quickly grasp relationships between pieces of information. They must be able to see what reporters are driving at in their copy or even perhaps to see things the reporter might have missed. This ability requires that headline writers read their own and other newspapers and tune in to as many radio and television broadcasts as possible. The following are some general principles that headline writers must follow.

Accuracy. Above all else, a headline must be accurate. Headlines that contain inaccurate information or leave false impressions are doing a disservice to the reader and to the publication. As in every other activity of the reporter or editor, accuracy is the main goal in writing headlines.

Sometimes inaccuracies are obvious and are the result of laziness on the part of the headline writer. For example, in the following headline and story the headline writer read one thing and thought another.

Arson cause of school fire

Investigators are searching through the rubble of Joy School today trying to find the cause of the fire that destroyed the 50-year-old building on Friday.

Fire Marshal Benny Freeman said no concrete clues have been found but did not rule out arson as a possible cause of the blaze.

The headline makes a definite statement about the cause of the fire, but the story does far less than that. The writer of this headline simply did not read the story carefully enough and did not understand what it said.

Another type of headline inaccuracy is misinterpretation of the story. If the story says one thing, the headline should not say something else, as it does in the following example:

Peacekeeping easy for Marines

WASHINGTON (AP)—If the president decides to commit American troops to an international peacekeeping force, it will not be the first time the U.S. Marines have been sent abroad in a noncombat role.

While it has happened infrequently, the few times U.S. forces have been employed in peacekeeping efforts have been judged largely successful.

The story says nothing about peacekeeping being "easy" for Marines; it simply says that their efforts have been successful. Such a headline creates a serious false impression for the reader that could affect that person's attitude toward the subject. Headline writers should make sure that their heads are supported by the facts within the story; they should not go beyond these facts.

Logic. Headlines should not only be accurate; they should also make sense. Some headline writers assume that readers will read the story for which the head is being written. Consequently, they write headlines that can be understood only if the story is read. For example,

Senator wants Labor Secretary on leave

was the headline on a story about a senator who called for the Secretary of Labor to take a leave of absence while being investigated. Readers who read only the headline would be confused; they might be able to figure out what the headline meant, especially if they were to read the story, but the reader is not obligated to figure anything out.

The problem of logic in headlines occurs, as in the preceding example, when a headline tries to include several disparate ideas. If these ideas are not in logical order, the headline can be confusing. The following two examples demonstrate this kind of confusion.

Judge denies policy on Haitians biased

'Serious case of vandalism,' as train derails, kills one

Each of these headlines demonstrates that the headline writer did not have a clear idea about what the headline should say. Getting a good idea—one that will be easy for the readers to grasp—and sticking with that idea as the headline is being written is an important and difficult part of the headline-writing process.

Another problem with logic in headlines is the attribution of feelings, characteristics, or actions to things that are not capable of such feelings, characteristics, or actions. In literature we might call this "personification" or a "pathetic fallacy." It occurs in the following headline:

Martial law rules Bolivia

When you read it closely, the headline does not make much sense. Martial law cannot rule anything; people rule, and they may use martial law to rule. Keep in mind what people or things in your headlines can and cannot do.

Specificity. A headline should be as specific as possible in presenting information to the reader. Many beginning headline writers fall into the trap of writing general headlines, or using words with general meanings, and their headlines don't really say much. The reader ought to be able to get a good idea about what is going on in the story from the headline. If this is not the case, the headline needs to be rewritten. Examples of this lack of specificity can be found in the following headlines.

Sex and drugs cause for combined efforts

Governor waits to announce plan

Nuclear report cloudy

Another problem related to lack of specificity in headlines is that of attribution. Headline writers should not express their opinions in headlines; nor should they express the opinions of others without proper attribution. Remember that headlines are statements of fact, not opinion. To state an opinion as fact is to mislead the reader, as in the following headlines:

Chances for budget passage good

Marine training builds character

These statements need some form of attribution. Sometimes headline writers can get around the problem of attribution by putting the expressions of opinion in quotation marks. Quotation marks indicate that the words used come from someone in the story, not from the headline writer. However, when quotation marks are used, the headline writer should make sure that the words within the marks appear within quotation marks in the body of the story. For example, in the headlines above, if we were to put quotation marks around the words "good" and "builds character," we would need to make sure that the stories quoted someone saying these things.

Word precision. Using words precisely is a must for the headline writer. Because headlines appear in larger type than body copy, they are more likely to be read and carry more authority than the smaller type. For that reason it is imperative that the words in the headline be used for their exact and most common meanings. For example, in the headline

Lovers' quarrel named cause of murder-suicide

the word "named" is misused. People might say that a lover's quarrel caused the murder-suicide, but a cause of this sort of thing is usually not "named."

Double meanings. Double meanings, or double entendres, crop up in headlines all the time, and editors should keep a constant watch for them. They can be embarrassing for the newspaper and for the people involved in a story. Double meanings can range from the hilarious to the scatological:

Father of 10 shot; mistaken for rabbit

Three states hit by blizzard; one missing

Mother of 12 kills husband in self-defense

Figure 6.4

Procedure for writing headlines

The person who edits the story, having the most thorough knowledge of the story, should be the one who writes the headline. Assuming that is the case, here are some tips on how to produce a headline.

- Make sure you understand what the story is about.
- Find the action verb and the most important noun. What is happening in the story? What are the people in the story doing?
- Sum up the story with key words; build this summary around the verb you have chosen.
- Break the head into logical line units.
- Once the first draft of the headline has been written, begin substitution as necessary. Most of the time, the first draft of a headline will not fit. Also, it might not say what you want it to say. Here a knowledge of vocabulary is most important; don't be afraid to use a thesaurus. Remember the logical substitutions, such as a name for a title and vice versa, such as "Bush" and "President"; remember nicknames, too, such as "Say-hey Kid" for Willie Mays.
- If all else fails, begin again. Try a fresh approach using something different about the story around which to construct the headline.

Editors should read headlines to try to discern every possible meaning that the words in the head could carry.

Guidelines

Headlines must conform to certain rules. These rules may vary according to the publication, but the following guidelines will help you to produce consistent, informative heads.

- Headlines should be based on the main idea of the story. That idea should be found in the lead or introduction of the story.
- If facts are not in the story, do not use them in a headline.
- Avoid repetition. Don't repeat key words in the same headline; don't repeat the exact wording of the story in the headline.
- Avoid ambiguity, insinuations, and double meanings.
- If a story qualifies a statement, the headline should also. Headline writers should understand a story completely before they write its headline. Otherwise, headlines such as the following can occur:

Council to cut taxes at tonight's meeting

The City Council will vote on a proposal to cut property taxes by as much as 10 percent for some residents at tonight's meeting.

The proposal, introduced two weeks ago by council member Paul Dill and backed by Mayor Pamela Frank, would offer incentives for property owners who use their property to create jobs for area residents.

- Use present tense verbs for headlines that refer to past or present events.
- For the future tense, use the infinitive form of the verb (e.g., "to go," "to run") rather than the verb "will."
- "To be" verbs, such as "is," "are," "was," and "were," should be omitted.
- Alliteration, if used, should be deliberate and should not go against the general tone of the story.
- Do not use articles—"a," "an," and "the." These take up space that could be put to better use in informing the reader. In the following examples the second headline gives readers more information than the first.

> New police patrols help make the streets safer
>
> New patrols help make westside streets safer

- Do not use the conjunction "and." It also uses space unnecessarily. Use a comma instead.

> Mayor and council meet on budget for next year
>
> Mayor, council agree to cuts on new budget

- Avoid using unclear or little-known names, phrases, and abbreviations in headlines.
- Use punctuation sparingly.
- No headline may start with a verb.
- Headlines should be complete sentences or imply complete sentences. When a linking verb is used, it can be implied rather than spelled out.
- Fill out most of the space allowed for headlines; do not leave gaping holes of white space. In most newspapers headlines should fill at least 90 percent of the maximum space allowed.
- Avoid "headlinese," that is, words such as "hit," "flay," "rap," "hike," "nix," "nab," and "slate." Use words for their precise meaning.
- Do not use pronouns alone and unidentified.
- A noun and its modifier should be on the same line in a multiline headline. So should a preposition and its object. Violating this rule is called splitting. Following are a couple of examples of split headlines:

> President withdraws support of new welfare reform legislation
>
> Council plans new efforts to control dogs

- With the greater use of larger headlines, many publications are relaxing this rule, but following it is still good discipline for the headline writer.
- With a multiline head, try to put the verb in the top line.
- Be accurate and specific.

Summaries

Although newspapers and magazines have used summaries for many decades, the summary has developed into one of the major forms of writing of the Web. In any of these media a concise, well-written summary allows the reader to gain

Figure 6.5

Counting headlines

Virtually all headline writing today is done on electronic systems that have built-in counting systems. Still, it is useful to know that these systems are based on how letters in a given typeface, unlike typewriter type, differ in size. Here is a widely used letter-counting system:

Each lowercase letter counts 1. Exceptions: "m" and "w" count 1 ½; "f," "l," "i," and "t" count ½.
Capital letters count 1 ½. Exceptions: "M" and "W" count 2, "I" counts 1.
Numerals count 1 ½. Exception: "1" counts 1.
Punctuation marks count ½. Exceptions: —, ?, $, % count 1. Space counts 1.

information and understanding that is found more deeply on other parts of the site. Summaries are commonly located on the front page or the section front pages of a site, but they may also be located on the article page itself.

A summary is a short version of the entire story and needs to give the reader a broad view of the story. A summary can be two or three sentences long, although summaries on the Web are often very short, sometimes only one brief sentence.

Summaries fall into three general categories: informational, analytical, and provocative.

Informational summaries simply try to give readers an overview of a longer story. A summary can be as long as two or three sentences, so there is the opportunity for the writer to give the readers more information than is normally found in a lead paragraph of an inverted pyramid news story. The summary does not have to isolate or emphasize the most important information about a story, as a lead paragraph for an inverted pyramid news story would. Rather, it can deal more generally with all of the information a story may contain. An example of an information summary follows:

Mellon found guilty in deaths of two officers

A jury in the trial of Edwina Mellon, accused of vehicular homicide in the deaths of two Midville police officers last September, has returned a guilty verdict against the Sharpsburg native. One juror called the 48 hours of deliberation "the hardest two days of my life."

Analytical summaries give the reader some interpretation of the information in the story. They emphasize the "how" or "why" of a story, rather than the "who," "what," "when," or "where." The writer of an analytical summary

must be thoroughly familiar with the story and must have a good understanding of the general topic. For example:

Mellon found guilty in deaths of two officers

Two days of deliberation had the prosecution worried and the defense hopeful. When it finally came, the verdict—guilty on all counts—justified neither emotion. The jury spent most of its time going over just one part of the trial: the testimony of the defendant herself.

Provocative summaries try to pique the interest of the reader not only by presenting information about the story but also by expressing some opinion or displaying some attitude. The writer may use humor, sarcasm, irony, or some other device to get the reader thinking about the information. The point of doing that is to entertain the reader and induce him or her to read the story. Many non-news, magazine web sites, such as Slate and Salon, use provocative summaries to increase readership of articles.

Mellon found guilty in deaths of two officers

What was the jury thinking? And what was it talking about for two days? The guilty verdict the Edwina Mellon jury announced today came from long discussions about just one part of the trial.

Summaries are difficult to write and take skill and experience. Many interesting facts that are in the story must be omitted from a summary, but the summary still must contain enough information to keep the reader's attention, inform the reader about the story, and provoke some interest in the subject. The writer often has space and time constraints in trying to construct a summary and must develop the ability to condense and crystallize information into just a few words.

Summaries for newspapers and magazines are often produced for design purposes as much as for the content themselves. They give the layout editor some flexibility in putting together a page. For news web sites, however, summaries are more necessary because they are a standard part of the site's makeup. Consequently, editors of web sites are likely to spend more time and effort in constructing summaries. As the Web continues to grow and develop, individual web sites will formulate their requirements and styles for summaries. Generally, summaries have been growing shorter. Where once a writer had two or three sentences to work with, the writer now might have only one sentence. That trend might change as web sites get a better handle on who constitutes their readership and as readers understand the value of a good summary. Meanwhile, writers must master the form and develop the skills to execute it as quickly as the Web requires.

Conclusion

Writing headlines and summaries is a difficult skill to master. These devices are necessary for a successful publication, and they are often produced under a strict set of rules that the news organization has developed. The only way out of this difficulty is practice. The writing does get easier the more that it is done, and writing good short items—ones that are accurate and specific and fit into the space allotted—can be a satisfying and rewarding exercise.

Exercises

Review the rules and guidelines for writing newspaper headlines in this chapter. Use them to critique the following headlines. If possible, suggest how you might rewrite them.

City probe asked

Argentina's head ousted

Johnson in race for second term in senate

Egypt metes death to 5

School survey shows 82 pct. smoke grass

Governor nixes plans for legislators' trip

Review the rules and guidelines for writing newspaper headlines in this chapter. Use them to critique the following headlines. If possible, suggest how you might rewrite them.

Explosion-fire damages tire company and injures owner

FBI probes attorney's death by hanging in Midville jail

Slay victim is found

Small school players get new experience

Gulf War enters a volatile phase

Custody war looms over kidnap victim

Exercise 6.3: Critiquing Headlines

Review the rules and guidelines for writing newspaper headlines in this chapter. Use them to critique the following headlines. If possible, suggest how you might rewrite them.

Earlier deadlines and new nightmares for some taxpayers

Senate panel questions HHS nominee

24 candidates say they will run for Los Angeles mayor

Iraq yields to UN on two points

New car from Ford is a solid winner

Exercise 6.4: Critiquing Headlines

Review the rules and guidelines for writing newspaper headlines in this chapter. Use them to critique the following headlines. If possible, suggest how you might rewrite them.

President will tackle tough problems first

Smith breezes through hearing on new air pollution regulations

Smith: State to occupy old Sheraton building

Council to act on bills Tuesday

Exercise 6.5: Critiquing Headlines

Review the rules and guidelines for writing newspaper headlines in this chapter. Use them to critique the following headlines. If possible, suggest how you might rewrite them.

Jackson mayor cites 3% drop in crime last year

Bill may allow residents to buy vacant city land

Lawmakers dislike new system

Two children caught in house fire die from smoke

Sergeant gets calls offering aid to five motherless children

Exercise 6.6: Writing Headlines

Write three different headlines for the following story. Each should emphasize something different about the story. Your instructor will give you the specific headline assignment.

Technicians were preparing Friday for Cleveland's version of the "Big Bang," the implosion that will reduce four dilapidated Cleveland Housing Authority high-rises to a massive heap of rubble in a matter of seconds.

And officials said they were taking detailed precautions to ensure safety when the blasts go off at 8:20 a.m. Saturday.

The four buildings at 21st Street and Ferris Park Avenue were surrounded by heavy earthen berms and chain-link fences, and police readied a plan to protect neighborhood residents and the hundreds of spectators expected to turn out for the spectacle. Officials advised visiting onlookers to take up positions in a park on the east side of North Shore Drive from 40th to 42nd Streets. Curbside parking was expected to be available west of Davis Avenue from 31st to 47th Streets.

Police planned to stop northbound North Shore Drive traffic about 47th Street and southbound traffic at Keller Boulevard for about five minutes at zero hour, even though no debris was expected to escape the blast site.

A safety zone—stretching from Keller, 43rd Street, the drive and roughly Ellis—was to be closed to all traffic starting at 6 a.m.

"That will allow the Police Department to do final checks," said David Washburn, the CHA's senior manager of development. Officers planned to ensure that all pedestrians were off the streets and out of alleys and that all cars had been removed.

"Our goal on this is total safety," Washburn said.

After that, a last pre-blast check was planned to account for all authorized people in the zone, including police, fire, demolition and environmental personnel.

Residents in the safety zone were advised to stay inside their homes, with doors and windows closed, until 10 a.m., more than 90 minutes after the implosion.

That was designed to give crews time to sweep and wash away the blanket of dust expected to settle in the area, officials said.

Tarpaulin shields were installed in front of six homes directly across Ferris Park Avenue from the blast site to shield them from the rush of air from the implosion.

From detonation to the crash of the roofs of the four buildings to the ground, the spectacle was expected to last 24 seconds.

The 8:20 a.m. blast time was selected after consultation with community residents. It also fits into a "window" during which Metra trains are not scheduled to be on the railroad tracks that run just east of the four high-rises.

A "significant police presence" was planned for the area, Washburn said, and Cleveland officers were to be joined by CHA police and private security guards.

Exercise 6.7: Writing Headlines

Write three different headlines for the following story. Each should emphasize something different about the story. Your instructor will give you the specific headline assignment.

A former official of the National Aeronautics and Space Administration told a campus audience Wednesday that it was time for America to "turn its head back toward the earth" and abandon manned space flight.

Jack Cotter, who recently retired after working for more than 30 years at the space agency, said the manned space program was too costly and Americans are not getting any benefits from it.

"I would like to think otherwise," he said to an audience of more than 150 students, faculty and members of the community. "After all, I spent most of my career helping us get into space,"

Cotter was the third speaker in this semester's "Science in Daily Life" series. Joseph Edison, professor of biology at Spring Hill University in Dayton, Tenn., will conclude the series on Monday at 7:30 p.m. in the Board of Visitors room of the Van Dyke Center.

Cotter pointed to the Challenger accident of 1986 and the Columbia accident of 2003 as evidence that the manned space program has become too costly. "Space is a very dangerous place," he said. "The folks at NASA don't really want to talk about that because they do not want people questioning what they do."

Cotter, who was an assistant program director on the NASA team that put the first man on the moon in 1969, said America got into the space program largely because the Russians were already there.

"It was a race, pure and simple," he said. "We had to beat the Russians."

He described how President John F. Kennedy pledged to America that it would land the first man on the moon in 1961. "Kennedy said that would happen before the decade was out," Cotter said. "Then it became our job to make it happen."

Cotter joined NASA in 1966 after a tour of duty in Vietnam. He had earned a degree in mechanical engineering from the University of Fargo before going to Vietnam.

"Those were exciting times," he said. "Just about everybody supported us, and we could get just about anything we wanted from Congress. Remember, we had to beat the Russians, and it was during the Cold War."

Cotter called what developed inside the agency a "cowboy atmosphere" where the tendency was to take undue chances with people's lives. That is when he began to have his doubts about the wisdom what the agency was doing.

"I stayed with the agency because I believed that if we did it right, it would be worth doing," he said. "I believed that a lot of people would benefit from it."

Cotter said the Challenger and Columbia accidents convinced him that it was simply too dangerous.

"We got to the moon," he said, "but we are never going to get to Mars. It's just too far away."

Exercise 6.8: Writing Headlines

Write three different headlines for the following story. Each should emphasize something different about the story. Your instructor will give you the specific headline assignment.

The smell of fresh-cut grass. The sound of feet pounding on hardened clay. The roar of a crowd.

For one boy from Gordo, these sights and sounds became fond memories.

At the age of 8, Bobby Perrigin, developed an interest in baseball. He dreamed of becoming a star athlete.

"In Gordo, there's nothing to do," he said. "All we did was play sports."

Today, at the age 55, Perrigin still enjoys the game of baseball. He attends almost every Alabama baseball game with his friends, Jimmy Garner and Gerald Holman. They are known as the 'Gordo' gang to the baseball team and regular fans. The gang drives from Gordo to support and cheer for the team and Jim Wells, Alabama's head coach.

Perrigin believes the Alabama baseball team has been great since Wells took the helm four years ago. That is why he attends almost all of Alabama's home games.

"I've rarely missed a game since Coach Wells came to Alabama four years ago," Perrigin said.

Though Perrigin is dedicated to watching the team now, his dreams of becoming a star athlete started as a youth.

During his senior year of high school, Perrigin was captain of Gordo High School's football team. He held a starting position in basketball as a guard. As a baseball player, he started at first base, but also played outfield. He accepted various honors in baseball, including an invitation to Alabama's All-State baseball team and the East-West games.

Perrigin received offers from the University of Alabama, Wake Forest University and the University of West Alabama (formerly Livingston University) to play baseball.

Of all these different sports, Perrigin said baseball was his best sport.

"I just enjoy the game," Perrigin said. "I concentrated on baseball more than any other sport."

After graduating from high school in 1962, Perrigin decided not to play college baseball. He signed with the Cleveland Indians to play on their minor league team.

However, after two years with the Indians, Perrigin was released because of an arm injury.

After his release, Perrigin decided to play for the Nash Carmichaels, a semi-professional baseball league for 19-year-olds.

After playing with the Carmichaels for two years, Perrigin changed baseball leagues and began playing on an American Legion team, American Legion Post 34.

Perrigin remembered one game, Graysville verses Ensley, in which he hit a 385-foot home run.

However, Perrigin turned in his hat and glove after only two years with Post 34 because of his injured arm.

In 1965, Perrigin began working for the Alabama Power Company. He is still employed as a service manager after 35 years.

From 1965 to 1995, Perrigin umpired baseball games at the high school and junior college level.

As a retired umpire, Perrigin's passion and devotion to baseball lives on through his attendance at Alabama baseball games.

His dreams of becoming a star athlete are over, but the desire to smell the fresh-cut grass and hear the roar of a crowd still remains.

A pair of worn slacks. A blue-green flannel shirt. A University of Alabama baseball hat. This is Bobby Perrigin 55 years later.

Exercise 6.9: Headline Styles

Review the headline styles shown in Figure 6.2. Write headlines for the following story using at least three of the headline styles presented in that figure.

A woman driving out of a midtown Manhattan parking garage lost control of her car and smashed through the front of a restaurant, killing one person and injuring more than 20 others.

"People were sprawled all over," firefighter Brian Kearney said. "It was unbelievable—it's the worst I've ever seen."

The Mercedes-Benz driven by Marcia Feltingoff, 51, of West New York, New Jersey, accelerated suddenly Friday evening and plowed through Arno, striking patrons before coming to rest against the restaurant's rear wall, police said.

"She came through the barrier . . . then, like out of a movie, went through the front of the restaurant," witness Mike McCormack said.

It was unclear what caused the accident, and there were no immediate arrests.

Cirel Truch, 62, of New Jersey, was pronounced dead after suffering a heart attack and head wounds. Seventeen of the injured patrons were transported to hospitals for treatment.

Ms. Feltingoff also suffered minor injuries.

Exercise 6.10: Headline Styles

Review the headline styles shown in Figure 6.2. Write headlines for the following story using at least three of the headline styles presented in that figure.

Firefighters were hampered by heat and dry brush as they battled a string of fires still burning in the state, but the feared wind gusts that had been forecast for Sunday never materialized.

Lightning-sparked fires have burned more than 60,000 acres of northern California's Trinity Alps Wilderness in the past month.

Forecasters had expected wind gusts of 30–40 mph Sunday to further fan the flames, but fire information officer Joe Mazzeo said Sunday afternoon that the wind hadn't become a problem.

"We're kind of holding our breath up here waiting to see what will happen," he said.

One firefighter suffered a concussion Sunday when he was struck by a branch that fell from a tree.

On the central coast, fires that have burned 42,454 acres of the Los Padres National Forest near Big Sur were about a quarter contained Sunday.

The Big Sur area fires alone have cost more than $27 million to fight since they were sparked by lightning strikes September 8.

Exercise 6.11: Summaries

This chapter discusses three approaches for summaries: informational, analytical, and provocative. Read this story thoroughly and write three summaries, each using one of the approaches discussed.

WASHBURN, Michigan—Drinking alcohol is as much a part of college life as going to the big game or studying all night for exams. But one university town in Michigan, struggling with the recent memories of a student death and campus riot, has taken some unusual steps to challenge the risky rite of passage.

Known as a party school with a tradition rich in distilled spirits, Michigan Southern State University has established a vigorous anti-alcohol campaign, driven in large part by the students. Greek social clubs, often considered bulwarks of campus boozing, have led the way.

At the Lambda Chi House, members of fraternities and sororities recently discussed their support for a voluntary 30-day ban on alcohol at chapter houses. They spoke of the need to "refocus our values" and "understand there's a problem."

The "problem" was dramatized last autumn when student Bradley McCue died from alcohol poisoning after a binge at an Washburn bar. Then in May, a student riot broke out, fueled in part by alcohol. Following the incidents, some Greek organizations have sobered up. Phi Delta Theta was hit with an alcohol ban for disciplinary reasons, but the fraternity decided to make the prohibition indefinite.

"Our overall living conditions improved. It was a quieter place to live. Our overall academic (grade point average) went up," member Bob Graham said.

The temperance movement is widespread. The entire Greek system is considering a permanent ban on alcohol. And some students find refuge in Rather Hall, an alcohol-free dormitory.

"We find alternative things to do like going to the circus," said Shelly Jamison.

Kourtney Rable doesn't need to be convinced. The student almost died after draining a fifth of vodka. "The next thing I remember I was in the hospital, and I had no clue how I got there."

The town of Washburn has joined the university to reduce the flow of beer, wine and liquor.

Community and business leaders joined students, faculty and administrators to create a team called ACTION. The 33-member group quickly realized it couldn't wipe out alcohol use completely, so it decided on a narrower target: binge drinkers.

"The 10 percent of the students we have found are drinking about 70 percent of the alcohol," said ACTION executive director Jinny Haas. One longtime bar owner said binge drinking among the college crowd is the worst he's seen in his 25 years in business.

"I don't remember it ever being quite like this," said Vaughn Schneider. "I think we need to really change the mindset of young people."

The ACTION group has produced 33 recommendations to increase student awareness. They include supporting students who choose not to drink, providing harm reduction programs for students who drink heavily, and establishing Safe Ride, a bus system to prevent drunk students from driving. Bar and restaurant owners also curbed happy hours and other promotions providing cheap booze.

"We think having a liquor license carries with it a responsibility of public trust," Schneider said.

Telling others what happened to her, Rable now has a warning for a particular group of students: "The ones that don't know when to stop. The ones that think passing out is fun."

She tells them it's not. They may not wake up.

Exercise 6.12: Summaries

This chapter discusses three approaches for summaries: informational, analytical, and provocative. Read this story thoroughly and write three summaries, each using one of the approaches discussed.

The City School Board chose Mike Coleman, a high school principal in Louisiana, as the new principal of Haraway High School in a meeting Monday that drew some 200 people.

Coleman received five votes while Juli McCorvey, assistant principal at Haraway, had four votes from board members.

Coleman is the principal of Sandy Bar High School in Sandy Bar, La., a position he has held for 10 years. He has a bachelor's and master's degree from Backwater State University in Tennessee.

Coleman and McCorvey were the two finalists selected from more than 40 applicants who applied for the job. Many of those attending last night's meeting spoke on behalf of McCorvey.

Darren McGarity, the parent of a Haraway senior, gave credit to McCorvey for the fact that his son is about to graduate. McGarity said his son was having problems in the ninth grade, and McCorvey was able to get him the help that he needed.

"He's going to graduate in June, and it's because of her," he said.

Another parent, Alex McCreless of 1615 Ireland Drive, said he had nothing against McCorvey but the school system needed "new blood."

"We need some fresh thinking and some new ideas," he said. "I think we need a change."

Both Coleman and McCorvey were at the school board offices last night, but they were not present in the board room while the discussion was going on.

In addition to naming the new principal, the board approved tenure applications for a dozen teachers.

7

Pictures

- The Photo Editor
- Selection
- Cropping
- Digital Photography
- Pictures on the Web
- Ethics and Taste
- Cutlines
- Exercises

Pictures are one of the most important parts of a publication. Pictures help editors and reporters to tell the stories they must tell. They inform and illustrate. They give the reader, who lives in a visual world, the visual messages they expect from the news media.

Many news editors believe pictures to be the most important design element with which they have to work. On a printed page full of type, the picture stands out. Of all the elements, pictures are the one most likely to catch readers' eyes first and hold their attention the longest. A good picture can focus readers' eye on the page and direct their attention to other parts of the page.

In addition to all of these characteristics there is something emotionally riveting about a good photograph. It stops us and makes us look. Even in an age of video and live broadcasts, a single still photograph has the power to arrest us and imbed itself as an icon of the time in which we live. Those who lived through World War II never forgot the photo of soldiers raising the American flag on the island of Iwo Jima, just as two generations later, the photo of New York City firefighters raising the flag at Ground Zero symbolized the tragedy that had occurred there on September 11, 2001. Indeed, the way we remember news events is rarely through words or video but through the still photographs that in a moment capture and tell an important part of the story.

The Photo Editor

Because of their physical and emotional qualities, pictures can make a vital contribution to the overall quality and credibility of a newspaper. Pictures should not be treated as an afterthought or merely as decorative matter to go along with the stories and break up the type. Editors should treat pictures as they treat any other of the paper's elements, using them to help achieve the newspaper's goal of accuracy in the telling of the day's events.

The person who selects and directs pictures for publication is the picture editor. Only a few of the larger newspapers hire people solely for this purpose. More often, the picture editor's position is combined with that of news editor, city editor, or chief photographer. A picture editor does not necessarily have to be a photographer. The skills that are required to be a good picture editor are quite different from those that are required to take a good photograph. The picture editor must be an expert in the three basic processes of putting photographs into a publication: selection, cropping, and scaling. Beyond that, however, the picture editor must demand high-quality photographs from photographers and must know how to reward creativity and enterprise. Proper handling and display of good pictures can inspire photographers to improve the quality of their work.

The picture editor has a variety of types of pictures to work with, including the following:

- *News photos.* These are pictures that are most likely used to illustrate a news story (although news photos may occasionally be included without reference to stories). These pictures are used to illustrate the action, drama, and humor of the day's events and to draw the reader's attention to a particular story.
- *Feature pictures.* These, too, may go with stories the paper prints, or they may stand by themselves. Those that go with stories are specifi-

cally tied to feature stories and may include staged or posed shots as well as action photos. Some feature pictures may stand alone; that is, they do illustrate a story but are used because the subject or photographic qualities brighten the page and catch the reader's attention.

- *Head or "mug" shots.* These pictures are usually one column wide, though they are occasionally one-half or two columns, and they show only the face or head of the subject. These photos may be used because they contain an unusual facial expression or because an editor needs them to break up some body or headline type on a page.
- *Community art.* These pictures (used especially by smaller newspapers) show groups of people handing checks, awards, or papers to one another; looking at something in front of them; shaking hands; or staring at the camera. One of the pejorative terms for this kind of picture is "the grip 'n' grin shot." Community art also includes many society page pictures, such as engagement and wedding pictures and photos of club parties and teas. With a little forethought regarding angle and composition, they can become interesting additions to the paper.

The photo editor for a publication or a web site has two major jobs in handling pictures: selection and cropping, which are discussed more fully in the next two sections. A third job is placement, which will be discussed in the chapter on design (Chapter 9).

Selection

What makes a good photograph? Why is a particular photograph selected for publication and another is not selected? What are the technical and aesthetic qualities that editors look for in selecting photographs for a newspaper? There are many answers to such questions. Many divergent factors go into an editor's decision to use a photograph, and there are no definitive guidelines governing their selection. The three major purposes of publishing photographs are to capture the reader's attention, to illustrate and supplement the editorial content, and to make pages look more presentable.

In the process of selection an editor will be concerned with all three of these purposes, but at the beginning of the process of selection the first purpose (capturing the reader's attention) will most likely be the major consideration. What kinds of photos do people look at? The following are some photographic elements that editors consider in the selection process:

- *Drama.* The pictures that tell a story are the ones most likely to be chosen by an editor for publication. Pictures that have high dramatic quality are those in which readers can clearly tell what is happening; in fact, several things might be happening, as in an accident scene with someone standing nearby wearing an anguished expression.
- *Emotion.* Like dramatic pictures, those with emotional qualities often tell a story. Yet they may also be the type that do not contain highly dramatic or storytelling qualities but rather evoke some emotion in the viewer. An old journalistic proverb says that readers will always look at pictures of children and animals. These are the kinds of pictures that make the readers feel something.

Figure 7.1

Life's Dramas

Photographs grab our attention as few other items in a publication or web site will do. They stop the common moments of life and occasionally show us how interesting they can be. Good photojournalists have a knack for being there at just the right moment. Actually, "being there" often takes a great deal of experience and planning.

Photos: Amy Kilpatrick.

Figure 7.2

Expressions

People's faces still make compelling photojournalism. Good photographers know how to get close enough to take a good picture of faces, and they learn to time their shots in a way that allows us to see how the subjects of the photo are feeling.

Photos: Amy Kilpatrick.

- *Action.* Editors and readers are most likely to be drawn to pictures that have some action or movement in them. Pictures that suggest movement will be seen and studied by readers more readily than will still-life pictures. Even though a photograph by itself cannot move, if its content indicates movement, the picture can serve as an extremely good attention-capturing device for the editor to use.
- *Artistic or technical quality.* Here we are talking about the good photograph, the one that has sharp, clear focus and good framing or that presents a subject in an unusual or pleasing manner. This kind of picture often appears in newspapers, especially with the change of seasons.
- *Bizarre or unusual subjects.* A picture of something unusual, something that readers are not likely to see in their everyday lives, makes a good candidate for publication. Unusual subjects may stem from the day's news events, such as a fire or a wreck, or they may be simply something that a photographer has happened upon or heard about, such as a twelve-pound tomato or an old man's wizened face.
- *Prominence.* Like the news value of the same name, prominence is a quality that editors often consider in selecting pictures. Pictures of famous people are always likely candidates for publication, even when they do not contain any of the qualities mentioned above. Readers will look at pictures of famous people; and editors will use such pictures for precisely that reason.

These elements are not a checklist of criteria for the selection of photographs; they are rather a list of things an editor may consider in deciding which pictures to publish. A good picture editor must have a feel for how to spot a good photograph, one that will capture the reader's attention, illustrate the editorial content, and enhance the overall quality of the publication.

Cropping

After the selection process has taken place, or along with it, comes the process of cropping. *Cropping* means taking out parts of a picture. It has two purposes: eliminating unnecessary parts of a picture and emphasizing or enhancing parts of a picture.

- *Eliminating unnecessary parts of a picture.* Some elements of a picture might simply be unnecessary to the subject and purpose of the photograph, and they should be eliminated. Often these parts are not only wasteful but also distracting. An editor must use the space in the paper efficiently, and proper cropping of a photograph is one way to do this. Good, tight cropping of pictures is just as important as editing to eliminate unnecessary parts of a story.
- *Emphasizing or enhancing parts of a picture.* One photograph may contain many pictures within it. A good picture editor must have an eye for these pictures within pictures and must be able to see and choose the picture that best fits the intended purpose. Cropping is a way of bringing out the particular picture the editor wants to use, of emphasizing the part of the picture that readers should notice. A

Figure 7.3

Cropping

Cropping is a relatively simple operation. An editor examines a picture to see what should be cut out or what should be emphasized. If the cropping is done physically, marks are then made on each side of the picture. The part of the picture within these marks can then be measured and scaled. Electronically, the sides of the picture window can be moved until the cropping is completed.

picture that seems ordinary at first glance can be made dramatic by good cropping.

Pictures that are published in newspapers are generally rectangular, and cropping must be done with straight lines along the side. Occasionally, pictures

are not rectangular but follow the lines of the subject. These are called drop-outs or cut-outs and may be used for dramatic effect.

In cropping a picture, an editor must keep in mind the necessities of scaling and proportionality. Scaling is the process of changing the size of a picture area by enlarging or reducing it while keeping the proportions of the original. Once an editor has selected and cropped a photograph for use in a publication, chances are that the picture will not be the exact size needed. Enlargement or reduction will probably be necessary to make the picture fit into the space allotted for it. When that reduction or enlargement is made, the editor will have to be able to calculate the new or reproduction size of the photo.

The concept of proportionality must be understood by those who work with the scaling process. For our purposes proportionality means that the width and depth of a picture must stay in the same proportion to each other whether the picture is enlarged or reduced. Let's say that a cropped picture is 2 inches wide and 4 inches deep, that is, the depth is twice the width. Given these dimensions, it does not matter how much the picture is enlarged or reduced; the depth will always be twice the width. The proportion must remain the same. The only way it can be changed is to recrop the picture.

Two of the most common ways to scale a print are through the use of arithmetic and through the use of a mechanical device, such as a picture wheel or slide rule. The arithmetic method involves some simple multiplication and division, with substitution of the dimensions being used into the following formula:

$$\frac{\text{Original width}}{\text{Reproduction width}} = \frac{\text{Original depth}}{\text{Reproduction depth}}$$

Let's say an editor has a cropped picture that is 4 inches wide by 6 inches deep and wants that photo to run as a three-column picture, which means that it should be about 6 inches wide. The editor will then have to find out how deep it will be by using the formula above. By substituting these dimensions into the formula, the editor will come up with the following:

$$\frac{4}{6} = \frac{6}{X}$$

The editor will then have to solve for the missing value by multiplying diagonally: $6 \times 6 = 36$ and $4 \times X = 4X$, then $4X = 36$. X would then equal 9. The reproduction depth of the picture is 9 inches.

The problem with the method of scaling is that it is frequently necessary to work with odd dimensions, such as 6 5/16 inches or 7 3/4 inches. Cross-multiplying these dimensions requires elaborate multiplication and allows more chance of error. One way of getting around this problem is to measure the picture in picas rather than in inches. By doing this, an editor is more likely to have whole numbers to work with than fractions.

An editor might not have to worry about the exact dimensions of a photograph if he or she is working with a page layout program such as Quark. With these programs, the editor simply has to draw a picture block on the electronic page and call the picture into that block. The picture can then be resized by using the tools available with the page layout program. (In Quark that involves changing the X and Y percentages.)

No matter what the medium, the circumstances, or the tools, the concept of proportionality must rule whenever an editor changes the size of a picture.

That is, the width of the picture must change in relation to the depth and vice versa. An editor working in Quark, for instance, must change both the *X* and *Y* percentages to the same number. A picture whose width (*X*) must be changed from 100 to 80 percent should also have its depth (*X*) changed from 100 to 80 percent.

A picture that is not changed proportionally will be distorted and will reflect badly on a news organization. Modern photography simulates the eye in the way images are recorded. We expect photographs to look like what we would see if viewing the image ourselves. Changing a picture nonproportionally is an indication that an editor does not understand this simple concept, and a distorted picture is likely to be easily detected by the reader. If there is one rule that a photo editor should follow without exception, it is this:

Pictures should always be changed proportionally.

Figure 7.4

Distorting a Picture

When the size of a picture is changed, it must be changed proportionally. That is, the new depth of a picture should be the same proportion to the original depth that the new width is to the original width. In a page layout program such as Quark Xpress the *X* and *Y* percentages should be the same. Nonproportional changes result in distortion of a picture, such as the picture on the right in this figure, something that no good journalist would allow. Distorted pictures are easy to spot and diminish the credibility of the news organization.

Digital Photography

Print publications underwent a revolutionary, two-stage change beginning in the 1960s, when writing and editing started to move from a manual to an electronic operation. Reporters scanned and later "entered" their stories onto computers rather than typing them on typewriters. Copy editors retired their copy pencils and pastepots and "called up" on their computer screens the stories the reporters had entered in order to correct them.

By the early 1980s that change had settled in, and the revolution migrated to its second stage: transforming the production operation of the publication. Computers were built (the Macintosh being foremost among them) that could show a page on a computer screen and could allow the operator to manipulate the objects (text, lines, and pictures) on the page without ever having them in a tangible paper form.

The process of journalism changed enormously because of this new technology. Editors took over the functions that had been reserved for the composing or paste-up room of the publication, giving editors more control over the publication but placing on them a much heavier production burden than they had ever known.

Through these three decades, photojournalism changed relatively little. Cameras became more sophisticated and easier to operate, film became more sensitive, and development because faster, but the essential processes of photojournalism stayed the same. What photographers had been doing for more than 150 years, they continued to do: exposing light to film and then developing film and making prints with chemicals and special paper. Many people predicted that photography would always be that.

But the electronic revolution was not finished. By the 1990s the adjective "digital" was appearing in front of "camera," and scanning, converting a print to a digital file, was becoming a common practice. Digital cameras did not need the space or the chemicals that film cameras required, and scanning negatives (if a photographer insisted on using a film camera or the publication could not afford to convert) eliminated expensive photographic paper. Many photographers resisted these changes. Some argued, with good reason, that digital cameras could not deliver the quality of photograph that film cameras could. Others simply did not want to change they way they and their professional ancestors had operated.

Neither of those attitudes could stand up to publishers and editors who viewed the digital revolution in photography as a chance to save large amounts of money and time. "Change," they said. "Quality will follow, and process is just process."

Now, in the early twenty-first century, the revolution is almost complete. Even though great technical improvements have been made in digital cameras, many photographers are dissatisfied with the quality of the pictures they produce. A few even miss the hours in the darkroom with their hands in developing chemicals, believing that they have lost a valuable part of the process of photography. But a new generation of photojournalists, who have never touched a film roller or turned on a safe light, is coming of age, and they are completely comfortable with digital photography.

The digital revolution not only changed the economics of photojournalism, essentially making it less expensive, but changed the process as well. Photo-

journalists always need to adjust to their equipment, and digital cameras have presented them with a set of options. What kind of storage media (in place of film) does the camera use? How are pictures to be uploaded and transmitted? What size settings does the camera have, and what is appropriate for a particular shooting assignment?

The major change that the digital revolution has brought in the process of photojournalism involves speed. With digital cameras pictures are produced instantly, and the only delay is getting them from the camera to a computer. What this has meant is that photographers can take more pictures and stay on the scene longer. They can transmit photographs from the scene of the action. They can even edit what they shoot at the scene before transmitting the photos. Consequently, a working photojournalist may be called upon to do many more tasks than were once expected.

Another major change has come with editing photographs. The dodging and burning techniques that went into developing a print in the darkroom are now about as useful as the nineteenth century skills of chiseling line drawings into wood blocks. Enhancing a photo now means calling a file up with Adobe Photoshop, the premier software program for this purpose, and performing an almost automatic set of tasks such as lightening, sharpening, and adjusting the color.

Photoshop allows the editor to go beyond working with the internal content of the photo. An editor can combine two or more photos into a collage or lay type over a photo or cast a shadow under it. Operations that once took years of practice and hours of work can now be completed in just a few seconds.

Not only has the digital revolution changed photo editing, but it has also changed photo editors. In the film and chemical days photographers kept control of the process because they were the ones who had learned the darkroom techniques. Few nonphotographer editors or reporters could go into a darkroom and operate with any skill or efficiency. In this digital age, picture taking and photo editing have become two separate skills that are not necessarily connected. People who have never picked up a camera professionally can learn Photoshop and become highly skilled editors.

Not only has photo editing slipped away from the exclusive grip of the photojournalist, but photography itself has become more egalitarian. As digital cameras become lighter and easier to operate, more reporters are taking cameras on their assignments. Freed from many of the technical considerations of camera operation, they are learning about lighting, value, focus, composition, and the decisive moment. They, too, are having to gather the information necessary to write appropriate cutlines.

The digital revolution has made photojournalism more economical and more democratic. It has sparked a miniconvergence in the newsroom; while photojournalism remains very different from the journalism of the written word, journalists themselves are finding it easier to practice both forms.

Pictures on the Web

News web sites offer opportunities that photojournalism has not known since the golden age of picture magazines in the 1940s and 1950s. During that period, *Life, Look,* and many other publications encouraged photojournalists with adventurous assignments, liberal expense accounts, and plenty of space to

display their work. That era faded in the 1960s, and by the mid-1970s most of the big picture magazines were no longer being published. Photojournalists found themselves confined to the shrinking space of newspapers and the smaller formats of news magazines.

The Web contains an infinite capacity for presenting pictures (and just about anything else), and the editor of a news web site no longer faces the untenable choice of having to select the very best photo from among several that are outstanding. A photographer who comes back from an assignment with a dozen good photographs can have a dozen photographs posted.

The opportunities that the Web offers to photojournalism, however, have yet to be fully realized. The Web has problems as a medium that journalists have not been able to solve. The most obvious one is size. News web sites are confined to the size of a computer screen. Photos, of course, must be displayed in a smaller size than that, and photos are often simply too small to be viewed well. Web site designers and editors have generally not been sympathetic to the arguments that pictures need more space.

Another problem is that content management systems—the software that powers many professional web sites—set up highly formatted web pages. These formatted pages, in turn, demand that pictures be a single size, and it is difficult for the managers of these systems to deviate from the format. Consequently, pictures on web sites often appear to be crammed into spaces that are not suitable for them.

Editors of news web sites face an additional question about how pictures should be displayed. Should they be presented with articles, or should they be placed in photo galleries that require readers to view them separately (and to

Figure 7.5

Web Photo Galleries

Photography on the Web is restricted by the size of the computer screen that the user has. Consequently, news web sites must show pictures at smaller sizes than they would in print, and photo editors must adjust accordingly. The advantage of the Web, of course, is that it can handle far more pictures than print can. The concept of photo galleries has thus been developed. News web sites such as those of the Washington *Post* (www. washingtonpost.com), the New York *Times* (www.nytimes.com), and MSNBC (www. msnbc.com) have pioneered the use of photo galleries for handling many pictures.

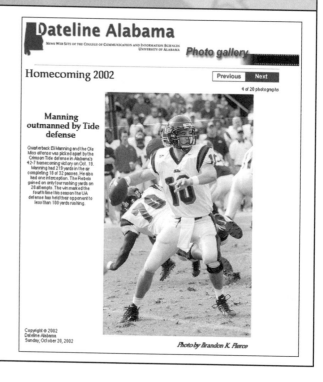

make an extra click to get there)? Many news web sites have chosen the photo gallery as the format that can best display a series of pictures. Designing these galleries so that they can display pictures in a variety of shapes and sizes and so that they can also display cutline text and navigation tools is not an easy task. No standard design has yet evolved for a photo gallery, but it is possible that a standard design will emerge as the Web continues to develop.

The photo gallery presents another problem for the photo editor of a news web site: sequencing. In what order should a series of pictures be presented? With some set of pictures, order might not matter. With others, however, the sequence in which a viewer sees the photos can be highly important to the viewer's understanding of the story that the pictures are meant to tell. This is particularly important when the chronology of a story will add to its meaning. An editor should give sequencing a good deal of thought in setting up photo galleries.

Finally, photo galleries on the Web have spawned a format that has never before been available to photojournalists: the audio photo gallery. This is a gallery that plays an audio description of the picture as it is being displayed. These descriptions are usually recorded by the photographer, and they are meant to add some color and information to the photograph. The New York *Times* has pioneered the use of the audio photo gallery on its news web site. These galleries are not easy to produce, of course, but they give photojournalists a powerful new tool to use in telling their stories.

Ethics and Taste

Consider the following situations:

- A local man who is nationally prominent dies. Many people from all parts of the country attend his funeral. The family has opened the funeral to the public but has said that no cameras should be used in the church or at the grave site. Thousands of people attend the funeral and burial. Your photographer comes back to the office with some dramatic photographs of the family leaving the grave site along with some highly prominent people.
- The president dozes off while listening to a visiting head of state speak to the White House press corps. The wire services send several photos of the president with his head down and eyes closed sitting behind the speaker.
- A movie star is decapitated in a car crash. The wire services send several pictures of the accident scene, including one of the actress' head placed on the car.
- Pictures of people jumping from the World Trade Center towers on September 11, 2001, show up on an editor's desk on the afternoon of the tragedy. The people cannot be identified; they are little more than dark dots on the photograph. Yet they depict real people jumping to certain death. The editor has to decide whether they should be printed in the publication or posted on the web site.

Pictures present editors with special problems of taste and ethics. These problems do not occur every day, fortunately, but they happen often enough

Figure 7.6

Controversial Photos

Because of their emotional impact, pictures can often be highly controversial. Whenever the nation goes to war, as it did in Iraq in 2003, questions arise about photographs of dead soldiers. It has been so since the beginning of photography. This 1865 photograph of a dead Confederate soldier after the battle of Petersburg (near Fort Mahone, nicknamed by the soldiers "Fort Damnation") is typical of many photographs taken by Civil War photographers. Few were published widely, however, because of their starkness and shock value.

Photo: Library of Congress.

that every editor eventually must make some decision for which he or she will be criticized. Some newspapers have tried to produce guidelines for handling certain kinds of pictures, but these guidelines do not cover all situations and sometimes do not provide the editor with sufficient guidance in making a decision. The following is not a set of guidelines but a list of things an editor should consider in deciding whether to run a photograph. None of these considerations is primary in every case; they should all be part of an editor's decision-making process.

- Editors should remember that their business is to cover the news and inform their readers. A newspaper is supposed to give a full and accurate account of the day's news. Sometimes it takes a photograph to accomplish this mission. Generally, editors should avoid making agreements before covering an event that would restrict its photo coverage.
- Editors should be sensitive to their readers. There are subjects that will offend readers or that parents will want to keep from their children. An editor should be aware of these subjects and the sensibilities of the readers. The editor should try to avoid publishing pictures that are unnecessarily offensive.
- Editors should be aware of the feelings of the people in the pictures. Even people who are photographed a great deal and who are highly visible have feelings that need consideration. Pictures can put people

in a bad light or in embarrassing situations even when editors print those pictures with the most innocent of motives. One example may serve to illustrate this point. A newspaper in a medium-sized town decided to publish a special section on home furnishings. In putting this section together, the editors looked in their files and found a picture of one of the town's prominent women in her living room. The picture was about a year old but fit perfectly with the theme of the section. The editors were all set to run the photo until they learned that in the year since the picture had been taken, she had lost nearly 100 pounds. The editors decided not to run the picture.

- Editors must remember that some photographs can get them into legal trouble. Even though a picture is taken in public and is coverage of a newsworthy event, it can constitute libel or an invasion of privacy. When there is any question about a photograph, editors should be extremely careful. The wrong decision in this regard could cost them and their newspaper thousands of dollars.

Decisions about pictures are often among the most difficult decisions an editor must make. Pictures are dramatic and powerful. They have an impact on readers, on their subjects, and on the newspaper itself. The watchwords for an editor in handling pictures are caution and sensitivity.

Cutlines

Cutlines are explanatory and descriptive copy that accompanies pictures. They range widely in style and length, from the one-line identifier called the "skel line" to the full "story" line. Cutlines are necessary to practically all pictures because of the functions they serve: identification, description, explanation, and elaboration.

A well-written cutline answers all of a reader's questions about a picture. What is this picture about? What is its relationship to the story it accompanies? Who are the people in it? Where are the events taking place and when? What does the picture mean? The cutline should answer these and other questions in such a manner that material found in any accompanying story is not repeated verbatim but is reinforced, amplified, or highlighted.

Every newspaper has its own particular standards for cutline writing and display. For example, a newspaper may use one typeface for "story cutlines" (cutlines for pictures without accompanying stories) and another for cutlines on pictures that are accompanied by a story. What is important is that each publication be consistent in its use of cutlines. An established style should exist for each particular type of cutline so that the reader will know what to expect from the publication and so that cutline writers experience a minimum of difficulty in deciding how to present information.

Cutlines are one of the most neglected parts of the newspaper. They are often written as an afterthought when all other parts of a story are finished. Sometimes reporters are assigned to write cutlines; other times it is the job of copy editors; and sometimes the photographers themselves have to write the cutlines. Whoever does the writing should remember that cutlines are as important as any other part of the paper and should be treated with care. The following are some general guidelines for writing cutlines.

Figure 7.7

Cutline Styles

No single style, guideline, or rule governs how a cutline—the lines beneath a picture—will look. Most publications have developed their own styles for cutlines, depending on the size and nature of the photograph and where it is placed on the page.

A tornado tore through the home of Hattie Lynn of North Brookwood yesterday. No one was hurt, but her mobile home was destroyed. Kristi Parker, a neighbor (right), comforts her as she returns to the wreckage.

SMITH ...
... symphony conductor

Striking workers join picket lines at ACE Corp.

John Smith
Symphony conductor

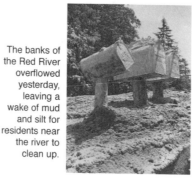

The banks of the Red River overflowed yesterday, leaving a wake of mud and silt for residents near the river to clean up.

Dramatic rescue

Workers and rescue personnel move fast to save Darnell Quick from death and serious injury yesterday. Quick was nearly buried alive when a trench in which he was working caved in. Quick was working at a new home construction site in Coventry.

Photos: Amy Kilpatrick.

- Use the present tense to describe what is in the picture.
- Always double-check identifications in a cutline. This rule cannot be stressed too much. Many newspapers have gotten themselves into deep trouble through misidentification of people in a cutline, so cutline writers should take great care.
- Be as specific as possible in cutlines. Add to the reader's knowledge, and go beyond what the reader can see in the picture. A cutline is useless if it simply tells the reader what can be seen already.
- Try to avoid cutline clichés. "Looking on," "is pictured," and other such expressions are trite and usually avoidable.

Because cutlines differ from other kinds of information the newspaper has to present, they should be displayed differently. The following are some commonly used guidelines that many newspapers use in displaying cutlines.

Cutlines should contrast with the publication's body type to make for easier reading. Using boldface or type that is one point size larger than body type can accomplish this.

Cutlines should be set at different widths than most body type. For instance, if a picture is three or four columns wide, a cutline should be set in two stacks of type under the picture. Cutlines should also take up all or most of the allotted space.

Catchlines (headlines above the cutlines) look best in 18- or 24-point type and are generally centered above the cutline.

Two general principles should govern an editor's use of cutlines. One is that every picture should have some kind of a cutline. The words that are used in the cutline may be few, but they can add enormously to the reader's understanding of the picture and the story the editor is trying to tell. The second principle is that everyone in a picture should be identified. Nameless people are not very interesting, and their presence indicates a lack of interest on the part of the editor in doing a thorough job.

Cutlines are important because of the information they contain and because of the way in which they enhance the appearance of the paper. Cutlines should be simply and clearly written and displayed, and they should be given the same attention by the editors that other parts of the paper receive.

Exercise 7.1: Cropping and Sizing Pictures

Crop the accompanying picture. You will need to decide (or your instructor may tell you) what the reproduction width of the picture should be. (You may also be using this picture in a layout exercise in Chapter 9.) Calculate the dimensions and the percentage of reproduction for the picture. Write a cutline for the picture based on the following information.

Cutline Information

Small group of dissident union workers; about 15; they defied union leaders yesterday; picketed Aces Mining Company in south Ticonderoga County; union leaders say these are not authorized picketers.

Original width _____
Original depth _____
Reproduction width _____
Reproduction depth _____
Percentage of reproduction _____

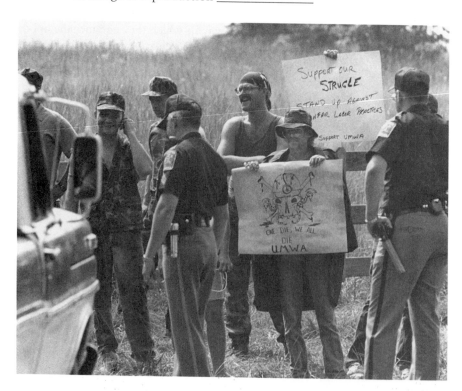

Exercise 7.2: Cropping and Sizing Pictures

Crop the accompanying picture. You will need to decide (or your instructor may tell you) what the reproduction width of the picture should be. (You may also be using this picture in a layout exercise in Chapter 9.) Calculate the dimensions and the percentage of reproduction for the picture. Write a cutline for the picture based on the following information.

Cutline Information

Lincoln Park Road overpass over I-75; driver, Joseph Coda, Cuba, Missouri; driver killed; police don't know why truck overturned; they're investigating; impact separated cab from the trailer; accident blocked traffic on interstate roadway going south for more than four hours; truck carried various automobile parts for nearby auto plant.

Original width _____
Original depth _____
Reproduction width _____
Reproduction depth _____
Percentage of reproduction _____

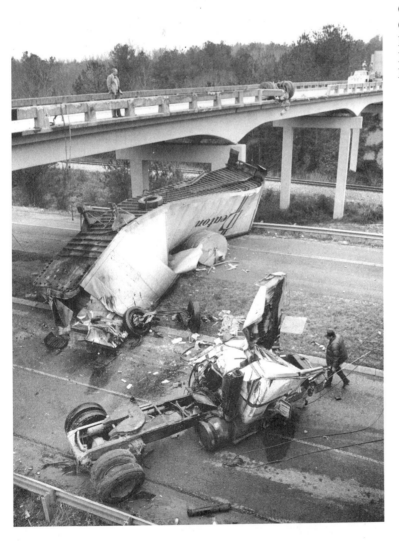

Exercise 7.3: Cropping and Sizing Pictures

Crop the accompanying picture. You will need to decide (or your instructor may tell you) what the reproduction width of the picture should be. (You may also be using this picture in a layout exercise in Chapter 9.) Calculate the dimensions and the percentage of reproduction for the picture. Write a cutline for the picture based on the following information.

Cutline Information

Tornado in western portion of county; struck yesterday about 5:40 P.M.; no warning from anybody; Carpenter Road subdivision; damaged at least ten mobile homes there; this one in the picture belongs to Velma Haskiel; completely destroyed it; that's Velma right there in the picture; she's going to have to live with her sister until she figures something out.

Original width _____
Original depth _____
Reproduction width _____
Reproduction depth _____
Percentage of reproduction _____

Exercise 7.4: Cropping and Sizing Pictures

Crop the accompanying picture. You will need to decide (or your instructor may tell you) what the reproduction width of the picture should be. (You may also be using this picture in a layout exercise in Chapter 9.) Calculate the dimensions and the percentage of reproduction for the picture. Write a cutline for the picture based on the following information.

Cutline Information

Molly the girafe; Flash the zebra; two of the favorites at the local zoo; they're getting new home; zoo has built a new facility for large mammals; the two and others got to move in yesterday; new facility costs $1.3 million, raised by private donations; Old Town Park zoo.

Original width _____
Original depth _____
Reproduction width _____
Reproduction depth _____
Percentage of reproduction _____

Exercise 7.5: Cropping and Sizing Pictures

Crop the accompanying picture. You will need to decide (or your instructor may tell you) what the reproduction width of the picture should be. (You may also be using this picture in a layout exercise in Chapter 9.) Calculate the dimensions and the percentage of reproduction for the picture. Write a cutline for the picture based on the following information.

Cutline Information

Two kids on bikes; one of them is in the picture; he's Marshall Grey; riding on Fifth Street about 8 o'clock last night with buddy, Sanders Ferry; car pulled in front of them; Marshall not hurt, but Sanders taken to the hospital with broken leg; guy driving the car was Abraham Remington; police charged him with drunk driving.

 Original width _____
 Original depth _____
 Reproduction width _____
 Reproduction depth _____
 Percentage of reproduction _____

Exercise 7.6: Cropping and Sizing Pictures

Crop the accompanying picture. You will need to decide (or your instructor may tell you) what the reproduction width of the picture should be. (You may also be using this picture in a layout exercise in Chapter 9.) Calculate the dimensions and the percentage of reproduction for the picture. Write a cutline for the picture based on the following information.

Cutline Information

Warm day in February yesterday; first time kids have been able to play outside in two months; temperature got up to 70, pretty unusual for this time of year; these kids go to school at Medford Middle School. Eighth-graders Mindy Webster and Brandi Aquinas; Brandi on the left.

Original width _____
Original depth _____
Reproduction width _____
Reproduction depth _____
Percentage of reproduction _____

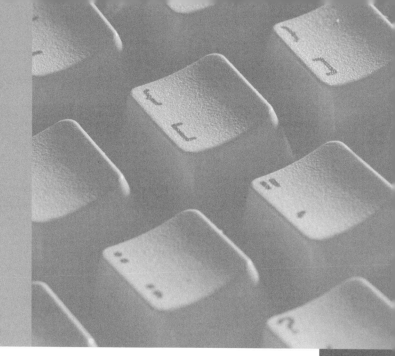

chapter

8

Infographics

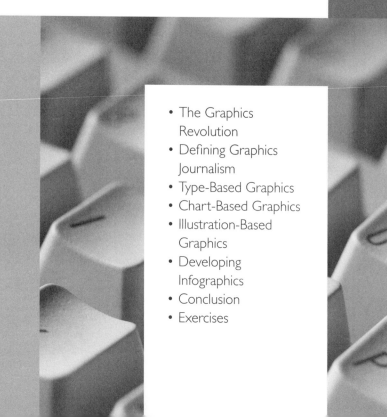

- The Graphics Revolution
- Defining Graphics Journalism
- Type-Based Graphics
- Chart-Based Graphics
- Illustration-Based Graphics
- Developing Infographics
- Conclusion
- Exercises

The world waited for five weeks in November and December 2000 to know the outcome of the presidential election in the United States. The election had been terribly close. The margin of victory in some states, such as New Mexico and Oregon, had been only a few hundred votes.

But the final decision on the election centered on Florida. Several counties in southern Florida had run into difficulties in counting their votes because of one thing: the design of the ballot.

Palm Beach County, along with a few others, used something called the "butterfly ballot." This was a ballot that listed the candidates for president in two columns. In between those columns was a set of black dots. A voter was to punch out one of those dots to indicate whom he or she wanted to be president. The ballot was designed to save space and to allow the names of the candidates to be set in a larger typeface.

The problem was that it didn't work. Although arrows pointed to the dots, it was not clear which dot was the correct one for a particular candidate. Once the ballots got into the hands of voters, a number of mistakes began to occur. Some people punched the wrong hole, thus casting a vote for someone they did not want to be president. Some people punched two holes, thinking that they had made a mistake on the first and then trying to correct it. Other tried to punch through one of the holes but made only an indention (thus giving rise to the term "pregnant chad"). Many of these ballots had to be discarded.

A month after the inauguration of George W. Bush as president in 2001, reporters and editors of the Palm Beach *Post* examined the ballots that the county had discarded and found that Bush's opponent, Al Gore, had lost about 6,600 votes. Bush, too, lost votes, but only about 1,600. Bush won the state of Florida by fewer than 1,000 votes, which gave him the margin he needed to be elected president. Had all the votes from Palm Beach County been counted, Albert Gore would be president.

Rarely does a graphic design have such serious consequences. But the lesson here is obvious: Design does matter. Clarity matters. That is the lesson that journalists should start with when they are learning about informational graphics.

The Graphics Revolution

Journalism that goes beyond the text paragraph to present information to the reader is growing in frequency and importance. We live in a visual world where the pictures and images that we see can have as much impact on us as the words we read. The good journalist—and particularly the good editor—knows when and how to use the graphics forms that can present information effectively to an audience.

The graphics revolution in newspapers and magazines began in the 1980s and gained momentum in the 1990s. Newspapers, magazines, and other publications literally changed their faces in front of their readers. Color, charts, illustrations, maps, and other graphic forms became part of the norm for the reader of news. The revolution continued in the late 1990s with the advent of the World Wide Web and the possibilities—still largely unrealized—that this medium offered to present news and information to the audience.

Figure 8.1

Butterfly ballot

The infamous butterfly ballot used in Palm Beach County, Florida, during the 2000 presidential election was meant to simplify the selection process for voters. Instead, it confused them, and most experts agree that it cost Democratic presidential candidate Al Gore many votes in that county—enough votes for him to lose the state of Florida and the election as a whole.

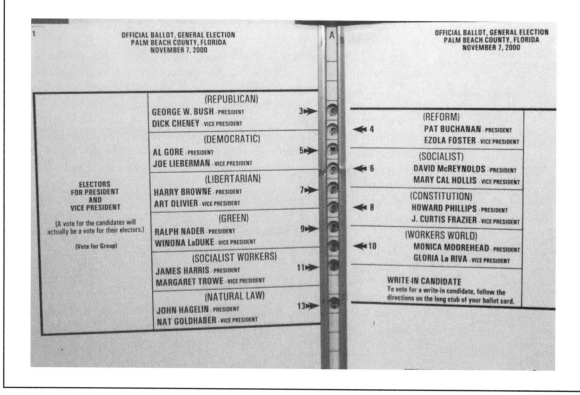

What happened to spark that revolution?

Graphics journalism, of course, did not begin in the 1980s. It has a long history in which it has taken many forms. Maps, political cartoons, graphs, and drawings are just a few of the devices that journalists have used to tell readers what they know. But in the 1980s a number of factors worked in concert to help journalists see how graphics could be used in a journalistic setting and that the textual paragraph was not the only—or sometimes the best—way to present information. Some of those factors are as follows.

USA Today. When *USA Today*, the national newspaper published by Gannett, began publication in 1982, it splashed onto the field of journalism, spilling color and graphics everywhere. The newspaper demonstrated the extent to which the graphic form could be used to present information. *USA Today*'s use of informational graphics was extensive and often controversial, but its influence on other newspapers was undeniable. Many newspapers copied its

colorful weather map, and the presence of charts, graphs, and maps increased in many newspapers and magazines.

Reader expectations. During the 1980s a feeling developed among many journalists that readers—particularly those who grew up with television—expected publications to be more visual and for information to be presented in smaller, more digestible bites. This feeling was reinforced by some readership research and by the fact that newspapers seemed to be losing the loyalty of young readers.

Computer technology. The 1980s were also the decade of the computer revolution. The development of technology that eventually would put the equivalent of mainframe computers onto people's desks and into their laps profoundly affected the way in which newspapers and other publications were produced. Many of the tasks that had been laboriously done by hand could now be done more precisely on the keyboard. Not the least of these was the building of a chart. What had previously taken the skills of a surgeon could now be handled by anyone who knew the right buttons to push. The leader in the development of this technology was Apple Computer, Inc., which produced the Macintosh computer. The basis of the Macintosh was a "graphic interface," and the very name signaled a move away from words and toward pictures and graphics.

Graphic sophistication. Mixed in with these other factors was a reconsideration on the part of many journalists about the types of information they were presenting to their audiences and the means they were using. This reconsideration led to the realization that some information could be better presented through the use of charts or illustrations. For instance, how an earthquake occurs is not easy to describe with words and is impossible to photograph. (Its effects can be photographed, but not its process through the earth.) The best way to present this information is through a drawing, a technique that many newspapers used to "describe" the 1989 earthquake in California. In the same manner, much information that is based on numbers is better presented in a chart than in a paragraph.

While acknowledging this reconsideration on the part of journalists, we should recognize that some journalists still resist any move away from the paragraph. Although the importance of graphics has been impressed on many professionals, some journalists still maintain that they grew into their profession as "word people." Many of them like to write and use the language and believe that the emphasis on graphic presentation is nothing more than a passing fad. Despite this resistance, it is likely that graphic presentation of news and information will continue to be a major form used by many publications. Editors of today and tomorrow will need to know how this form should be used appropriately, and they should understand when and why graphics are the best form for presenting information.

Defining Graphics Journalism

Most people think that informational graphics are charts and graphs. For our purposes we should expand our definition to say that an informational graphic is anything that is not clearly a headline, body copy, a picture, or a cutline. That

is, informational graphics make use of type in special ways as well as using graphs or chart forms.

The two major content principles of informational graphics are accuracy and clarity. Above everything else—and like everything else in a publication—an informational graphic should present information accurately. This is important to remember because graphics are easy to distort. Graphics often present relationships, and the basis of those relationships should be clear to the reader.

Clarity is the second major principle. Clarity begins in the mind of the editor. He or she should have a clear idea of what information is being presented and of how it can best be presented. Although a single graph may show different things, it should be governed by a central idea, much as a good story should have a central theme or idea behind it.

Three general types of informational graphics are used in newspapers: type-based graphics, chart-based graphics, and illustration-based graphics. Each may use elements of the others, but this classification is a good way to begin to understand what they are.

Type-Based Graphics

Type-based graphics are those in which text, or type, is the major graphic element. Sometimes it is the only graphic element. These graphics use type to draw attention to themselves in addition to providing informational content. The following are some common types of text-based graphics.

Lists. Some of the best graphics are nothing more than lists, and lists are readable and popular with readers. They are clean and easy to produce, and they give readers interesting information quickly. A list might be a simple listing of items, such as a movie reviewer's five favorite movies of the year, or it may contain some additional information about the items.

Tables. A table is a list with additional information attached to each item on the list. A table is set up with columns (information that runs vertically) and rows (information that runs horizontally). A table usually presents textual and numeric information, and its main purpose is the comparison of information in the table. Tables are also designed so that some set of information is presented in a logical order. A table should contain enough headings and explanation to make it easily understandable for the reader.

Refers. The word "refer" (pronounced "REE-fer") is short for "reference" in newspaper jargon. It is a way of telling the reader that there is another story on the same subject elsewhere in the paper. It is also a good graphic device that breaks up body type. A refer may include only the page number, or it may have other information about the item.

Pull quotes. A pull quote is part of an article that is set off in larger type. It generally serves two purposes: It is a good way of breaking up large amounts of body copy type, and it gives the reader some interesting point or flavor of a story.

Figure 8.2

Type-based graphics

Type-based graphics are those that use type as a graphic device as well as for the purpose of relating specific information. This figure shows four of the most commonly used type-based graphics.

List

Estimated Deaths by Cancer	
Oral	8,350
Colon-Rectum	53,300
Lung	142,000
Skin	8,800
Breast	44,300
Uterus	6,000

Refer

und, returned to mother in Al

rangers. Like ᵴ, do not talk Ms. Tarlton,

ying praying ᴉe Lord that ᴉome to us," ⵜ least they're ᴈ a second take care of ᶃ, and I want

Search ends with sighs of relief, prayers of thanksgiving
Page 3

to try to make a good life for him."
FBI agent Kathy Canning,

who accompani· the commercia Friday, said offic the ordeal woulc baby.
"But ever sii he's been fine ᴈ said. "I think he
Meanwhile, Money, 26, of (and Terry Micℎ

Pull quote

und, returned to mother in Al

rangers. Like ᵴ, do not talk Ms. Tarlton,

ying praying ᴉe Lord that ᴉome to us," ⵜ least they're ᴈ a second take care of ᶃ, and I want

"I've been praying praying and believing in the Lord."
Julia Tarlton

to try to make a good life for him."

FBI agent ℩ who accompani· the commercia Friday, said offic the ordeal woulc baby.
"But ever sii he's been fine ᴈ said. "I think he
Meanwhile, Money, 26, of (

Summary box

und, returned to mother in Al

rangers. Like ᵴ, do not talk Ms. Tarlton,

ying praying ᴉe Lord that ᴉome to us," least they're ᴈ a second take care of

A search for a child that lasted nearly two weeks has ended happily.

to try to make a good life for

FBI agent ℩ who accompani· the commercia Friday, said offic the ordeal woulc baby.
"But ever sii he's been fine ᴈ said. "I think he
Meanwhile,

Summaries. One of the best graphic devices for getting information quickly to the reader is the summary box. A summary box can be used for almost any story. It is best used when a story has several parts or important points. For instance, a city council might take a number of actions in one meeting. A summary box can list these actions so that the reader can quickly know what they are.

Chronologies. Events rarely occur without some significant historical context. That context may be very recent, but it also may be important in explaining to the reader what has happened and why. Chronologies take a good deal of time and care to produce, but they can help to heighten reader interest in a story.

Organizational charts. These charts (also called tree charts) demonstrate relationships within an organization. The most common are those that show the

Figure 8.3

Use of type as a graphic device

The designer of this page uses very little material (just two pictures) other than type to make a visually interesting presentation for the readers. The type is used in a variety of ways, all of which can be set up simply and easily in a good page layout program such as Quark or InDesign.

A-3 THE INGLEWOOD CITIZEN, AUGUST 10, 1994

WATERGATE

Sayings produced by political scandal still populate the language

James McCord, one of the Watergate burglars testifies at the Senate Watergate hearings.

AFTER burying him with praise just a few months ago, Americans this week remember Richard Nixon s shame — Watergate, the "third-rate burglary" that ended what could have been a first-rate presidency.

As the 20th anniversary of his resignation from the presidency over the Watergate scandal looms, it s time to kick Nixon around one more time for the damage he did to the respect Americans traditionally held for the presidency.

At his funeral in April, attended by every living ex-president, it was a time to remember his opening to China, his flawed peace in Vietnam, his bold try at detente with Russia and his efforts to limit the nuclear arms race.

Now with the anniversary of his resignation on August 9, 1974, it is time to recall a meanness of spirit and a capacity for cover-up that combined to make him the only man to quit the presidency in disgrace.

"What did he know and when did he know it?" was the question asked of the president who had his own dirty tricks squad, his own enemies list, his own bugging equipment, and his own set of grudges and grievances that spread over decades.

That question so infected American public life that it became a litmus test of subsequent presidencies. The acid drip of Watergate made a large hole in the fabric of American confidence in the integrity of elected officials.

It became almost routine for people to wonder about the dirty tricks of the men that followed Nixon into the Oval office.

Did Gerald Ford cut a secret deal with Nixon in return for a pardon? Did Ronald Reagan secretly authorise the sale of arms to Iran to fund Nicaraguan contra rebels? Did George Bush know of the effort by his political appointees to get Bill Clinton s passport records?

Did Clinton play fast and loose with the financing of the Whitewater property development?

The Random House Historical Dictionary of American slang notes that Watergate has given birth to a seemingly never-ending series of scandals called "gates" - - Koreagate, Billygate, and Whitewatergate, to name a few.

Unlike its puny competitors, however, Watergate has lasted in the public memory. The other "gates" slammed shut fast.

The reason may be that there was more to Watergate than just an attempted break -in at Democratic Party National headquarters by a bunch of misguided ideologues funded by a lavish campaign treasury.

The break-in was part of a whole series of illegal actions taken by a president almost paranoid that the world was conspiring against him.

Shortly after taking office, Nixon secretly bugged the telephones of his top foreign policy aides to determine if they were leaking his administration s secrets.

Then with the leaking of the Pentagon Papers, Nixon launched a vendetta against its leaker, Daniel Ellsberg. The "White

House Plumbers Unit" broke into the office of Ellsberg s psychiatrist to steal his notes on what was wrong with Ellsberg.

UNLIKE ITS PUNY COMPETITORS, HOWEVER, WATERGATE HAS LASTED IN THE PUBLIC MEMORY. THE OTHER "GATES" SLAMMED SHUT FAST.

Enemies lists, buggings, illegal break-ins, weird plans to kidnap opponents and firebomb buildings, became the stuff of government.

Watergate stained the Constitution of the United States and left American democracy weaker. It also cut short a presidency of real accomplishment.

Although Nixon never admitted his guilt, on the day he flew out of the White House to his long, lonely exile, he declared: "Never be petty. Always remember others may hate you, but those who hate you don t win unless you hate them, and then you destroy yourself."

As The Times reporter Fred Emery noted in his recent book Watergate, that comment became both Nixon s epitaph and the advice he should have taken before he dispatched his first plumber to fix the first leak of his first administration.

 What did the president know and when did he know it?
Senator Howard Baker asked this question during the Senate Watergate hearings.

 . . . a third-rate burglary.
Ron Zeigler, Richard Nixon's press secretary, describing the Watergate break-in a few days after it happened.

Sen. Sam Ervin (D-N.C.) chaired the Senate Watergate hearings and quickly became a TV star because of it.

. . . at this point in time.
A favorite redundancy of many of those involved in Watergate. It later became the title of a book about Watergate by Fred Thompson, the minority council in the Senate Watergate hearings. In 1994 Thompson was elected to the U.S. Senate from Tennessee.

 Follow the money.
One of the chief sources for Robert Woodward and Carl Bernstein, the Washington Post reporters, who first investigated the Watergate break-in was known as Deep Throat because he wanted his identity kept secret. This was his advice to Woodward.

smoking gun
Many of the president's defenders often said that President Nixon wasn't responsible for the Watergate coverup because there was no "smoking gun," no piece of evidence that would specifically prove that Nixon participated in the coverup. The White House tapes eventually revealed that there was indeed a smoking gun.

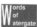 *I am not a crook.*
Richard Nixon at a press conference defending his actions in the Watergate caper.

Watergate
The word itself is possibly the scandal's most enduring legacy. The suffix -gate has been applied to almost every political scandal since 1974.

 Saturday night massacre
This was the name given to the firing of Archibal Cox, the Watergate special prosecutor, on a Saturday evening in October 1973. Nixon ordered the firing because Cox would not give up his fight for the White House tapes. Elliot Richardson, the attorney general, and William Ruckleshaus, his deputy, quit rather than give the order to fire Cox.

Photos: Library of Congress.

relative positions of jobs within a corporation. A standard way of presenting this kind of chart is to have the names of positions within boxes with lines connecting the boxes that represent reporting channels and responsibilities.

Another type of organizational chart is most often found on the sports page. This chart will show the match-up of teams or individuals that are playing in a tournament and how they will proceed to a championship. Still another type of organizational chart is the genealogical chart that traces a family's history through several generations (thus the term "family tree"). All of these charts make it easy for the reader to see some relationship of a part of the chart to a larger entity such as an organization or a family.

Chart-Based Graphics

Chart-based graphics are graphics that present numerical information in a non-text form. These forms are likely to be proportional representations of the numbers themselves. These are what many people refer to when they talk about informational graphics.

Chart-based graphics have become highly popular in today's newspapers. Computer software has made them relatively easy to produce (as we will see

Figure 8.4

Organizational charts

An organizational chart uses mostly type within a structure that has some meaning itself. The structure of the chart indicates the power, influence, and authority of the positions shown. The words name those positions. This organizational chart is a simple and quick way of showing how a typical news organization of a newspaper is structured.

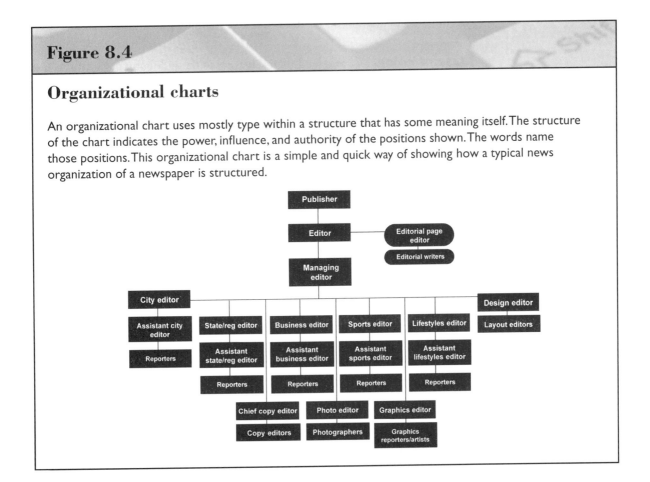

later in this chapter). Many journalists today spend a great deal of time gathering the information that can be presented in charts.

In addition to the principles of accuracy and clarity discussed above, informational graphics should share a number of other characteristics. Some of those characteristics are included here.

Simplicity. Graphics can be complex, but their appearance should be uncluttered. One of the criticisms of many graphics is that they are "chartoons"—that is, they have too many little figures and drawings that do not add to the reader's understanding of the information in the graphic. A graphic should contain the minimum number of items necessary for understanding the information and the maximum number of items for good appearance.

Consistency. Publications often develop a graphics style just as they adopt a writing style. This style includes rules about what kind of type is used, when color is appropriate, how information is attributed, and a variety of other matters. Like style rules for writing, these rules help both the staff in producing graphics and the reader in understanding them.

Attribution. Information in graphics should be attributed, just as information in news stories should be attributed. As with other information in a publication, sometimes the source is obvious and does not need to be specified. In other cases attribution is vital to the understanding of a graphic.

Use of color. Charts lend themselves to color, and many publications use charts to showcase their ability to handle color. Color helps to emphasize certain parts of the graphic; it also contributes to a pleasing appearance for the graphic. Color is easy to overuse, however, and editors should be careful that the use of color does not get in the way of the information in the chart.

Headlines. Oddly enough, one of the most difficult things about producing an informational graphic is writing its headline. Headlines for graphics do not have to follow the rules of headlines for articles; in most publications they can simply be labels. They need to identify the central idea of the graphic, however, and this is difficult to do in just a few words. One approach that many graphic journalists use to write a headline for a graphic is to write it before the graphic is built. Doing that gives them the central idea to keep in mind while producing the graphic.

Most mass media publications use three types of chart-based graphics: the bar chart, the line chart, and the pie chart. (There are other types of charts for presenting numerical information such as the scattergram, but these are not commonly found in the mass media.) Each type of chart is best used for presenting certain types of information and is inappropriate for other types of information. Editors need to understand what charts are appropriate for what types of information.

Bar charts. The bar chart is the most popular type of chart because it is easy to set up, and it can be used in many ways. The bar chart uses thick lines or rectangles to present its information. These rectangles represent the amounts or values in the data presented in the chart. (There are technically two types of bar

Figure 8.5

Parts of a chart

This figure shows the standard parts of a chart that represents numerical data in a bar or line form.

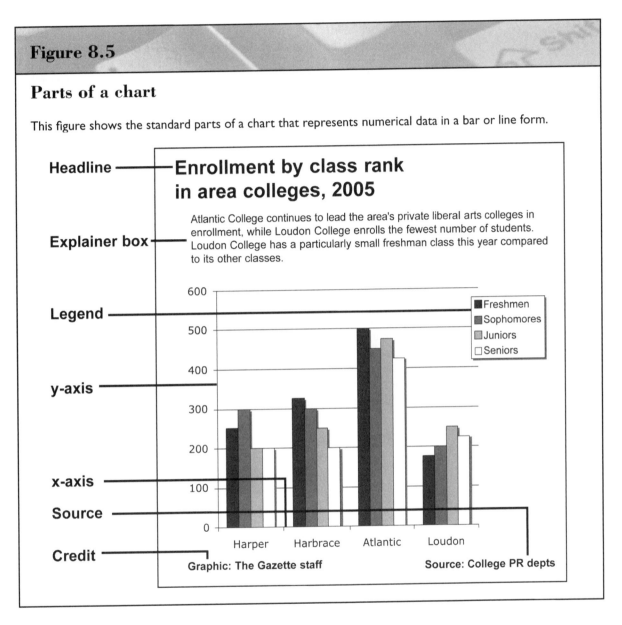

charts. One uses the name *bar chart* and refers to charts in which the bars run horizontally. The *column chart* is a bar chart in which the bars run vertically. Column charts are more commonly used when time is an element in the data. For the purposes of this text, however, we will not make a distinction between the bar and column chart.)

The two major lines in a bar chart are the horizontal axis, known as the *x*-axis, and the vertical axis, known as the *y*-axis. Both should have clearly defined starting points so that the information in the chart is not distorted, particularly the axis that represents the amounts in the graph.

One of the reasons a bar chart is so popular is that it can show both amounts and relationships. It can also show a change in amounts and relationships over time. The chart in Figure 8.5 demonstrates the bar chart's ability to show relationships, particularly when there is a large amount of data. From a brief look at this chart, the reader knows how these colleges compare to one another as well as something about each school. The reader can quickly see that

each college has a different number of students and that Atlantic College has more students than the other three. Loudon College has the smallest number of students. While Harper and Harbrace colleges have about the same number of students, Harper has more sophomores than freshmen, and Harbrace has more freshmen than sophomores. What would explain that?

The bar chart can also be used to demonstrate changes in relationships over time. Studying the chart in Figure 8.5 might suggest some possible reasons for the changes.

Line charts. Whereas the bar chart may show change over time, the line chart must show change over time. It can also show a change in relationships over time. In some instances the line chart is preferable to the bar chart because it is cleaner and easier to decipher.

The line chart uses a line or set of lines to represent amounts or values, and the x-axis represents time. One of the standard conventions of the line chart is that the x-axis represents the time element and the y-axis represents the amounts or quantities being represented.

Line charts can use more than one line to show not only how one item has changed but also the relationship of changes of several items. Data points can be represented by different shapes for each item. The danger with multiple line charts is that too many lines can be confusing to the reader. Graphic journalists should avoid putting more than three lines in a line chart. A variation on the line chart is the area chart. This type of chart is good for showing how the division of something changes over time.

Pie charts. The pie chart is another popular means of showing data, but its use is specialized. A pie chart should show how an entity or item is divided up, and the divisions are most commonly expressed in percentages that add up to 100 percent. Figures also may be used to identify the parts of a pie chart, but it is important that the creator of a pie chart keep the concept of percentages in mind.

Despite the strict limits on the kind of data that can be shown in a pie chart, this type of chart can be used in a variety of ways. A pie chart can show only one set of data at a time, but several charts can be used together to help compare sets of data, as in the set of pie charts on this page that depict the racial breakdown of populations in three major cities.

Some graphic journalists have found some unusual ways to use the pie chart form. Taking shapes that are not circles and dividing them up as pie charts is something readers will occasionally see. This technique can be artful and attention-getting, but care must be taken that the data are not distorted.

Illustration-Based Graphics

Newspaper illustration has a long and rich history dating back to the 1700s. Many nineteenth century American artists, such as Winslow Homer and Frederick Remington, began their careers in journalism. For much of the twentieth century, newspaper illustrators were relegated to the sports pages and to editorial cartooning, but in those places readers could find top-notch artists. With the

Figure 8.6

Types of charts

Journalists have three basic types of charts that they can use to present numerical data: the bar chart (top), line chart (middle), and pie chart (bottom). Each must be used appropriately, however. That is, the data that are presented must be complete and must be the type for which the chart is designed. Examine the data in each of these charts and decide for yourself whether the charts are appropriate.

**Top circulation newspapers
in the United States, 2003**

Nationally circulated *USA Today* continues to lead all of the nation's newspapers in daily circulation, as it has done for several years. The only other two dailies that circulate more than a million copies a day are the *New York Times* and the *Wall Street Journal*.

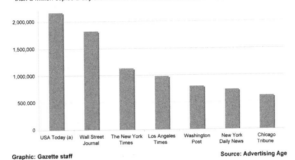

Graphic: Gazette staff Source: Advertising Age

**Amount (billions of dollars)
of Pell Grants awarded, 1992-2003**

The amount of money awarded to college students in the form of Pell Grants has almost doubled since the early 1990s. Students are turning to Pell Grants because of the decrease in other funding sources for college expenses.

Graphic: Gazette staff Source: College Board

**How closely are people
paying attention to the election?**

A *Washington Post* survey shows that most people say they are paying attention to the ongoing presidential election campaign. The survey was conducted Sept. 15–17 and interviewed 1,200 registered voters nationwide.

Graphic: Gazette staff Source: Washington Post

Figure 8.7

Illustration-based graphics

This article has an illustration that was drawn by hand and scanned into the paper's computer system. Scanning allows the editor to change the size of the picture to fit in the space allotted for it.

Russell estate donates papers to local library

Longtime Daily Inquisitor sports writer Rusty Russell hasn't been inducted into baseball's Hall of Fame yet, but he will be getting his own room in the Ticonderaga Public Library.

Russell's widow, Velma Harmon Russell, has donated many of the writer's papers, photographs and other memoralbilia from his 40-year-plus writing career to the library.

Russell's estate is also giving the library $350,000, which will finance the building of an extension on the main building of the library to house the donation.

"This is a wonderful and generous donation from Mrs. Russell and her children," Moxley Pritchard, director of the library, said.

Moxley said that Russell had covered many of the major events in baseball history from the 1930s to the 1970s and that the collection of his papers would be a valuable resource for baseball historians.

"When Joe DiMaggio ended his hitting streak in 1941, Rusty was there. When Willie Mays made his famous catch during the World Series in 1954, Rusty was there. When Roger Maris hit his 61st homer in 1961, Rusty was there," Moxley said.

The collection includes many of the original stories and columns that he wrote about the things he saw and people he met.

Moxley said he could not estimate the number of items in the collection and that the library was still cataloguing them.

He said that the extension on the library would probably be finished by "opening day next year."

"Rusty would have liked that," he said.

Russell graduated from Darnley College in 1929 and

worked as a sports reporter for several newspapers before landing a baseball writing job with the Ticonderoga Daily Inquisitor in 1932. He quickly established himself as one of the premier sportswriters of his day, regularly hobnobbing with the likes of Grantland

Rice, Frank Graham and Red Smith.

Russell retired from the newspaper in 1975 and died in 1980.

Rusty Russell was captured by sports cartoonist Hal Lipsey when he covered the Giants-Dodgers playoff in 1951

current emphasis in newspapers on graphics has come a renewed interest in newspaper illustration. Many newspapers are expanding their art staffs and looking for people who can combine artistic skills with a sense of news and information. They are also looking for people who are adept at using the computer.

As the name implies, illustration-based graphics use illustration rather than type or charts to form the basis of the graphic. An illustration may be hand drawn or generated by a computer, or it may be hand drawn and then enhanced by a computer.

Publications use illustrations for two purposes: to draw attention to a story and to make a point about the story. Usually, illustrations do not duplicate photographs. They go beyond the photograph in helping the editors to emphasize something about the story or in some way adding to the reader's understanding of the information in an article.

Drawings. A drawing may be generated by hand or with the aid of a computer. When a drawing has been originated by hand, it is entered into a computer

system by means of a scanner. A scanner operates like a photocopying machine, but instead of transferring the image onto another piece of paper, it translates the image into a set of computer signals that can be recognized by a software program. The image is picked up by a drawing program (such as FreeHand or Illustration) and can be enhanced in a number of ways; for instance, it can have color or shades of gray added to it. It can also be combined with other images that have been generated by computers or scanned into computer systems.

Many publications use clip art files as a basis for their illustrations. Clip art is a set of drawings stored in a format that can be accessed by a publication's computer system. These drawings are sold on disks and cover a vast array of subjects. Publications buy the rights to use the drawings when they purchase the disks. These drawings can be called up by a staff artist and changed in whatever way is necessary for the publication.

Drawings can illustrate things that cannot be photographed. One of the most common uses of drawings in this way is to illustrate courtroom stories. Many courtrooms still do not allow the use of video or still cameras, but most will let illustrators make drawings of the participants.

Drawings can also be used to help explain why things happen. For instance, if a bridge collapses, a photograph can record the aftermath and effects of the event. A drawing can present the structure of the bridge and emphasize the points where the collapse occurred. Both photographs and drawings can help the reader to understand the event.

One point should be emphasized about good newspaper illustration and especially drawings: They take time to produce, and generally the better the drawing, the more time it takes. Computers can speed the process along, but a good illustration still takes the time of a talented person.

Maps. One of the most common and useful graphic devices in today's mass media is the map. Maps are quick and easy to use. They provide readers with important information that can be used to help explain events and put them in physical context. In addition, they help to educate a public that many have tagged as geographically illiterate.

Certain conventions should be followed in using maps. First and foremost, a map should always be proportional to the geographic area that it represents; that is, it should be "to scale." Let's say that a country is 2,000 miles long from north to south and 1,000 miles long from east to west. The longitude (north to south) to latitude (east to west) scale is 2 to 1. Any map that represents that area should have a north–south line that is twice as long as the east–west line.

Another important convention of maps is that the northern part of the area that is represented is always at the top of the map. This northern orientation dates from ancient times and is one of the assumptions that most people make when they look at a map.

A third convention of maps is that they include a distance scale, usually somewhere close to the bottom of the map. Not every map needs a distance scale because sometimes such a scale is irrelevant. On maps where the area is likely to be unfamiliar to the reader, distance scales are extremely helpful. A distance scale usually consists of two parts: a line that is marked off to indicate units of a distance on the map and text that tells what the scale is, such as "1 inch = 5 miles."

Many maps in newspapers or magazines appear with insets—smaller maps that show a particular part of the area shown in the map. For instance, the map of Virginia in Figure 8.8 includes an inset that shows one of the counties in that state.

Figure 8.8

Locator maps

Maps are an excellent way of informing readers about the location of events. This one has an inset that shows a particular area. The area within the inset is known as the area of detail.

Washington County, Va.

The print media put maps to three basic uses with which you should be familiar.

Symbols. The shapes of many states and countries are well known and are excellent graphic devices. They are particularly useful when an article is divided up as a series of reports on different states or countries (or, on a more local level, counties). Although such a use does not require that these maps have a distance scale, they should follow the conventions of being proportionally scaled and having north at the top.

Location. Using maps to indicate the location of events is what we think of as the most common and logical use of maps. Here, all of the conventions of map usage should come into consideration.

These maps can be enhanced by a number of devices. Cities, towns, and other locations can be identified. A map may also include buildings or other sites that would help the reader to get the point of the map. Hills, valleys, mountains, rivers, forests, and other topographical factors can be indicated on a map with drawings or shadings.

Maps can serve as backgrounds for other information that journalists want to convey to their readers. For instance, to give readers a better sense of the story about a trip by the pope, a publication might include a map with text and arrows pointing to the different locations the pope will visit and the dates on his schedule.

Location maps do not always have to be of areas that we think of as geographic locations. For instance, the floor plan of a house or other building can be treated as a map if it helps readers to understand something about a story. In the general sense, maps are a way of looking down on something and seeing it as a whole rather than seeing part of it from the limits of ground level. Such a bird's-eye view can be revealing and insightful.

Data. In 1854, central London experienced an outbreak of cholera. In searching for a way to arrest the spread of the sickness, John Snow, a local physician, took a map of the area where the deaths occurred and plotted with dots the residence of everyone who had died of cholera. He also marked the location of the public water pumps in the area. His map indicated that many of the deaths were clustered around the Broad Street water pump. Upon discovering this, he had the handle of the pump removed, so that the pump could not be used, and thus ended the cholera that had claimed more than 500 lives in that area.

Snow used what we refer to as a data map as a life-saving device. A data map places numerical data on geographic locations in a way that will produce relevant information about the data. Data maps can aid in our understanding of the data and the areas in which it occurs. Data maps also allow readers to view large amounts of information at a single sighting in an orderly and logical way.

Data maps take time and effort to produce, and they should be created with great care. Data maps that are not carefully thought out can allow viewers to reach superficial or incorrect conclusions. Creators of data maps should be particularly careful that the data they have are, in fact, related to geographic location rather than being distributed randomly.

Icons and logos. Publications often use relatively small pieces of art to enhance their appearance and to draw attention to an article. Two of these types of art are icons and logos. Icons are small drawings created for a particular story that contain no specific information but give the reader an idea of what the story is about. A logo is a symbol that the publication can use on a continuing basis to identify a subject, column, or author that appears regularly in the publication.

Developing Infographics

Large newspapers have multiperson graphics departments that devote themselves full time to producing infographics, particularly for breaking news. The Chicago *Tribune,* for instance, maintains a staff of graphics coordinators (or reporters) who work on information that will go into a news graphic and a set of artists who will design and execute the graphic.

Figure 8.9

Data map

A data map ties numerical information to geographic locations. In this map, the location of churches in the Primitive Baptist denomination are located by counties in the United States. What can you tell about the denomination by looking at this map?

Credit: Edward Davis, professor of geography, Emory and Henry College.

What these coordinators find is that graphics reporting differs in some significant ways from news reporting. Graphics reporting demands that the journalist focus in on a part of the story and find specific, detailed information that a person writing a news story might not have to have. For instance, a news reporter might be able to quote a source saying the number of independently owned drug stores had decreased during the last ten years. A graphics reporter, if he or she were going to create a chart showing that, would have to have precise figures for each year of the period shown.

On the other hand, a news reporter would be concerned with quoting people and getting the quotations exactly right so that they could be included in a story. A graphics reporter might talk to many sources of information but rarely worries about quoting those people.

One skill that a graphics reporter must develop is writing succinctly. Most infographics have an extremely limited amount of space for text, and a graphics reporter must learn to use words with exceptional efficiency. Such honing of language is hard work and takes time. Often it is done with a looming deadline, so the person who becomes a graphics reporter must have confidence in his or her use of the language.

A graphics reporter also deals in a specialized kind of information, and knowing the nature of this information is important for editors to understand how infographics should be developed. When a news story needs an infographic, graphics reporters and editors tend to think along the following lines:

- *Numbers.* Are there numbers that need to be shown with this story? Will showing the numbers add to the reader's understanding? A newswriter who must handle a substantial amount of numbers in a story will find that an infographic could be a great solution.
- *Location.* Are readers likely to know where a story is taking place? Even if they do, could a map show information more efficiently than a paragraph description? Should it be a simple locator map, or does it need to be married with some other information? Is a data map called for—does the geography relate to the numbers?
- *History and context.* How did the events of the story get to this point? Is there a history that the reader needs to know about? Timelines, as we mentioned earlier, are good ways of showing the events of a person's life or the history of an issue. Another form that this takes is the fact or profile box. Can we add to the reader's understanding of an organization or person that would not be included in a story?
- *Process.* Should we show the reader how something works? Sometimes we can do that with text or text combined with pictures.
- *Procedure.* Is there a step-by-step procedure that shows how something happened? Somewhat akin to a timeline, a procedural chart can show how an event occurred. (Although the words "process" and "procedure" might be interchangeable, I distinguish them in this context in the following way: A *process* refers to something that is not unusual and happens periodically; a *procedure* refers to a single, often unique, event.)
- *Profile.* This might be thought of as "information-plus." An organization, company, person, or almost any element in a story can be outlined or explained with extra information in a variety of ways.

Good graphics demand the same kind of accuracy, completeness, precision, and efficiency that good news writing demands. Editors must have an understanding of what it takes to make a good graphic and why they can be an efficient way of getting information to a reader.

Conclusion

This chapter has taken a brief look at the wide and expanding world of informational graphics. The work of many journalists in the 1980s showed that information graphics should be taken seriously. These journalists proved to their colleagues—and, more important, to readers—that important and entertaining information could come in forms other than the paragraph. Twenty-first century journalists are continuing to expand the definition of informational graphics, and the opportunities for creative people who want to enter this field are widening.

Sidebar 8.1

Visual and Verbal: The Paradox of the Visual Journalist

By Celeste Bernard

Tell people that you work at a newspaper and the first thing they'll likely ask is, "So, are you a reporter?" If you say yes, they'll likely pepper you with questions, berate the media's liberal bent, or, if you're lucky, give you a lead on a good story. But respond that you're a visual journalist, and you'll get a blank stare followed by a conversation-ending "Oh."

I know, because I've been there.

The problem is that everyone understands what a reporter, editor, or photographer does, but not a visual journalist. The title sounds vague and seems to imply that words aren't an essential part of the job.

Not true. Not by a long shot.

Careful reporting and writing are behind every respectable graphic, for obvious reasons. Diagrams can't be drawn unless the concepts or processes they illustrate are fully understood. Charts can't be plotted without considering the source of the data, nor can they be explained without context. Most important, graphics won't do their job if the information contained in them is obscured by bad writing or editing, regardless of how beautiful the image.

This is why good writing is so critical. Visual journalists must craft words that thread together concepts, pictures, or trends. They must do so carefully, so as not to blatantly repeat the lead of the story or dilute the point of the graphic. It is difficult work and usually means that a day's worth of reporting is boiled down to a few well-chosen words. But it serves the readers, who are pressed for time but still crave knowledge.

Now when people ask me if I'm a reporter, I always say yes. Then I explain that I'm the person behind all those maps, charts, and diagrams they see in the paper each day. Their response is usually "Cool."

And it is. By a long shot.

Celeste Bernard is the former assistant managing editor for visuals of the Seattle Post-Intelligencer. She is also the former associate editor for news graphics at the Chicago Tribune.

Carefully studying the figures in Chapter 8 will help the student in completing these exercises. Appendix C offers instructions on how to use Microsoft Excel in building charts.

Exercise 8.1: Editing Graphics

Edit each of the accompanying graphics. You should first check to ensure that each contains all of the basic elements necessary to present good information to the reader (see Fig. 8.5). Does the headline describe what the graph shows? Are there mistakes in the grammar, spelling, punctuation, or AP style that need to be corrected? Is the type of chart used appropriate for the data it presents? Is the information presented accurately and in a way that is understandable to the reader? Do you have any questions or comments for the person who created the graphic?

English spoken here

This graph shows that English is the closest thing the world has to a universal language.

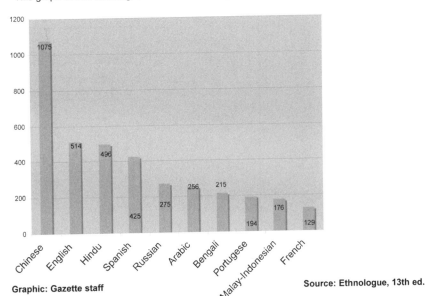

Graphic: Gazette staff

Source: Ethnologue, 13th ed.

Prevalence of smoking of men and females, 2002

this grap[h proves that smoking in the United States is going down. The percentages shown in both categories is going down.

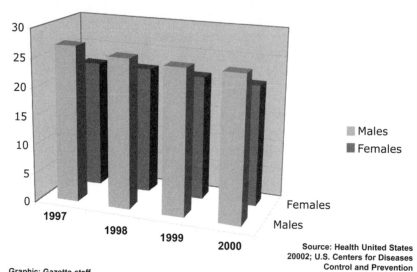

Males
Females

Females
Males

Source: Health United States
20002; U.S. Centers for Diseases
Control and Prevention

Graphic: Gazette staff

Average Starting Salaries
of Various Professions
1975–1988

Teaching

$8,233 $10,764 $15,406

$19,400

Engineering

$12,744 $20,136 $26,880

$29,856

Accounting

$11,880 $15,720 $20,620

$25,140

**Economic/
Finance**

$10,212 $14,472 $20,964

$23,928

1975 1980 1985 1988

Exercise 8.2: Editing Graphics

Edit each of the accompanying graphics. You should first check to ensure that each contains all of the basic elements necessary to present good information to the reader (see Fig. 8.5). Does the headline describe what the graph shows? Are there mistakes in the grammar, spelling, punctuation, or AP style that need to be corrected? Is the type of chart used appropriate for the data it presents? Is the information presented accurately and in a way that is understandable to the reader? Do you have any questions or comments for the person who created the graphic?

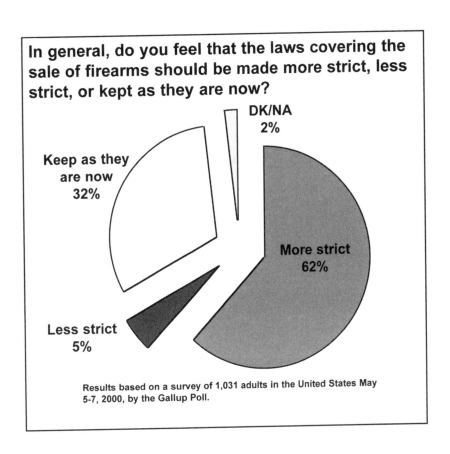

In general, do you feel that the laws covering the sale of firearms should be made more strict, less strict, or kept as they are now?

DK/NA
2%

Keep as they
are now
32%

More strict
62%

Less strict
5%

Results based on a survey of 1,031 adults in the United States May 5-7, 2000, by the Gallup Poll.

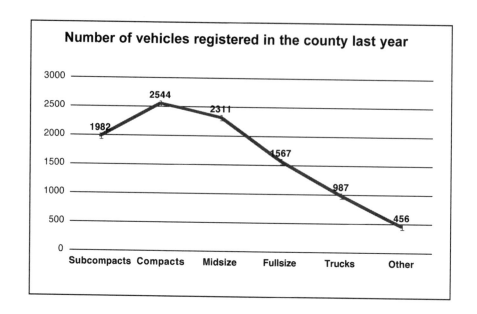

Number of vehicles registered in the county last year

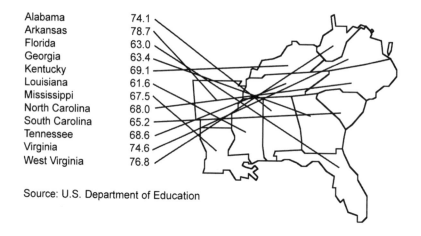

High school graduation rates in the Southeast, 1988

Alabama	74.1
Arkansas	78.7
Florida	63.0
Georgia	63.4
Kentucky	69.1
Louisiana	61.6
Mississippi	67.5
North Carolina	68.0
South Carolina	65.2
Tennessee	68.6
Virginia	74.6
West Virginia	76.8

Source: U.S. Department of Education

In the next three exercises you will be given sets of data and information. You are to decide which type of chart (bar, line, or pie) is most appropriate for the data and then draw a rough version of the chart, as in the following examples. You should also write a headline and an explanatory box of no more than fifty words. If you have access to a computer with graphing software, you should enter the data into the software and let it build the graph. Then finish the graph off with a headline, explanatory box, credit, and source.

World's Tallest Buildings

When the World Trade Center towers were built in the early 1970s, they were the tallest buildings on earth—each slightly more than 1,360 feet tall. They were soon eclipsed by the Sears Tower in Chicago. By the time they were destroyed on September 11, 2001, they didn't even make the top five tallest buildings, which are as follows:

Rank	Building	Height
1.	Taipei 101, Taipei, Taiwan:	1,670 feet
2.	Petronas Tower 1, Kuala Lumpur, Malaysia:	1,483 feet
3.	Petronas Tower 2, Kuala Lumpur, Malaysia:	1,483 feet
4.	Sears Tower, Chicago:	1,450 feet
5.	Jin Mao Building, Shanghai:	1,381 feet

Source: Council on Tall Buildings and Urban Habitat.

Line and bar charts

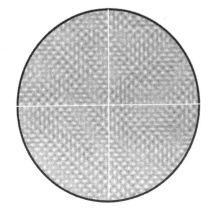

Pie charts

Headline _____

Explainer box _____

Headline ⟶ World's Tallest Buildings

Explainer box _____

The twin towers of the World Trade Center when they were destroyed on September 11, 2001, were not among the world's five tallest building. The others are still standing, but only one is in the United States.

Source: Council on Tall Buildings and Urban Habitat

201

Blood Types

Human blood is not created equal. It is classified into four major groups—A, B, AB, and O—according to the protein factor found in the blood. Each of these groups has a positive and negative category. Among Americans the most common blood type is O, but the O types do not constitute a majority. Here is the breakdown of percentage of blood types among Americans:

Blood types	Percentage
O+	37
O–	6
A+	34
A–	6
B+	10
B–	2
AB+	4
AB–	1

Source: American Red Cross.

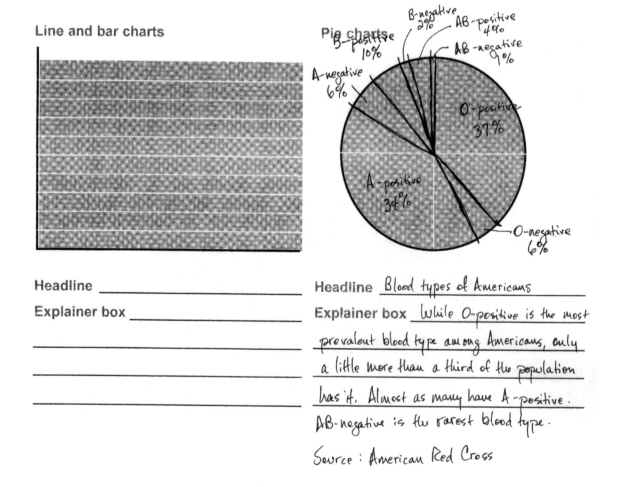

Line and bar charts

Pie charts

B-negative 2%
AB-positive 4%
B-positive 10%
AB-negative 1%
A-negative 6%
O-positive 37%
A-positive 34%
O-negative 6%

Headline _____

Explainer box _____

Headline Blood types of Americans

Explainer box While O-positive is the most prevalent blood type among Americans, only a little more than a third of the population has it. Almost as many have A-positive. AB-negative is the rarest blood type.

Source: American Red Cross

Exercise 8.3: Building Charts

In this exercise are three sets of numerical information. Each could be presented by using a bar chart, line chart, or pie chart. Decide which type of chart is the most appropriate for each set of data, and using one of the frames below each set, sketch the graphic by hand. (See the example that precedes this exercise.) If you have access to a charting program such as Excel, you might want to enter the data into that program and let the program draw the chart. You will need to write a headline and a short explanatory box (fewer than fifty words) for the graphic.

Mortality

People around the world die of all sorts of things. This table shows the leading causes of death around the world in 2002. The source of this information is The World Health Report 2002 and the Who Health Organization (WHO).

Cause of Death	Percentage
Ischemic heart disease	12.6
Cerebrovascular disease	9.7
Lower respiratory infections	6.8
HIV/AIDS	4.9
Chronic obstructive pulmonary disease	4.8
Diarrheal diseases	3.2
All others	52

Line and bar charts

Pie charts

Headline _____

Explainer box _____

Headline _____

Explainer box _____

Costs of Higher Education

Total costs for attending public and private colleges and universities increased
substantially in the 1990s. Those increases are continuing in the new decade.
This information comes from the U.S. Department of Education, the National
Center for Education Statistics, and the Digest of Educational Statistics 2003.
The numbers are for 1986 through 2002. These costs are averages for all
institutions in these categories.

Year	Public Institutions	Private Institutions
1986–1987	$3,805	$9,676
1991–1992	5,138	13,892
1995–1996	6,256	17,208
1996–1997	6,530	18,039
1997–1998	6,813	18,516
1998–1999	7,107	19,368
1999–2000	7,310	20,186
2000–2001	7,586	21,368
2001–2002	8,022	22,413
2002–2003	8,556	23,503

Line and bar charts

Pie charts

Headline _____ Headline _____

Explainer box _____ Explainer box _____

_____ _____

_____ _____

_____ _____

Endowments

Most colleges and universities have endowments—money that is kept in a separate fund and invested in various ways. The money in the endowment (sometimes call the "corpus") is never spent. Only the money that is earned from the investments is spent. Do you know how much of an endowment your college or university has? The following table shows the top ten endowments for colleges and universities in the United States in 2003.

College and University Endowments, 2003

Rank	Institution	Endowment
1.	Harvard University (Cambridge, Mass.)	$19,294,735,000
2.	Yale University (New Haven, Conn.)	11,048,891,000
3.	Princeton University (Princeton, N.J.)	8,730,000,000
4.	Leland Stanford Junior University (Stanford, Calif.)	8,613,805,000
5.	Univ. of Texas System Administration (Austin, Tex.)	8,588,471,301
6.	Massachusetts Institute of Technology (Cambridge, Mass.)	5,133,600,000
7.	Columbia University (New York, N.Y.)	4,343,151,000
8.	Emory University (Atlanta, Ga.)	3,812,033,219
9.	Washington University (St. Louis, Mo.)	3,569,344,000
10.	University of Pennsylvania (Philadelphia, Pa.)	3,547,473,030

Source: Council for Aid to Education, a subsidiary of RAND (www.cae.org).

Line and bar charts

Pie charts

Headline _____

Explainer box _____

Headline _____

Explainer box _____

Exercise 8.4: Building Charts

In this exercise are three sets of numerical information. Each could be presented by using a bar chart, line chart, or pie chart. Decide which type of chart is the most appropriate for each set of data, and using one of the frames below each set, sketch the graphic by hand. (See the example that precedes Exercise 8.3.) If you have access to a charting program such as Excel, you might want to enter the data into that program and let the program draw the chart. You will need to write a headline and a short explanatory box (fewer than fifty words) for the graphic.

Textbooks—Where the Money Goes

What happens to every dollar you spend when you buy a textbook? The Association of American Publishers has broken it down this way: publisher's costs, 57.6 cents; authors' royalties, 11.6 cents; publisher's income (profit), 7.1 cents; bookseller's costs, 23.7 cents. The publisher's costs include paper, printing, binding, marketing, and warehousing the books.

Line and bar charts

Pie charts

Headline _____

Explainer box _____

Headline _____

Explainer box _____

Homicide Rates

The U.S. Department of Justice compiles all sorts of statistics on crime in the United States. One of the most important and interesting is the homicide rate. This rate is the number of homicides for every 100,000 people. The following table gives the homicide rate for the years 1990–2002.

Homicide Rate (per 100,000), 1950–2002

Year	Rate
1990	9.4
1991	9.8
1992	9.3
1993	9.5
1994	9.0
1995	8.2
1996	7.4
1997	6.8
1998	6.3
1999	5.7
2000	5.5
2001	5.6
2002	5.6

Source: Crime in the United States 2002 and Uniform Crime Reports.

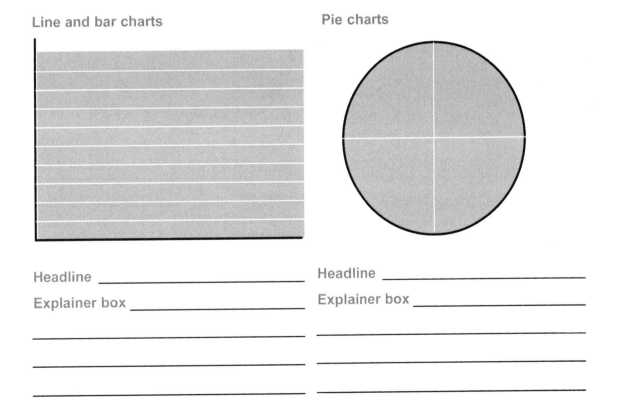

Line and bar charts

Pie charts

Headline _____

Explainer box _____

Headline _____

Explainer box _____

Top Occupations for Women

What types of jobs are most likely to be filled by women? The following table shows some various occupations and the percentage of those jobs that are held by women. The source is the U.S. Department of Labor Bureau of Labor Statistics, and the numbers are for the year 2001.

Occupation	Percentage
Secretary	98
Receptionists	97
Registered nurse	93
Bookkeepers, accounting and auditing clerks	92
Nursing aides, orderlies, attendants	90
Hairdressers and cosmetologists	90
General office clerks	84
Elementary school teachers	83

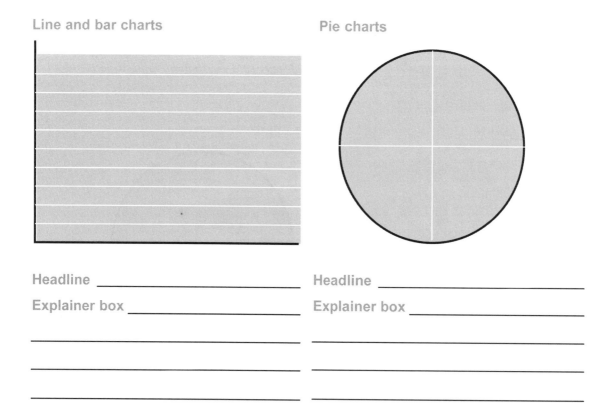

Line and bar charts

Pie charts

Headline _____ Headline _____

Explainer box _____ Explainer box _____

_____ _____

_____ _____

_____ _____

Exercise 8.5: Building Charts

Following are three sets of numerical information. Each could be presented by using a bar chart, line chart, or pie chart. Decide which type of chart is the most appropriate for each set of data, and using one of the frames below each set, sketch the graphic by hand. (See the example that precedes Exercise 8.3.) If you have access to a charting program such as Excel, you might want to enter the data into that program and let the program draw the chart. You will need to write a headline and a short explanatory box (fewer than fifty words) for the graphic.

Top-Selling Albums

The Recording Industry Association of America has listed the top selling albums of all time, and the top one is a 1971–1975 release. It is *Eagles: Their Greatest Hits*, which had sold about 28 million copies through the middle of the year 2004. The table here lists some of the top sellers.

28 Million	*Eagles: Their Greatest Hits 1971–1975*, Eagles (Elektra)
26 Million	*Thriller*, Michael Jackson (Epic)
23 Million	*The Wall*, Pink Floyd (Columbia)
22 Million	*Led Zeppelin IV*, Led Zeppelin (Swan Song)
21 Million	*Greatest Hits Volumes I & II*, Billy Joel (Columbia)
19 Million	*Rumours*, Fleetwood Mac (Warner Bros.)
	Back in Black, AC/DC (Elektra)
	The Beatles, The Beatles (Capitol)
	Come On Over, Shania Twain (Mercury Nashville)
17 Million	*Boston*, Boston (Epic)
	The Bodyguard (Soundtrack), Whitney Houston (Arista)
16 Million	*Cracked Rear View*, Hootie & the Blowfish (Atlantic)
	Greatest Hits, Elton John (Rocket)
	Hotel California, Eagles (Elektra)
	The Beatles 1967–1970, The Beatles (Capitol)
	No Fences, Garth Brooks (Capitol Nashville)
	Jagged Little Pill, Alanis Morissette (Maverick)

Line and bar charts

Pie charts

Headline _____

Explainer box _____

Headline _____

Explainer box _____

Murders by Weapons

The way in which people have died from murder changed substantially during the second half of the twentieth century. Federal Bureau of Investigation statistics are presented below for murders in 1965 and 1995. In 1965 there were 8,773 murders; in 1995 there were 20,232. (*Tip:* Convert the numbers for each year into percentages; then consider doing a graph for each set of percentages.)

Year	Guns	Cutting/ stabbing	Blunt object	Strangulation	Arson	Other
1965	5,015	2,021	505	894	226	112
1995	13,790	2,557	918	1,438	166	968

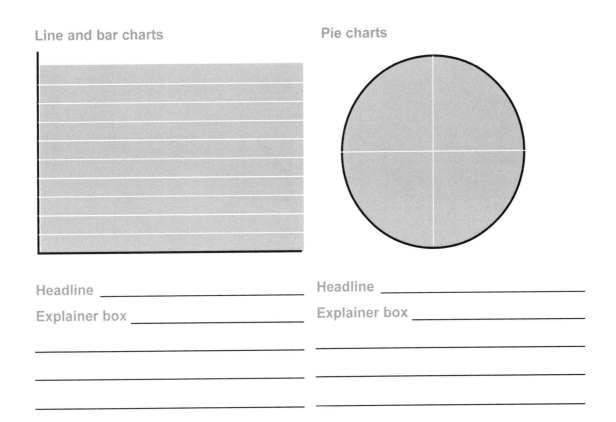

Line and bar charts

Pie charts

Headline _____

Explainer box _____

Headline _____

Explainer box _____

Prisoners in the United States

The total number of people in U.S. jails has increased by almost 50 percent since 1990. In 2001 it exceeded the 2,000,000 mark for the first time. The following table gives the breakdown of the nation's prison population.

Prisoners in the United States, 1990–2003

Year	Total	Federal	State	Local jails
1990	1,148,702	58,838	684,544	405,320
1995	1,585,586	89,538	989,004	507,044
2000[1]	1,937,482	133,921	1,176,269	621,149
2002[1]	2,033,331	151,618	1,209,640	665,475
2003[1]	2,078,570	159,275	1,221,501	691,301

[1] Total counts include federal inmates in nonsecure privately operated facilities (6,143 in 2000, 6,598 in 2002, and 6,493 in 2003).
Source: Prison and Jail Inmates at Midyear 2003, U.S. Bureau of Justice Statistics.

Line and bar charts

Pie charts

Headline _____

Explainer box _____

Headline _____

Explainer box _____

Exercise 8.6: Data Map

The following table presents the percentage of people in each state who do not have health insurance. The numbers in the table come from the March 2003 Current Population Survey of the U.S. Census Bureau and reflect data from the year 2002. Although all states have people without health insurance, some states have more than others. One way to group the states is to have three groups: one with less than 10 percent of the population uninsured, one with 10 to 15 percent uninsured, and one with more than 15 percent uninsured.

Take a black and a gray colored pencil. On the blank map provided for you, color in the states with more than 15 percent uninsured with the black pencil. Color in the states with 10–15 percent uninsured with the gray pencil. Leave the other states white.

Look at the map carefully. Are there regions or sections of the country that are more likely to have a high rate or a low rate of uninsured people? Once you have studied the map, write a headline and explanatory box for your graphic.

Percent of Americans without Health Insurance by State, 2002

State	Percent
Alabama	12.7
Alaska	18.7
Arizona	16.8
Arkansas	16.3
California	18.2
Colorado	16.1
Connecticut	10.5
Delaware	9.9
District of Columbia	13.0
Florida	17.3
Georgia	16.1
Hawaii	10.0
Idaho	17.9
Illinois	14.1
Indiana	13.1
Iowa	9.5
Kansas	10.4
Kentucky	13.6
Louisiana	18.4
Maine	11.3
Maryland	13.4
Massachusetts	9.9
Michigan	11.7
Minnesota	7.9
Mississippi	16.7
Missouri	11.6
Montana	15.3
Nebraska	10.2
Nevada	19.7
New Hampshire	9.9

New Jersey	13.9
New Mexico	21.1
New York	15.8
North Carolina	16.8
North Dakota	10.9
Ohio	11.9
Oklahoma	17.3
Oregon	14.6
Pennsylvania	11.3
Rhode Island	9.8
South Carolina	12.5
South Dakota	11.5
Tennessee	10.8
Texas	25.8
Utah	13.4
Vermont	10.7
Virginia	13.5
Washington	14.2
West Virginia	14.6
Wisconsin	9.8
Wyoming	17.7
Total U.S.	**15.2**

Source: U.S. Census Bureau, *March 2003, Current Population Survey.*

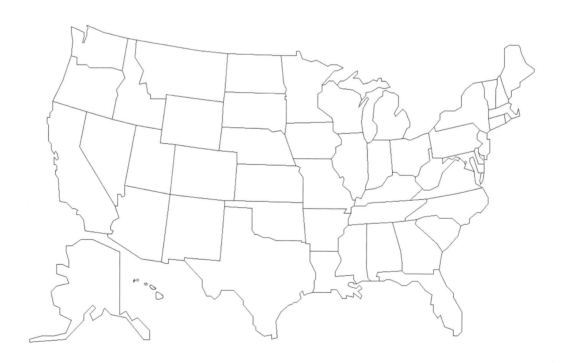

Exercise 8.7: Data Map

The following table presents the number of people executed in each state since 1977. The year 1977 is significant because in 1972 the Supreme Court ruled that capital punishment, as it was then administered, was "cruel and unusual" and therefore unconstitutional. On July 1, 1976, however, the Court overturned the ruling by a 7–2 decision, and capital punishment was reinstated.

As you can tell from the table, only one state—Texas—has executed more than 100 people. The next highest number is Virginia, with 89. Take a set of colored pencils (or you can do this on a computer by scanning the map provided for you here) and pick a color for Texas. Pick another color for those states that have executed fifty or more people. Pick a different color for those states that have executed from one to forty-nine people. Leave the states that have had zero executions blank.

Look at the map carefully. Are there regions or sections of the country that are more likely to have a high number or low number of executions? Once you have studied the map, write a headline and an explanatory box for your graphic. (You may include the information in the first paragraph in your explanatory box.)

Number of Persons Executed by Jurisdiction, 1977–2003

State	Executions
Texas	313
Georgia	34
New York	0
California	10
North Carolina	30
Florida	57
South Carolina	28
Virginia	89
Ohio	8
Alabama	28
Louisiana	27
Mississippi	6
Pennsylvania	3
Arkansas	25
Missouri	61
Oklahoma	69
Kentucky	2
Illinois	12
Tennessee	1
New Jersey	0
Maryland	3
Arizona	22
Washington	4
Indiana	11
Colorado	1
District of Columbia	0
West Virginia	0
Nevada	9

Federal system	3
Massachusetts	0
Delaware	13
Oregon	2
Connecticut	0
Utah	6
Iowa	0
Kansas	0
New Mexico	1
Montana	2
Wyoming	1
Nebraska	3
Idaho	1
Vermont	0
New Hampshire	0
South Dakota	0
U.S. total	**885**

Note: 65 people were executed in 2003.
Source: Capital Punishment, 2003, U.S. Bureau of Justice Statistics, and Death Penalty Information Center (www.deathpenaltyinfo.org).

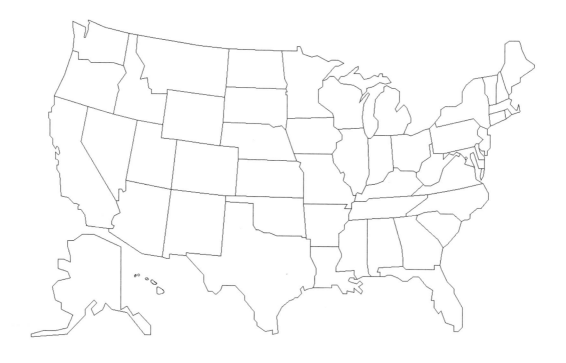

Exercise 8.8: Locator Map

Read the accompanying story and locate the points on the map that are referred to in the story. These should be at least five points. Number those points in chronological order as they occurred in the event being written about. Below the map, write a brief description of what happened at each location. Follow additional instructions given to you by your instructor.

Police baffled by many clues in south county murder

Police are searching through an abundance of clues today, trying to find more in the case of a young bank clerk who was found shot to death on Thursday.

The body of John Bailey, 27, was discovered by a passing motorist in a car at 6 p.m. Thursday just off Highway 69, one mile north of the Hale County line. He had been shot in the head. The county medical examiner's office estimated the time of death at 5 p.m.

Bailey was seen arguing earlier at a convenience store parking lot five miles north on Highway 69. Witnesses told police that the argument was with a woman. Neither of them had been inside the convenience store, and it is unclear how long they had been there. Bailey left the store about 4:45 p.m., driving south on Highway 69, and the woman left immediately after him.

Bailey was driving a red, late model Toyota, and the woman was driving a blue Chevrolet. Both were seen driving away at a high rate of speed.

About two miles south of the convenience store, a motorist driving north noticed two southbound cars that fit the description of the cars Bailey and the woman were driving. Both were speeding, and the Toyota was on the shoulder of the road, while the Chevrolet was in the driving lane.

"It looked like the blue car was trying to run the other one off the road," Wayne Marshall, the motorist, said. Marshall said he felt both drivers were acting so dangerously that

he stopped to call the police. Marshall's call came in to the sheriff's department at 5:05 p.m.

A car fitting the description of the blue Chevrolet was found parked on the banks of the Black Warrior River just west of where Bailey's body was found. The car was discovered about an hour after police examined Bailey. Police then followed a pathway that leads north along the river bank. About a mile up the pathway, a small caliber pistol was spotted, and police said that it had been fired recently.

"That's it – that's where the trail ends," Homicide Detective Hugh Kilpatrick said today. "If the woman was walking up that path, she simply vanished. We haven't been able to find anything that would get her off of that path, but she's not there."

Bailey worked as a bank clerk at the Cottondale branch of the Third National Trust Bank. He left work Thursday about 4 p.m.

1.

2.

3.

4.

5.

Exercise 8.9: Locator Map

Read the accompanying story carefully. It describes in some detail the four places where the tornado hit. Locate those points on the map and mark them with a number inside a circle. Below the map next to the corresponding number, write a brief description of what happened at each point. Your descriptions should be no longer than fifteen words.

Tornado rips through River City

A vicious tornado spun a deadly tapestry of havoc and destruction around River City yesterday, killing at least five people and wrecking more than 200 homes and businesses.

Despite the death and destruction, city officials counted a few blessings as they sifted through the rubble.

"It was terrible, just terrible," Charles Robert Bone, the mayor, said, "and yet it could have been so much worse. The tornado missed the downtown area where there were many people still on the job.

It all happened in the space of about 30 minutes.

A thin black funnel cloud touched down in at least four places around the city: the Riverview subdivision, just south of the Cumberland River and east of Riverbend Ave.; the north side of the Veterans Hospital on the northeast edge of Battlefield Hill; the Houston Woods busines district on the north side of Stone Boulevard, just before it becomes Bear Creek Hill Road; and the Coventry subdivision north of Northside Road just west of Overlook Hill.

The Houston Woods business district suffered the most severe damage. At least four people were killed, and several dozen were injured, some severely. Officials at the River City Memorial Hospital said they treated more than 100 people for injuries related to the tornado. They said 23 were hospitalized, and three of those were critically injured.

At least one other person was killed in the Riverview subdivision. As darkness fell last night, emergency workers were combing all of the affected areas to see if anyone was trapped or hurt in the rubble.

Officials would not release the names of the fatalities until their families had been notified.

More than 50 businesses were destroyed and another 20 badly damaged in the Houston Woods area.

Morley Barrow, a spokesman for the Veterans Hospital, said the only damage at that facility occurred to some storage buildings. There were no injuries or fatalities. The tornado touched down there at about 2:20 p.m.

The tornado struck less than 10 minutes before that in the Riverview subdivision, where resident Joe Guidry said he heard high winds and then a lot of crashing, and then nothing.

"After about 10 seconds, it was over -- gone," he said. "We never knew what hit us."

The tornado damaged about 60 homes in the subdivision, but many of them were unoccupied.

The Houston Woods business district was hit about 2:35 p.m. The force of the tornado picked up items at random and threw them for several blocks. One car that had been parked on Stone Boulevard was later found north of Gordon Lane.

In the Coventry subdivision, which was hit about 2:45 p.m., the tornado touched down on the northwest side of the subdivision. About 10 homes were destroyed and a few others damaged, but no serious injuries were reported.

Across the city, the high winds spawned by the storm downed limbs and power lines. Rush hour traffic was affected by traffic lights that had been disabled by lack of power, and commuting traffic had to be routed around the damaged areas on Stone

Where the tornado hit

1

2

3

4

Exercise 8.10: Graphics Reporting—Elections Comparison

Exercise 8.10 requires that you engage in graphics reporting—gathering the information necessary for a chart or graph—as well as creating the graphics themselves.

Find a map of your state that has county borders. The geography department of your institution might have such a map, or you can find one at http://quickfacts.census.gov. (These maps are created by the government and can be used without restriction.) When you go to that web page, select your state from the menu of states. When the new screen comes up, click on "view map." When the map comes up, download it to your computer. Make two copies of it.

Now select two statewide elections that are comparable. For instance, you might choose the last two gubernatorial elections, the last two in which a U.S. senator was elected, or two presidential elections (as in the example below). Find the county-by-county results of those two elections. There are a variety of sources for this information. In most states, the secretary of state's office keeps such information and usually puts it on the office web site.

Once you have the maps and the election results, take one map and one set of election results. Find the counties in which one of the political parties (Republican or Democrat) won a majority or plurality and color them with a colored pencil (or select a color for them if you are working on a computer with a drawing program such as Illustrator or Photoshop). You can leave the remaining counties white or pick another color for them. Now take the second set of results and the second map and do the same thing.

Study the two maps carefully. What are the differences? Your goal is to create a graph like the one shown here.

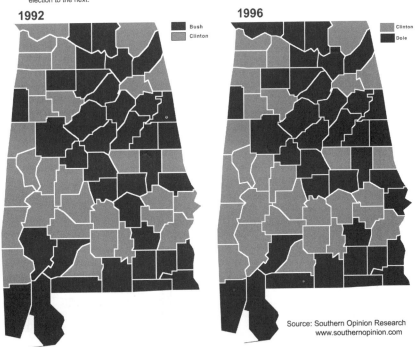

Presidential elections in Alabama, 1992 and 1996

Bill Clinton lost the state of Alabama in both the 1992 and 1996 presidential election campaigns. Despite his four years in office, Clinton made little headway in the state in 1996. The electoral map changed little from one election to the next.

1992

- Bush
- Clinton

1996

- Clinton
- Dole

Source: Southern Opinion Research
www.southernopinion.com

Exercise 8.11 requires that you engage in graphics reporting—gathering the information necessary for a chart or graph—as well as creating the graphics themselves. This assignment can be done as an individual, team, or even class project.

Gather as much information as you can about the students at your college or university. Most schools have an office of institutional research that keeps a great deal of information on the students there, or you might begin at the school's public relations office.

Your goal is to create as many graphs as possible (or as many as your instructor designates) about students at your college. You should try to find out information on the size of classes (freshman, sophomore, etc.), the number of males versus females, the number of people who join fraternities and sororities as opposed to those who do not, where students are from, how many are on scholarship, ACT or SAT scores this year and in past years, number of majors in departments or colleges, and where students live. Try to find information that would be appropriate for at least one line, bar, and pie chart. Each graph should have a headline, explanatory box, credit line, and source line.

Alternatively, if this information about your school is difficult to come by, you might want to gather information about students nationally. Many web sites contain this kind of information. You might start with the National Center for Education Statistics (nces.ed.gov), the U.S. Census (www.census.gov), and the College Board (www.collegeboard.com). Your goal is to generate graphics such as the ones shown here. You should try to be creative in your thinking about this assignment and in the place you look for information.

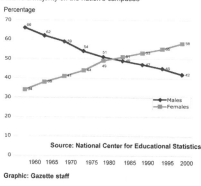

Females student gaining greater majority on college campuses

The makeup of college campuses has changed dramatically since 1960. Male students, once a nearly overwhelming majority, are now a distinct minority. Sometime around 1980, females became a majority on the nation's campuses

Source: National Center for Educational Statistics

Graphic: Gazette staff

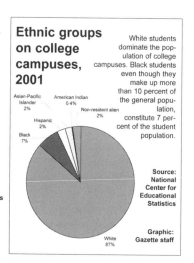

Ethnic groups on college campuses, 2001

White students dominate the population of college campuses. Black students even though they make up more than 10 percent of the general population, constitute 7 percent of the student population.

Source: National Center for Educational Statistics

Graphic: Gazette staff

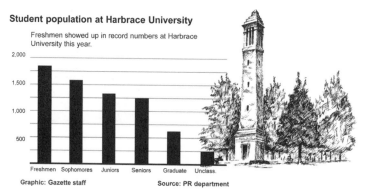

Student population at Harbrace University

Freshmen showed up in record numbers at Harbrace University this year.

Graphic: Gazette staff Source: PR department

chapter

9

Design and Layout

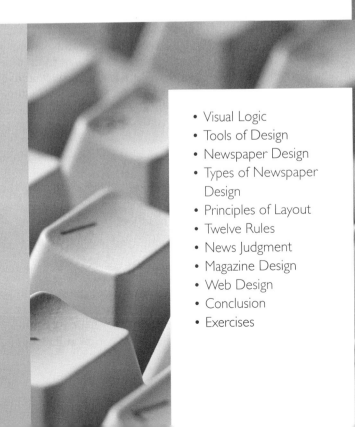

- Visual Logic
- Tools of Design
- Newspaper Design
- Types of Newspaper Design
- Principles of Layout
- Twelve Rules
- News Judgment
- Magazine Design
- Web Design
- Conclusion
- Exercises

Design is a visual process with content as its chief factor. Design is a way of presenting a reader with information and a way of communicating to the reader something about that information. The visual is a highly important way of communicating—in fact, it is the oldest. Images predate text by many centuries.

All of us understand to some extent how important appearance is. Most people spend time grooming themselves and selecting what they wear because they know that their appearance sends a message to others about who they are. It is the same for publications. They communicate to their readers what they are and what they are about by their appearance.

Unlike our basic appearance, however, publications are not made by nature. They are the result of conscious decisions that designers and editors make. Everything on a web site or a newspaper page or in a magazine layout is the product of a decision that someone has made. In design, nothing happens by itself.

Students who are learning design must understand this fact. They control everything that goes on their page. They might be following certain rules, edicts, or traditions when they put together a publication, but physically, there is nothing about design that they cannot change. They must then understand why design for certain types of publications is done in certain ways.

Students must also become observant about design. Our educational systems do a woeful job in teaching us about design and visual logic. Although we spend many hours learning to write or learning to do math, we spend practically no time at all leaning why things look the way they do. Consequently, most of us grow up being completely unaware of design principles. We tend to believe that things "are the way they are" or that they "look the way they look" without any understanding of why this is so.

This chapter will give you some tools to be a good observer of design as well as to teach you some of the principles of publication layout. You should look at a publication from now on and ask yourself why the editor chose to make it look that way—why he or she put articles in certain places, used a specific style of type, or connected elements in particular ways.

Asking these questions will help you to sharpen your visual sense and will make you more aware of what can be done with a publication. People who develop their skills to the point at which they can control the look of a publication often come to enjoy knowing that they can create something that readers pay attention to and that has an impact on the publication. So be aware of design and layout. Give it your critical and analytical attention.

Design refers to the overall appearance of a publication. Layout is the day-to-day use of design rules and principles. Design takes in not only the way in which the elements are laid out on any one page but also how different sections of a publication relate to each other with body type, headline, the way pictures are cropped, the positioning of advertisements, and the types of designs and shapes that are used in standing heads and logos.

Editors must make many decisions in developing a design for their publications. These decisions provide the general rules or guidelines for the layout of the publication.

Visual Logic

Why do we look at things the way we do? The answer to that question is a combination of nature and training that results in what we call *visual logic*.

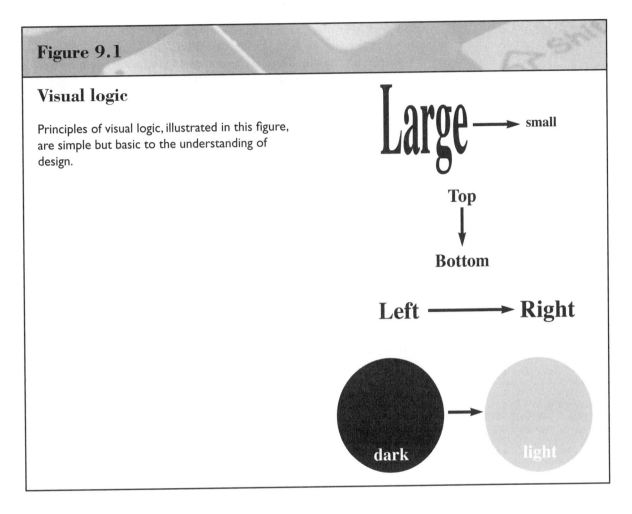

Figure 9.1

Visual logic

Principles of visual logic, illustrated in this figure, are simple but basic to the understanding of design.

The eye, directed by the brain in some way, tends to look at certain things first and other things next. Those directions are simple to observe and easy to catalog.

- *Big to small.* We see big things first, smaller things next. In publications, as in many other parts of life, size matters. We ascribe certain characteristics to "big" and other characteristics to "small."
- *Top to bottom.* For reasons that come from nature and from training, we tend to start at the top and go to the bottom. Reading material is certainly arranged in that fashion, but so are other things in life. Again, we think of the "top" as having certain characteristics while "lower" or "bottom" has other characteristics.
- *Left to right.* With a few exceptions most people in the United States have learned to read from left to right. This training carries over into other aspects of our lives as we encounter the world. Left-to-right is not so much a natural tendency as it is one of training, but it is so much a part of our actions that we tend to think of it as a natural reaction to the visual world.
- *Dark to light.* We tend to look at darker (or more colorful) items first and lighter (or less colorful) items next. It is easier to "see" a darker item than it is a lighter one; our eyes have to work a bit harder on the lighter items.

These principles of visual logic are not immutable. There are exceptions certainly, and the rules can be violated. A publication designer uses these principles, wittingly or unwittingly, to send messages to the reader. Sometimes the design can interrupt these principles to make a point.

With these principles in mind, a designer must understand some basic concepts in putting together elements on a page (or on a web site). Like the principles of visual logic, these concepts are simple, and they are easy to observe—if you are looking for them. (Some of the concepts will be repeated later in this chapter as they apply specifically to newspaper design.)

Balance. This concept refers to putting the elements of design together so that all have the chance to be seen by the viewer. No element that is meant to be seen should be obscured. Big elements should not overwhelm small ones; dark elements should not obscure light ones. (Many web site designers like to use black or dark backgrounds, demonstrating that they are not sensitive to the concept of balance. The dark background overwhelms the type and makes it unreadable.)

Contrast and focus. Contrast is the relationship of design elements as they are viewed by the eye; contrast refers specifically to the difference between these elements. Focus is the way a designer uses contrast to direct the eye of the reader.

Economy/Simplicity. A page designer can do many things, but most things that can be done should not be done. The purpose of design is not design but to present content. Every element that is used in a design should help the reader focus on the content of the publication. No element should be there to call attention to itself.

Repetition/Variety. Any musician can tell you how important repetition is; any publication designer should be able to tell you the same thing. Repeating elements gives strength and stability to a design. That is why designers generally choose one body type and size for their publication. Repeating that element allows the reader to focus on the content that is being presented.

But the reader needs variety as well as repetition. The reader should be shown what to look at first and should be directed to certain items on the page. In musical terms repetition is the beat of the song, while variety is its melody.

Tools of Design

A publication designer has three basic tools with which to work: type, illustration, and white space.

Type. One of the most important tools that an editor has to work with is type. Type is what we use the most. It is a marvelously versatile tool, but we need to understand type from the ground up to be able to use it effectively. In this section we introduce some of the basics about type.

Typefaces are grouped into families, which means that the typefaces share similarities. Those similarities include the weight, or thickness, of the strokes that make up the type and the width of the characters. Type families may have different characteristics, such as bold, extra-bold, roman, and italic.

Modern typefaces are characterized by vertical stress, that is, emphasis on the vertical lines in the typeface; great contrast between thick and thin strokes and hairline serifs. Old-style typefaces have small contrast between the thick and thin strokes, diagonal stress, and capitals shorter than ascenders.

Type families may be divided in other ways, such as display type for headlines, which are designed to gain the attention of the reader, and body type for large groups of characters, or body copy, that are not so intrusive in their purpose. Using a display type for body copy (and vice versa) is one of the major mistakes that page designers can make.

Another way of distinguishing type is by identifying it as serif or sans serif (see the sidebar). Typefaces that have small extensions at the ends of strokes are called serif typefaces; sans serif typefaces do not have these extensions. In serif faces, the strokes that make up the various characters vary in thickness, whereas in sans serif faces they do not.

The chief concern for the page designer in using type is to make it easy for the reader to read. The following are a few of the guidelines that have been developed to aid in this process:

- Use serif type for body copy and sans serif type for headlines.
- Avoid lines of all capitals; they are hard to read. Small caps sometimes provides a good alternative to all caps. If you want to emphasize something, use boldface.
- Italics are harder to read than Roman; avoid blocks of copy in italics.
- Don't overuse boldface, particularly in body copy; bold fonts are well used in headline and other such usages.
- A reverse (using white or light type on a dark background) is a good way to set off type, but don't overuse it. Generally, sans serif rather than serif should be used for reverses.
- Mixing type fonts should be done carefully; the use of too many type fonts on a page is distracting. Newspapers as a rule use three: one for body copy; one for headlines, cutlines, pullouts, etc.; and one for all other uses, such as refers, flags, and logos. Remember that when you have one font, you really have three typefaces because of the ability to use each font in plain, bold, and italic forms. You can load up your computer with a wide variety of typefaces, but don't fool yourself into thinking that you are creative just because you use a lot of them.

Illustration. The second tool of design is illustration. Illustration can be considered anything on a page other than type that uses ink; on a web site it is anything that is not type and not negative space or background.

What we are talking about, of course, is a variety of elements: photographs, illustrations, drawings, charts, graphs, maps, symbols, icons, logos, lines, dingbats, and so on. The major purpose of these elements is to aid in delivering the content of the publication. Sometimes they are heavily content laden themselves (such as pictures), and other times they simply play a supporting role (such as lines that separate other elements).

Sidebar 9.1

Type

Designers must know the different parts of a typeface and its characters to be able to understand how it works. Here are a few of those things you should know.

Classifying Type

The most common classification of type is serif and sans serif. Serifs are small extensions onto the strokes of the typeface. They improve readability of type, and serif type is often used for body type.

Serif and sans serif

serif sans serif

Styles

The four basic styles of type are plain (sometimes called Roman), italic, bold, and bold italic. Bold type is used to capture the reader's attention, but using too much bold destroys that effect. Italic type, especially when it is presented in blocks, is more difficult to read than other styles.

 Roman or plain

 italic

 bold

 bold italic

Leading

Leading is the amount of space measured from the baseline of one line of type to the baseline of another line of type. Leading should always be greater than typesize. For instance, 10-point type should have more than ten points of leading to keep the lines from overlapping.

Leading

Four score and seven years ago, our fathers brought forth on this continent a new nation, conceived in liberty and dedicated to the proposition that all men are created equal.	Four score and seven years ago, our fathers brought forth on this continent a new nation, conceived in liberty and dedicated to the proposition that all men are created equal.	Four score and seven years ago, our fathers brought forth on this continent a new nation, conceived in liberty and dedicated to the proposition that all men are created equal.	Four score and seven years ago, our fathers brought forth on this continent a new nation, conceived in liberty and dedicated to the proposition that all men are created equal.
Palatino **10 point** **10.5 point leading**	**Palatino** **10 point** **11 point leading**	**Palatino** **10 point** **11.5 point leading**	**Palatino** **10 point** **12 point leading**

Sidebar 9.1 (Continued)

Size

Type is measured in points; a point is a part of a measuring system that was developed by printers. There are twelve points to a pica; there are about six picas to an inch (and thus seventy-two points to an inch).

Kerning

Kerning is the amount of space between characters of type. When we talk about kerning type, we are talking about changing the amount of space between the letters.

Kerning

Ty Ty Ty

Anatomy of Type

An important factor about type is its x-height. The x-height of a typeface is one of its most distinguishing features. X-heights can vary greatly from typeface to typeface, and the relationship of the x-height to the other parts of the typeface is important. In many typefaces the larger the x-height, the more readable the type is at smaller point sizes.

The ascender is the part of the type that extends above the x-height.

The descender is the part of the type that extends below the baseline.

Size of type

type 10 point

type 12 point

type 14 point

type 18 point

type 24 point

type 30 point

type 36 point

type 48 point

type 60 point

type 72 point

Anatomy of type

ascender

x-height

descender

baseline

Figure 9.2

Illustration

Strong illustration—in the form of photographs or artwork—can give great impact to a page and can take the reader beyond the words of type. These two compelling pages are good examples of that.

Illustration can help to draw the reader's attention. It can separate elements, or it can unify them. It can give the page visual variety, or it can give the publication the repetition and consistency that we discussed earlier.

In working with illustration elements, designers should always remember that form follows function. That is, delivering the content, which is the first goal of a journalistic publication, is the primary function. The form that the designer creates should help in achieving that goal.

White space. White space (or negative space on web sites that use color backgrounds) is an extremely important but often ignored design tool. If it weren't for white space, we would not be able to see any of the other tools of design. Yet many people who are learning design do not recognize the importance of white space and give little or no consideration to it. They butt headlines and body type against one another, or they put type next to a vertical

Figure 9.3

White space

The effective use of white space can make a page more inviting and readable for the viewer. On this page there is plenty of information, but the designer has managed to leave enough white space that each item on the page can be easily seen. White space is included where it is especially needed: in the large block of body type in the middle of the page.

line. They do not understand that the eye needs "breathing room" to help it separate visual elements.

Other beginners do not understand that too much white space is as bad as too little. They leave vast amount of white space on their pages, revealing that they have no idea about how elements fit together. These pages tend to look tattered and unfinished, yet the creators cannot recognize what is wrong with them because they have not been trained to use white space as a design element.

The key concept in using white space is proportion. There should be enough white space around an element that it can be seen. There should not be so much that the white space becomes distracting. Larger items need more white space; smaller items need less.

The idea of proportion is almost as elusive as the idea of good taste. Yet a sense of proportion can be developed by careful observation and analysis. Students should look at well-designed pages and attempt to analyze what is good about them, particularly the way in which these pages use white space.

Newspaper Design

Newspaper design has three basic and interrelated purposes:

- It should make the paper easy to read. A newspaper has a set design for the same reason that it has a set style: consistency. A reader will

Figure 9.4

Items on a page

This illustration shows the names of some of the items that are commonly found on a newspaper page.

Flag

Headline

Head shot

Gutter

Catchline

Reverse type

Gray screen

Cutline

Box

Byline

Jump line

THE DAILY NEWS

January 20, 1998

Evenson gets 20 years for role in bank robbery

A Brownsville woman received a 20-year prison sentence yesterday for her part in a robbery of the Trust National Bank last year.

Anne Evenson, who lived with her mother on Mine Road before the robbery, wept softly as Circuit Court Judge John Sloan read the verdict to a packed courtroom. The 20-year sentences means that she could be eligible for parole in seven years.

Evenson's attorney, Harriet Braden, said after the court recessed that she is planning to file an appeal.

"I think that we will be able to demonstrate that Miss Evenson was an innocent victim and did not receive a fair trial," she said.

Braden said the appeal will be filed sometime next week.

District Attorney Ed Sims said, however, that he thought the trial had been a fair one and that Evenson had received the sentence she deserved.

Evenson was convicted last week of first degree robbery for driving the get-away car for her boyfriend, Reggie Holder, after he robbed the bank of almost $29,000. Holder was convicted last month for first-degree robbery and also received a 20-year sentence.

Evenson testified during

Ed Sims

Continued on page 4

Wildcat strike
Some workers at the local JVC plant have begun a wildcat strike action against the company. See story on page 5.

The Inside Track

Kenyan President Moi Sworn In, Page 2

Searchers Find SilkAir Crash Voice Recorder, Page 4

China Denies Harboring Pol Pot, Page 2

White House Seeks Social Security Overhaul, Page 4

Report: US Scientists Create "Living Breasts," Page 16

Massacres in Algeria, Burundi, Page 2

Report: Early Rolling Stones Recordings Found, Page 16

Calls for Tax Cuts Premature, White House Says, Page 5

Fertilizer Warehouse Burns in Ohio, Page 7

Winds hammer parts of Europe

By Geoffrey Cornford

LONDON (Reuters) - Gale force winds ripped across Europe at the weekend, causing several deaths, and cutting power to tens of thousands of homes in Britain and France.

The 10-man crew of a crippled trawler 200 miles off southern England were whisked to safety by helicopter Sunday as their vessel threatened to go down in huge seas.

The nine Spaniards and an Irishman were not thought to be injured after their hourslong ordeal, spokesmen for the British coastguard said.

Their trawler, Sonia Naci, had been drifting, battered by 60-foot waves, after engine failure, coastguards in the port of Falmouth said.

Across Britain, roofs were blown off, trees uprooted and power lines cut.

One man was killed after a tree fell on his car in high winds in Wombourne in the West Midlands, police said.

Across Britain, more than 100,000 homes from Cornwall and South Wales to the English Midlands were without power, British media reported.

At Mumbles in south Wales, the local coastguard recorded a wind gust of 115 miles per hour.

The streets of Lyon, France are cluttered with debris after high winds ripped through the city this weekend.

Continued on page 4

Police puzzling over many clues to solve real life murder mystery

By Alexis Smith

Police are searching through an abundance of clues today, trying to find more in the case of a young bank clerk who was found shot to death on Thursday.

The body of John Bailey, 27, was discovered by a passing motorist in a car at 6 p.m. Thursday just off Highway 69, one mile north of the Hale County line. He had been shot in the head. The county medical examiner's office estimated the time of death at 5 p.m.

Bailey was seen arguing earlier at a convenience store parking lot five miles north on Highway 69. Witnesses told police that the argument was with a woman. Neither of them had been inside the convenience store, and it is unclear how long they had been there. Bailey left the store about 4:45 p.m., driving south on Highway 69, and the woman left immediately after him.

Bailey was driving a red, late model Toyota, and the woman was driving a blue Chevrolet. Both were seen driving away at a high rate of speed.

About two miles south of the convenience store, a motorist driving north noticed two southbound cars that fit the description of the cars Bailey and the woman were driving. Both were speeding, and the Toyota was on the shoulder of the road, while the Chevrolet was in the driving lane.

"It looked like the blue car was trying to run the other one off the road," Wayne Marshall, the motorist, said. Marshall said he felt both drivers were

Tuscaloosa

The remains of Fossett's balloon when it landed in Russia.

acting so dangerously that he stopped to call the police. Marshall's call came in to the sheriff's department at 5:05 p.m.

A car fitting the description of the blue Chevrolet was found parked on the banks of the Black Warrior River

Continued on page 4

be confused if he or she finds several spellings in the paper of the same word; so too will the reader be confused if there are numerous styles of body type and headline faces, odd shapes and sizes, and various locations for the daily features of the paper. A good newspaper design sets the rules for reading the paper; these rules should be consistent and functional and should be changed only for specific purposes.

- Newspaper design (the overall objective) and layout (the day-to-day execution) send messages to the reader. The layout of a newspaper is not content-free; that is, with the design and layout, an editor tells the reader what stories are the most important, what elements (pictures, headlines, and story) go together, and which groups of stories are related. A good newspaper design sets the rules for the editor (and the reader) but also allows for some flexibility in day-to-day work.

- Design and layout establish a newspaper's "graphic personality." It is important for a newspaper to establish a particular appearance for the reader and to be consistent in that appearance. Many newspapers, such as the New York *Times*, the Louisville *Courier-Journal*, and the *Wall Street Journal*, have done just that. On appearance alone there is no mistaking these newspapers. It is true that bad newspapers may be clothed in good design, but it is also true that good newspapers with bad or inconsistent designs put added strain on their readers' loyalty. There is no reason for a newspaper to sacrifice form for function; the best papers have both. A newspaper with a pleasing and consistent design—a good "graphic personality"—builds faith and credibility with the reader.

Another important reason for a newspaper to have a clean, consistent graphic personality is that it shows craftsmanship and professionalism on the part of the editors and builds pride among the staff. Staff writers who know that their stories will be well displayed, easy to find, and easy to read will probably work harder to make sure the facts are straight, the stories are well written, and the deadlines are met.

Types of Newspaper Design

Since the advent of headlines, pictures, and other typographical devices, three types of newspaper design have evolved into general use: vertical, horizontal, and modular. Most other designs are variations on these general models, and the student of layout and design should be familiar with the characteristics of each.

Vertical. Vertical design demands an up-and-down movement of the reader's eye on the page. Pages that use this design have a long, narrow look to them. They feature one- or two-column headlines with long strips of body type dropping down from them. The most prominent example of vertical design is the *Wall Street Journal*.

Horizontal. In horizontal design, the elements on a page typically lie along horizontal rather than vertical lines. This effect is created by larger pictures, multicolumn headlines, wider columns of body type than are normally found in

Figure 9.5

Types of design

These simulations take many of the same elements and show the differences between the three major types of design for newspapers. The vertical design (top) is characterized by elements that run up and down on the page and by somewhat smaller headlines than the other two. The horizontal design (lower left) has the elements running from left to right and has generally larger pictures and more multicolumn headlines. In the modular design (lower right) , most of the shapes are rectangular, and all story packages fit into rectangles.

vertical design, and generous but carefully controlled white space. The theory behind horizontal design is that natural eye movement is across a page rather than up and down. Horizontal design evolved as modern printing methods were developed that allowed editors to break column rules (the lines between columns of type) or eliminate them altogether, include larger pictures and headlines, and set copy in differing widths. Many newspapers have now adopted this design.

Modular. Modular design, the most popular today, requires that story packages—headlines, photographs, illustrations, and body type—be shaped into rectangles on the page. These boxes create a unified and unmistakable space for all related items on a page. Such pages are laid out with these boxes in mind rather than the individual elements within each module. Modular design is an outgrowth of computerized layout and editors' tendency toward horizontal design and away from vertical design.

Principles of Layout

Once a consistent design, or graphic personality, has been developed, editors must attend to the daily production of the paper. Someone must lay out each page according to the rules the publication has set. In doing this, editors must give consideration to the five major aspects of newspaper layout: proportion, balance, focus, dynamics, and unity.

Proportion. Proportion is concerned with two interrelated items: the shape of the elements on the page and the relationship of these elements to one another. The most pleasing shapes are those of the 3 x 4, 5 x 7, and 10 x 8 variety. Shapes in which the sides are wildly out of proportion to one another are distracting, confusing, or even boring (such as the square).

A newspaper should work to create pleasing shapes of proper proportions for its readers. Such shapes are simple, familiar, and easy on the eye and give the appearance of a neat, well-planned page. In other words, they make things easy on the readers.

This is not to say that every shape in the newspaper must be rectangular or modular. There is certainly room for variation. However, editors should avoid the jagged or ragged shapes that are caused by inattention to the bottom portions of a story unit or multiline headlines that do not fill out their assigned space. Proportion also refers to the relative sizes of the elements on the page. It means that the headline space should have the proper relationship with the body of the story and with other headlines on the page, that the pictures should be large enough to show the subject adequately, and that large blocks of type unbroken by other elements should not dominate the page. In fact, no typographical element should have accidental dominance over the page.

Balance. Balance refers to the relationship of all the elements on the page and the impression this relationship has on the reader. Pages with a lot of pictures or heavy typographical elements in any one particular part of the page are referred to as being heavy (top-heavy, for example), and except on rare occasions, editors should try to avoid heaviness. Instead, the page should have a good distribution of pictures and headlines.

Figure 9.6

Balance

The balance that this page achieves is achieved because of the placement of the major graphic elements: the pictures. A balanced page has a major graphic element to draw the reader's eye, but it also has other elements that will eventually catch the reader's attention.

The page should also have a mixture of headline styles; that is, there should be a mix of one-, two-, and three-column heads, as well as some single-line and multiline heads. A paper may also use devices such as kickers and hammers (see Figure 6.2 for examples of these). to create white space in the middle of the page and to offset the areas of heavy graphics. Inside pages can be balanced in part by placing pictures away from ads or other unrelated pictures.

Focus. It is natural for the reader's eye to be drawn to some typographical element on the page. The editors should control what that element is, and they should take care that other lines, shapes, and elements on the page do not distract from that focusing element.

A page should be built around a major element, usually a picture. Pictures should not be buried next to ads; nor should pictures or other elements be in competition with each other. The reason editors should pay close attention to the focus of their pages lies in another of the major considerations of newspaper layout: visual dynamics.

Figure 9.7

Focus

Pictures are the most obvious and commonly used graphic elements for focus, as demonstrated on this page. A strong headline can also be a focal point of the page.

Visual dynamics. Readers generally look at a page in a Z-like fashion, beginning with the upper left and moving down the page. It is important for an editor to select a focus above the fold to control the reader's beginning. If the upper left portion of the page is a jumble of heads, pictures, and other typographical elements, readers will be confused and easily distracted from what may be really important. Not knowing where to go on the page, they might miss something or may turn to another part of the paper entirely.

Another way of understanding dynamics is through the concept of rhythm. Rhythm refers to the logical flow of elements that readers are trained to expect when they see a newspaper. A page that has headlines or pictures bunched together can disrupt a reader's rhythm. Readers may then be unconsciously thrown off balance and not know what to expect or where to go in the paper to find the items they really want.

Unity. Newspaper pages should be thought of as a unit rather than a set of typographical elements. These elements should relate well to one another

Figure 9.8

Contrast

The use of contrast on this page is subtle but effective. The designer has surrounded each major item on the page with enough white space that the item is distinctive and highly visible.

on the page, just as the elements of a story package (story, headline, picture, cutline) should form a cohesive unit. The concept of unity takes into account all of the factors discussed above. A page should look as if it were planned on one editor's desk, not on the desks of several people with differing ideas of how the final product should look.

Twelve Rules

The following are some basic rules governing layout of newspaper pages. Not every newspaper follows every rule all the time, and there are cases in which these rules can legitimately be broken. Most of the time, however, these rules should be observed as closely as possible.

1. Avoid "tombstoning" headlines. *Tombstoning* means running different headlines side by side on the page. When headlines are run

together, they can confuse the reader and create an unattractive and cluttered appearance for the page. News editors should try to isolate major elements on a newspaper page. Headlines are more easily seen and break up gray areas better when they stand alone.

2. Avoid placing one headline directly under part of another without copy between (this is called "armpitting"). Again, the idea is to isolate the headline to help it be seen. If headlines run directly under one another, they lose isolation and create confusion.

3. Avoid splitting the page. A split occurs when the vertical space between two columns—called an *alley* in some layout programs and a *gutter* in others—is not crossed by a headline or a picture somewhere on the page. Modern design calls for a unified page. If an alley runs the length of the page, it splits the page in two, destroying both the unity of the page and the reader's eye flow.

4. Avoid large blocks of body type. Masses of gray type discourage even the most interested reader from becoming involved in the story. Make sure there is a good variety of body, headlines, pictures, and other typographical devices on every part of the page.

5. Place major stories on the primary focal point of the page, usually the upper left-hand corner. This should be the strongest part of the page—where the editor places the strongest typographical elements.

6. Use contrasting but not conflicting headline typefaces and styles. The typefaces and styles should complement each other and be consistent. Wholesale use of serif and sans serif faces violates this principle. Simplicity of design and uniformity of page development are the objectives.

7. Use few typefaces and vary size and style (Roman and italic, plain and bold). This guideline is again designed to isolate headlines and make them distinctive. Simplicity is also an abiding consideration. A reader should not have to wade through a great variety of typefaces but should have a page that presents enough variety to be interesting. Let the ad designer come up with new typefaces.

8. Follow the step-down rule. The step-down rule requires that larger headlines appear at the top of the page, with gradually smaller headlines appearing below them. This rule may be violated to maintain balance, especially at the bottom corners, but these violations should occur only to accomplish specific objectives.

9. Let pictures seem to stand on or hang from something. That is, the top of a picture could be aligned with the top of a headline. Photos are major attention getters. They should always help to lead the eye through the page.

10. Never run the copy of a story out from under its headline (except when using a side head) or related photo. Headlines should provide a kind of umbrella for the story. Running copy out from under that umbrella leads to confusion, especially if that copy moves below another headline.

11. Try to avoid running columns of type under a headline in such a way that it creates odd shapes. The more regularly shaped a set of columns is (rectangular, square, etc.), the easier it is for a reader to isolate it visually.

12. Make sure the tops of story packages are level. Story packages include the headline, body type, pictures, and any other material related to the story grouped together on a page. The tops of these groups should form

Guidelines for Laying out a Page

When a news editor has assembled the elements with which he or she will work on any given day, the complex procedure of putting the pages together begins. The procedure is a complex one because numerous decisions have to be made at once, and almost every single decision has some effect on all other layout decisions. For instance, while deciding what to put at the top of a page, the news editor must also be considering what will go at the bottom of the page to create proper balance and contrast.

Because the procedure is so complex and because it will change daily owing to the different elements to be used, there is no step-by-step guide on how to lay out a page. There are, however, some general guidelines or considerations that can be suggested to beginning students who are faced with various typographical elements and a blank computer screen. An editor needs to begin by considering all of the stories, pictures, illustrations, and any other elements available. Using these elements, the editor can form a general picture of the page in his or her imagination. At that point, the editor is ready to place elements on the page.

1. Begin at the top. If the flag is stationary (that is, always located at the top of the page), place it in the layout grid first. If the flag floats (can be moved to another position on the page), make some decision about where it should go on the page.

2. Make some preliminary decisions about where the photos and pictures will be placed on the page. Readers generally will begin looking at a page at the upper left (which is called the primary optical area, or POA). The editor should therefore select for this area the most important item or the one that will best capture the reader's attention. When a decision about the primary optical area has been made, the next logical decision is usually about what will go in the upper right corner of the page.

3. Decide what will be in the lower right corner of the page. This decision needs to be made next, because the upper left element will need some balancing element in the lower right. As with the top of the page, making this decision might also help the news editor decide what should be placed in the lower left corner of the page.

4. When the corners of the page have been filled, the editor should go back to the top of the page and fill in toward the center. Here, of course, the decisions that have already been made on the page will determine what the editor can and cannot do with the rest of the page. Working from the corners to the center of the page is preferable to starting from the top and working down because this way the editor is less likely to leave small or odd holes at the bottom of the page. The center of the page offers the news editor more flexibility than the borders.

a straight line on the page. Avoid, for instance, a three-column headline with a four-column related headline under it. Also avoid placing an adjacent, related photograph or illustration part of the way down a block of related type. It should square up—even with the top of the headline.

News Judgment

On many newspapers the person who lays out the news pages is called the news editor. This person does not carry the title of layout editor because it would not be fully descriptive of the job. The news editor has a more important function than drawing the text and picture boxes for the different pages. The editor's function is one of selection and placement of stories, pictures, and other elements in the story.

To do the job correctly, a news editor not only must have a sense of what will look good on a page and how a page will fit together but also must have a keen sense of news judgment. News judgment is the ability to choose and position the stories, pictures, and other materials that are important to the readers and that are expected from the paper.

The news editor's first job is to select the news of the day. In doing this, it is essential that the editor keep up with the day's events and be able to understand their relative importance. The editor must first read the paper to know what stories have been printed and what needs continuous coverage. A newspaper cannot afford to be episodic in its coverage of important, continuing news events. The news editor must also be aware of the content of other media, not only other newspapers but also radio and television. Many newspapers provide their newsrooms with television sets so that editors and reporters can watch the local news to make sure they have not missed any major items; they may also watch the national news to get an idea of what other journalists have deemed important for that day.

The news editor must also make sure that the paper carries the standard items its readers have come to expect, such as weather reports, advice columns, and news briefs. Compiling and placing such items are tedious jobs, but they are necessary for providing continuity to the paper.

Not only must news editors select items for inclusion in the paper, they also must decide where to place them. (At many newspapers these decisions are made at a daily meeting of editors, but often these decisions provide only guidelines for the news editor.) These decisions about placement are often difficult and sometimes delicate. A story may be "played up" or "played down," according to where it goes in the paper and what kind of headline the news editor assigns to it. To make these decisions, a news editor must have a definite idea of what kind of publication the editors and publishers want the newspaper to be and what the readers' expectations are.

The news editor plays a critical role in the life of a newspaper. On a daily basis this editor's decisions have more to do with the kind of publication that is presented to the reader than do the decisions of any other editor. It should be noted that different departments within the news and editorial division often have separate editors who function as news editors. For example, the sports, living, entertainment, national, and foreign desks may each have such an editor. On small and intermediate-sized papers, copy editors themselves might make many of the decisions on what stories and pictures to use and where to place them.

Figure 9.9

The column inch

A layout editor needs a way of measuring the length of an article in order to fit it onto a page. On many publications one means of doing that is by referring to stories in "column inches." A column inch is the amount of type in a standard body size that would fill one inch of a standard column of the publication. For instance, a story might be six column inches long. This means that the story would fill up 6 inches of one column of the publication. Once the layout editor knows this, he or she can use simple arithmetic to figure out how stories will fit on the page if they are broken into more than one column. For instance, a six–column inch story would fit into 3 inches of two columns or 2 inches of three columns. Understanding the column inch is important to your being able to complete the exercises in this chapter successfully.

4 column inches in two columns

BEIJING - In an effort to raise more funds for economic reforms, China's largest commercial bank has received permission from Beijing to open its first offices in the United States and South Korea, state-run media reported Thursday.

The Industrial and Commercial Bank of China (ICBC) recently won approval from China's central bank, the People's Bank of China, to open a branch in New York and a representative office in South Korea, the official China Daily said.

"Opening more overseas offices is in line with ICBC's development strategy of speeding up international business this year," the article said.

"The purpose of this is to raise

4 column inches in one column

BEIJING - In an effort to raise more funds for economic reforms, China's largest commercial bank has received permission from Beijing to open its first offices in the United States and South Korea, state-run media reported Thursday.

The Industrial and Commercial Bank of China (ICBC) recently won approval from China's central bank, the People's Bank of China, to open a branch in New York and a representative office in South Korea, the official China Daily said.

"Opening more overseas offices is in line with ICBC's development strategy of speeding up international business this year," the article said.

"The purpose of this is to raise

4 column inches in three columns

BEIJING - In an effort to raise more funds for economic reforms, China's largest commercial bank has received permission from Beijing to open its first offices in the United States and South Korea, state-run media reported Thursday.

The Industrial and Commercial Bank of China (ICBC) recently won approval from China's central bank, the People's Bank of China, to open a branch in New York and a representative office in South Korea, the official China Daily said.

"Opening more overseas offices is in line with ICBC's development strategy of speeding up international business this year," the article said.

Sidebar 9.3

Handling Inside Pages

The following are some guidelines and suggestions for handling inside pages:

1. Each page should carry a dominant headline.
2. Each should have a good attention getter, a focus around which other elements on the page revolve.
3. Each should have a good picture, especially at the top of the page and set away from the ads. This could be the attention getter referred to above.
4. If a page is tight (that is, if there isn't much room for editorial matter on the page), one long story is preferable to several shorter ones.
5. If a page is open (that is, at least one third is left for news), try to align a story with the highest ad and thus square off the rest of the page for editorial matter. Doing this can increase your flexibility in laying out the rest of the page (see illustration.)

6. Another thing editors who deal with front and inside pages must be concerned with is "jumps." A story that begins on one page and continues onto another is known as a "jumped story." The part of the story that is continued on the second page is called the "jump," and the headline over that part of the story is called the "jump head." "Jump lines" are those lines at the end of the first part of the story ("Continued on Page 2") and at the beginning of the jump ("Continued from Page 1").

A newspaper should have a consistent style in handling jumped stories, jump lines, and jump heads. Some newspapers, such as *USA Today,* try to avoid jumps almost entirely, but most papers find that this policy is not feasible. The best jump lines try to inform the reader of the jump head and the page number of the jump, such as "See PRESIDENT, Page 2." Jump heads may be just one word or rewrites of the first page headline, or they may refer to an element in the jumped portion.

Magazine Design

The fundamentals of design of print publications do not differ radically from publication to publication. What differ are the content of the publication, its purpose, and its audience. Magazines are certainly different from newspapers, but many of the same principles that we have discussed for newspaper design and layout apply to magazines.

Figure 9.10

Dummy sheet

A dummy sheet serves as a guide to what the designer wants to do with a page. It does not have to be extremely detailed, but it does need to indicate the placement of the major items on the page.

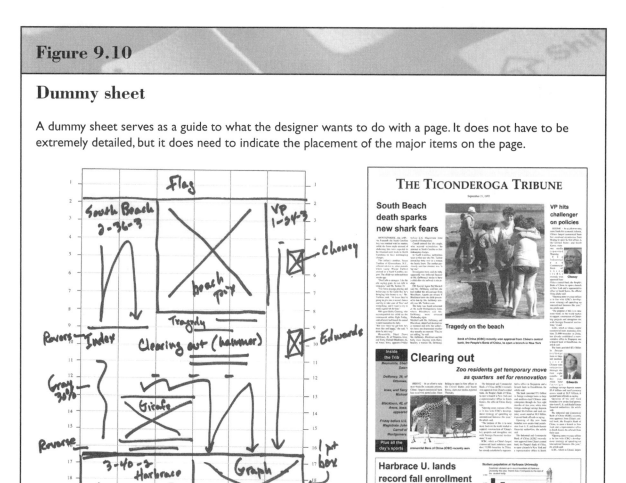

Magazine designers (sometimes called art directors) must observe the same rules of visual logic that were presented earlier in the chapter. They also have the same tools: type, illustration, and white space. What, then, are the differences? There are a few that are obvious:

- Magazines are generally published in smaller formats than newspapers. Many magazines are printed on 8- × 11-inch paper. A designer will have less space to work with on a single page but will have more pages at his or her disposal.
- Magazines are likely to have fewer layout rules and less standardization. Many people who work in design believe that they can exercise more creativity in the magazine field than in newspapers (although many newspaper people would take exception to this idea). Many parts of many magazines are heavily formatted; that is, they remain the same from issue to issue. But other parts of the magazine, particularly the feature articles, allow designers to use type, photos, and illustrations in ways that newspapers could not afford.

- Content is more likely to influence design in magazines than in newspapers. An individual article in a magazine might suggest or dictate its design. The purpose of the design of an article is to help distinguish it from other articles within the publication (not necessarily, as in newspapers, to use space efficiently).
- White space is used more freely in a magazine than in a newspaper. White space, as we learned earlier, increases the emphasis on the items it surrounds; the more white space, the more emphasis an item—whether it be type or illustration—has. Part of a magazine designer's job is to decide how much and where this emphasis should be put. Magazines do not have unlimited space. In fact, one of the regular complaints that magazine designers make is that they are too confined; they do not have enough pages to work effectively. Still, white space is generally used more frequently in magazines than newspapers.
- Magazine design should help the reader to read through an entire article. Designers are concerned with more than the beginning of the article. They try to make each page of the article legible and inviting. Each publication develops devices such as pull quotes or illustrations that can break up the columns of type on each page and offer visual aids for getting the reader through the article.
- Covers for magazines get special attention from designers. One of the most important parts of a magazine is its cover, and most magazines spend a lot of money and time in producing the right cover each time an issue of the magazine is published. A cover is the first look that a reader has, and many magazines try to be especially provocative or informative (or both) on the cover. If a large part of the magazine's circulation comes from sales at newsstands, an attention-getting cover can be a necessity.

Web Design

In the first decade of their existence—and with relatively little experimentation—most news web sites developed a set of standard elements and a fundamental standardization of their look. Critics of the way in which news organizations treated the Web (often with benign neglect, sometimes with outright hostility) blame this homogenization of design on the unwillingness of these organizations to put time and resources into their sites. Others who are less critical of journalism's treatment of the Web say that readers quickly developed expectations that news web sites had to meet.

Whatever the case, most news web sites today have a flag, a navigation bar that contains links to various sections of the site, a headline and summary for the top story or stories, and a picture. Some news web sites try to emulate, in some ways, the look of their parent print organizations. (For some years the New York *Times* web site used the same type font for its Web headlines that was used in the print edition. The *Times* has since stopped that practice.)

Web designers have the same rules of visual logic, the same principles of design, and the same tools of design that other publication designers have. But

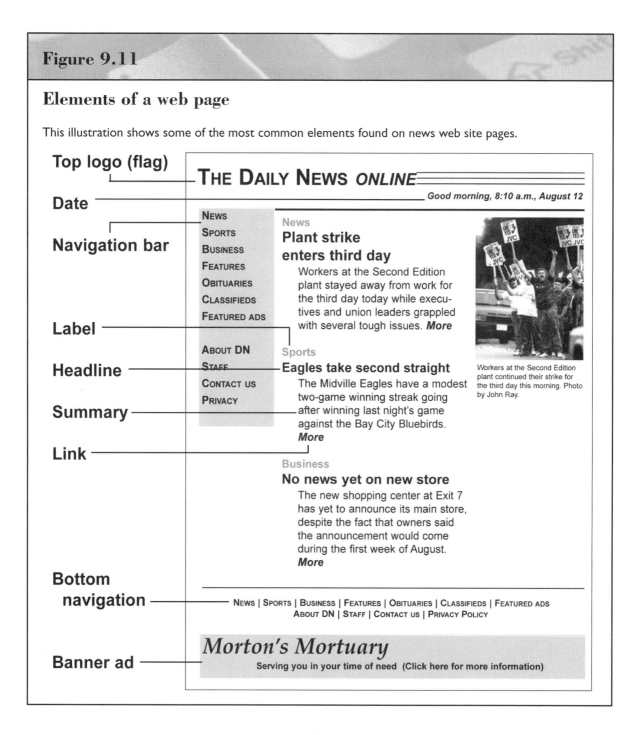

Figure 9.11

Elements of a web page

This illustration shows some of the most common elements found on news web site pages.

Top logo (flag)

Date

Navigation bar

Label

Headline

Summary

Link

Bottom navigation

Banner ad

THE DAILY NEWS *ONLINE*

Good morning, 8:10 a.m., August 12

NEWS
SPORTS
BUSINESS
FEATURES
OBITUARIES
CLASSIFIEDS
FEATURED ADS

ABOUT DN
STAFF
CONTACT US
PRIVACY

News
**Plant strike
enters third day**
Workers at the Second Edition plant stayed away from work for the third day today while executives and union leaders grappled with several tough issues. *More*

Sports
Eagles take second straight
The Midville Eagles have a modest two-game winning streak going after winning last night's game against the Bay City Bluebirds. *More*

Business
No news yet on new store
The new shopping center at Exit 7 has yet to announce its main store, despite the fact that owners said the announcement would come during the first week of August. *More*

Workers at the Second Edition plant continued their strike for the third day this morning. Photo by John Ray.

NEWS | SPORTS | BUSINESS | FEATURES | OBITUARIES | CLASSIFIEDS | FEATURED ADS
ABOUT DN | STAFF | CONTACT US | PRIVACY POLICY

Morton's Mortuary
Serving you in your time of need (Click here for more information)

because the Web is a different medium from print or magazines, it challenges designers with a different set of considerations:

- The area of the computer screen is relatively small. Although some computer screens are large, most people will be viewing a news web site with a screen that is only about ten to twelve inches wide. Such a dimension will limit what a designer can do with the content he or she has to present. Readers will tolerate vertical scrolling, but horizontal scrolling places too much of a burden on the reader.

- A fundamental characteristic of the Web is linking: the ability of the reader to go from page to page on a site and even to move to and from a site. A Web designer has to take this characteristic into consideration when designing web pages. The designer can control how much (or how little) the reader can navigate and how easy this navigation is to find and use. Links should be clearly identified so that they are not only seen by the reader but also easily understood.
- The way in which a web site is organized has a great effect on its design. Most news web sites follow a standard organization: a front page, sections (news, sports, etc.) and section front pages, and article pages. Each of these types of pages requires a similar but distinctive design, one that is consistent with the overall look that the site wants to present but different enough to be recognized and understood by the reader.
- A web site should load as quickly as possible onto a user's screen. This factor—load time—is dependent on how much information a page contains. Web pages that have a lot of pictures and graphics are thought to be "heavy" in the sense that they take longer to load than those that do not. Text is the "lightest" element to load. A web page designer has to achieve a balance between making a page light and making it visually interesting. Such a balance is not easy to achieve.

During the first decade of the Web as a medium for news, journalists tended simply to load what they had produced for other media onto the web site. In some cases this "shoveling" of content onto the Web worked fairly well, but journalists have begun to realize that the Web is truly a different medium. In recognition of this fact, as the Web proceeds into its second decade of use by journalists, more and more journalistic content is being produced exclusively for the Web.

One characteristic of this Web-exclusive content is that it is shorter. Reading is harder on a screen than it is on a page, and readers are more likely to abandon long, multipage articles than they are the short snippets and bits of information. Weblogs, also known as "blogs," are an excellent example of the reduction of the number of words that are used on the Web. Summaries (also discussed earlier) are another example. As this trend continues, the design of web sites will undoubtedly adjust to accommodate and enhance this content.

Conclusion

The principles and tools of design are relatively simple and do not change radically from medium to medium. Because they are so stable, these principles and tools allow designers to learn the basics quickly and to begin working creatively in a short amount of time. Those who would enter this field must learn to look at publications critically, break down their elements, and analyze their uses carefully.

chapter

9

Exercises

The exercises in this chapter section are designed to give students practice in various aspects of design and layout. The general purpose of these exercises is to enhance the student's skills in handling the general elements of design: type, illustration, and white space. The exercises are also designed to teach the basics of newspaper design; although the chapter discusses some of the aspects of magazine and Web design, those techniques are beyond the scope of this book.

The first four exercises are designed specifically for students and classes with access to page layout programs such as Quark or InDesign. Instructors who are using this book as a text should contact Allyn and Bacon or the authors directly for a disk with the electronic files that go with these exercises.

The remainder of the exercises may be completed with or without access to a computer lab. If computers and page layout software are not available, students can still select stories and photographs for pages, crop and size photos, and draw a design on one of the dummy sheets in this section.

Instructors should remember that elements of exercises in previous chapters can be integrated into these exercises. For instance, the following can be done:

- Students can be assigned to edit a story from one of the early chapters of the book and to include that edited story in their layouts.
- Students can be asked to use one of the pictures from the exercises in Chapter 7 as part of their layouts.
- Students may be required to build and use one of the charts in the exercises in Chapter 8 in developing their layouts.

In preparing to complete these exercises, students and instructors should study the layouts produced for the figures in this chapter. Simulating what they see in those layouts—the designs, picture cropping, headline styles, and so on—would be an excellent starting point for students working in this section.

The sequence of the exercises is important. Each one builds on the skills developed in preceding exercises. Students should master those skills before moving on.

Exercise 9.1: Five-Minute Layout

This exercise will help you in learning how to use your page layout program. Practice this exercise until you are able to set this page up in about five minutes.

1. Draw a text block for the headline. It should start at 1 inch down and 1 inch across and should be 6.75 inches wide and .667 inch high. Type in "Lincoln's Gettysburg Address." That should be in 30-point bold of a sans serif type such as Helvetica.
2. Draw a second text block. It should start at 1 inch across and 1.75 inches down; it should be 3 inches wide and about 9 inches high. Call in the file "Gettysburg address" from Exercise folder 9.1. Change the type to 10-point of a serif type such as Palatino. At the end of the file, hit the Return key a couple of times and type your name. Expand your text block if necessary.
3. Draw a picture block to the right of the second text block. It should start at 4.5 inches across and 1.75 inches down on the page. Call in the file "Lincoln cartoon" from the Exercise 9.1 folder. Resize the picture so that X is 75 percent and Y is 75 percent. Move the picture to the left so that it is centered in the picture block.
4. Save your file with an appropriate name.
5. Print out your file.

The screen shot shown here indicates how the page might look in a page layout program. You can see the borders of the text and picture blocks. The second picture shows the page as it should look when it is printed.

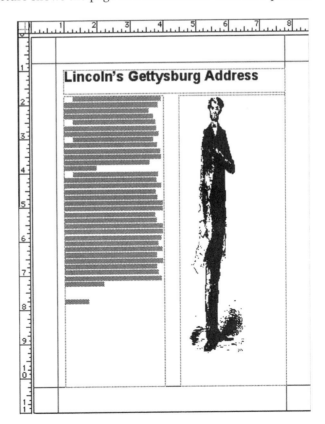

Lincoln's Gettysburg Address

Four score and seven years ago, our fathers brought forth on this continent a new nation, conceived in liberty and dedicated to the proposition that all men are created equal.

Now we are engaged in a great civil war testing whether that nation, or any nation so conceived and so dedicated, can long endure.

We are met on a great battlefield of that war. We have come to dedicated a portion of that field as a final resting place for those who here gave their lives that the nation might live. It is altogether fitting and proper that we should do this.

But, in a larger sense, we cannot dedicate, we cannot consecrate, we cannot hallow this ground. The brave men, living and dead, who struggled here have consecrated it far above our poor power to add or detract. The world will little note nore long remember what we say here, but it can never forget what they did here. It is for us the living, rather, to be dedicated here to the unfinished work which they who fought here have thus far so nobly advanced. It is rather for us to be here dedicated to the great task remaining before us – that from these honored dead we take increased devotion to that cause for which they gave the last full measure of devotion; that we here highly resolve that these dead shall not have died in vain; that this nation, under God, shall have a new birth of freedom; and that the government of the people, by the people, for the people, shall not perish from the earth.

Joe Student

Exercise 9.2: Thirty-Minute Layout

This exercise will help you learn your page layout program. It will also give you some practice in working with the standard elements of a newspaper page. You should practice doing this page until you are able to complete it in about thirty minutes.

Read the following guidelines carefully:

- All headlines should be in a sans serif bold font.
- All body copy should be in a serif font, 10 point, and justified. Tabs should be .25 inch.
- Runarounds for pictures should be 3 points.
- Bylines should be sans serif, 12 point, bold, italic, and a 1-point line should run below them.
- Jump lines should be sans serif, 12 point, bold.

As much as possible, try to make your page look like the one shown here.

THE DAILY NEWS

January 20, 1998

Smith asks for reduction in commissioners' pay

Jonathon Malloy

Midville - A citizens' group says it has the answers to Washington County's financial crisis: reduce commissioners' salaries and benefits, and eliminate a local law that allows tax money to be used for private roads.

Led by Joe Smith, a Midville automobile dealer, about 26 residents have circulated a petition that outlines a plan to restructure the county government and have filed a lawsuit that would stop the use of county money to build, maintain and repair private roads. S.J. Laurie, the group's attorney, said both actions should reduce the county's debt.

"The county is in a dire financial straight," Laurie said.

"And what we're saying is, 'Hey, if you're broke, let us tell you how to fix it. Let us tell you how to be unbroke.'"

In fiscal year 1995, Washington County borrowed $400,000 to meet operating expenses such as payroll, utilities and the unpaid portion of the solid waste debt. The debt was repaid this year, county officials said.

For the past three or four years the county has taken out a short-term loan to pay operating expenses, county officials said.

Washington County, with a

population of about 16,000 people, has an estimated budget of almost $6 million.

Probate Judge John Armstrong said both measures by the citizen's group have been designed to torpedo the 2-cent sales tax issue that is expected to appear on the June primary ballot. "They'll tell you the two are not related, but I say they are," he said.

Proceeds from the tax would be used to offset the county's unpaid solid waste debt, expected to reach $550,000 this year

Continued on page 4

John Smith

Wildcat strike
Some workers at the local JVC plant have begun a wildcat strike action against the company. See story on page 5.

The Inside Track

Kenyan President Moi Sworn In, Page 2

Searchers Find SilkAir Crash Voice Recorder, Page 4

China Denies Harboring Pol Pot, Page 2

White House Seeks Social Security Overhaul, Page 4

Report: US Scientists Create "Living Breasts," Page 16

Pope Deplores Massacres in Algeria, Burundi, Page 2

Report: Early Rolling Stones Recordings Found, Page 16

Calls for Tax Cuts Premature, White House Says, Page 5

Fertilizer Warehouse Burns in Ohio, Page 7

Weather, Page 16

Sports, Page 24

Winds hammer parts of Europe

By Geoffrey Cornford

LONDON (Reuters) - Gale force winds ripped across Europe at the weekend, causing several deaths, and cutting power to tens of thousands of homes in Britain and France.

The 10-man crew of a crippled trawler 200 miles off southern England were whisked to safety by helicopter Sunday as their vessel threatened to go down in huge seas.

The nine Spaniards and an Irishman were not thought to be injured after their hours-long ordeal, spokesmen for the British

coastguard said.

Their trawler, Sonia Naci, had been drifting, battered by 60-foot waves, after engine failure, coastguards in the port of Falmouth said.

Across Britain, roofs were blown off, trees uprooted and power lines cut.

One man was killed after a tree fell on his car in high winds in Wombourne in the West

Midlands, police said.

Across Britain, more than 100,000 homes from Cornwall and South Wales to the English Midlands were without power, British media reported.

At Mumbles in south Wales, the local coastguard recorded a wind gust of 115 miles per hour.

Ferry services from Dover to Calais were disrupted as Sea-France suspended all sailings and P & O cancelled half, port officials said.

A Stena Lines ferry sailing from Harwich in England to the Hook of Holland Sunday lost

Continued on page 4

The streets of Lyon, France are cluttered with debris after high winds ripped through the city this weekend.

Police puzzling over many clues to solve real life murder mystery

By Alexis Smith

Police are searching through an abundance of clues today, trying to find more in the case of a young bank clerk who was found shot to death on Thursday.

The body of John Bailey, 27, was discovered by a passing motorist in a car at 6 p.m. Thursday just off Highway 69, one mile north of the Hale County line. He had been shot in the head. The county medical examiner's office estimated the time of death at 5 p.m.

Bailey was seen arguing earlier at a convenience store parking lot five miles north on Highway 69. Witnesses told police that the argument was with a woman. Neither of them had been inside the convenience store, and it is unclear how long they had been there. Bailey left the store about 4:45 p.m.,

driving south on Highway 69, and the woman left immediately after him.

Bailey was driving a red, late model Toyota, and the woman was driving a blue Chevrolet. Both were seen driving away at a high rate of speed.

About two miles south of the convenience store, a motorist driving north noticed two southbound cars that fit the description of the cars Bailey and the woman were driving. Both were speeding, and the Toyota was on the shoulder of the road, while the Chevrolet was in the driving lane.

"It looked like the blue car was trying to run the other one off the road," Wayne Marshall, the motorist, said. Marshall said he felt both drivers were acting so dangerously that he stopped to call the police. Marshall's call came in to the sheriff's

Tuscaloosa

The remains of Fossett's balloon when it landed in Russia.

department at 5:05 p.m.

A car fitting the description of the blue Chevrolet was found parked on the banks of the Black Warrior River just west of where Bailey's body was found. The car was discovered about an hour after police examined Bailey. Police then followed a pathway that leads north along the river bank. About a

Continued on page 4

Exercise 9.3: Placement of Elements—Writing Headlines

The purpose of this exercise is to get some practice in working with a page layout program and to gain some understanding about how pages are built. Follow the instructions below and copy the page shown here as closely as possible.

1. Begin by opening a new file in your page layout program. Select the legal size format and designate that you want your page divided into three columns. Now save your file and give it an appropriate name. Remember to save your file periodically.

2. Draw a text block across the top of the three columns that is about 1.5 inches deep. Type in "The Daily News" (or some appropriate name), center the words, and make them as big as possible inside the text block (suggested size: 48 point).

3. Draw a second, much smaller text block under the first. It should also extend across the three columns. Type the date in this block and center it. Now, using the line tool, draw lines across the top and the bottom of the text block.

4. Draw two more text blocks under the date text block. The first should be 1 inch deep, and the second should be about 3.5 inches deep. The second text block should be divided into three columns. Call in the "Kidnapping" story from your file folder (or any other story if that one is not available) into the second text block. The type should be 10 point and a serif type font. Justify the type. In the text block above that, write a headline for the story that you used. You should use a serif type in 30 or 36 point.

5. Repeat the steps in the previous instructions for the next two stories. Write headlines for the stories that you use.

6. Draw a picture block on the page on top of the text block in the middle of the page, as shown in the picture. Call the "China map" file into that text block. You will need to reduce the width and length of the picture by 35 percent.

THE DAILY NEWS

October 1, 2005

Headline

MONTGOMERY, Ala. (AP) — An 8-month-old North Carolina boy was reunited with his mother, while the Iowa couple accused of abducting him were expected to be returned next week to North Carolina to face kidnapping charges.

The infant's mother, Susan Tarlton of Greensboro, N.C., offered advice to other parents when Larry Wayne Tarlton arrived at a North Carolina airport. The child was abducted three weeks ago.

"Don't talk to strangers. Like the old saying goes, do not talk to strangers," said Ms. Tarlton, 25.

"I've been praying praying and believing in the Lord that he's bringing him home to us," Ms. Tarlton said. "At least they're going to give me a

second chance and try to take care of 'Boo' and everything, and I want to try to make a good life for him."

FBI agent Kathy Canning, who accompanied the child on the commercial airline flight Friday, said officials had feared the ordeal would traumatize the baby.

"But ever since we got him, he's been fine and happy," she said. "I think he khis way."

Meanwhile, Sheri Dawn DeMoney, 26, of Ottumwa, Iowa, and Terry Michael Blackburn, 42, of Ames, Iowa, appeared Friday before U.S. Magistrate John Carroll of Montgomery.

Carroll ordered that the couple, who waived extradition, be returned to North Carolina to face kidnapping

charges.

In North Carolina, authorities want to find out why Ms. Tarlton turned her baby over to a woman she barely knew. The mother previously said her mistake was "a big one."

Investigators have said the baby apparently was abducted because of Ms. DeMoney's desire to have a child after she suffered a miscarriage.

FBI Special Agent Pat Mitchell said Ms. DeMoney told him she had hidden the miscarriage from Blackburn. Agents are unsure if Blackburn knew the child presented to him by Ms. DeMoney actually was Ms. Tarlton's son.

The baby was found unharmed at the north Montgomery home where Blackburn and Ms. DeMoney were

Headline

BEIJING – In an effort to raise more funds for economic reforms, China's largest commercial bank has received permission from Beijing to open its first offices in the United States and South Korea, state-run media reported Thursday.

The Industrial and Commercial Bank of China (ICBC) recently won approval from China's central bank, the People's Bank of China, to open a branch in New York and a representative office in South Korea, the official China Daily said.

"Opening more overseas offices is in line with ICBC's development strategy of speeding up international business this year," the article said.

"The purpose of this is to raise more funds on the world market to

support construction of China's key projects and strengthen ties with foreign financial institutions," it said.

ICBC, which as China's largest commercial bank maintains more than 31,000 branches in China, has already

Headline

CAMBRIDGE, Mass. (AP) — A 17-year-old British math prodigy has accepted a one-year post as a visiting lecturer at Harvard University, becoming one of the youngest Ivy League faculty members ever, Harvard officials said Friday.

Ruth J. Lawrence was taught by her father in their home in Huddersfield, England, and had never been to school before she entered Oxford University at age 11 in 1983.

She graduated from the prestigious British university just two years

later, at age 13, and expects to receive a doctorate in mathematics there this year.

"She's a very pleasant, well-balanced person, happy to talk about various topics and not particularly aggressive or particularly shy," said Vaughan Jones, a professor of mathematics at the University of California at Berkeley.

Lawrence was courted by several leading American universities, including Berkeley and the Institute for Advanced Studies at Princeton

University in New Jersey, before she accepted Harvard's offer.

Jones, who has visited Lawrence in England, said she is a vegetarian and likes bicycling on a tandem bike with her father, a computer consultant.

While at Oxford, she earned a reputation as "the best undergraduate ever in math there," Jones added.

Harvard officials said she will arrive in the fall and spend her first semester in Cambridge doing research, free of teaching responsibili-

Exercise 9.4: Placement of Elements—Writing Headlines

The purpose of this exercise, as with the previous exercise, is to let you copy a layout to practice working with a page layout program and to gain some understanding about how pages are built.

1. Begin by opening a new file in your page layout program. Select the legal size format and designate that you want your page divided into three columns. Now save your file and give it an appropriate name. Remember to save your file periodically.

2. Draw a text block across the top of the three columns that is about 1.5 inches deep. Type in "The Daily News" (or some appropriate name), center the words, and make them as big as possible inside the text block (suggested size: 48 point).

3. Draw a second, much smaller text block under the first. It should also extend across the three columns. Type the date in this block and center it. Now, using the line tool, draw lines across the top and the bottom of the text block.

4. Draw in the text blocks at the appropriate parts of the page. Call in the stories to the text blocks from the Exercise 9.4 folder or some other place where articles are stored. The "General Mills" story is the top story; the "British airline" story is in the middle; the "Guinness" story is at the bottom of the page. (Other stories may be used, of course, if these stories are not available.)

5. On the lower left of the page you will need to create an index box. Shade the box with a black, 20 percent background. The type should be a serif font, 14-point bold, and you will need to supply the sections and page numbers.

6. All of the body copy in the stories should be in a serif font, 10 point, and justified. For each story there is more copy than will fit into the text blocks that you have drawn. Don't worry about that now.

7. Draw a picture block on the page where it is indicated at the upper right. Call in a picture from your folder for this exercise and size it proportionally to fit the space.

8. Write the headlines that are assigned on the page. Follow any other instructions that are given.

THE DAILY NEWS

October 1, 2005

2-36-2
Headline

MINNEAPOLIS – Food giant General Mills Thursday issued a consumer alert of a potential almond allergy problem involving selected boxes of Kix cereal.

The company said it was issuing the alert "as a cautionary measure after learning that a very limited number of Kix packages may contain pieces of another General Mills breakfast cereal whose ingredients include almonds."

While not a problem for most consumers, the potential presence of almonds in Kix is a concern for consumers who are allergic to almonds.

There is nothing on the Kix cereal package ingredient listing to indicate the presence of almonds in the cereal, General Mills noted.

General Mills said that the potentially affected packages of Kix cereal are limited to 9 and 13 ounces with a "Better If Used By" code of 22 MAR 94 X212 or 23 MAR 94 X212 or 23 MAR 94 X210 printed on the top of the box.

Packages of Kix cereal with other code dates are not affected, the food company said.

General Mills said it is having any Kix cereal carrying the code dates

3-30-1 Headline

LONDON — Britain's biggest charter airline announced Tuesday it was to cut 560 jobs as part of a 250 million pounds ($387 million) modernization program.

Britannia said the bulk of the jobs would be lost from its engineering work force because it was reducing the size of its aircraft fleet and replacing older Boeing 737s with new Boeing 757s.

The airline, the second-largest in Britain, said it would acquire seven new Boeing 757s by May 1994. These are to be powered by Rolls Royce RB211 engines.

In the next 15 months, Britannia will add a total of 14 new Boeing 757s to its fleet, increasing its total passenger capacity by 5 percent, but reducing the total number of aircraft it operates to 29, from 38.

Around 100 of the job losses will come from the transfer of its ground handling operation at its base, Luton Airport, about 20 miles (32 km) north of London, to Servisair Ltd.

A Britannia spokesman said that Servisair was likely to keep on many of the Britannia ground staff.

2-30-2
Headline

LONDON — Alcohol-giant Guinness PLC announced plans Tuesday to cut 700 jobs from its whisky business in Scotland over the next two years as part of a reorganization plan.

"This major reorganization and investment program reaffirms our commitment to modernize and upgrade our production facilities for Scotch whisky, and to take the steps we believe are necessary to continue to lead the industry," company Chairman Tony Greener said.

Guinness said the job cuts would affect its United Distillers unit, which employs some 5,000 people.

Guinness also announced reorganization of its Spanish beer operations — a move the company said would lead to an unspecified number of job cuts there, too.

The alcohol-maker said the two reorganizations represent part of a 3-year, $155 million investment program.

As part of the plan, Guinness plans to concentrate its Scottish packaging operations in three sites, as well as reorganize its distilling facilities "to bring production in line with future expected demand," the company said in a statement.

However, Guinness said it would try to eliminate the 700 jobs through voluntary layoffs, early retirement and attrition.

As for its Spanish operations, Guinness said that in response to "changed conditions in the Spanish beer market," the company plans to accelerate reorganization of its Cruzcampo brewing group, Spain's leading brewer.

Guinness said the reorganization would include an early-retirement program for Spanish employees.

As part of the plan, Guinness plans to concentrate its Scottish packaging operations in three sites, as well as reorganize its distilling facilities "to bring production in line with future

Index	
World news	Page 2
State news	Page 4
Editorials	Page 7
Features	Page 10
Business	Page 14
Lifestyles	Page 18
TVlistings	Page 24
Comics	Page 28
Weather	Page 30

Exercise 9.5: Copying Layout—Writing Headlines and Cutlines

If you have successfully completed the exercises up to this point, you are ready to take on something a little more complex. This exercise asks you to copy the layout shown here. Make your page look as much like the one you see as possible. The text and picture files for this exercise are found in the Exercise 9.5 folder, or your instructor may supply you with a different set of files.

Begin by opening a new file in your page layout program. Select the Tabloid size for a page format and divide the page into five columns. As you did in previous exercises, create the flag at the top of the page. Now draw the headline and text blocks for the stories, and call the story files into the appropriate blocks. Draw the picture blocks and text blocks for the cutlines.

Do not be concerned that the stories do not fit into the text blocks. Where they do not fit, create a text block at the bottom of the story that says "Continued on Page 2" as shown here.

Write the headlines and cutlines for this page in the appropriate text blocks that you create for the page. Use the following information in writing the cutlines:

Auto talks march. UAW workers, marching in New York City near the Chrysler building; workers not on strike but say march is to serve as a warning to company.

In the swing. Students at Alberta Elementary; yesterday; during recess; warmest day of the month so far. Photo by Amy Kilpatrick.

THE DAILY NEWS

October 1, 2004

Headline

DETROIT — Top negotiators for Chrysler Corp. and the United Auto Workers bargainedMonday night toward a midnight expiration of their extended contract, but theunion urged workers to remain on the job until told otherwise.

Chrysler s 67,000 U.S. hourly employees have been working since Sept. 15under extension of a contract negotiated in 1988. On Friday, however, frustratedby the slow pace of bargaining, the UAW told the No. 3 carmaker that pact would-expire at 11:59 p.m. EST Monday.

This allows the UAW to authorize a company-wide walkout, or more likely,target specific Chrysler plants like its minivan plant in Fenton, Mo., if atentative accord is not reached.

UAW spokesman Bob Barbee said bargainers were negotiating in subcommitteesessions all day, but that no central meetings had taken place by midevening.

Last week, the union scheduled a Thursday meeting in Detroit of its100-member Chrysler Bargaining Council, an indication that it expected to have atentative agreement in hand by Tuesday at the latest. The council must approveany agreement before workers vote on it.

The UAW is insisting that Chrysler follow the pattern

agreement reached with industry leader General Motors Corp. last month, and at second-ranked FordMotor Co. early this month.

Chrysler, which earlier Monday posted a third-quarter loss of $214 millionor 95 cents a share — its second quarterly loss since 1982 — said it cannotafford the contracts reached at GM and Ford, which contain generous pensionincreases and job and income guarantee packages.

Instead, company negotiators said Chrysler needs special consideration toremain competitive, with one issue being pension costs. Chrysler has the highestratio of retirees to active workers and the oldest workforce among the nation sBig Three automakers.

But late last week, Chrysler Canada signed a pact with the Canadian AutoWorkers union in Toronto that follows the CAW contracts reached at the Canadianoperations of GM and Ford. That fueled speculation that Chrysler would have toaccept a similar deal on this side of the border.

But industry analyst Ronald Glantz, of Dean Witter Reynolds San Franciscooffice, said Chrysler's latest losses call into question the UAW sinsistence on matching the GM and Ford contracts.

Those losses were aggravat-

Continued on page 2

Cutline

Headline

CAPE HATTERAS, N.C. — The severed bridge that is the only link between Hatteras Island and themainland could be repaired within 45 days, state officials say.

Previous estimates indicated repairs could take at least six months. Adredge battered the bridge during a Friday storm, causing a 370-foot section ofthe structure to collapse.

Residents of Hatteras and nearby Ocracoke Island are anx-

ious to see theHerbert C. Bonner Bridge repaired. Hundreds of cars were waiting Monday morningfor ferry service across Oregon Inlet to the mainland, officials said.

Sunday night, more than 500 cars waited to catch ferries from Ocracoke tothe mainland. Red Cross volunteers distributed food, coffee and blankets tomotorists who waited in line throughout the night to keep their spots.

Officials told residents on Sunday it would take at least 30 hours to moveeveryone waiting in line off Ocracoke. Tourists were told to remain on Hatterasuntil the traffic thinned.

State and local officials met with residents Sunday at Cape Hatteras Schoolto brief them on bridge repair plans and emergency response efforts. Thirty-ninepeople on Sunday stayed at

Continued on page 2

Headline

Cutline

PITTSBURGH — The liver of a baboon transplanted into a 62-year- old man was functioning satisfactorily Tuesday, surgeons at the University of Pittsburgh Medical Center surgeons said.

The man, whose identity was not released, remained in critical condition after the world s second such transplant at Presbyterian University Hospital in a 13-hour operation that ended early Monday. Surgeons said the man was dying from the hepatitis B and did not have the option of a human-to-human liver transplant.

Surgeons said the man, who was awake Tuesday, may be weaned from his ventilator within a few days.

Dr. Thomas Starzl, director of Pitt's Transplantation Institute, said the man was one of four patients considered for the trans-species transplant and the only one who survived long enough to undergo the procedure.

Dr. John Fung, chief of transplantation, said the man may have been a few weeks from death before the operation. Fung said because of the patient s condition, several centers rejected him as a candidate for a human organ transplant.

Fung said the operation was a final attempt to try to save this gentlemen s life.

The first recipient of a baboon liver transplant was a 35-

Continued on page 2

Exercise 9.6: Tabloid Page Layout

This exercise asks you to come up with a tabloid layout on your own. (It assumes that you have successfully completed the previous exercises.) Before beginning, review the layout guidelines listed in this chapter. Before starting with the page layout program, you might want to use the blank dummy sheet included with this exercise to draw a design that will guide you in setting up the page. The text and picture files for this exercise are found in the Exercise 9.6 folder, or your instructor may supply you with a different set of files.

Begin by opening a new file in your page layout program. Select the Tabloid size for a page format and divide the page into five columns. As you did in previous exercises, create the flag at the top of the page.

In creating the page, do not be concerned that the stories do not fit into the text blocks. Where they do not fit, create a text block at the bottom of the story that says "Continued on Page 2" as you did in Exercise 9.5.

The first thing you will have to do is choose which stories and pictures you want to use. You have the following stories in your folder to choose from:

Canada steelworkers 434 words (12 inches)

TORONTO—Union officials representing about 10,000 striking Canadian steelworkers said Monday's tentative settlement with Stelco Inc. was a major victory for its members that includes full pension indexing.

Disneyland 209 words (6 inches)

ANAHEIM, Calif.—Disneyland, the grandfather of modern amusement parks, will boost its admission prices by $2 for adults and children, a park spokesman said Tuesday.

Teenage hostage 432 words (12 inches)

CHARLESTOWN, W. Va.—A teenager described as a "good guy" who "wouldn't hurt anybody" took a teacher and about 15 students hostage at gunpoint Monday in a high school classroom, gradually releasing his captives until the standoff ended more than eight hours later.

Tornado damage 349 words (10 inches)

A tornado touched down in the southern portion of the county near the community of Goshen, damaging ten mobile homes in the Carpenter Road subdivision.

Mob grave 438 words (13 inches)

NEW YORK—Federal agents and state police continued digging up a suspected secret mob grave Monday, where the remains of at least three people were found buried in a garage behind a locksmith shop, officials said.

Woman gets death penalty 349 words (10 inches)

CHILLICOTHE, Mo.—A jury has recommended that a 69-year-old woman be sentenced to death for the murders of four transient farm workers whose bodies were found buried in northwestern Missouri last year.

You will need to crop and size the pictures appropriately for your layout. The following is information for cutlines for pictures:

Power lunch. Squeaky the cat; Bob the canary; both the property of Ray and Ramona Ritchard, 201 Bluefield Drive; photo taken yesterday. Photo by Amy Kilpatrick.

Storm damage. Tornado in western portion of county; struck yesterday about 5:40 P.M.; no warning from anybody; Carpenter Road subdivision; damaged at least ten mobile homes there; this one in the picture belongs to Velma Haskiel; completely destroyed it; that's Velma right there in the picture; she's going to have to live with her sister until she figures something out.

Photos: Amy Kilpatrick

Power lunch

Storm damage

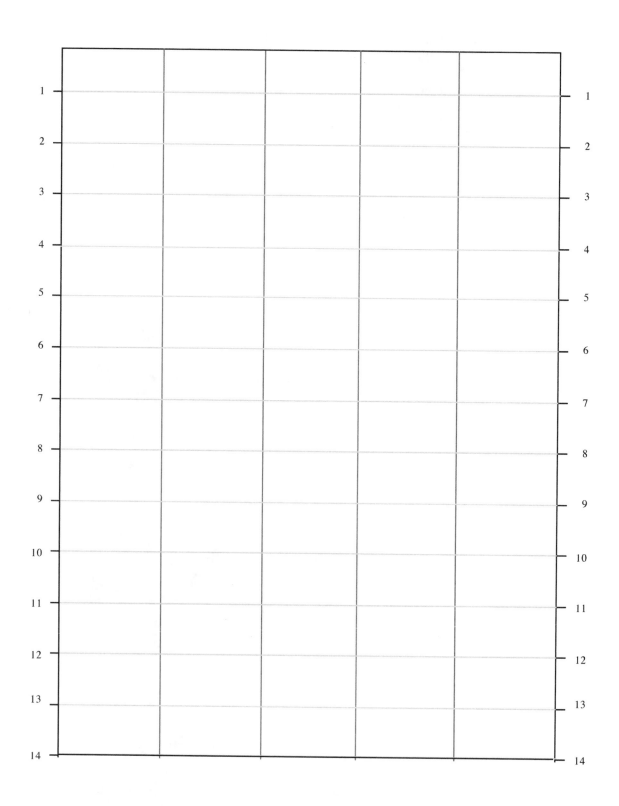

Exercise 9.7: Copying Layout—Writing Headlines and Cutlines

Like Exercise 9.5, this exercise asks you to copy the layout shown here, only this time we are using a full-size page rather than a tabloid size. Make your page look as much like the one you see as possible. The text and picture files for this exercise are found in the Exercise 9.7 folder, or your instructor may supply you with a different set of files.

Begin by opening a new file in your page layout program. Select the full size for a page format (or 13.5 inches by 22 inches) and divide the page into six columns. As you did in previous exercises, create the flag at the top of the page. Now draw the headline and text blocks for the stories, and call the story files into the appropriate blocks. Draw the picture blocks and text blocks for the cutlines.

Do not be concerned that the stories do not fit into the text blocks. Where they do not fit, create a text block at the bottom of the story that says "Continued on Page 2" as in the picture you are using for a guide.

Write the headlines and cutlines for this page in the appropriate text blocks that you create for the page. Use the following information in writing the cutlines:

Flood. Rains flooded the valley of the Green River in West Texas; 3 inches of rain fell in 5 hours; area has had 10 inches of rain more than normal this year.

Auto accident. Rescue workers Max Shores (top), Jamie Bernard; auto accident victim LaKisha McDune; one-car accident on Coventry Road; late yesterday afternoon; she broke arm; treated and released at County Hospital. Photo by Amy Kilpatrick.

THE DAILY NEWS

October 1, 2004

Headline

CAPE CANAVERAL, Fla. — A Delta rocket boosted a $90 million mobile communications satellite into orbit Tuesday in a spectacular night flight, marking the 200th launch of a workhorse Delta since the program's debut 30 years ago.

The $50 million 126-foot Delta 2's main engine and strap-on boosters ignited with a flash of fire and a thundering roar at 6:16 p.m. EST, instantly pushing the rocket away from the Cape Canaveral Air Force Station and into the darkening sky.

"We have ignition and we have liftoff, liftoff of Delta number 200," said launch commentator Ray Adams as the slender rocket streaked away on a fiery flight visible for miles along Florida's space coast. "This is the kind of flight we enjoy — watching that bird go up and do its job."

Perched atop the Delta 2 in a protective nose cone was Inmarsat-2 F1, the first of a new generation of high-power communications satellites built by British Aerospace for the 62-nation International Maritime Satellite Organization, or Inmarsat.

Twenty-two minutes after launch, the rocket's third stage fired to put the solar-powered 2,100-pound satellite into a preliminary elliptical orbit. An onboard rocket was scheduled to fire later to boost the satellite into a circular orbit 22,300 miles above the Indian Ocean equator.

"Inmarsat-2 is a new kind of satellite, specifically designed to handle mobile communications applications. Inmarsat Director General Olof Lundberg said in a statement. "It will ... provide communications to Earth stations small enough to be hand portable.

The flight marked the 200th Delta mission dating back to May 13, 1960, when a less powerful version of the McDonnell Douglas Space Systems Co. booster debuted carrying an Echo 1 communications satellite.

That mission ended in failure, but a Delta launched three months later, on Aug. 12, 1960, was successful, kicking off one of the most reliable American rocket programs ever mounted. In 199 launches before Tuesday's flight, only 12 were failures.

Constantly upgraded to improve performance, Delta rockets have evolved through 16 different configurations. The Delta 2 currently in service was built by McDonnell Douglas specifically to launch 20 Air Force Global Positioning System satellites under contracts valued at $669 million.

McDonnell Douglas also markets the rockets on a commercial basis and prior to Tuesday's launch, the company's record stood at 21 successes in a row dating back to May 3, 1986, and a perfect 13 straight for the upgraded Delta 2, including six commercial launches.

Inmarsat-2 F1 is the first satellite owned and operated by the London-based Inmarsat consortium, which has focused on providing global satellite communications service for ships at sea using leased radio transponders aboard eight other satellites.

Ahmad Ghais, director of engineering and operations for Inmarsat, said the organization plans to greatly expand service in the 1990s to include users on the ground and in the air around the world. The company's motto for its expanded service is "global mobile."

"Anyone on the go should be able to use our satellites to communicate anywhere on Earth," Ghais said.

Inmarsat paid $160 million for its first wholly owned satellite, the Delta 2 rocket and ground services. The price tag also included the cost of about $70 million in insurance that was purchased commercially at a rate of 16.5 percent. The balance of the mission cost was self-insured by the company.

Inmarsat currently provides direct-dial voice, fax and data transmission services for ships at sea. But the company is aggressively marketing small terminals that can be used aboard aircraft or in the field.

Mobile transmission units currently cost about $15,000, but the price is expected to drop into the $5,000 range in a few years, bringing instant satellite communications into the reach of small

Continued on page 2

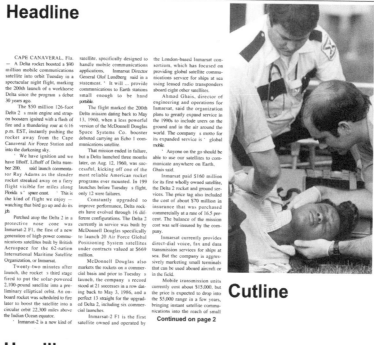

Cutline

Headline

HOLLYWOOD — The nation's movie theaters have grossed nearly $4 billion so far this year, only about 1 percent behind last year's record-setting pace, when box office sales reached $5 billion by year's end.

Despite a traditionally slow mid-fall performance, the year-to-date box office hit $3.99 billion over the weekend, compared with $4.05 billion for the same period last year, Daily Variety said Tuesday. In 1988, the total at the same juncture had reached $3.57 billion.

The top 10 movies of the weekend — led by Stephen King's Graveyard Shift — drew $30.8 million over the weekend, off 7 percent from the previous weekend's $33.1 million and 6 percent behind the $32.6 million scored by the top 10 a year ago.

For the week, the domestic box office reached $68.5 million, off from $81.2 million for the year-ago week. In 1988, the same week produced ticket sales of $64.1 million.

The low box-office figures are unlikely to cause much concern within the industry, as they come just before the big push for Christmas-season films. The only major release expected to open this weekend will be Adrian Lyne's mystery-thriller "Jacob's Ladder.

But the Christmas season fig-

Continued on page 2

Headline

WICHITA, Kan.— Air Midwest Inc. said Monday it would sell certain assets and aircraft of its Trans World Express operations in St. Louis to Trans State Airlines Inc. of St. Louis for $16 million.

The purchase by Trans State — also a Trans World Express operator out of St. Louis — includes the assumption of about $7.4 million in Air Midwest's long-term debt obligations.

Air Midwest said the transaction covers eight EMB120 aircraft, fifteen J32 aircraft, spare parts, certain facilities, leases and other obligations from its Trans World Express operations.

The companies expect the sale to be completed and Trans States to begin operating the former Air Midwest system by March 31. The agreement requires approval by Trans World Airlines Inc., regulatory authorities, and lessors.

Air Midwest said its net book gain from the transaction would be more than $8 million. Proceeds would be used for increased working capital.

The airline has operated as Trans World Express under a service agreement with TWA since October 1986, providing feeder service to the big carrier from smaller communities which TWA itself does not service.

Air Midwest said it recently signed an agreement with USAir to serve as USAir Express from Kansas City, beginning Jan. 15. The operation would continue with Air

Continued on page 2

Headline

WASHINGTON — Protesters came to Ku Klux Klan rally ready for violence, and city officials criticized a judge's ruling that allowed the robed marchers to cover a longer route through downtown of the predominantly black city.

Police in riot gear guarded 30 Klan members Sunday on their 1-mile march to the Capital along Constitution Avenue, while 1,200 protesters battled police in their wake.

Police arrested 40 demonstrators and 14 people, including eight police officers, were injured.

"Obviously people came down here for planned violence," Police Chief Isaac Fulwood said. "There were roving gangs with bricks in knapsacks.

In northern California, fog blanketed Eureka and Humboldt Bay near the state's northern border, hampering visibility.

New York was partly cloudy, breezy and cold with a low of 35 to 40 degrees and winds from the northwest at 10 to 15 mph with gusts.

It was mostly cloudy and cold throughout the Great Lakes region with a few snow flurries in Buffalo, N.Y., where temperatures bottomed out in the low 30s and winds were northwest at 10 to 20 mph.

Clear skies and cold weather covered much of the Plains and Midwest, with Topeka, Kan., reporting 40 degrees and clear and Cleveland with 45 degrees.

It was sunny and warm along the Gulf Coast of Florida as Tampa reported clear skies and 81 degrees. Showers and temperatures in the high 70s dominated the weather in Miami.

Other warm spots included San Antonio, where the tempera-

the chief said. "We're the only experts in this goddamned town. If people weren't messing around with us there would be no problem. You can quote me on that.

A spokeswoman for the All Peoples Congress, which staged the rally, termed the protest a success, saying a group of 20 anti-Klan protesters made it to the Capitol grounds to demonstrate in view of the Klan.

The protests began at noon when demonstrators gathered for the start of the march. They tried to break through a police line, but were repulsed. As the Klan moved down Constitution Avenue, the protesters streamed toward the Capitol.

The crowd reassembled at about the march's midpoint, chanting "Smash the Klan, smash the Klan and anyone in the way! Seconds later, a shower of rock, sand bottles rained on police who began marching against the crowd.

Some police officers used their nightsticks to break up the crowd.

Police then pushed the crowd away, and squad cars were pelted with rocks and bricks. Fulwood said windows were smashed on at least 12 cars during the day.

The Klan held its rally on the southwest lawn of the Capitol, on the other side of the mall from the bulk of the protests and away from the public. When they finished, they climbed into vans and were escorted out of the city by the police.

One protester attributed the outbreak of violence to frustration.

"As an African-American, I personally think they have a right to march, but I also think we have a right to protest," said Michael

Continued on page 2

Headline

Record lows in the Midwest and cool weather elsewhere chilled much of the nation Monday with strong winds and storms in the extreme Northwest and Northeast and heavy fog in Southern California.

In New England, skiers hit the slopes as the season's first major snowfall blanketed northern mountains. At least one resort in northern Maine reported 15 inches of new snow.

On the West coast, heavy rain and gusts topping 35 mph churned 18-foot seas near Cape Lookout on the Oregon coast.

A record low temperature for the date was set in Muskegon, Mich., where the mercury dipped to 22 degrees, breaking by 1 degree the previous record set in 1980.

Elsewhere, a gale warning was in effect for Narragansett Bay in Providence, R.I., where gusty northwest winds approached 40 mph.

Thick fog settled along parts of the California coast from San Diego to Eureka. In San Diego, a dense fog advisory was posted for a 12-mile strip along the coast with visibility at one-eighth of a mile in some areas.

Cutline

Continued on page 2

Exercise 9.8: Full-Size Page Layout

This exercise asks you to come up with a full-size layout on your own. (It assumes that you have successfully completed the previous exercises.) Before beginning, review the layout guidelines listed in this chapter. Before starting with the page layout program, you might want to use the blank dummy sheet included with this exercise to draw a design that will guide you in setting up the page. The text and picture files for this exercise are found in the Exercise 9.8 folder, or your instructor may supply you with a different set of files.

Begin by opening a new file in your page layout program. Select the full size for a page format (or designate the page size as 13.5 inches by 22 inches) and divide the page into six columns. As you did in previous exercises, create the flag at the top of the page.

In creating the page, do not be concerned that the stories do not fit into the text blocks. Where they do not fit, create a text block at the bottom of the story that says "Continued on Page 2" as you did in Exercise 9.7.

The first thing you will have to do is choose which stories and pictures you want to use. You have the following stories in your folder to choose from:

Magellan signal lost (6 inches)

PASADENA, Calif.—The Magellan spacecraft, on a mission to map the planet Venus, experienced a 40-minute signal loss Thursday, its third since it went into orbit around the planet in August.

Stockbroker sentenced (20 inches)

NEW YORK—A federal judge sentenced former Wall Street speculator John Mulheren, Jr. to a year and a day in prison for conspiring with fellow wheeler-dealer Ivan Boesky to illegally manipulate stock prices.

Aviation fuel (20 inches)

CHICAGO—Increased military demand for jet fuel and loss of production from a major refinery in Kuwait have caused aviation fuel prices to increase more than crude oil prices, an oil industry economist said.

Van Gogh painting (17 inches)

NEW YORK—A disappointing auction of art from the collection of the late Henry Ford II cast gloom over an upcoming sale boasting a Van Gogh flower study and other important Impressionist and modern paintings.

Large meals (11 inches)

EASTON, Pa.—A new study has confirmed what many women have known for years: It's not socially advantageous to eat large meals in public.

Garbo paintings (5 inches)

NEW YORK—Three of four French Impressionist paintings owned by the late actress Greta Garbo were sold Tuesday at Sotheby's auction gallery for $16 million, well within the pre-sale estimate of their value.

Smoking chest pains (8 inches)

DALLAS—Cigarette smoking may hamper a smoker's ability to feel the chest pains that may be an important early warning sign of heart disease, researchers reported Wednesday.

Hepatitis (22 inches)

BELLEVUE, Wash.—Government health experts Wednesday launched a nationwide, federally funded program to detect hepatitis B among pregnant women and immunize their infants against the serious liver infection.

Use the following information to write cutlines for the pictures:

Van Gogh Irises. 1889 painting; Irises; goes with Van Gogh story.

Truck wreckage. Lincoln Park Road overpass over I-75; driver, Joseph Coda, of Cuba, Missouri; driver killed; police don't know why truck overturned; they're investigating; impact separated cab from the trailer; accident blocked traffic on interstate roadway going south for more than four hours; truck carrier various automobile parts for nearby auto plan.

Bike accident. Mike Stanton, rescue worker; Alonzo Brown is the kid; Alonzo is 11 years old; was riding down 15th Street when he wrecked his bicycle; taken to County Hospital; broke his arm; sent home after examination and treatment.

Van Gogh Irises

truck wreckage

bike accident

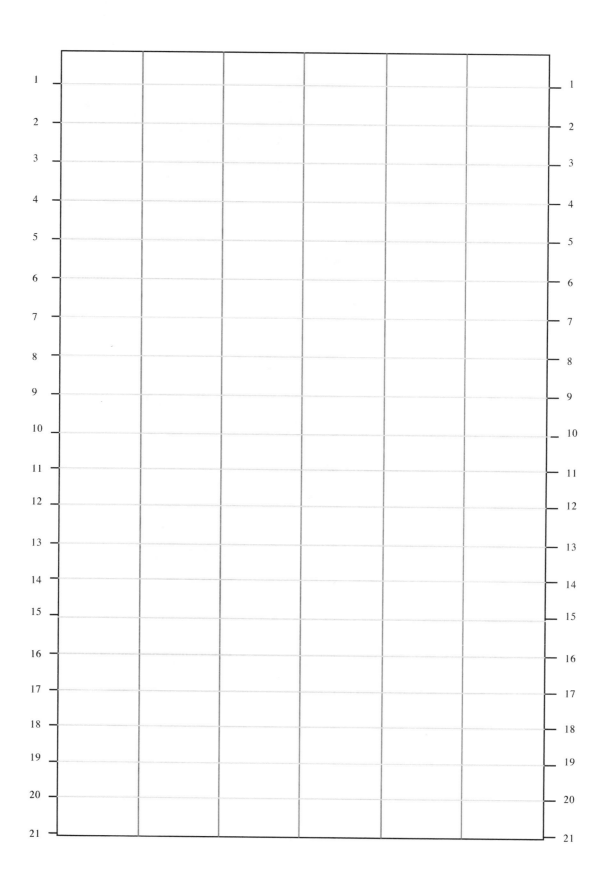

Exercises 9.9: Single-Page Subject

Shown here is a full-size page devoted to a single topic: the opening of a local soccer season. The designer had no pictures to work with but rather used some staff-produced drawings. The designer also did some innovative things with the type and created plenty of white space on the page.

Take the same elements on this page and lay them out in a different manner. If you have access to the electronic files for this exercise, they are located in the Exercise 9.9 folder. If you do not have access to these files, you can draw your new layout on the full-size dummy sheet included with this exercise. (Your instructor may add further requirements to this assignment.)

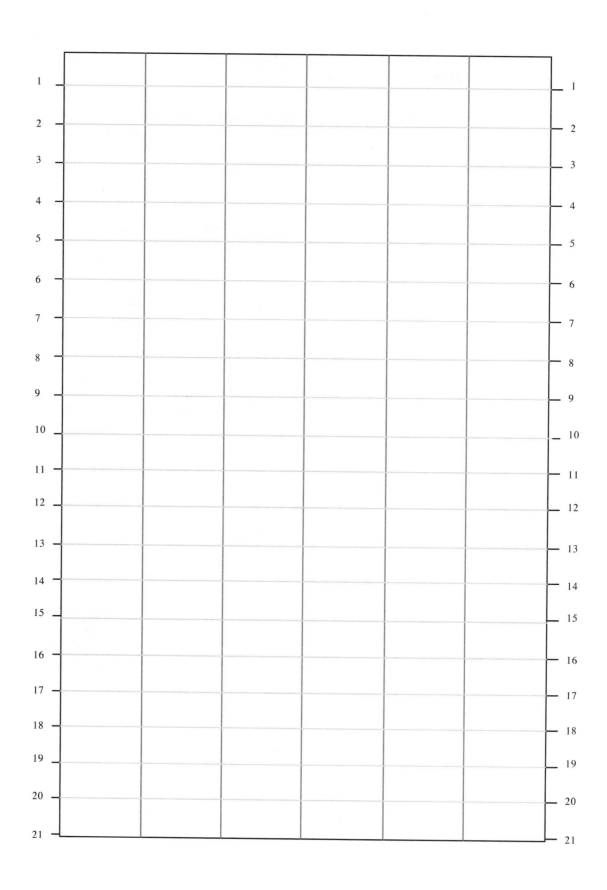

Exercise 9.10: Team Project

This exercise can work as either an individual or a team project. If students work as a team, ideally there should be three: one to write a news story based on the following reporter's notes, one to work with the photos and the map (preferably a student who knows Photoshop), and one to do the layout.

The situation is this: The Cornish River near West Harperville has flooded. This has happened before, but the situation is unusually severe this time. A reporter who is on the scene (his name is Thomas Cahill, and he is a staff writer for your newspaper) has called in the following notes. One of the editors will have to put together the story on the basis of those notes. In addition to the notes, you have a listing of the major floods along the river. This might make a good timeline or other type of graphic presentation.

You also have a map showing the flooded areas. The map on this page identifies some of the areas referred to in the notes, but the electronic file contains only the map. One of your editors will have to decide how those areas are to be identified in a way that is compatible with the layout you develop. Small versions of the pictures you have available are included on these pages.

Your assignment is to produce a single full-size page devoted to the flooding story. You might want to make it the front page of your paper, in which case you will need to design a flag at the top of the page. If you have access to the electronic files for this exercise, they are located in the Exercise 9.10 folder. If you do not, you may draw your layout on the full-size dummy sheet provided with this exercise.

Flooding Reporter's Notes

Heavy rains for three days; flooding on several parts of the Cornish River near West Harperville; one bridge out along Highway 14.

75 people evacuated from homes; 200 houses have received some damage; one church, Cornish United Methodist, had basement flooded.

Kyle Render, Ticonderoga County Emergency Management Service: "Worst flooding in 15 years; all crew are out seeing if there are people or animals that we can pick up; don't know of anyone who is trapped, but we aren't sure about everybody."

Police chief Billy Herbert says one person reported missing; Carl Carter; reported missing by daughter; his is one of the houses that is under water up to the second story now.

Bridge along highway 27 okay, passable, according to police.

Herbert: "We are urging people to stay away from the area. Don't go down there looking. We need to keep the roads clear in case we find someone that we need to get out quickly."

Keith Schneider, pastor of Cornish UMC, said church basement contained a lot of furniture that is ruined; church still under water; won't be able to

go in until waters recede. "My heart is broken about this. These people just finished paying off the mortgage last year before I became pastor. Now they're going to have to face some pretty hefty repair bills."

Morley MacMann, farmer whose fields were flooded. "Fortunately the water didn't get to my house. I guess we can be thankful of that. But these are my best fields that are under water now. I was going to start planting in a day or two, but now I'll have to wait until the field is okay."

Police say people who need shelter can go to the First Presbyterian Church in West Harperville; a variety of assistance offices will be set up there.

Flooding occurred just after midnight when water began to flow over the banks at Niles Bend; just as that was happening came two hours of torrential rain; weather service said three inches fell in the area during that two hours; during the past three days there have been seven inches of rain in the area.

Major floods along the Cornish River

April 1992: 3,000 acres flooded; 50 homes and businesses damaged; Highway 14 bridge out for three days; no casualties; river rose 27 feet above flood stage.

August 1981: Flooding along banks of river near West Harperville for three miles; 2 people killed; river rose 10 feet above flood stage.

June 1963: 5,000 acres flooded, 100 homes damaged, 20 destroyed; Highway 14 bridge out for two weeks; Needles Cemetery near Methodist Church had caskets uprooted; some were found 20 miles down the river; river rose 41 feet above flood stage.

April 1951: Great Easter Flood; killed 10 people; flash flood when Harperville Dam burst; 12,000 acres flooded; damage estimated $50,000,000; river rose 55 feet above flood stage.

March 1946: 2,000 acres flooded above Highway 14; mostly farms; few houses destroyed or damaged; estimated 3,000 head of cattle lost; river rose 12 feet above flood stage.

Pictures

Picture 1. Members of the Ticonderoga County Rescue Squad; in boat going down a stretch of Highway 14; looking for flooding victims.

Picture 2. Morley MacMann, farmer whose fields were flooded; at shelter in West Harperville.

Picture 3. Keith Schneider, pastor of Cornish UMC.

Picture 4. Section of Mackey Creek that flooded; knocked out a bridge along Bailey Road. Picture is Rowley Ridner, county rescue squad member.

Picture 5. Waters have receded along upper part of Highway 14; picture shows houses that were nearly covered with water at height of flooding.

Picture 1

Picture 2

Picture 3

Picture 4

Picture 5

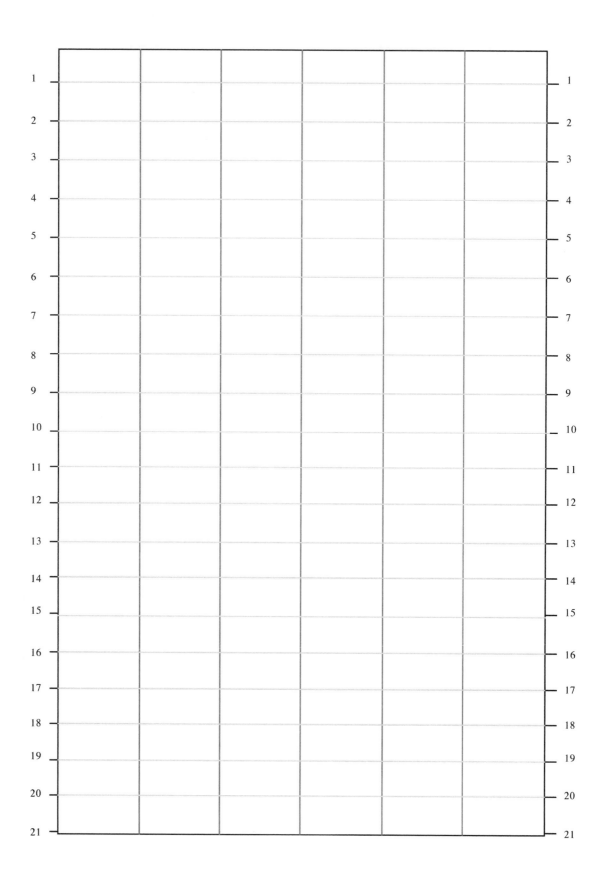

The Editor and the Law

- The Legal System
- The First Amendment
- Libel
- Defenses against Libel
- Constitutional Defenses
- Privacy
- Defenses against Invasion of Privacy Charges
- News Gathering
- Constant Vigilance

Editors today live in a world of litigation. The United States has become a society that places increasing reliance on the judicial system. Our law schools are graduating more lawyers than many legal experts believe are necessary to service the system. Congress, the federal bureaucracy, state legislatures, and city and county governments continue to fill volumes of statute books with new laws and regulations. Citizens are turning to the courts more frequently for redress of their grievances. Editors find themselves more and more often the focal point of legal disputes, so it has become incumbent upon editors to know the law and to know how to use it to their advantage.

Editors need a thorough understanding of the law and the legal system not only to keep them out of legal difficulties with what they publish but also to help them in understanding the world they cover and in making the appropriate journalistic judgments for their news organizations.

The Legal System

A great deal of today's television drama and much of our popular fiction focus on or revolve around the legal system. In addition, there is rarely a time when there is no trial or important legal matter in the news. We are fascinated with courts and trials. They are where the big social issues come into conflict, and they produce memorable and controversial personalities. Consequently, most of us have a basic understanding of the judicial system and courtroom procedures.

But the judicial system is much more complex than what we are likely to see on "Law and Order" or in the news coverage of the trial of a celebrity such as Michael Jackson or Martha Stewart. The United States is covered several times over with court systems, and editors must understand the structures of these systems, the types of cases they hear, and how they work together.

Two types of judicial cases exist: criminal and civil. Criminal cases involve acts that are so offensive to society that they merit fines or time in jail. These, of course, do not need to be crimes of violence. Larceny, fraud, and obstruction of the judicial procedure are crimes that can result in jail sentences. Only governments—local, state, and federal—can initiate criminal charges. Our "law and order" political environment during the past four decades has resulted in more acts being termed criminal and more people being sent to jail. More than two million people are incarcerated in the nation's federal and state prisons—nearly 1 percent of the entire population. Despite these numbers, criminal cases account for a relatively small percentage of the cases that courts oversee.

Civil cases—disputes between two parties over agreements or interpretation of the law—make up the vast proportion of legal activity in the United States. In civil cases a person or organization (the plaintiff) sues another person or organization (the defendant). The purpose of the suit might be to stop the defendant from doing something or to punish the defendant for actions that have already been taken. That punishment usually comes in the form of money, but sometimes a defendant can also be ordered to do something. Governments, companies, organizations, and private citizens can initiate civil cases.

At its roots the United States has two court systems: the federal system and the system for each state. Every American has access to both systems. The federal system enforces and litigates laws passed by Congress. In some cases it also provides a court for disputes between citizens of two different states.

Both of these court systems—the federal and state systems—are structured in essentially the same way. They have three different levels: trial courts, intermediate appellate courts, and supreme courts. A state system will have trial courts in each county and in many cities. These courts go by different names, such as municipal courts or district courts. They litigate disputes under laws passed by the state legislatures and county and city legislative bodies. In the federal system the trial level court is called a district court. A single federal district may cover several counties in a state, depending on the population of the area.

This is the level of the court systems at which trials are held. Charges are brought, juries are impaneled, evidence is presented, and verdicts are rendered. The trial level is the stage at which most of the drama that you read about and see in the legal system takes place. Trials might be dramatic, but they are also expensive and time consuming. Most legal disputes never make it to a full-blown trial. They are settled, and those settlements may be confirmed by a trial judge. If this were not the case, the legal system would be hopelessly clogged with trials.

Appellate-level courts, as the name describes, deal with issues or outcomes at the trial court level that one of the parties in a dispute are not happy with or want to see reviewed. Most issues and verdicts can be appealed, but a "not guilty" verdict cannot be appealed. In general, appellate courts review the procedures of a trial to see whether it has been conducted fairly. For instance, let's say that a defendant in a trial asked that a trial be moved to a different location (called a change of venue motion) because he believes that he cannot get a fair trial in the place where the crime was committed. The trial judge denies the motion, the trial proceeds, and the defendant is found guilty. The defendant's lawyers might then file an appeal claiming that the trial judge made a mistake. The appeals court would have to decide whether or not to hear the appeal and then would hear arguments presented by both sides—the prosecution and defense in this case—about whether or not the decision was the right one.

Appellate courts do not try or retry cases. Rather, they hold hearings in which lawyers present briefs (written arguments) and oral arguments. They do not impanel juries and generally do not hear from witnesses or consider new evidence. Appellate judges make rulings on the basis of the applicable laws. They are there to confirm or reject the work of the trial court. Sometimes a trial court's verdict will be reversed on a technicality, a fine point of the law or an issue that was not central to the trial but one that the appellate court deems important enough that it prevented a fair trial from occurring. Most trial judges try to follow the law and procedures as closely as possible because they do not want their work reversed by an appeals court.

Whereas different states organize their appeals courts in various ways, the federal courts have eleven appellate circuits. Each division covers several states and has at least a dozen judges working full time. Not every judge hears every case; panels of three or five judges may be formed to hear a particular case. A very important case might be heard by all of the judges in the division.

The highest court in any system is the supreme court. (Some court systems have a different name for its highest court.) These courts consist of a relatively few judges (called justices)—the U.S. Supreme Court traditionally has nine justices, but there is no law specifying the number—and they take on relatively few cases. A supreme court might decide to hear a case if the issues are large and go beyond the circumstances of that individual case. They might also decide to hear a case if they believe that a ruling on the case will help settle an important constitutional question. They might also hear a case if they believe

that important mistakes have been made at the trial and appellate levels and those mistakes need to be corrected.

The U.S. Supreme Court is one of the nation's most important institutions, and the nine justices are considered to be among the most powerful and influential of all Americans. One of the most important jobs of the Supreme Court is to interpret the U.S. Constitution, the basis for all federal laws and many state laws. The Supreme Court tells the nation what the Constitution means and how laws should be applied to be consistent with that meaning. What the court says in any area of American life has wide and lasting impact.

Throughout the twentieth century the Court made many decisions on the meaning and application of the terms "free speech" and "free press," concepts that are found in the First Amendment to the Constitution. Those decisions, some of which are explained in the remainder of this chapter, have had a major impact on the journalistic environment in which editors work.

The First Amendment

The thrust of most of today's court battles, laws, and regulations involving the media is to keep editors from getting and publishing information or to punish them for having already published information. Many forces are allied in these battles against editors, from those who seek to protect their reputations to those who want to hide their actions from public scrutiny. Editors should remember that their primary responsibility is to publish accurate information, and they should do so in a way that can best serve their readers and that will help them to avoid as many legal hassles as possible.

The best weapon that editors have on their side is the First Amendment to the U.S. Constitution:

Figure 10.1

Warren Burger
On what editors are for

For better or worse, editing is what editors are for; and editing is selection and choice of material. That editors—newspaper or broadcast—can and do abuse this power is beyond doubt, but that is no reason to deny the discretion Congress provided.

Warren E. Burger
Chief Justice, U.S. Supreme Court
Majority opinion in 7–2 ruling that allowed radio and television stations to refuse to sell time for political or controversial advertisements, May 29, 1973.

Congress shall make no law respecting an establishment of religion, or prohibiting the free exercise thereof; or abridging the freedom of speech, or of the press; or the right of the people peaceably to assemble, and to petition the government for a redress of grievances.

Interpretation of the forty-five words of the First Amendment continues to be a controversial exercise. Yet as it stands, the First Amendment is a powerful statement for the right to speak and to publish and for the tradition of the United States as an open society. Editors should work diligently for a liberal and expansive interpretation of the First Amendment and should be unwilling to compromise on its basic meaning. The First Amendment offers basic protections for all citizens, not just editors, but editors are often required to fight a lonely battle in its defense.

Libel

Libel is the most dangerous problem facing an editor. Libel laws are extensive and in many areas are being strengthened. The threat of a libel suit often causes reporters and editors to withhold information that the public should have. Large libel judgments have a devastating financial impact on a publication and increase the chances that other libel suits will follow.

Figure 10.2

Libelous words

Libel actions usually develop out of lack of thought or temporary mental lapses on the part of the communicator. No list of problem words and phrases is ever quite complete, but this is a beginning. Use these words and phrases with caution.

adulterer	fascist	kept woman	sadist
AIDS victim	fink	Ku Klux Klan	scam-artist
alcoholic	fixed game		scandal monger
ambulance chaser	fool	lewd	scoundrel
atheist	fornicator	lascivious	seducer
attempted suicide	fraud	liar	short in accounts
			shyster
bad morals	gambling house	mental disease	skunk
bankrupt	gangster	mental incompetent	sneak
bigamist	gay	molester	stuffed ballot boxes
blackmail	grafter	moral degenerate	
bordello		murderer	underworld connections
briber	herpes		unethical
brothel	hit-man	Nazi	unmarried mother
	homosexual		unprofessional
cheat	hypocrite	paramour	unsound mind
collusion		paranoid	
communist	illegitimate	peeping Tom	vice den
con man	illicit relations	perjurer	villain
convict	incest	pervert	viper
corrupt	incompetent	pimp	
coward	infidelity	plagiarist	
	influence peddler	price cutter	
drunk	informer	profiteer	
death-merchant	insane	pockets public funds	
divorced (when not)	intemperate	prostitute	
drug addict or druggie	intimate		
		rapist	
embezzler	Jekyll-Hyde personality	recidivist	
ex-convict	junkie	rogue	

In the 1960s, courts, beginning with the U.S. Supreme Court's *New York Times* v. *Sullivan* decision in 1964, built a substantial wall protecting publications from the devastating effects of libel suits. The Supreme Court realized that libel judgments were being used as a means of punishing and repressing publications that displeased particular individuals or groups. The court believed that for the First Amendment to work in the way in which it was intended, concerns about libel must not be an oppressive burden for editors.

Despite this, libel suits have become a more potent instrument of punishment and even repression. More and more suits are being filed, and the cost of defending them is enormous. Juries today are more inclined to interpret libel laws liberally and to award massive judgments against media organizations. One recent study has found that media defendants lose about 80 percent of the libel cases that go to trial and lose an even greater percentage of those that are decided by a jury. Many of these judgments are reversed on appeal, but by then the media organization has gone to considerable expense and trouble to defend itself. Courts might fashion a 1960s-like protection for the media at some point in the future, but until then, editors should be well versed in libel law and in the ways to avoid and to defend themselves in libel suits.

Libel is injury to reputation that exposes a person or group to hatred, ridicule, shame, contempt, or disgrace. Libelous material may also be considered to be that which lowers a person in the eyes of a part of the community or prevents a person from making a living in his or her chosen line of work. The law requires proof of four things before a libel action can be sustained: defamation, identification, publication, and fault.

Defamation. The words that a libel plaintiff complains of must cause harm to a person's reputation, either in and of themselves or within their context.

Identification. The libel plaintiff must be identified as the object of the defaming words. The plaintiff cannot get by with simply saying, "I know the article was about me even though I wasn't named"; rather, plaintiffs who are not named specifically must establish concretely that they were the objects of defamatory words. The idea of identification can become a prickly one when a libelous statement is made about a group of people. Courts have said that if the group is small enough for each individual to be identified, then each member of the group may have a valid libel case. If the group is a large one, such as an entire race of people, individuals cannot establish identification.

Publication. A libelous statement must be transmitted to a third party. It does not necessarily have to be printed or broadcast in the mass media. A letter that is mailed to a person who is not the object of the libel or a statement that is made to a small group of people may constitute publication.

Fault. In those situations in which the person named is a public official or public figure, it will be necessary for the person to establish that the media acted with actual malice. That is, it must be proved that the offending material was published either with knowledge of its falsity, with reckless disregard of its truth or falsity, or with deliberate intent to harm. When private people are named, those who are suing the media must normally establish media "negligence," or carelessness.

Defenses against Libel

When a libel suit is filed, editors have a number of defenses available.

Truth. A number of states have written into their libel laws that truth is an absolute defense for libel—that is, if the truth of a libelous statement can be proved, the plaintiff has no case. That sounds good, but an editor should not fall into the trap of feeling safe because what he or she has printed is "true." Truth can be a weak defense because a statement must be *provably* true, and the editor must present evidence that a statement is true. Even seemingly strong evidence can be challenged in court and can be open to varied interpretations. In a libel case, evidence is almost always open to various interpretations.

Privilege. Privilege is a good defense when a libel suit revolves around coverage of public or government meetings and actions. Courts have tried to protect reporters and editors from libel actions resulting from journalists having to report libelous statements that are made by public officials or during public events. Although the courts recognize two kinds of privilege, in general it is the lesser or weaker privilege that journalists have available as a defense. Qualified or conditional privilege usually applies to coverage that is about public issues or events. Such reports must be fair and accurate; they must also not be made with either traditional malice (spite or ill will toward the subject of the report) or actual malice (reckless disregard of probable falsity). Absolute privilege was originally accorded only to members of Congress, judges, and the like in the performance of their official duties. More recently, the courts have used this term in referring to reporting about what occurs in open court or what occurs on the floor of the legislature (either state or federal). The courts seem to assume that such coverage will be full, fair, and accurate.

Fair comment. The fair comment defense applies more to statements of opinion than to statements of facts. Many courts, including the U.S. Supreme Court, have recognized that the holding of opinions should not be penalized even though at times those opinions may be libelous. Although we have a long legal tradition that declares that there is no such thing as a false idea, courts are now less protective of this notion. The U.S. Supreme Court has recently cut back on the scope of protected opinion. Fair comment is a reasonable defense, but today it is not an especially strong one. When applied to editorial and arts criticism it is reasonably effective unless there is an intent to harm.

Constitutional Defenses

Although the traditional defenses for libel are good ones, in times of social tension they might not be sufficient. During the civil rights movement of the 1960s a new legal approach to libel was created. In *New York Times* v. *Sullivan* the U.S. Supreme Court decided that a constitutional defense against libel should be created that would encourage the press to report more aggressively information

about public officials and public issues. To accomplish this, the Supreme Court established "actual malice." Defined as knowledge of falsity or reckless disregard of whether the material is true or false, actual malice as a fault standard was designed to make it more difficult for public officials to win libel cases. This standard came to be applied to libel actions brought by public figures, people who typically are not public officials but who are nonetheless involved in important issues, typically by their own voluntary actions. For a brief period even those who were involuntarily caught up in public events were considered "public" and had to prove actual malice to be successful in litigation against the media. By 1974 the definition of "public figure" had become so all-inclusive that the Supreme Court began to restrict it. This process of redefinition is still occurring.

The "public" question is almost always the most important fact in libel cases involving the media. Because the court has never been explicit in defining who is a public figure, this decision is reached on a case-by-case basis. Courts have also been narrowing the definition of a "public official."

The following are some guidelines that may help in avoiding libel suits. Although there is no way to guarantee that a libel action will not follow stories that do harm to a reputation, these guidelines may lessen that possibility. At the same time, should a defense prove necessary, adherence to these guidelines may make it easier to put forth a strong case in court.

1. Anticipating what might go wrong and trying to avoid it is the best way to prevent a suit entirely or to defend against it. When beginning a highly sensitive investigative story, make sure that safe parameters and procedures have been developed. A preliminary discussion with your paper's attorney and others who are involved in the editing process can be most helpful. If a suit is filed later, you will have established a strong "due care" or "prudent publisher" defense.

2. If you have deep feelings about a subject or are personally involved with a subject of the topic of an article, try to withdraw from the handling of the story. Do not assign a reporter to a potentially libelous story if you think the reporter has strong feelings about the subject. To do otherwise creates a problem with "malice" if a libel suit should develop.

3. If, in the course of working on a story, doubts develop as to the accuracy of the information or the honesty of a source, resolve those doubts or drop the story. In the end, it will often be your personal conviction as to the accuracy of your information that will prove the key to a defense.

4. Do not use the "camera rolling" or hidden mike technique, and do not authorize the use of these techniques by reporters. Although well-known news programs sometimes use such techniques, well-known news programs have a lot more money to spend on legal fees. You are attempting to report news, not make it.

5. Do not break the law—that is, do not attempt to interview members of a grand jury, impersonate a police officer, trespass, steal evidence, and so on. Any such activity makes an editor and reporter vulnerable to attack. In addition, such activity does not favorably impress a jury.

6. Do not, either inside or outside the newsroom, make disparaging remarks about story subjects. Such comments make it easy for the

opponent to establish "intent to harm." Comments of this type also destroy many usually effective defenses. Make sure your discussions of the story, your sources, and your intent are fit to be taped.

7. Use the following rules of thumb to determine whether you have a potentially libelous story: (a) Is the information accurate? (b) Is the story fair? (c) If the story were about you, what would your reaction be?

8. Before providing assurances of apology, retraction, or correction, discuss the matter with other editors and an attorney. Sometimes, in the process of "correcting" the problem, you can make it worse. On the other hand, retractions can reduce damages in many states.

9. If at all possible, get a comment from the subject of a story who is being cast in a bad light. Make certain that the subject talks for the record and include these comments in the story. (Doing so makes it difficult for the subject to later claim malice.)

10. Bankruptcy has become an increasing problem in today's economic climate. When reporting about this, especially regarding private companies, use public records. If you add material from your files or from sources other than public records, make certain that the content is specifically related to the pending bankruptcy.

11. Use extreme caution when making evaluative or competency statements about professionals, such as lawyers and doctors. Damages are so easy for professionals to establish that liability tends to be most expensive. Check, double-check, and use public records and sources when possible.

12. Have reporters use on-the-record sources and be prepared to defend yourself and your reporters on the basis of accuracy. Remember that even an accurate quote simply means that you have company in the possible suit. Because a source usually speaks to a single person—you or your reporter—and you in turn speak or write to many, yours is the greater contribution to any resulting harm to the subject. In such situations it is best to use double and triple sources, use documents, and use public records. An accurate quote does not grant you absolute protection.

13. Do not use confidential sources in those situations in which an accusation is made. Should your source insist upon making an accusation, insist that it then be on the record.

14. Double-check pictures of criminals and indicted persons to make sure that they are of the correct person and that use will not endanger that person's chances of receiving a fair trial. In broadcasting, use an audio identification and, when possible, a visual identification.

15. Get releases from minors or institutions giving you permission to use their pictures. A written consent form should do nicely. Because news photos frequently survive as feature photos, it is a good idea to get releases when possible. Always get releases for non-news photos.

16. Headlines may of themselves provide the basis for a libel suit. Make certain that the headline matches the content of the story, that it is accurate, and that it is not open to a libelous interpretation.

17. Avoid guilt by association. If you have an accurate story about Smith being a crook, do not mention his prominent friends unless there is evidence that they were aware of or party to his illegal

activities. Although it makes interesting reading to include associates, the legal cost can be high.

18. Play lawyer yourself while writing or producing the story. Think through the potential problems. Use other reporters, editors, lawyers, and others to do the same. Anticipated problems can often be eliminated by redrafting or modification. Others can successfully be defended because of record keeping or procedural change. Note: Confidentiality is not compromised by providing editors with the names and backgrounds of confidential sources. Caution: Some courts will be prejudiced against a journalist who grants confidentiality. Provide confidentiality only after considerable thought.

19. If you are sued for libel, always use a communication attorney; general practitioners might not be sufficiently knowledgeable in the field to adequately (or successfully and efficiently) defend you. In addition, when in doubt about whether a story is libelous, consult an attorney. As an editor, keep in mind that you will be named personally in any charges that are filed because of your story or clip; you therefore have a special need to have such counsel.

Privacy

Compared to libel, privacy is a fairly recent legal concept. Libel has been around for centuries. Privacy is a twentieth century phenomenon. The right of privacy has achieved some constitutional standing in the federal courts and has been accorded either constitutional or common law status in most states. Some states have specific privacy laws. Consequently, legal privacy can mean one thing in some places and something else in others.

Most of us think of privacy as the right to be left alone. Legal privacy covers more than that, however. There are four major areas of privacy: appropriation, intrusion, publication of private facts, and false light.

Appropriation. Appropriation, or the right of publicity, is the right to use one's name and image for one's own benefit. It means that someone else should not take your name, your face, or your property and make money from it without your consent. For instance, an advertisement that uses your face or name in endorsing a product is illegal unless you have given your consent.

Newspapers make money in part by printing the names and pictures of people who are in the news. Generally, appropriation does not apply to news organizations, however. Courts have ruled that people who are in the public eye and who make news do not have the right of appropriation when it comes to their newsworthy activities. If a person makes a speech that is open to the public, he or she may be photographed, and those pictures may be run as part of the coverage of a news event. This is true only as long as the coverage is demonstrably newsworthy. If the news organization used the photograph in some other way, however, the question of appropriation might arise.

Intrusion. Newspeople may not go onto private property to gather information or to take pictures without the specific or implied consent of the property owner or legal resident. Nor may photographers use long-range lenses to

take pictures of people in private places. Journalists are also barred from going into places where police or firefighters are investigating incidents unless there is a general policy allowing access or unless they have been specifically invited by the investigating officials.

If journalists take pictures or describe the activities of people in public places—places that can be viewed by the general public—such pictures or descriptions are not considered intrusion. If a photo or description focuses attention on a person or small group and there is a possibility of embarrassment or harm to someone's reputation, that coverage could be the basis for a privacy action. If journalists illegally enter a place that is barred to the public or if they misrepresent themselves to gain entry, they may be guilty of intrusion.

Intrusion differs from other parts of privacy law in one important respect: The intrusion occurs when the illegal act occurs, not when something is published about it. Not long ago, intrusion was considered a minor problem for journalists, but recent court cases and the closing of many places to journalists have increased the possibility that a journalist might be accused of intrusion. The increased use of data retrieval systems and data banks to store private information also represents a danger for journalists. The journalist might not always realize when he or she is engaging in intrusive behavior.

Publication of private facts. The courts have deemed that some information is too private or embarrassing for publication, particularly when it concerns people who are not well known. Courts have been reluctant to define what facts may be too private or embarrassing for publication because of First Amendment considerations, but journalists still need to be careful.

An area that could mean trouble for media defendants here is the "passage of time." Publication of private or embarrassing facts may be defended at the time because of their newsworthy nature. However, republication at a later date might not have the same defense. Some courts have ruled that newsworthy subjects can cease to be newsworthy after the passage of time, but they have not been specific about how much time must pass before this occurs. Editors should take care in such situations to make sure that the subjects they are writing about are still newsworthy and of public interest.

False light. Creating a false image of a person or placing that person in an atypical light can put an editor and a publication in legal difficulty. For example, a publication might run a story about mob control of gambling casinos and illustrate the story with pictures of people around a blackjack table. Those people might not be connected with organized crime, but their appearance with the story could place them in a false light. As such, they might have the basis for a successful suit against the publication.

Another area of false light is the inventing or fictionalizing of incidents about a real person. Several years ago a man wrote a book about a famous baseball player in which conversations between the player and acquaintances were reported verbatim. It turned out that the writer had made up these conversations, and the baseball player successfully sued the writer for placing him in a false light. The mixing of imagination and fact—adding detail, constructing conversations, and otherwise augmenting reality—is genuinely dangerous for journalists. Such activities, of course, are not the standard procedure for responsible journalists, and we would hope that journalists would have little fear of this area of privacy law.

False light is important to journalists, however, because of its connection with libel law. Often, when libel suits are filed, they contain concurrent charges

of invasion of privacy and false light violations, and publications must defend themselves against these charges. It is sometimes difficult to defend against both these charges.

Defenses against Invasion of Privacy Charges

Two defenses are available for journalists who are charged with some varieties of invasion of privacy: newsworthiness and consent.

Newsworthiness. We have already referred to the newsworthiness of a subject several times in this chapter. Because of the First Amendment, courts have been reluctant to place limits on the editorial discretion of editors. Judging what is and is not news is the job of journalists, not judges. Consequently, newsworthiness, according to modern and accepted definitions of news, is a strong defense. Journalists are expected to cover events that are important and of interest to society, as long as they do so within the law. Courts have been generally willing to protect them in that activity.

Consent. Consent is a strong defense if it is obtained properly and given by people who can give their consent. Some people, such as children and the mentally handicapped, cannot always give their consent. However, consent to interview or to enter places, when it is given by authorized people, can be valuable to journalists. As a rule, photographers should carry picture release forms with them at all times and should ask their subjects to sign the forms if there could be any question about invasion of privacy. The same is true for all reporters who are dealing with non-news subjects. Although the granting of an interview is usually viewed as implied consent, some courts do not always hold to this view.

News Gathering

Journalists are encountering many difficulties in gaining access to places where news occurs and in getting records necessary for news stories. They are also coming under fire for wanting to keep certain information, such as sources, confidential. Legislatures and courts have had much to say about these controversies recently. Although many of these situations initially involve only reporters, it does not take long for editors to be brought into them. Editors should know the law thoroughly in these areas so as to be able to give the proper direction to reporters.

Access to places. One of the few victories that journalists have gained recently in the area of access to places was contained in the U.S. Supreme Court's 1980 *Richmond Newspapers* v. *Virginia* decision. The court confirmed that journalists have a constitutional right to gather news—something it had never said before—and that they have a limited right to gain access to places where

news occurs. However, *Richmond* and later cases following its reasoning have been limited to access to courts.

Journalists are still restricted from many places where news can be obtained. As we mentioned earlier, reporters may not automatically have access to places where police or firefighters are investigating incidents. Access to these places is often controlled by a "custom and usage" rule—that is, what has been done before will be upheld as the rule. Courts have also ruled that officials may restrict access to federal prisons and prisoners.

State open-meeting laws have helped journalists to gain access to meetings of many government and quasi-governmental bodies. These laws require that most sessions of city councils, county commissions, school boards, and other regulatory bodies be open to the public, and they usually require that proper public notice be given of such meetings. There are weaknesses in many of these laws, however. Many states allow or require closure of meetings when the "name and character" of a person are being discussed. Because many topics can be discussed under this heading, this exemption allows officials a lot of leeway in closing meetings. Journalists should work for narrow interpretations of these exemptions and for changes in the laws to allow greater access to meetings of public bodies.

At the federal level, an open-meeting law requires that meetings of regulatory bodies be open to the public. Consequently, journalists now may attend most meetings of the various regulatory commissions. The flaw in this law is that staff meetings are not included. As a result, journalists who cover the federal agencies have said that the federal open-meeting law has not had much effect on their ability to report on the agencies' activities.

Open records. Many states have laws that state that certain city, county, and state records must be open to the public. By the same token a number of laws restrict access to records, particularly medical records of people housed in state institutions, records of juvenile justice, and records of welfare and child assistance. What journalists should also realize is that many city, county, and state officials are as unaware of records laws as are most citizens. When officials try to withhold records from journalists, they should always be challenged, and journalists are at a distinct advantage when they know the law thoroughly.

The Freedom of Information Act (FOIA) governs access to records at the federal level. The act was passed originally in 1966 and amended in 1974 and has the purpose of making available to the public as many records and documents as possible. The act contains nine exemptions, definitions of the records that an agency may legally withhold. Each of these exemptions has been the subject of litigation, but not always to the advantage of journalists. In a number of cases the Supreme Court has refused to expand the definition of a record and has granted agencies the right to refuse to release records in a number of questionable instances.

Getting records under the FOIA is a lengthy and sometimes costly procedure. Identifying what records are to be requested is often the most difficult part of the search. Agency public information officers and the *Federal Register* can help in this regard, but the journalist should be as specific as possible. When the identification has taken place, a letter should be written to the appropriate agency requesting the documents under the FOIA.

If a request is denied, an appeal should be made to the agency. This appeal must be filed soon after the denial. If the appeal is denied, a court suit may be

initiated. Journalists should remember that the FOIA applies only to agencies of the federal executive branch, not to Congress or the judicial system. They should also remember that requests, and lawsuits, can be expensive. Although agencies can find many reasons for withholding records, the FOIA needs to be used to the fullest extent and expanded by journalists. Its original intent—to make government more open—is in line with the intent of the First Amendment, and journalists have a responsibility to see that this intent is carried out.

Shield laws. The question of the journalist's privilege, or shield, has also been the subject of much controversy during the last two decades. Journalists have argued that they have the right to keep certain information (such as the names of sources) confidential even from police or courts. This privilege between a journalist and a source, they say, is much like that granted to lawyers and clients or to doctors and patients. Because many journalists use confidential sources in gathering information, many journalists believe that such a privilege is necessary if they are to remain effective.

More than half of the states have recognized this need and have enacted shield laws that give journalists some protection from having to reveal the names of sources during criminal investigations or court proceedings. Shield laws come with a variety of inherent problems, however. Some shield laws define journalists so narrowly that not everyone who considers himself or herself a journalist is protected by the laws. Other shield laws provide so many exceptions that they become meaningless. Because shield laws are state laws, the protection that they provide varies from state to state. Finally, courts have interpreted shield laws narrowly. There have been several instances in which journalists have gone to jail for failing to reveal information even in states that have "strong" shield laws. In general, shield laws today offer journalists little in the way of protection if a judge is determined to get the information that a journalist has. Editors and reporters should not place too much reliance on state shield laws.

No federal shield law exists, even though Congress has talked from time to time about passing one. Current Justice Department guidelines prevent federal prosecutors from forcing a journalist to reveal a confidential source unless that information goes to the heart of a case and all other avenues of obtaining that information have been explored. In the federal courts a qualified privilege based on the First Amendment has been recognized in some instances, but that privilege is not yet a strong one and is certainly nothing that journalists can rely on.

The whole question of the use of confidential sources is an ethical one as well as a legal one, and editors would do well to come to some mutual understanding with their reporters about it. Reporters should have a clear understanding of the editors' attitude toward the use of confidential sources and their willingness to support a reporter's claim of confidentiality. Confidential sources should be used with care and caution, and shield laws notwithstanding, reporters and editors should be prepared to go to jail if a promise of confidentiality is given.

Newsroom searches. The press scored one victory for confidentiality in 1980 when Congress passed the Privacy Protection Act, which in most instances prevents law enforcement officers from obtaining search warrants for newsrooms. This came in response to police use of such warrants rather than

subpoenas to obtain information. A search warrant allows police to look at anything in the newsroom, including confidential files. A subpoena requires that certain information be produced but does not allow police to search for it. Journalists had been fearful that police would use search warrants to comb through their files at random, particularly since the Supreme Court had upheld such actions in the 1978 *Zurcher* v. *Stanford Daily* decision.

The present law requires that federal and state police officers present a subpoena for the information or evidence they are seeking except in a few circumstances. Journalists may then respond to the subpoena. Police officers may obtain a search warrant for a newsroom only to prevent physical harm to individuals or in cases in which national security information is involved or a journalist is believed to have committed a crime.

Constant Vigilance

The words of the First Amendment can be read as both a legal and a social statement. Legally, they grant certain rights and freedoms to all citizens. Socially, the words of the First Amendment describe a free and open society in which citizens can gather peaceably and talk with whomever they choose; where they can speak and write what they want to; where they can worship, or not worship, as they please; and where they can petition their government and engage in the political process without fear of repression.

These freedoms are delicate, however, and each of us can find good and rational reasons to restrict them. As editors and professional communicators, however, our inclinations should be to resist such attempts at restricting First Amendment freedoms. The ability of citizens to think, speak, and write freely is one of the few things that makes this nation different from most others in the world. Editors should take these freedoms personally and should work for their protection and expansion. It is their professional responsibility to do so, certainly, but more important, it is their social responsibility.

Appendix A
Copy Editing Symbols

The marks shown here are some of the most commonly used copy editing marks in journalism.

Indent paragraph	The president said
Take out letter	occassionally
Take out word	the red hat
Close up words	week end
Insert word	take the money and run
Insert letter	encyclopdia
Capitalize	president washington
Lowercase letter	the President's cabinet
Insert hyphen	up to date
Insert comma	Sept. 8 1948
Insert period	end of the sentence
Insert quotation marks	the "orphan quote
Abbreviate	the United States
Spell out	Sept. 2001
Use figure	one hundred fifty-seven
Spell out figure	the 3 horses
Transpose letters	pejoartive
Transpose words	many problems difficult
Circle any typesetting commands	bfc clc
Connect lines	the car wreck xxxxxx
	injured two people

Appendix B
Diagnostic Test

This test contains items in three categories: grammar, spelling, and punctuation. Some items are easy; others are hard. Do your best to answer all items within the one-hour time limit.

Part I. Grammatical Usage

Directions: Read each sentence and decide whether there is an error in usage in any part of the sentence. If you find an error, note the letter printed immediately after the wrong word or phrase, and write that letter on your answer sheet. If you do not find an error, write the letter "E." No sentence has more than one error. Some sentences do not have any errors.

> Sample:
> Roger, Jane, (A) and Henry is (B) coming to (C) the party at (D) our house.

In this sentence, "is" is wrong. Place the letter "B" on your answer sheet.

> Sample:
> The (A) Indian (B) flung (C) his tomahawk (D) at the intruder.

In this sentence there is no error before any of the letters; therefore, an "E" should be written on the answer sheet.

1. Its (A) up to him (B) to complete (C) the job on time, according (D) to the contract.
2. Whatever the consequences, (A) he (B) and her (C) must unfailingly be absolved (D) of all responsibility.
3. The Spanish took the first printing press (A) in North America to Mexico City, where it's (B) first issue (C) was a religious (D) work.
4. Armbruster confessed that, unlike most men, (A) he actually (B) enjoyed the procession (C) of fad's (D) in women's hats.
5. "It's (A) she!" (B) Conrad breathed softly as the spotlight illuminated (C) for a moment (D) a hauntingly beautiful face in the crowd.

291

6. Having (A) fought in World War II, (B) your Aug. 25 editorial, (C) "Civilian Casualties in Vietnam," (D) is puzzling.

7. Although (A) Drake was not expected to give UCLA much of a battle, everyone (B) got their (C) money's (D) worth when the Uclans finally won in overtime, 85–82.

8. Each one of the Miss Teen-Agers were (A) judged on her (B) talent, her (C) poise and her (D) personality.

9. They invited (A) my wife and I (B) to the party, but neither (C) of us was (D) able to go.

10. If you hope to use the English (A) language correctly, (B) you must be sure each (C) pronoun agrees with their (D) antecedent.

11. Among the countries (A) that fought over feudal (B) claims during (C) the 12th century was (D) France and England.

12. Among the 10,000 people (A) who sometimes lived at Louis XIV's (B) Palace of Versailles were hundreds of parasites (C) and hangers-on. (D)

13. "Lay (A) down and be quiet for an hour," (B) he ordered. "If you make a sound, I'll (C) skin you alive." (D)

14. The 6-year-old (A) boy was just sitting (B) there in the ruins, (C) trying (D) not to cry.

15. After lunch she laid (A) down for a nap, (B) but the doorbell rang (C) before she could fall (D) asleep.

16. Its (A) one of the fastest-growing (B) and most profitable (C) lines in (D) the entire steel industry.

17. Whom (A) do you think will be eliminated (B) in the semifinals (C) of the golden gloves tournament (D) Saturday?

18. He was tall, dark, and (A) good looking, (B) in the lean-and-hungry (C) tradition (D) of the American West.

19. "I wonder who's (A) bicycle (B) this is," the patrolman (C) mused as he stood at the scene of the mysterious (D) crime.

20. According to my uncle's (A) will, the automobile will be her's (B) and the colonial (C) furniture (D) at the house will be mine.

21. Henry was elected chairman by unanimous (A) vote, and (B) will officiate only at irregular (C) intervals. (D)

22. Neither of the winners were (A) willing to shake hands after the disastrous (B) match at Wimbledon (C) last (D) year.

23. The crow is often thought of as a predator; (A) hence, (B) it's (C) function as a scavenger (D) is sometimes overlooked.

24. There (A) he stands on the bluff, looking (B) moodily (C) across the Mississippi toward (D) the lost lands of his ancestors.

25. She, (A) as well as many others of her sex, do (B) not appreciate (C) the fine art of wrestling. (D)

26. Nobody (A) is more (B) generous (C) than him, (D) not even my own father.

27. Quentin payed (A) his debts in full; (B) then, almost penniless, (C) he began the promotion that was to make him (D) a millionaire, once more.

28. Swinging from the telephone wire, they (A) saw the remnant (B) of a kite's (C) tail and some tattered (D) paper.

29. The Optimists Club and the newer (A) group, the Civic Society (B) for Advancing Commerce and Culture, was (C) helping in the drive. (D)

30. A box of tongue (A) depressors (B) are (C) a useful object (D) to have around the house, according to a report in the "AMA Journal."
31. He (A) and she (B) makes (C) big plans to honor the seven well-known (D) guests.
32. Only (A) one of us are (B) going to town today, although (C) three of us (D) will go tomorrow.
33. The rose smells sweetly, (A) particularly (B) when it blooms in a southern garden bathed (C) in the light of an early August (D) moon.
34. The seven-man (A) team gives (B) it's (C) trophies to its (D) sailing club.
35. The oldest (A) twin was born (B) shortly before midnight (C) on Dec. 31, 1834, in the midst (D) of one of the worst snowstorms of the century.

Part II. Spelling

In some of the following groups of words, one word may be misspelled. If you find a wrongly spelled word, note the letter printed before it and write that letter on your answer sheet. If you think all four words are correctly spelled, write "E" on the answer sheet.

36. a. bountry
 b. certain
 c. audible
 d. bankruptcy
 e. none wrong
37. a. development
 b. deceitful
 c. allies
 d. cheif
 e. none wrong
38. a. abscess
 b. condemn
 c. accommodate
 d. committee
 e. none wrong
39. a. caulk
 b. drowned
 c. artillery
 d. bananas
 e. none wrong
40. a. equaled
 b. battalion
 c. basically
 d. boisterous
 e. none wrong

41. a. customary
 b. contemptable
 c. buries
 d. chauffeur
 e. none wrong
42. a. unanimous
 b. vaccinate
 c. warrent
 d. yield
 e. none wrong
43. a. varicose
 b. coller
 c. wherever
 d. zephyr
 e. none wrong
44. a. exorbitant
 b. entrance
 c. fundamental
 d. fragrent
 e. none wrong
45. a. guidance
 b. hopeless
 c. ghost
 d. heroine
 e. none wrong

46. a. itself
 b. judicial
 c. irrevelant
 d. knowledge
 e. none wrong
47. a. ptomaine
 b. rehearsal
 c. rhyme
 d. seperate
 e. none wrong
48. a. utility
 b. verified
 c. wholly
 d. until
 e. none wrong
49. a. wheather
 b. yourself
 c. visa
 d. zoology
 e. none wrong
50. a. encourage
 b. frivolous
 c. gueusome
 d. hazardous
 e. none wrong
51. a. interfere
 b. loneliness
 c. menu
 d. nullify
 e. none wrong
52. a. annual
 b. accomodate
 c. forty
 d. height
 e. none wrong
53. a. ladies
 b. khaki
 c. illiterite
 d. jealous
 e. none wrong
54. a. alot
 b. bureau
 c. article
 d. biscuit
 e. none wrong
55. a. defendent
 b. chimney
 c. detriment
 d. continually
 e. none wrong

56. a. tariff
 b. sherrif
 c. radiator
 d. quarter
 e. none wrong
57. a. ambiguous
 b. built
 c. chassis
 d. desperate
 e. none wrong
58. a. gnawing
 b. February
 c. handkerchief
 d. economize
 e. none wrong
59. a. recieve
 b. knuckle
 c. immigrate
 d. legislation
 e. none wrong
60. a. kindergarten
 b. lavender
 c. immovable
 d. inaccuracy
 e. none wrong
61. a. magizine
 b. nearby
 c. oblige
 d. pageant
 e. none wrong
62. a. pathos
 b. obscene
 c. necessary
 d. mahagany
 e. none wrong
63. a. nickel
 b. occurence
 c. necessary
 d. paralysis
 e. none wrong
64. a. indetify
 b. pendulum
 c. monstrous
 d. neutral
 e. none wrong
65. a. rarity
 b. quietly
 c. sauerkraut
 d. temprament
 e. none wrong

Part III. Punctuation

Read each sentence and decide whether there is an error in punctuation at any place in the sentence. If you find an error, note the letter printed immediately after the place where the error occurs and write that letter on your answer sheet. If you think the sentence is punctuated correctly, write the letter "E" on your answer sheet. No sentence has more than one error. Some sentences do not have errors.

Sample:
The tough, (A) hard-(B) boiled center (C) began to cry, (D) his leg was broken.

In this sentence the comma after cry is wrong; it should be a semicolon. Therefore the letter "D" should be written on your answer sheet.

66. The average person (A) is not financially able to do a great deal of traveling, (B) therefore, (C) he will probably never have the chance to see the places he reads about. (D)

67. The executioner, (A) who inherited his rituals from his father and grandfather (B) reported only the customary, doleful (C) "It is done!" (D) to the commissioner of police.

68. In his long, (A) glowing letters to his son-in-law (B) in the old country, Old Jules, (C) the patriarch of the settlement (D) made the desert seem like an Eden.

69. Knowing nothing, (A) of the terms of the contract, (B) Peterkin hesitated; (C) nevertheless, (D) driven by anxiety, he signed it.

70. Waters said that the network documentary depicting hunger among migrant workers did not startle the American people, (A) it only stirred them momentarily in their (B) "fat," (C) smug complacency. (D)

71. Columbus' (A) luck changed (B) after he made three acquaintances; (C) a shipbuilder, a financier (D) and a friend of the King of Spain.

72. Since air is dissolved by water at the surface (A) the shape of an aquarium is important; (B) too small an opening (C) may cause an oxygen deficiency. (D)

73. The dean, (A) so far as I could tell (B) shared my feelings; (C) but he made little effort to establish responsible student government. (D)

74. The hot (A) days of summer (B) make me feel (C) that I could cheerfully leave Dubuque, Iowa (D) forever.

75. For breakfast (A) I usually have an egg, (B) some toast (C) coffee (D) and a glass of prune juice.

76. "Get off at the next main intersection," (A) the bus driver shouted. (B) The (C) park entrance is two blocks to the right." (D)

77. Last night's (A) paper had been used (B) to wrap garbage (C) but I found one dated two weeks (D) earlier.

78. Mrs. Bones tried not to gasp as she viewed her daughter's garb; (A) pointed black tights (B) and skirt, orange lipstick (C) and bleached yellow hair pulled back (D) in an untidy bun.

79. The assistant (A) who ordinarily is highly efficient, (B) was all thumbs (C) in today's (D) experiment.

80. A week later the murder remained unsolved, (A) however, (B) Lt. (C) Holmes' (D) squad had discovered some new clues.

81. He wasn't (A) much help on the farm that year, (B) he was always off chasing butterflies and (C) looking for birds' (D) nests.

82. The night manager (A) said that he sought a man who had four qualities (B) in particular: (C) honesty, (D) imagination, inquisitiveness and responsibility.

83. "Usually, (A) he wasn't (B) available (C) Jane, so we had to find another helper," (D) Farley explained to the girl.

84. Harvey soberly told the group that, (A) "there's (B) not a chance" (C) of repairing (D) the heavily damaged bridge.

85. Members of the advisory (A) board were as follows; (B) John Fox, Miami; Joseph Horn, Denver; (C) and Arthur Block, (D) Pittsburgh.

86. "If I'm (A) not allowed to go (and I suspect I won't be), (B) I'll (C) just have to make the best of a dull vacation here," (D) Mary said.

87. The governor's (A) temporary financial adviser, (B) had no time for what he considered (C) stupidity (D) but was tolerant of laziness.

88. Twenty-five tons of TNT (A) were used in blasting the 300-(B) foot tunnel (C) at the west terminal of King's (D) Highway.

89. The award went (A) to George Kellers, (B) 17, (C) of 2345 Heather Dr., (D) who submitted a group of five poems.

90. "I can't (A) find Liechtenstein on this map," said Lovel, (B) "but (C) my best guess is that its (D) near Switzerland."

91. Finally grasping Twain's (A) purpose (B) in retelling (C) the story (D) the crowd roared.

92. The Clean Government Society, (A) an organization (B) opposed to the present (C) city administration (D) will meet tonight.

93. The Indian ambassador said (A) that Americans shouldn't (B) expect developing nations (C) to copy the United States' (D) economic institutions.

94. "You'll (A) never understand Victorian (B) England, (C) Myrtle (D) unless you grasp the significance of the Industrial Revolution," Miss Prentice lectured her pupil.

95. Jasper W. Whipp, (A) grand kleagle of the Hominee County chapter (B) thundered, "The time has come (C) to return to the robes and the torches!"(D)

96. The busy housewife (A) may walk 20 miles a day (B) and never leave her home, (C) furthermore, a lot of travel (D) may be up and down a flight of stairs.

97. Snow choked the sidewalks, (A) streets and highways and buried the bushes (B) and park benches, (C) it covered windows and doors of the ranch- (D) style homes in suburban Elmwood Heights.

98. The social worker found the little house tremendously cluttered with badly worn furniture, books, clothing and babies' (A) toys; (B) but the children were reasonably clean (C) and obviously most happy with their pleasant, (D) if somewhat untidy, mother.

99. They scraped up a hasty, (A) catch-as-catch-can (B) dinner from the assortment of canned foods before beginning the 28 (C) mile hike to the trail (D) camp.

100. In most respects the hotel (A) is admirably situated. (B) It is near the corner of Fifth Avenue and 52nd Street, (C) within walking distance of mid- (D) town points of interest.

Appendix C
Creating Charts in Excel

The spreadsheet program Excel does a good job of creating charts from numeric data. The following are some basic steps to create a chart. (The steps may differ slightly according to the version of Excel you have.)

1. Enter your data into the cells in an Excel spreadsheet and drag over it so that those cells are selected. Click on the chart icon. That will get you into Excel's Chart Wizard.

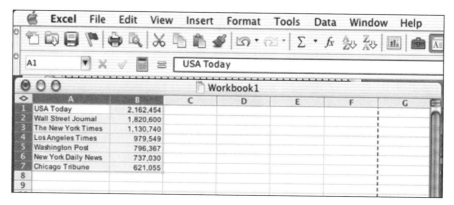

2. Chart Wizard is a multistep process that Excel uses to draw the chart. The first thing to do is select the type of chart that you want it to draw.

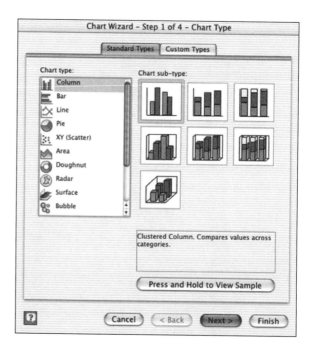

3. Chart Wizard will make an initial drawing of your chart. Here you can check to make sure that all of your data are included and that the chart is oriented in the correct way.

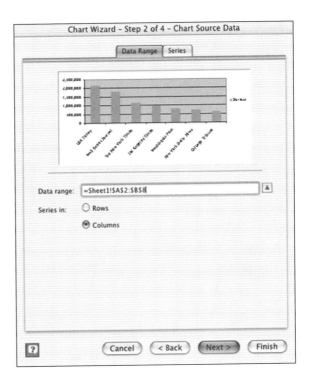

4. The next step offers you a variety of options in deciding how your chart will look. Each of the file tabs will take you into a window that will allow you to make selections about the appearance of different parts of the chart. You should explore all of these options and become very familiar with the things you can do with your chart.

5. In this particular chart, we decided to eliminate the legend because a chart that has only one type of data does not need a legend. The legend function of Chart Wizard allows us to do that.

6. The final step of Chart Wizard asks where we want to put the chart. In this case we will put it back onto the worksheet.

7. The chart will appear on the worksheet, but it can still be changed. You can do that by double-clicking on various parts of the chart. That will take you back into the Chart Wizard options.

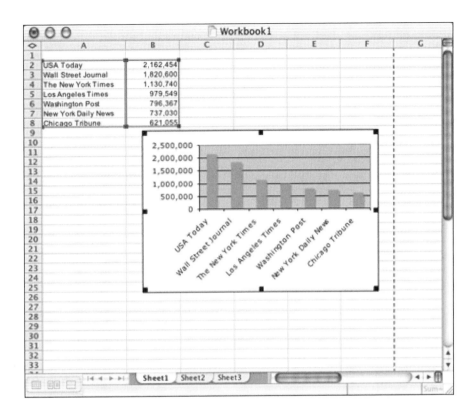

8. Here, for instance, we have eliminated the gray background.

9. In another step, we eliminated the vertical axis. We also reduced the chart horizontally by grabbing the right middle handler and dragging it to the left.

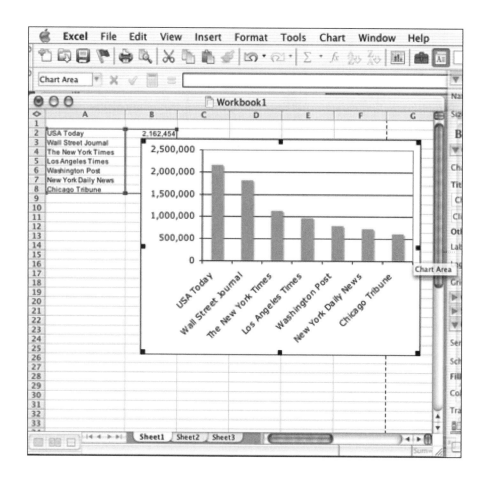

10. When you have manipulated the chart to the point at which you are satisfied, the Excel file should be saved with the chart on the spreadsheet. The easiest way to get it into Quark or another page layout program is to click on the chart and copy it into the computer's clipboard. Then go to your page layout file, draw a picture block, and paste the chart into the picture block. You should do most of your text work in the page layout program rather than trying to create much text in the Excel program.

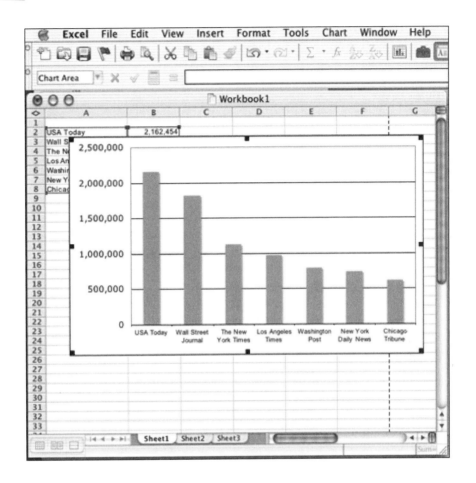

Index

Abbreviation, 56
Acceleration, of news process, 14
Accuracy, 76–80, 102
 of headlines, 140–141
 of infographics, 182
 of numbers, 78, 107, 113
 of titles, 9, 78
Action, in pictures, 160
Active voice, 28
Advertisers, 105
Almanacs, 79–80
Analytical summaries, 145–146
Apostrophes, 29
Appellate-level courts, 277
Appositive phrases, 29
Appropriation, 284
Armpitting, 237
Artistic quality, in pictures, 160
Associated Press Stylebook, 9,
 55, 56
Atlases, 79
Attributions, 10–11, 59–60, 85, 186

Balance, 58, 224, 233–234
Bar charts, 186–188, 189
Bernard, Celeste, 196
Bernstein, Theodore M., 27
Bias, 110
Bizarre situations, 6, 160
Blair, Jayson, 75, 106–107
Blogs, 245
Brevity, 84
Briefs, 84–85
Burger, Warren, 278

Capitalization, 56
Chart-based infographics, 185–188
Chicago Bulls, 133–135
Chronologies, 183
Civil cases, 276
Clarity, 80–83, 113, 182
Clichés, 11
Coaching, 103
Colons, 30

Color, in infographics, 186
Column charts, 187, 189
Commas
 appositive phrases and, 29
 between subject and verb, 29
Comma splices, 29
Community art, 157
Completeness, 8–9, 102
Compound sentences, 29
Computers
 in editing process, 4
 infographics and, 181
Conclusions, 87
Confidentiality, 59, 283, 288
Conflict, in news, 6
Conflicts of interest, 108–109
Confusion, 81
Consent, as defense against invasion
 of privacy, 286
Consistency, of infographics, 186
Constant vigilance, 289
Constitution, U.S.
 defenses against libel, 281–284
 First Amendment, 278, 289
Contractions, 29
Contradictions, 110
Contrast
 in layout, 236
 in visual logic, 224
Cooke, Janet, 107
Court systems, 276–277
Covers, magazine, 243
Credibility, 85
Criminal cases, 276
Cropping, 160–163
Currency, of news, 6–7
Cutlines, 169–171

Dangling participles, 28
Data maps, 193, 194
Dates, 57, 77
Defamation, 280
Descriptions, language sensitivity
 and, 61

Design, 222–233
 layout and, 233–239
 magazine, 241–243
 news judgment and, 239
 newspaper, 230–241
 tools of, 224–230
 visual logic and, 222–224
 Web, 243–245
Detail, attention to, 62
Dictionaries, 79
Digital photography, 164–165
Directories, 80
Disability, language sensitivity and,
 61–62
Double meanings, 142
Drama, in pictures, 157, 158
Drawings, 190–191
Dummy sheet, 242

Economy, in visual logic, 224
Editors
 beginning editing process, 7–13
 classic language books for, 37
 in editor–writer relationship,
 101–102, 103
 job of, 3–4, 12, 26–37, 102–104,
 112–113
 journalistic conventions, 57–60
 language sensitivity and, 60–62
 modern challenges for, 13–14
 photo, 156–157
 tools of, 4–5
Editor's notes, 104
Efficiency, 103
Emotion, in pictures, 157, 159
Encyclopedias, 80
Errors, common writing, 33–37
Ethics, 106–110, 167–169
Ethnicity, 61
Etymology, 32

Fair comment, as defense against
 libel, 281
Fairness, 58, 105, 110

False light, 285–286
Falsifying information, 75, 106–107
Fault, in libel charges, 280
Feature photos, 156–157
First Amendment, 278, 289
Focus
 in layout, 234–235
 in visual logic, 224
Freedom of Information Act (FOIA),
 287–288

Glass, Stephen, 107
Grammar, 9, 27–28, 32
Graphics coordinators/reporters,
 193–195, 196
Guidelines, 143–144

Headlines, 85, 133–144
 counting, 145
 defenses against libel, 283–284
 developing, 139
 in infographics, 186
 principles of writing, 140–143
 procedure for writing, 143
 role of, 136–137
 types of, 137–139
Head shots, 157
Homonyms, 32–33
Honesty, 105
Horizontal design, 231–233

Icons, maps and, 193
Identification, in libel charges, 280
Illness, language sensitivity and,
 61–62
Illustration-based graphics, 188–193,
 225–228
Impact, of news, 5
Infographics, 85, 179–196. See also
 Pictures
 chart-based, 185–188, 189
 defining graphics journalism,
 181–182
 developing, 193–195
 graphics revolution and, 179–181
 illustration-based, 188–193
 type-based, 182–185
Informational summaries, 145
Inner logic, 78
Inside pages, layout of, 241
Internet, 4, 13–14
 pictures on, 165–167
 Web design, 243–245
Introduction, 87
Intrusion, 284–285
Inverted pyramid, 57, 85, 111–112

Jargon, avoiding, 81
Jefferson, Thomas, 13
Jordan, Michael, 133–135
Journalistic conventions, 57–60
Journalist's questions, 6–7

Kelly, Jack, 107
Kerning, 227

Label headlines, 137
Language
 editors as keepers of, 37
 sensitivity to, 60–62
Layout
 guidelines for, 238
 of inside pages, 241
 magazine, 241–243
 news judgment and, 239
 newspaper, 233–241
 principles of, 233–236
 rules of, 236–239
Leading, 226
Leads, 8, 58
Legal issues, 225–289
 constant vigilance, importance
 of, 289
 First Amendment, 278, 289
 legal system and, 276–278
 libel, 279–284
 news gathering and, 282–283,
 286–289
 privacy, 284–286
Lexicon, 32
Libel, 12, 279–284
 constitutional defenses against,
 281–284
 defenses against, 281–284
 false light and, 285–286
 guidelines for avoiding, 282–284
 libelous words, 279
 requirements for, 280
Line charts, 188, 189
Linking, 245
Lists, 182, 183
Load time, 245
Location
 infographics and, 195
Locator maps, 192–193
Logic, 78, 113
 of headlines, 141
 visual, 222–224
Logos, maps and, 193
Long narratives, 86–87

Magazine design, 241–243
Maps, 191–194

Mathematics, 107, 113
Modular design, 232, 233
Mood, 9
Mug shots, 157

Names, accuracy of, 9, 78
Narratives
 long, 86–87
 short, 85
News, making of, 5–7
News editors, 239
News gathering, 282–283, 286–289
Newspapers
 design in, 230–241
 layout in, 233–241
 variety of other news outlets, 14
News photos, 156
Newsroom searches, 288–289
Newsworthiness, as defense against
 invasion of privacy, 286
New York *Times*, 75, 76, 106–107
New York Times v. *Sullivan*, 280,
 281–282
Nouns, as verbs, 35
Numbers
 accuracy of, 78, 107, 113
 graphics reporters and, 195
Numerals, 56
Nut graph, 87

Objectivity, 9, 58
Offensive action, 12
Official Congressional Directory, 80
Open-meeting laws, 287
Open records, 287–288
Organizational charts, 183–184, 185

Parallel construction, 35
Paraphrasing, 10, 85
Parker, Bill, 133–135
Participles, dangling, 28
Passive voice, 28
Percentage, 107, 113
Percentage of change, 107, 113
Phonology, 33
Photographs. *See* Pictures
Photoshop, 165
Phrases, appositive, 29
Pictures, 165–171. *See also*
 Infographics
 cropping, 160–163
 cutlines, 169–171
 digital photography, 164–165
 drawings, 190–191
 editing, 165
 ethics and, 167–169

illustration-based graphics, 188–193, 225–228
proportionality, 162, 163
selecting, 157–160
taste and, 167–169
types of, 156–157
on the Web, 165–167
Pie charts, 188, 189
Places, accuracy of, 78
Plagiarism, 108
Plurals, 31
Point-of-view bias, 110
Possessives, 29
Precision, 102, 112–113, 142
Privacy, 109–110
defenses against invasion of, 286
invasion of, 284–286
Privacy Protection Act, 288–289
Privilege, as defense against libel, 281
Prominence
of news, 5–6
of pictures, 160
Pronouns
pronoun-antecedent agreement, 27–28
sexist, 60
Proportionality, 162, 163, 229, 233
Provocative summaries, 146
Proximity, of news, 6
Publication
in libel charges, 280
of private facts, 285
Pull quotes, 182, 183
Punctuation, 9, 29–30, 56

Questions, journalist's, 6–7
Quotations, 10–11, 59–60, 85, 104, 182, 183

Race, 61
Redundancy, 12, 35, 36, 84
References, types of, 79–80
Refers, 85, 182, 183
Repetition, 12, 84, 224
Responsibility, of editors, 3–4, 12, 26–37, 102–104, 112–113
Richmond Newspapers v. *Virginia,* 286–287

St. Paul *Pioneer Press,* 2
Scoops, 2
Secondary headlines, 139
Selective reporting, 110
Semantics, 32
Semicolons, 30
Sentence headlines, 137–139
Sexist pronouns, 60
Shield laws, 288
Short narratives, 85
Simplicity, 81
of infographics, 186
in visual logic, 224
Skepticism, 105–106
Slang, 35
Sources, 59, 87
Specificity, 82, 142
Spelling, 9, 30–31, 56–57
Standards, 14
Statistical Abstract of the United States, 79–80
Step-down rule, 237
Stereotypes, 61
Stories
structure of, 8
types of, 58
Story packages, 238–239
Style, 9, 55–62
importance of, 55
nature of, 55
wire service stylebooks, 55, 56–57
Subjects
commas between verbs and, 29
subject–verb agreement, 27
Summaries, 85, 144–146
Summary box, 183
Symbols, map, 192

Tables, 182
Taste, 9, 167–169
Technical quality, in pictures, 160
Timeliness, of news, 5
Time sequence, 82
Tired words, 83
Titles
accuracy of, 9, 78
language sensitivity and, 61
Tombstoning, 236–237
Tone, 9

Transitions, 12, 82–83, 87
Trends, in news, 6–7
Triteness, 11
Truth, as defense against libel, 281
Type
in design, 224–225, 226–227
in layout, 237
type-based infographics, 182–185

U.S. Supreme Court, 277–278, 280
Unity, 86, 235–236
Unnecessary words, 84
Unusual situations, 6
Unusual subjects, of pictures, 160
Usage, 57
USA Today, 180–181

Variety, in visual logic, 224
Verbs
commas between subjects and, 29
nouns as, 35
subject–verb agreement, 27
Vertical design, 231, 232
Vigilance, constant, 289
Visual dynamics, 235
Visual logic, 222–224
Voice, 28

Weblogs, 245
White space, 228–229, 243
Wilson, E. O., 3
Wire service stylebooks, 9, 55, 56–57
Wordiness, 12
Words
commonly confused, 32–33
dealing with, 31–33
World Almanac and Book of Facts, 79
World Wide Web. *See* Internet
Writers, in editor–writer relation-ship, 101–102, 103
Writing, types of, 84–87

Zutcher v. *Stanford Daily,* 289